100 THINGS
AVENGERS FANS
SHOULD KNOW & DO
BEFORE THEY DIE

100 THINGS AVENGERS FANS SHOULD KNOW & DO BEFORE THEY DIE

Dan Casey

TRIUMPH
BOOKS

This book is available in quantity at special discounts for your group or organization. For further information, contact:

Triumph Books LLC
814 North Franklin Street
Chicago, Illinois 60610
(312) 337-0747
www.triumphbooks.com

Printed in U.S.A.
ISBN: 978-1-62937-086-6
Design by Patricia Frey
Comic book covers registered trademarks of Marvel Comics.

To my father, Joe, for always sharing his comic books, his incredible intellect, and his last Reese's Cup with me.

Contents

Introduction

Comic books have been an essential part of my life for as long as I can remember. As an only child with crippling shyness growing up in a small town outside of Boston, I found refuge in the rich, vibrant, four-color paneled worlds inhabited by the likes of Spider-Man, Captain America, Batman, and the Flash. While I read my body weight in books, there was just something about cracking open an ancient comic book, its pages yellowed by time and rough to the touch thanks to the poor quality of the paper stock. And then there's that smell. I lost my sense of smell at age 12—no horrible accident; it just went away—but the scent of comic book paper pulp is forever burned into the wrinkles of my brain. Honestly, Yankee Candle, if you're reading this story, I would pay an obscene amount of money for that elusive old-paper scent.

My father was a voracious reader and a lifelong collector of comic books, a passion that he shared with me. Some of the happiest moments of my youth were spent making the weekly trip each Wednesday to our local comic book shop, cleverly named Web Head Enterprises. Returning with a fresh haul of brand-new, hot-off-the-presses issues, we would sit at the kitchen table together with a glass of milk and a Reese's Peanut Butter Cup and tear through that week's adventures. As I grew older, I found myself curious to know more about the stories I was reading. The characters had been so elaborately created I wanted to know their history, the backstory of their lives (and of their creators). My father would smile and either answer my question to the best of his ability or send me scurrying down to our basement to sort through the sea of boxes of comic books he kept down there. It was like having my very own Library of Alexandria filled with all the superhero stories my young heart could desire.

Being an only child, I enjoyed the solo characters well enough, but the stories I enjoyed most brought all of my favorite characters together to fight against impossible odds. Perhaps it was my innate desire for friends, but I think it's that team books are just a lot more fun, period. In particular, DC Comics' *Justice League* and Marvel Comics' *Avengers*, two titles that assembled the A-list of their respective universes, were particularly appealing, largely because of their strong archetypes and straightforward storytelling, but also because they got to hang out with Batman on the regular—no small detail to this young reader. As I grew older, however, that fable style of storytelling stopped interesting me; I found myself drifting more towards Marvel's characters, which felt more grounded in reality, more steeped in the kind of struggles and experiences I was having as a teenager. Yes, the Avengers were Earth's Mightiest Heroes, but they were deeply flawed in their own ways, and had to deal with many of the same human struggles that plague most societies, from domestic unrest to alcoholism. Though such hardships had not touched my life, I recognized them as very real and very human, and I appreciated the depths to which these writers were willing to go to inject that human element into their characters.

To say I was elated when *X-Men* opened in theaters would be a gross understatement. What I didn't expect, however, was my instant rise to comic book–guru status among my peers. They peppered me with questions about the genesis of the comic book characters, some of the same burning questions I had posed about their backstories. They also asked about the accuracy of their cinematic counterparts, an important question, especially for those raised on the "real thing." When the *Spider-Man* films followed a few years later, I felt like Hollywood was finally beginning to speak my language; I felt at home because I could recognize the essence of the real Spider-Man in the Hollywood version on screen.

Fast-forward to 2008 and *Iron Man* hits theaters, creating a certified phenomenon and making "Tony Stark" a household name,

something that I never in a million years would have dreamed possible. Moreover, the phenomenon was only just beginning. When *Avengers* opened in 2012, it grossed more than a billion dollars at the box office. Suddenly, my little hobby wasn't just a hobby—it was a part of the cultural zeitgeist and the foundation of my career in entertainment journalism. Seriously, you can't imagine my amusement when I realized that my years of poring over back issues of *West Coast Avengers* and *Amazing Spider-Man* in my basement turned out to be one of my greatest assets in my professional life.

Today, Marvel Studios is one of the most powerful movie studios in the world, with the ability to routinely attract some of the biggest movie stars on the planet. Reading comic books, while still inherently nerdy, is no longer a niche hobby. With the immense success and popularity of these large-scale productions, I think it is safe to say that reading comic books has become a cultural pursuit—all thanks to the Avengers, Earth's Mightiest Heroes, who have been fighting the good fight since 1963. Now with more than 10 films under their belt, Marvel is poised to take over hearts and minds the world over with its highly anticipated *Avengers* sequel, *Avengers: Age of Ultron.* Those of us who are longtime fans were over the moon when we heard that Ultron was going to be the bad guy in the Joss Whedon–directed sequel (and that James Spader would be playing him), but what about the casual fan? With more than 50 years(!) of backstory, history, and labyrinthine storytelling, Marvel has a daunting amount of history behind it. If you thought learning all the names on *Game of Thrones* was hard, you clearly haven't tried learning all about the shapeshifting alien Skrulls. Clearly the time has come to make the Marvel Universe accessible not only to hardcore fans, but also to newcomers. After all, without new fans to keep reading comics, the industry will die out, and then there won't be anything on which to base the movies. Fortunately, this book is here to the rescue.

Rather than attempt to write the comprehensive guide to all things Marvel Comics, I set out to provide enough current and historical critical detail to satisfy any reader, whether a fan of comic books, the movies, or both. In this book, I have compiled 100 things that all Avengers fans should know *and* do before they die. My goal was to provide ample information to expand the knowledge of any reader, from the casual fan to the hardcore Marvelite. Moreover, if my efforts prove successful, this historical overview should make it easier to see and grasp the connective tissue between the Marvel Cinematic Universe (MCU) and the original Marvel comic books. If nothing else, I suspect you, the reader, will find at least a few items of historical interest with which to impress your pals while you wait in line for the midnight showing of *Age of Ultron*. I could have easily written 100 more, but this manuscript is a solid starting place from which to begin an exploration of one of the more fascinating collections of written works by some of the most imaginative minds of the last century. The information here will take you from neophyte to nuanced over the course of 100 chapters. And if I left out something you dearly love, I do apologize. Flag me down on the San Diego Comic-Con floor; I'll be there thumbing through back issues, waiting with bated breath to hear what Marvel has up its sleeve next.

1 Avengers Assemble

They have been Mighty. They have been Secret. They have been New. They have even been West Coast and Great Lakes. Most of all, they have been Avengers, Earth's Mightiest Heroes. Over the years, 102 characters have been a part of the team, with 23 honorary members and 46 having active comics of their own.[1] The Justice League may have done the superhero team genre first, but for many, the Avengers did it best. Now, over 600 issues and 50 years later, the Avengers are more relevant than ever and poised to take over pop culture as we know it once more with their highly anticipated sequel, *Avengers: Age of Ultron*. Yet, before Joss Whedon led a group of unlikely heroes to over a billion dollars at the box office, before Marvel grossed over 5.6 billion dollars at the box office, before the *Age of Ultron* was upon us, the *Avengers* was a comic book, an experiment by Marvel Comics in order to goose their ailing sales figures, and an important turning point in the company's history.

The year was 1963 and Marvel Comics was in dire need of a hit. Two years earlier, the company had found success with *Fantastic Four,* a team-up comic designed to ape the *Justice League.* Its individual comics were doing well enough, and the Marvel editorial department was really beginning to carve out a name for itself. "Enough of that 'Dear Editor' jazz from now on!" read the letters column of *Fantastic Four* #10. "Jack Kirby and Stan Lee (that's us!) read every letter personally, and we like to feel that we know you and you know us."[2] With that column, a cult of personality was born, and as the Marvel Universe grew in size, the dynamite duo at the heart of it all realized they needed to bring together some of their biggest on-page personalities. Their Distinguished

1

Competition (a nickname for DC Comics) had found great success by uniting its heavy hitters in *Justice League* in October 1960, and now it was Marvel's time to do the same.

In early 1963, Marvel, with its ever-expanding lineup of books, adopted a new narrative marketing tactic: cross-promoting its books by creating crossover appearance in their catalog of titles. Yet, Spider-Man showing up in a two-page *Fantastic Four* sequence wasn't enough for the House of Ideas. In September 1963, Stan Lee and Jack Kirby created two brand new titles: one introduces us to a cast of all-new characters, a group of misunderstood teenagers with mysterious powers that we would come to know as *The X-Men*. The other assembled together some of the best and the brightest heroes in the Marvel Universe to tremendous effect, uniting five superhero superstars against a common evil. They were the Earth's Mightiest Heroes. They were *The Avengers*.

This new configuration may have made for a spectacular team, but they began as individual heroes with very unique powers and personalities. The first *Avengers* issue found five heroes—the Hulk, Iron Man, Thor, Ant-Man, and the Wasp—coming together to stop the villainous Asgardian god of mischief, Loki. The result was dazzling, and provided Jack Kirby a vast new canvas on which to show off his eye for action, cinematic fight choreography, and keen sense of character. For Stan Lee, the main writer of most of the Marvel Comics lineup at that time, this new alliance of heroes presented a different, though arguably exciting challenge. Lee had to really hone each character's voice in such a way that would retain the individuality of each team member without diminishing the all-important sense of team unity. In essence, Lee had to help unify them without making them appear uniform. What Lee and Kirby achieved in the creation of this new team of heroes cannot be overstated.

Four issues later, Captain America joined the team, and the rest is history. Over the years, the team has undergone many

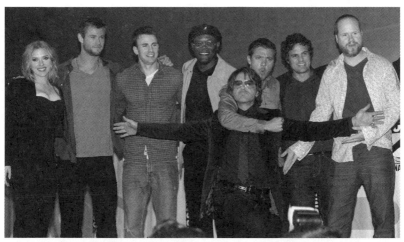

The cast at the 2010 Comic-Con. They were so young (AP Photo/Denis Poroy)

changes in creative teams, roster, and even name, but one thing has remained—their status as the premiere title and superhero group around which much of the Marvel Universe—and now the Marvel Cinematic Universe—revolves.

On July 14, 2000, Marvel Comics partnered with 20th Century Fox to unleash its most ambitious superheroic silver screen undertaking to date, *X-Men*. A box office sensation, the film grossed more than $296 million worldwide, and paved the way for nearly a dozen more Marvel films over the next decade-and-a-half.[3] In 2008, Marvel struck gold once more with *Iron Man,* and began to implement its now-famous Phase 1, a cinematic road map of sorts, outlining the construction of a cinematic universe over the course of five years. Introducing us to characters like Iron Man, Thor, Captain America, Hawkeye, Hulk, and Black Widow, Marvel Studios then pulled off its riskiest move yet—bringing their superheroes together under one banner in 2012's *The Avengers*. Under the watchful eye of fan-favorite director Joss Whedon and carefully shepherded by producer Kevin Feige, *Avengers* went from fanboy fantasy to international pop culture phenom, obliterating box office records to bring in $1,518,594,910.[4]

Now, every casting announcement is met with intense scrutiny. Every Marvel Comic is eyed by fans and Hollywood producers alike, pondering its big screen viability first and the contents of its pages second. With the unparalleled success of *The Avengers*, a new age of cinema was born, marked by a shared cinematic universe in which the different, disparate parts could have tangible effects on one another, and one in which superheroes reign supreme. This is the Marvel Age, and we are simply living in it.

2 Stan Lee, a True Believer

Before we delve into the long, storied history of *The Avengers,* both on cineplex screens and in monthly, serialized comic books, it's essential to know the many talented and dedicated people who gave birth to Marvel Comics. Contrary to popular belief, the Marvel Universe has not always existed; it was a labor of love, a culmination of years of blood, sweat, and tears from a dedicated group of men and women dating back to the 1940s. While we will address Jack "King" Kirby, the legendary illustrator and co-creator of much of the Marvel Universe as we know it today, we must first look at the Bob Kane to his Bill Finger, the most vocal cheerleader of all things Marvel, and one of the most colorful characters in comics: Stan Lee.

Before he was "Stan Lee," he was Stanley Martin Lieber, born on December 28, 1922, in a New York City apartment on the corner of West End Avenue and West 98th Street in Manhattan.[5] Growing up in Manhattan's Washington Heights neighborhood, Lieber was the son of poor, hardworking parents, and spent much of his formative years lost in the fantastic worlds of novels and Hollywood films, especially those that starred Errol Flynn playing

a dashing hero performing feats of derring-do.[6] While in school, Lieber displayed an aptitude for English composition, encouraged by teachers to pursue his writing talent professionally. Indeed, for many years, Lieber held aspirations of writing the Great American Novel. While he would never get around to writing that novel, a rich career in writing and publishing awaited him—he just didn't quite know it yet.

In late 1940, Timely Comics was preparing for *Captain America Comics* #1 to hit newsstands across the country. As readers across the country were about to meet a new star-spangled hero punching Adolf Hitler square in the jaw, Timely Comics found themselves with a brand new assistant: Stanley Lieber. Referred by his cousin, circulation manager Robbie Solomon, Lieber was looking to pursue a career in publishing, having recently been fired from the exciting world of trouser manufacturing. After a brief interview with Captain America co-creator, Timely Comics editor Joe Simon, Lieber was hired to perform menial, administrative tasks around the office.[7]

A few months later, Simon came to Lieber with a small writing job—in order to qualify for reduced magazine postal rates, text features were needed to accompany the graphic novel portion, so Simon asked Lieber to write a short Captain America story to accompany a two-panel illustration. Twenty-six inexpert paragraphs later, Lieber produced the very precisely titled "Captain America Foils the Traitor's Revenge," and signed it with a pseudonym to protect his future endeavors as a serious novelist. With that publication, "Stan Lee" was born.[8]

From that point forward, Lee (as he will henceforth be referred to), wrote an increasing amount of assignments for Timely. As Captain America's popularity continued its skyward trajectory and the stable of titles continued to grow, Lee's colleagues Jack Kirby and Joe Simon were quietly freelancing elsewhere. It was not long before a dispute over royalties and outside work arose between

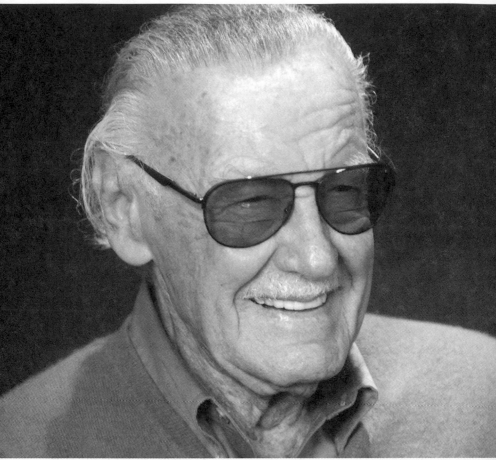

The inimitable Stan Lee in 2014. (Albert L. Ortega/Getty Images)

Kirby, Simon, and Timely Comics owner Martin Goodman, one that ended abruptly with Kirby and Simon's departure. At the tender age of 18, Lee found himself the interim editor of the entire Timely line, a job he performed with surprising aplomb, level-headedness, and joviality in spite of his relative youth.[9]

After Japan bombed Pearl Harbor on December 7, 1941, Lee turned his attention away from comics and enlisted in the United States Army Signal Corps. When those in command learned that Lee was a writer, he found himself writing training manuals for

payroll officers, instructions for tank operations, and even posters about the silent killer, venereal disease. Transferred to North Carolina and Indiana, Lee also found time to pen the occasional *Captain America* issue under the moniker of "Private Stan Lee." The book was a certified smash hit, especially during wartime, growing from 15 million to 25 million books sold per month in just two years' time.[10]

In 1945, Lee returned to Timely, only to find it was a markedly different company from the one he had left. Under the management of wartime editor Vincent Fago, Timely began producing vast amounts of humor comics, starring "funny animals." Still, Lee managed to adjust and adapt to his new environment, hiring a battalion of new editors and creative talent to churn out content like clockwork. In 1947, Lee married Joan Clayton Boocock, to whom he would have long, happy marriage. But not everything in Lee's life was quite so blissful. By the mid-1950s, the superhero genre was on the outs, Timely Comics had rebranded itself as Atlas Comics, and despite writing everything from romance to horror to Westerns, Lee found himself increasingly dissatisfied with his field of choice and even considered leaving altogether.[11]

Towards the end of the 1950s and the beginning of the 1960s, the superhero genre underwent a resurgence, thanks in no small part to DC Comics editor Julius Schwartz updating the Flash for a modern audience and pairing its heavyweight heroes like Batman, Superman, and Wonder Woman together in the Justice League of America. Yet, it was Stan Lee and his recently returned creative co-conspirator Jack Kirby who would change the name of the superhero game. After a golf game between Martin Goodman and head of rival DC Comics Jack Liebowitz, Lee was given an edict: steal the concept behind DC's *The Justice League of America* and make a version of their own. Dejected and intending on quitting, Lee went home to his wife who talked him out of it, telling him to write the kind of stories he'd always wanted to write and inject his

personality. If he was already planning on quitting, what was the worst Timely could do, fire him?[12]

As it turns out, the advice was exactly what Lee needed to hear. In 1961, Kirby and he created *The Fantastic Four.* While it wasn't exactly the *Justice League* clone Goodman was looking for. Still, the combination of aloof genius, his mild-mannered girlfriend, her cocksure younger brother, and gruff street tough turned test pilot resonated with readers. In the first issue, the characters weren't in costume, they argued among each other constantly, and they were rough around the edges. But something strange happened: it was a success. The book sold, quickly, and letters poured in by the dozens from eager, fervent fans hungry for more.

This new publication led to a rebranding of Timely Comics to the now ubiquitous Marvel Comics, and a deluge of brand new comic delights, sparking Lee and Kirby to create the Hulk, Thor, Iron Man, and the X-Men. Lee also collaborated with Sub-Mariner creator Bill Everett to create the blind lawyer-cum-crimefighter Daredevil, and with monster-comics artist Steve Ditko to create their most popular character, Spider-Man. Despite their fantastic abilities, these characters were flawed, deeply human, and resonated with audiences in a way that others had not. What's more, Lee and his Merry Marvel bullpen made waves by creating a sense of continuity between titles, a shared universe in which all of Marvel's many toys could play together.

Comics historian Peter Sanderson called Marvel of the 1960s the "counterpart to the French New Wave," noting that Lee and Kirby were "pioneering new methods of comics storytelling and character-ization, addressing more serious themes, and in the process keeping and attracting readers in their teens and beyond."[13] Nowhere was this more evident than in September 1963, when Lee and Kirby finally gave Goodman the *Justice League*-alike he wanted: *The Avengers.* No one could have predicted that the simple story at the core of *Avengers* #1, five heroes uniting to take down a rogue Norse god, would

blossom into one of the most complex, sprawling mythologies in modern comics; then again, hindsight is 20/20.

How did *The Avengers* go from 1960s comic book sensation to international icons? Well, it's complicated to say the least. Unlike many of his creative collaborators, Stan Lee wasn't a man with a singular vision. That isn't to say he was uninspired; rather, he was reactive and adaptive to what circumstances demanded. In a 2006 interview he confessed, "To tell you the truth, I think I'm probably the quintessential hack writer." Bold words coming from a man who helped give the world Spider-Man, the X-Men, the Avengers, and too many more to list. "I don't get inspirations as such. And when I don't have something to write, I'm not thinking about it at all," he said.[14] Yet, where Lee thrived was on the tight deadlines and last-minute pressures of the publishing industry. Rather than meticulously planning things out, Lee could sit down, under the gun, and churn out script after script without ever suffering from writer's block, an ability of which all of us—myself included—are intensely envious.

More than 50 years after *The Avengers* creation, it's easy to look at Lee and deify him for all that he has done for modern comics, but when it comes to Earth's Mightiest Heroes, he is but half the equation. An important half, but half nonetheless...

Hail to the King: Jack Kirby

One of the most celebrated figures in comic book history, Jack Kirby was an American original, a powerhouse of an artist who broke the mold for modern graphic novel storytelling, and a man rightly acclaimed by creators past and present alike. While Stan Lee was and remains one of the faces most associated with the Marvel

Comics brand, he was but half of the equation. From Kirby's prodigious pen erupted fantastic characters, breathtakingly dynamic artwork, and the fabric from which an entire universe was wrought. Truly, without "King" Kirby, as he came to be known, few of the Marvel Comics and even fewer of the movies would be possible.

Born on the Lower East Side of Manhattan in New York City on August 28, 1917, Jack Kirby (neé Jacob Kurtzberg) grew up in relative poverty, the son of Austrian Jewish immigrants.[15] Growing up in a rough-and-tumble neighborhood, Kirby spent plenty of time getting into street scuffles, but he also found himself escaping this surrounding through drawing. Influenced by cartoonists like Milton Caniff, Hal Foster, and C.H. Sykes, Kirby was self-taught and met with plenty of rejection until he finally found a way to show off his considerable talents by doing cartoons for the Boys Brotherhood Republic newspaper.[16]

At the tender age of 14, Kirby enrolled in Brooklyn's Pratt Institute, but left after a week. Shortly thereafter, Kirby made his entry into the world of professional artistry as an "in-betweener" (an artist who fills in the action between major frames) at Fleischer Studios, working on *Popeye* cartoons. The hectic pace and machine-like nature of the work at Fleischer bothered Kirby, who once remarked that it was "a factory in a sense, like my father's factory. They were manufacturing pictures."[17] Fortunately, the American comics industry was doing quite well at the time, and soon Kirby found himself working for Eisner & Iger, a firm that created comic books for publication elsewhere. Penning science fiction adventures, Westerns, and animal-driven humor stories for a variety of clients under various pseudonyms, Jack Kirby (a name he chose because it reminded him of James Cagney), had finally begun his career in comics.[18]

In the summer of 1940, everything changed for Kirby when he met the love of his life, Rosalind "Roz" Goldstein, in their shared apartment building. Their love blossomed quickly, and on her 18th birthday, Kirby proposed. After leaving Eisner & Iger, Kirby

began working for Victor Fox, the head of Fox Feature Syndicate, a "notoriously low-paying publisher of comic books," who put him to work on *The Blue Beetle*, the company's big star at the time and one of the first costumed superheroes.[19] While *The Blue Beetle* only ran from January to March 1940, something far more lucrative came out of Kirby's tenure at Fox: he met and began collaborating with Fox editor Joe Simon, a man with whom he would work closely for a decade-and-a-half.

The pair landed at pulp-magazine publisher Timely Comics (the future Marvel Comics) and began working on a new character, a star-spangled, square-jawed, All-American hero: Captain America. With the release of *Captain America* #1 on December 20, 1940, Timely landed a winner, and readers across the country began lining up behind their new hero. Its tale of a meek, milquetoast of an Army reject named Steve Rogers who gets transformed into a hyperstrong he-man after being administered a top-secret "super soldier" serum resonated with readers. To many, he seemed a rip-off of a similarly super-strong All-American hero, the Shield, but Kirby's dynamic artwork propelled the book to superhuman sales figures, nearly 1 million copies.

Despite Captain America's unexpected success, Kirby and Simon felt more than a little upset with the comparatively meager piece of the pie they were receiving. Having signed a contract with Timely's Martin Goodman, Kirby and Simon received 25 percent of the profits from the initial feature, and salaried positions as the company's art director and editor respectively. Now established as a creative force with which to be reckoned, Kirby and Simon felt that Goodman was reneging on his end of the deal, so they negotiated an arrangement with National Comics (later DC Comics) that would pay them $500 per week, a far cry higher than the $75 per week they earned at Timely Comics.[20] Fearing Goodman's retribution, Kirby and Simon kept the deal a secret, letting young Stan Lee in on what was happening once they discovered Lee had been

snooping around, and even then only on condition of his silence. Still, Goodman eventually found out and the pair, positive that Lee had ratted them out, left Timely Comics after completing work on *Captain America* #10.[21]

Little did he know, Kirby would soon follow in Captain America's footsteps as he shipped off to fight in World War II, Kirby married Roz Goldstein on May 23, 1942, was drafted into the United States Army on June 7, 1943, and landed on Omaha Beach in Normandy on August 23, 1944, where he served as an infantryman. Upon learning of his skills as a comic book artist, Kirby recalled, a lieutenant tasked him with the dangerous duty of sneaking forward as an advance scout on reconnaissance missions so he could draw maps and sketches of what the advancing soldiers would face.[22] Over the course of the war, Kirby fought in the campaign at Metz, earning a Combat Infantryman Badge and a European/African/Middle Eastern theater ribbon with a bronze star for his service, as well as hospitalization for severe frostbite on his feet. Ever resilient, Kirby recovered from the frostbite and was honorably discharged on July 20, 1945, when he returned to his two great loves: his wife, Roz, and the world of comics.[23]

Although the comic book market had boomed during the war, primarily due to GIs overseas ordering issues of books like *Captain America*, the postwar market was a horse of a different color. Reteaming with Joe Simon, Kirby began working for the Harvey Comics Company on a variety of mystery, western, and crime comics. Together, the duo also pioneered the popular romance comic genre through titles like *Young Romance* and *Young Love*, which they published through Crestwood Publications.[24] A brief foray into self-publishing quickly folded as Simon and Kirby found themselves facing distribution difficulties, and as the public began turning away from superhero stories and comic books in general, the one-time dynamite duo of Simon and Kirby began drifting apart, eventually parting ways in the mid-1950s.

Bouncing from one newspaper publisher to the next, Kirby continued to freelance at a frenetic pace, working on newspaper strips like Frank Giacoia's *Johnny Reb and Billy Yank* and *Sky Masters and the Space Force*, which he co-created with brothers Dick and Dave Wood. During this time, Kirby also continued working for DC Comics on books like *House of Mystery* and *Green Lantern,* and briefly for Timely Comics, which had been renamed Atlas Comics, for some penciling work.[25] For a time, Kirby was flush with work. Unfortunately, a distribution dispute led to a halt in Atlas' comics production, forcing Kirby to leave once again. It would be another year before Kirby would return to his once and future employer.

What caused Kirby to leave the generally higher paying DC Comics? In what seems like a running theme in Kirby's life, it was a contract dispute over royalties. This time, it was Kirby who found himself on the receiving end of a lawsuit, when editor Jack Schiff, who helped secure the *Sky Masters* contract for Kirby and the brothers Wood, sued for a portion of royalties owed. Several months later, even though Kirby was still bitter over his perceived mistreatment by Stan Lee, he went to work for Lee at Atlas Comics as a freelancer.[26] Both Lee and Kirby were between a rock and a hard place, financially. Many of Lee's once-successful titles had begun to wane in popularity, and Kirby, once able to command industry-leading page rates, found his connections rapidly disappearing as many left the industry to pursue careers in fields like advertising, something which never held his interest. The end of the 1950s seemed rather bleak for the men who made Marvel what it is today, but thankfully the 1960s were right around the corner.

Alongside returning artists like Steve Ditko, Lee and Kirby set to work on keeping their sinking ship afloat. Working at a furious pace, Kirby would sit in the basement studio of his Long Island home, affectionately dubbed "the Dungeon," where he would chomp cigars and churn out eight to 10 pieces of artwork each day,

a superhuman amount, working 10 hours at a stretch, mostly on monster comics.[27]

Editor Stan Lee had created a new method of producing books, what would become known as the Marvel Method: rather than starting with a completed script that the artist would then illustrate, both writer and artist would have a story conference to hammer out the beats of the story. The story would then be drawn and paced out by the artist, and the writer would add dialogue to fit the artwork after the fact. This new method of storytelling meant that artists had a greater degree of creative freedom, but that they must also be adroit storytellers in their own right. Thankfully, Kirby, and his colleagues Dick Ayers, Steve Ditko, and Don Heck, were all more than up to the task.[28]

Yet monster comics weren't as profitable as publisher Martin Goodman hoped they would be. After that fateful golf game with DC publisher Jack Liebowitz, Goodman was adamant about having his creative duo make a Marvel version of the Justice League by any means necessary. Again, though not the Justice League loo-kalike Goodman envisioned, The Fantastic Four would become a popular and lasting phenomenon. Hastily assembled and chaotically plotted, *The Fantastic Four* #1 didn't resemble anything else on store shelves on August 8, 1961. The heroes wore no brightly colored costumes, the white background gave off a less-than-finished quality, and the heroes appeared to be out of their depth in the face of a massive monstrosity emerging from the city street.[29] There was undeniable energy that crackled throughout the book's pages and its space race themes resonated with an audience yearning for escapism.[30]

The response was immediate as fan mail poured in with questions about these new, complicated characters, and the book seemed to improve with each subsequent issue. And audiences wanted more. Timely Comics had completed its transformation into Marvel Comics and launched its new line of Marvel Super

Heroes. Soon, *The Fantastic Four* were joined by other Kirby creations: in 1962, an Atomic Age Jekyll and Hyde debuted in the form of *The Incredible Hulk*; a scientist developed a serum that would shrink him to merely six inches tall, and a helmet that allowed him to control ants as Ant-Man made his debut in *Tales to Astonish;* a lifelong passion for myth and history led to Asgardian god of thunder Thor, who hammered his way on to the scene in *Journey into Mystery*; although he was too busy to pencil it, Kirby designed Iron Man, who appeared in the Don Heck–drawn *Tales of Suspense.* Practically the only character that Kirby didn't invent at that time was the supremely popular Spider-Man, created by Steve Ditko and Stan Lee after scrapping the work that Kirby had done (which was, in truth, a reworked version of a character named the Fly he'd penned for Archie Comics in 1959).[31] Still, from Kirby's prolific pen erupted a cavalcade of characters that, alongside Lee's scripts, entranced a generation of readers.

Then, in September 1963, Kirby and Lee made Marvel history once again by launching *The Avengers*. The all-star team-up gathered all of Marvel's superstars together in one book, *Justice League*–style, and really gave the sense that these heroes weren't operating in a void, but rather in one larger shared universe. The plot of *Avengers* #1 may seem simplistic by modern standards—Iron Man, Thor, Ant-Man, the Wasp, and Hulk band together to thwart Thor's brother/archenemy Loki—and it is replete with chunky, awkward blocks of text, but the dynamism of the artwork, a hallmark of Kirby's comics work, elevated the material in the eyes of readers. Four issues later, the duo dusted off another classic Kirby creation, Captain America, and inserted him into the core Avengers roster. The rest, as they say, is history. And more than half a century later, we are still enthralled by the incredible characters that Kirby (and Lee) first gave life to on the printed page many moons ago.

As an artist, Kirby's legacy is unassailable. Even when others took over on titles like *The Avengers,* Lee would bluster in the letters

page with platitudes singing Kirby's praises. "Don Heck drew this one with Dick Ayers helping out on the inks," Lee wrote in one letters column, "and you'll be amazed at how closely it parallels King Kirby's great style!"[32] Yet, as Marvel grew in size, it grew increasingly corporate, which rubbed Kirby the wrong way. In 1970, Marvel fans were shocked that, after more than 100 issues of *Fantastic Four,* and creating characters like the X-Men, Black Panther, Sgt. Fury and his Howling Commandos, and so many others, Kirby was leaving to take up an editorial position at DC Comics. He would return to Marvel from 1976 to 1978, but not nearly in as influential of a capacity as in the early days. Still, the fact remains that the House of Ideas is very much the House that Jack Built.

4 Iron Man

He may not be the most iconic comic book character in Marvel's Avengers roster, but there is no doubt that in the modern cinematic landscape, Iron Man is one of the most recognizable characters the world over. A founding Avenger, both on paper and on screen, Iron Man is essentially Marvel's answer to Batman: deeply flawed, exceedingly rich, and hell-bent on delivering justice wherever it needs dispensing. Moreover, Tony Stark is the axis around which much of the Marvel Cinematic Universe spins; he is indelibly tied to every aspect of Marvel's sprawling cinematic empire, as it was largely the success of 2008's *Iron Man* film that enabled Marvel to achieve the position of box office dominance it enjoys today. But before Robert Downey Jr. could bring Stark's snark to smiling, sharp-suited life, Iron Man was a vehicle through which Marvel could plumb the depths of the Cold War on the printed page.

Conceived at the height of the Cold War, Iron Man was Stan Lee's vision of a "quintessential capitalist hero," a collaborative vision between Lee; his younger brother and scripter, Larry Lieber; artist Don Heck; and cover artist/character designer Jack Kirby.[33] First appearing in *Tales of Suspense* #39 in March 1963, Tony Stark was an American genius billionaire playboy philanthropist who plied his trade designing and selling high-grade weaponry. Gravely wounded after being kidnapped by the terrorist leader Wong Chu during a field test of Stark Industries military hardware, Tony Stark found himself imprisoned with a piece of shrapnel lodged near his heart. In his prison cell, which he shared with renowned Nobel Prize–winning physicist Professor Ho Yinsen, whose work Stark greatly admired in college, Stark was ordered by Wong Chu to use his incredible intellect to make powerful weapons of war for the terrorist group, especially one of the battlesuits which Stark had been developing. If he complied, Wong Chu promised, the camp's surgeons would operate on Stark's ailing heart and save his life.

One does not graduate from MIT with a degree in electrical engineering at the age of 15 and two master's degrees at the age of 19 by being stupid. Clearly spotting Wong Chu's trap, Stark and Yinsen put their prodigious heads together and developed a crude suit of armor from scrap iron that was equipped with a magnetic field generator to keep the shrapnel from reaching his heart and rudimentary magnetic weaponry for defense. Stark was on the verge of death when the suit was nearly completed. The battery for the magnetic field generator was still charging when Wong Chu's men attempted to intervene and seize the weapon, but Yinsen created a diversion to buy Stark some time. Yinsen was killed in a hail of gunfire by Wong Chu's flunkies, but Stark escaped, taking revenge on his captors by tearing Wong Chu's camp apart and seemingly killing Wong Chu in an ammo dump explosion. Along with the help of American pilot James "Rhodey" Rhodes, Stark made his

way back to the United States where he struggled to adjust to his new, machine-dependent life.

Back on American soil, Stark realized that the shrapnel lodged in his chest cannot be removed without killing him, and as such resigns himself to the fact that he must wear the armor's magnetic chestplate as a regulator for his heart at all times. Positioning the frequently appearing Iron Man as his personal bodyguard and corporate mascot, Stark maintained a double life, gadding about as a billionaire industrialist by day and fighting crime as a billionaire industrialist in a mechanized suit of armor by night. Over the years, Stark's origin story has undergone several changes and updates—e.g. replacing the Vietnam War backdrop with the Gulf War or,

Suit Up!

With so many suits of armor at Tony Stark's disposal, it's only natural that others would take up the mantle of Iron Man from time to time. Indeed, over the years, a wide array of people have suited up at one time or another in order to mete out metallic justice. Over the years, ex-boxer Eddie March became Stark's alternate whenever the stress became too much to bear, longtime driver Happy Hogan wore the armor from time to time, and Jim "Rhodey" Rhodes filled in when Stark's alcoholism left him unable to properly act as Iron Man. In addition, Mary Jane Watson, Captain Britain, Pepper Potts, Bethany Cabe, Carl Walker, and Michael O'Brien all found themselves wearing a Stark-engineered suit at one time or another.

Most unexpectedly, Peter Parker's Aunt May even wore Iron Man's armor once upon a time. Sure, it was a humorous 1982 issue of *What If?* (#34, to be precise), but Mark Gruenwald and seminal Iron Man artist Bob Layton transformed Aunt May from humble mother figure to the Invincible Golden Oldie! To be fair, she's also been a herald of Galactus, so Iron Man isn't *that* much of a stretch for the woman who essentially raised Spider-Man.

(Arrant, Chris. "Top 5: People Who've Worn the Iron Man Armor (Besides Pepper Potts and Jim Rhodes)." *iFanboy.* N.p., 14 May 2013. Web. 19 Oct. 2014. <http://ifanboy.com/articles/top-5-people-whove-worn-the-iron-man-armor-besides-pepper-potts-and-jim-rhodes/>.)

on the big screen, the War in Afghanistan—but the core of it has remained the same: Tony gets kidnapped by a vicious warlord, presumably with connections to the Mandarin, and works alongside Yinsen to develop a suit of life-saving powered armor.

When Iron Man first debuted, he was used as an anti-communist hero, smashing fifth columnists and exploring the role of industry and technology in America's ongoing struggle to preserve democracy and capitalism the world over. An idealized version of the American inventor—and loosely modeled after Howard Hughes, a defense contractor in his own right—Tony Stark was an outlet through which Stan Lee and company tried to examine a culture of burgeoning corporate innovation in which individuals saw their ideas and inventions subsumed and their entrepreneurial freedom quashed under the boot of governmental supervision.

His original armor was clunky and gunmetal gray, then replaced by a marginally enhanced golden suit of armor that equipped "the Golden Avenger" with jets, drills, transistor-powered magnets, suction cups, and more thanks to artist Don Heck. It wasn't until Steve Ditko streamlined the look of the armor and added the iconic red-and-yellow color scheme that Iron Man truly began to take flight, evolving both artistically and as a character too. Later, Stark would have his shrapnel-filled heart replaced by a synthetic one after a Life Model Decoy (a highly sophisticated android body modeled to look and act like Stark) developed a personality of its own and stole his identity.[34] He would also reach his rock bottom when the pressures of his working life and crime-fighting career drove him to drinking, and led to a severe case of alcoholism, a personal demon that he eventually conquered.

Iron Man's role in the Avengers is nothing short of pivotal as he is a founding member of the supergroup, both in the comics and on the big screen. Tony Stark, his identity then a secret, also served as the group's sponsor, bankrolling everything from the Avengers Mansion to their constantly exploding Quinjets with

his seemingly limitless coffers. In addition, Stark helped uncover Captain America's comatose body, frozen in ice, during the events of *Avengers* #4, and he went on to help establish Marvel's international espionage agency S.H.I.E.L.D., whose mission was to help combat growing terrorist threats. As a character, Stark is a prism through which writers like Lee, David Michelinie, John Byrne, Archie Goodwin, Matt Fraction Warren Ellis, and artists like Bob Layton, Don Heck, Jack Kirby, John Romita Jr., Salvador Larroca, and countless others examined themes of corporate greed, the human cost of weapons manufacturing, alcoholism, loyalty, American individualism, and much more.

On the silver screen, Stark has an even more important role to play. Not only is he the face of the franchise, grossing more than a billion dollars over the course of his three standalone films, but he'll also play a pivotal role in this spring's *Avengers: Age of Ultron*. Whereas Hank Pym (the hero known as Ant-Man, Yellowjacket, Goliath, and Giant-Man) created the hyper-advanced, villainous artificial intelligence known as Ultron in the comic books, the megalomaniacal machine will be a product of Tony Stark's design in the Marvel Cinematic Universe, lending a whole new layer of depth to Stark's ongoing struggle to balance the man with the machine. Stark has never been much of a father figure, but he's going to have to learn to bring his "son" under heel fast or else it could be lights out for Earth's Mightiest Heroes. (Wouldn't it be something, though, if they all died and *Avengers: Infinity War* was a brand new cast of characters?)

5 Captain America

Blond haired, blue eyed, and completely star spangled—everything about Captain America screams "superhero." From his chiseled good looks to his trademark metal shield to his old-world sensibilities, Captain America (aka Steve Rogers) towers over the Marvel landscape. His first film's subtitle, *The First Avenger,* may be a bit of a misnomer, but there are few figures more iconic in the modern comic book and comic book cinema landscape than Captain America. In truth, Steve Rogers didn't join the Avengers until the series' fourth issue, when he was found frozen in a block of ice. Still, he is considered by many to be one of the original Avengers and has been one of the most constant and integral parts of the team almost constantly since its inception in 1963. Though, as a pop cultural institution, he predates all of his onscreen peers by nearly two decades and without the groundwork he laid, none of them would be possible.

Conceived in 1940 by Jack Kirby and Joe Simon for Timely Comics (later to be renamed Marvel), Captain America was a conscious political reaction to the actions of Germany's Nazi Party in the days and months leading up to U.S. involvement in the war. "The opponents of the war were all quite well organized. We wanted to have our say too," Simon explained.[35] *Captain America Comics* #1 told the story of Steve Rogers, a meek, scrawny youth who desperately wanted to enlist in the United States Army in order to do his part. Unfortunately, Rogers was too frail to meet the physical requirements necessary for enlistment, but he received an invitation to participate in Operation: Rebirth, a clandestine project intended to enhance American soldiers to peak physical condition using a "Super Soldier serum" designed by defected German scientist professor Abraham Erskine. Injected with the

Donning the Cap

Despite the fact that Steve Rogers has been Captain America for nearly 75 years, there have been times where the Super Soldier himself could not wield the shield for one reason or another. After Captain America disappeared in 1945, the U.S. government decided to conceal his disappearance by contacting William Naslund, the costumed hero known as Spirit of '76, and a young boy named Fred Davis, who assumed the identities of Cap and Bucky from 1945 until the 1950s, when Cap's comic was briefly cancelled. After a brief revival, Captain America was rebranded as a "Commie Smasher," and it was revealed that Naslund had died in the field of duty, replaced by a man named Jeff Mace, who previously fought injustice as the masked vigilante the Patriot. Alongside the Golden Girl, who briefly replaced Bucky, Mace fought for truth, justice, and the American way until Cap came back in the 1960s.

Others have tried their hand at filling Cap's big red boots—the criminal Carl Zante, local goon Scar Turpin, and Bob Russo, who lasted a whole entire five minutes before breaking his arm. Others lasted slightly longer, like a street tough named Roscoe who even went so far as to train with the Falcon before being slaughtered by the Red Skull, and illegally bio-engineered super soldier John Walker, who would eventually become U.S. Agent. And, of course, after Captain America was assassinated during *Civil War*, Bucky Barnes himself took up the mantle for a spell, operating as a darker version of Captain America until he was seemingly killed during *Siege*.

Most recently, it was revealed on *The Colbert Report* that Cap's longtime partner-in-crimefighting, Sam Wilson, aka/ the Falcon, would be donning the Stars and Stripes in Steve's stead. Truth be told, Wilson isn't the first black Captain America; that honor belongs to Isaiah Bradley, a man who was experimented on in an effort to recreate the Super Soldier serum in the 2003 miniseries *Truth: Red, White, and Black*. The truth of the matter is—it doesn't matter who wields the shield so long as they stand for the same ideals as Captain America himself.

(Kistler, Alan. "Who Else Has Been Captain America?." *Nerd Approved*. 21 July 2014. Web. 19 Oct. 2014. <http://nerdapproved.com/approved-products/who-else-has-been-captain-america/>.)

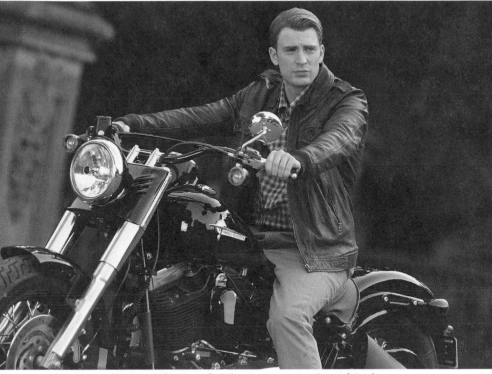

Chris Evans filming on location for The Avengers *in Central Park on September 2, 2011, in New York City.* (James Devaney/Getty Images)

secret solution and exposed to blasts of "Vita-Rays" that activated the chemical compounds, Rogers emerged a changed man—like Steve Urkel transforming into Stefan Urquelle—standing tall, with rippling musculature. By all accounts, Steve Rogers was a success, but before the experiment could be repeated, a Nazi assassin murdered Professor Erskine and, with him, any chance of replicating the process that led to Rogers' superhuman transformation.

Given an All-American uniform to counteract German propaganda, Rogers served as a counter-intelligence agent, operating across Europe and thwarting Nazi plans wherever they arose. Indeed, Captain America made quite the splash in his debut issue,

which featured a cover of Cap socking Adolf Hitler square in the jaw. Fighting alongside his trusty sidekick Bucky Barnes (named for a boy on Joe Simon's high school basketball team), Captain America did battle with evil Nazi scientists like Baron Zemo, who tried replicating the Super Soldier serum on subjects of their own, the nefarious Nazi propaganda master Red Skull, and all manner of fascists.[36] During the final days of the war in 1945, Captain America and Bucky returned to London in order to prevent Baron Zemo from launching an experimental aircraft armed with high-grade explosives. Clinging to the plane, Cap and Bucky desperately tried to disarm the device, but it exploded in mid-air, seemingly killing Barnes and sending Rogers hurtling into the ocean where he was caught in an ice floe and preserved in suspended animation.[37] It would not be until 1963 that Captain America would emerge once again to combat the evils that lurk in the hearts of men.

A man literally out of time, Captain America was haunted by memories of the past, including the death of his young ward, and struggled to adapt to life in the 1960s. This conflict between Cap's old-school sensibilities and newer attitudes toward crimefighting, justice, and government lay at the crux of many *Captain America* and *Avengers* stories as Rogers tried to reconcile the life he left behind with the one he found himself in now. With his incredible combat record, time spent fighting with WWII-era hero group the Invaders, and undeniable tactical genius, Captain America quickly assumed a leadership role and has borne the mantle ever since. Over the years, Rogers has led the Avengers against hordes of murderous androids, battled for the fate of existence itself when Thanos seized control of the Infinity Gauntlet, and even died for his beliefs in the aftermath of *Civil War*. Today he's still leading the Avengers against those who would threaten Earth (or Marvel's box office dominance) on the big screen too. Whether or not he'll be able to pick up pop culture references is another matter entirely.

6 Thor, God of Thunder

Stop! Hammer time. Normally, these words would infer that MC Hammer was about to come on your local radio station, presumably as some cruel joke, but today they serve another purpose: to let you know it's Thor o'clock. The Mighty Thor has been a mainstay of the Avengers since its formation, both on the silver screen and on the printed page, and he is widely considered to be one of the strongest heroes in the Marvel Universe, which makes sense that he stands among the ranks of Earth's Mightiest Heroes. One of the highlights of the Silver Age of comic books, Thor made his dynamic debut in *Journey into Mystery* #83 (August 1962), and was the creation of editor Stan Lee, artist Jack Kirby, and scripter Larry Lieber.[38] Though in subsequent interviews, both Kirby and Lee claim sole credit for creating Thor, officially, he is credited as being created by the trio of creative talent. On the silver screen, though, there is only one man who is considered the definitive portrayal of Thor: Chris Hemsworth.

When Thor first debuted, the character was unlike much of what Marvel had in its roster. Rather than the relatable earthbound heroes we had come to know and love, Thor was a divine being who split his time between Midgard (Earth) and the kingdom of Asgard, which served as a point of departure for him to go on heady, wild adventures across the Nine Realms. Battling Frost Giants, outwitting his mischievous brother Loki, and wielding his mighty hammer Mjolnir, Thor was more than a superhero; he was the star of a sprawling saga of which readers couldn't get enough, brought to life by Jack Kirby's fantastical pencils. According to artist Chic Stone, who inked several early *Thor* stories, "Kirby

could just lead you through all these different worlds. The readers would follow him anywhere."[39]

Raised alongside his half-brother Loki in Asgard, Thor was stripped of his memories and physical form and placed by Odin into the body of the lame-legged medical student Dr. Donald Blake, in an effort to teach him humility. While on vacation in

Have at Thee!

Apart from wielding the mighty hammer Mjolnir and his flowing blond locks, one of the most recognizable qualities about Thor is his penchant for archaic language. The Asgardian God of Thunder lobs around thees and thous with a frequency that would make William Shakespeare blush. But how accurate is that? In truth, not at all; there are many inaccuracies between Marvel's Thor and the mythological Thor. Perhaps most glaring is the fact that Thor was never exiled from Asgard to walk the Earth as the lame doctor Donald Blake. Furthermore, not only would the god of the ancient Norseman not speak any manner of English, but was a red-headed, full-bearded warrior that would likely have been more supervillain than superhero.

In the comics and films, Thor's lady love is the human Jane Foster, an astrophysicist portrayed by Natalie Portman on-screen and Dr. Donald Blake's trusty nurse in the comics; in myth, he married the warrior goddess Sif (played by Jaime Alexander). Another discrepancy: Thor can summon his hammer back to him with a mere thought and flick of his hand, whereas Norse mythology said he needed a special pair of magic gloves to make his hammer go full boomerang. Likewise, he needed a special belt to unleash the full power of Mjolnir, a detail which Marvel included in the *Ultimates* comics. You know how Thor can fly? Well, in the mythology, he can only do so by riding a chariot drawn by Toothgrinder and Toothgnasher, two of the most bad-ass goats that have ever lived. And you thought those screaming goats from the Taylor Swift YouTube parody videos were talented!

(Bricken, Rob. "8 Things Marvel Got Wrong About Thor and Norse Mythology." io9. Gawker Media, 05 Nov. 2013. Web. 16 Oct. 2014. <http://io9.com/8-things-marvel-got-wrong-about-thor-and-norse-mytholog-1458989921>.)

Thor and Mjolnir—when they show up, someone's getting hammered.

Norway, Blake encountered an alien scouting party, and fled into a cave to take refuge. Inside the cave, Blake discovered a walking stick and struck it against a rock revealing it to be the mythical hammer Mjolnir and transforming himself into the Thunder God Thor. In later issues, we would learn that Blake had always been Thor and it was Odin's enchantment that suppressed his memories of godhood, but for the early issues, Blake served as Thor's alter ego.

Working in a private practice, Dr. Donald Blake would strike his trademark walking stick on the ground in order to turn into the Mighty Thor. However, if Mjolnir left his hand for more than a minute, he would revert back to his meek, mortal form. Alongside nurse Jane Foster, Blake would treat the ill and find increasingly implausible excuses to slip away and fight villainy as Thor. In the Marvel Cinematic Universe, they do away with the Donald Blake

alter ego, and Jane Foster (Natalie Portman) is an astrophysicist who studies the "wormhole" that brought Thor from Asgard to Earth. One constant throughout both versions, though, is that Thor fell in love with Jane Foster and then, against his father's wishes, refused to return to Asgard in order to remain on Earth as one of its stalwart protectors.

When it comes to the Avengers, Thor is actually quite essential. His hateful, jealous brother Loki, attempting to draw Thor out of hiding, used an illusion of the Hulk to lure Thor into battle. The prospect of a rampaging Bruce Banner proved powerful enough to draw out other heroes too, like Iron Man, Ant-Man, the Wasp, and the Hulk himself, who joined Thor to put an end to Loki's maniacal machinations. After defeating Loki in battle and saving the day, the group decided to continue teaming up to fight larger-than-life threats as the Avengers, an origin we saw mirrored in 2012's *Avengers* as well. As we enter into the *Age of Ultron*, the catastrophic-sounding events of *Thor: Ragnarok* and Thanos' overarching plans for world domination become clear, they'll need Thor's strength more than ever if Earth's Mightiest Heroes have a chance of survival.

7 The Incredible Hulk

They say that we wouldn't like him when he's angry, but somehow we can't seem to get enough of Marvel's not-so-jolly green giant, the Incredible Hulk. Billed as "the Strongest Man of All Time," mere months after *Fantastic Four* #1 made its debut, *The Incredible Hulk* #1 hit store shelves and introduced the world to both Bruce Banner and his rage-filled alter ego, the Hulk. According to Jack Kirby, the Hulk was created when he saw a

Banner's Men

Over the years, several actors have lent their considerable talents to bringing the Marvel Universe's not-so-jolly green giant to life. One of the hallmarks of Marvel's Cinematic Universe is paying homage to its past through cleverly disguised Easter eggs and cameos for the particularly eagle-eyed viewer. Many fans know about Lou Ferrigno, who played the Hulk in the long-running, sad piano music-backed *Incredible Hulk* television series, and his cameo as a security guard in 2008's *The Incredible Hulk* film. Little did you know, that film also contains another former Hulk! Remember Stanley, the pizza shop owner who gives Bruce Banner a place to keep his head down while he's in hiding? Well, that's none other than Paul Soles, the voice of Bruce Banner from the 1960s *Hulk* animated series! And, in what is a perfect circle for former Hulk actors, Ferrigno actually provided the uncredited voiceover for the Hulk in *The Avengers*. Now, be sure to keep your eyes peeled for Eric Bana and Edward Norton munching on some shawarma in the background of *Avengers: Age of Ultron*!

woman lift a car in order to save her child, who was trapped beneath it. "Her baby was caught under the running board of this car," Kirby explained. "His mother was horrified. She looked from the rear window of the car, and this woman in desperation lifted the rear end of the car. It suddenly came to me that in desperation we can all do that—we can knock down walls, we can go berserk, which we do."[40] And thus, the seed that would grow into the Hulk was planted.

Blending elements of the *Jekyll & Hyde* story with Cold War paranoia, *The Incredible Hulk* told the story of a milquetoast nuclear physicist, Bruce Banner, who designed a highly experimental bomb that emitted gamma radiation. While supervising a live trial of his radiated weapon, a teenager wandered onto the testing site. Without any concern for his personal safety, Banner ran out into harm's way and managed to shove the ignorant youth, a boy named Rick Jones, into a nearby ditch. Unfortunately, Banner

was caught in the blast, and bathed in life-threatening amounts of deadly gamma energy. Although Banner survived, he was a changed man—literally. He could now transform into a brutish gray beast with incredible superhuman strength called the Hulk, but he couldn't control it. Yes, the Hulk was gray when originally conceived, but printing technology at the time meant that gray could not be mass produced on a consistent basis, so they opted for the more something more reliable, the now-iconic green.

Originally, Banner would transform into the Hulk at sunset and revert to human form at dawn, but as time passed, he would mutate into the Hulk when his adrenaline levels spiked regardless of time of day. While in his brutish form, he is immensely strong, easily emotionally manipulated, and prone to uncontrollable fits of rage, which made him dangerous to be around and a difficult partner for fighting crime. Unfortunately for Bruce Banner, the Hulk's limited intelligence was often exploited by enemies like the Leader, Tyrannus, and Captain Omen, which meant that he would often wind up fighting Earth's Mightiest Heroes as well as fighting alongside them. As a result, he has been deemed a menace to society, and his one-time benefactor, General Thaddeus "Thunderbolt" Ross, has dedicated his life to hunting him down.

More often than not, Hulk was able to harness his incredible strength for good. Baited into a trap by Loki, the Asgardian god of mischief, the Hulk wound up teaming up with four other heroes to form the Avengers. Although he would leave the group shortly thereafter, the Hulk has long been an essential member of the team as his incredible intellect in human form and unparalleled strength in Hulk form allow him to combat problems using both brains and brawn. Both in the Marvel Cinematic Universe and in the comics, the Hulk is a founding Avenger and one of the team's heaviest hitters.

Still, perhaps more than most, the Hulk leads a tragic existence. His wife, Betty Ross, died of radiation poisoning, a fact

The Incredible Hulk doing what he does best— smashing!

that drove Banner nearly mad with guilt, presuming that it was his gamma radiation that had killed his ladylove. When he learned that it was one of his nemeses, the Abomination, who had injected Betty with radioactive blood, he beat him to within an inch of his life. Likewise, in the wake of M-Day, when the Scarlet Witch depowered a majority of the world's mutant population, Hulk was enlisted by Nick Fury to stop a renegade S.H.I.E.L.D. weapon that threatened the Earth's safety. After barely managing to save the day, the Hulk boarded a spacecraft he believed would take him back to Earth; instead, a group of the Earth's heroes, including Iron Man, Mr. Fantastic, Dr. Strange, Namor, Black Panther, and others, collectively called the Illuminati, sent the craft, which they then jettisoned into the farthest reaches of space with the intent of

stranding the Hulk on a planet devoid of life. It would seem like the poor guy just can't catch a break.

Or could he? A miscalculation meant that the Hulk landed on the planet Sakaar, a barbarian planet dominated by tribes of gladiatorial warriors, ruled by a corrupt empire. Like an intergalactic, green Marcus Aurelius, Hulk fought his way through the gladiatorial circuit to become the planet's ruler. With an armada at his heels, Hulk set his sights on Earth and lashed out at those who betrayed him, launching a massive Marvel Universe–wide event called *World War Hulk*. Eventually, the Illuminati managed to stop the Hulk from destroying the Earth and reverted him to his Bruce Banner form. Back in his puny human state, Bruce Banner decided to work for S.H.I.E.L.D. as a weapon in exchange for the ways and means to help the world with his research altruistically and philanthropically. The fact remains that, whether he is fighting with the Avengers or against them, the Hulk is an integral part of the Avengers experience and always ensures a smashing good time.

Ant-Man

Scientist, superhero, subject to size change: these are but a few words that describe Dr. Hank Pym, the supremely intelligent yet deeply flawed Avenger known as Ant-Man. Although he didn't have quite the same stature as teammates like Captain America, Iron Man, or Thor, Ant-Man's unique scientific genius and incredible inventions have had long-lasting and undeniable effects on both the Avengers and the Marvel Universe as we know it. First appearing in 1959's *Tales to Astonish* #27, scientist Henry "Hank" Pym discovered an elixir that would allow him to shrink down to

the size of an insect. Rather than conduct clinical trials, he took the typically inadvisable scientific step of testing it on himself, shrinking down to a minuscule size. While exploring an ant hill, he soon realized that the monstrous creatures chasing him were simply trying to defend their home and found himself contemplating the implications of what he had done.

It wouldn't be until eight issues later in *Tales to Astonish* #35 that Pym would revisit his incredible discovery. Crafting a protective suit and a special helmet that allowed him to communicate with ants, Pym manages to stop a gang of Russian agents from trying to steal a top secret anti-radiation formula. Thus, a new hero is born—Ant-Man—and there is no crime too big for this Lilliputian lionheart.

Over the weeks and months that followed, Ant-Man squared off against a variety of villains, including the bilious brainiac Egghead, the dimension-hopping despot Kulla, and the awesomely named Master of Time. At long last in *Tales to Astonish* #44 (1959), Ant-Man found a partner in Janet Van Dyne, a beautiful young woman whose father, a brilliant scientist in his own right, perished when a gargantuan alien called Kosmos invaded the Earth.[41] Donning a costume of her very own, Janet became the Wasp, fighting alongside Ant-Man to defeat the cosmic criminal and, unbeknownst to either of them, planting the seeds of love that would soon blossom between the two.

Fighting together against a cavalcade of criminals, including alongside the Fantastic Four to stop the nefarious Doctor Doom, Ant-Man and Wasp would truly come into their own when they joined Iron Man, Thor, and the Hulk in order to stop Loki, the Asgardian god of mischief, from wreaking havoc upon the Earth. This unprecedented team-up was the very first issue of *Avengers* in 1961, and Ant-Man has been an essential factor both in the group's evolution and development over the following 50 years.

Most interestingly, though, the man behind Ant-Man never really seemed beholden to one identity in particular. In the second issue of *Avengers*, Pym, having reverse-engineered his special shrinking formula to allow him to grow to immense heights, has a slightly modified costume and calls himself, appropriately, Giant Man.[42] Although he would use the Ant-Man persona from time to time, much of his time as an Avenger over the next few years would be spent as Giant Man. Why the change? It was revealed during a flashback in *Avengers Forever* that feelings of inadequacy from comparing himself to teammates like Iron Man and Thor led him to reinvent himself as the 12-foot-tall hero.

Pym wasn't the only man to wear the iconic Ant-Man regalia though. After he left his Ant-Man identity behind, a man named Scott Lang (who will be played by Paul Rudd in 2015's *Ant-Man*) donned the red spandex and silver helmet to fight the good fight as Ant-Man (Pym will be played by the formidable Michael Douglas). Unlike Pym, though, Lang wasn't always a hero; rather, he was a criminal. Lang was an ex-con who served three years in Rykers and found himself working at Stark Industries. He even ran afoul of the Avengers at one point when Wonder Man mistook him for an intruder. Created by David Michelinie and John Byrne, Lang's life forever changed after his daughter Cassie became seriously ill as a result of a rare heart condition. With no money and nowhere to turn, he decided with a heavy heart to return to his old burglarizing ways as a last resort. Lang broke into the home of none other than Dr. Henry Pym and stole both the Ant-Man uniform and canisters of shrinking gas.

With his slick new shrinkable threads, Lang broke into Cross Technological Enterprises searching for Dr. Erica Sondheim, an elite cardiologist and the only person capable of saving his daughter's life. As he would soon discover, Dr. Sondheim was taken prisoner by Darren Cross, a ruthless industrialist who suffered from an experimental "nucleorganic" pacemaker (which can't be a sillier

conceit than the one episode of *Homeland*), because he needed the good doctor to perform a heart transplant to save his life. After tussling with Cross, Lang watched the madman die thanks to a bit of scalpel-based sabotage from Dr. Sondheim herself. It just goes to show you that bedside manner is a two-way street.

Although Lang had a criminal past and illegally obtained the Ant-Man gear, he fully intended to turn himself in to the authorities after Cassie received her life-saving surgery, Pym ultimately took him aside and officially bequeathed the Ant-Man legacy unto him. From that point forward, Lang made the most of his new lease on life, fighting alongside the Avengers, proving instrumental in helping to clear his name and cementing himself as a true hero. As a member of the Avengers, he proved pivotal in battling villains like Taskmaster (arguably his archnemesis), helping to clear Tony Stark of bogus murder charges, figuring out who stole Iron Man's armor designs during *Armor Wars*, defeating the Masters of Evil when they captured the Avengers and invaded the Mansion, and much more.[43] Truly, Lang is proof that no one is beyond the point of redemption.

Unfortunately, for the onetime criminal turned hero, death was inescapable. During the continuity-smashing *Avengers Disassembled* event, a zombified Jack of Hearts, his longtime friend and the man who gave his life to save his daughter, was briefly restored to life and used as a bomb, killing Scott Lang in the process. Though Scott would return from the dead later (as many Marvel heroes are wont to do), it was a shocking loss to Earth's Mightiest Heroes, and one that stayed with them for quite some time. In current continuity, Lang is working with the Future Foundation, an offshoot of the Fantastic Four designed to best serve the interests of humanity.

To quote late-night infomercials, "But wait, there's more!" In the midst of *Civil War*, a third Ant-Man arose, a low-level S.H.I.E.L.D. agent named Eric O'Grady who inadvertently stumbled upon the newest incarnation of Pym's Ant-Man suit

in S.H.I.E.L.D. headquarters. Not the most savory of characters, O'Grady. To wit, the book in which he starred was called *The Irredeemable Ant-Man*. Neither hero nor villain, O'Grady stole the Ant-Man gear, wounding his colleague Agent Mitch Cason in the process, and used it for voyeuristic purposes to spy on unsuspecting women. For a while, he joined Damage Control as "Slaying Mantis," which sounds like it'd make a great roller derby name. He went on to join Iron Man's Avengers Initiative in the wake of Civil War, and even fought alongside both the Thunderbolts and Captain America's black ops team, the Secret Avengers. Selfish, avaricious, and generally unheroic, O'Grady managed to redeem himself in the final moments of his life, saving the life of an innocent child before being savagely beaten to death by servants of the man known as "Father."[44] And you thought you had daddy issues.

9 The Wasp

Although we've yet to see her on the big screen—in spite of her appearing in earlier drafts of Joss Whedon's scripts—Janet Van Dyne, better known as the Wasp, is one of the most essential characters in both the formation and evolution of Earth's Mightiest Heroes. Not only was the Winsome Wasp (as she was alliteratively dubbed) one of the founding members of the group in the comics, but she is the one who came up with the name "the Avengers" ("It should be something colorful and dramatic like...the Avengers, or...").[45] At first, the Wasp seemed little more than a bubbly sidekick/love interest to Hank Pym's Ant-Man, but she rose to a position of true prominence and importance within the team, eventually outshining her husband and providing a strong female

character during a time in which there weren't many to be found in the Marvel Universe.

Making her debut in *Tales to Astonish* #44 (1959), Janet Van Dyne was the socialite daughter of wealthy scientist Dr. Vernon Van Dyne. When her father died during an attack on Earth by the alien beast Kosmos, Janet swore revenge, enlisting her father's associate, Dr. Henry Pym, to help her. By undergoing an advanced biochemical procedure, Janet Van Dyne gained the ability to shrink to nearly microscopic size using Henry Pym's appropriately named "Pym Particles." While in her diminutive form, Janet could also sprout wings which allowed her to fly and fire bioelectric energy blasts to stun enemies, which she dubbed her "Wasp's stings." Together, as Ant-Man and the Wasp, they beat back the monster that took her father's life and sealed it away in another dimension. Afterward, they realized they made an awfully good crimefighting duo and continued to fight together against a variety of villains. It's also worth noting that the Wasp's first solo victory—which came amid Ant-Man's protests—was against the malevolent Magician.

When Loki, the Asgardian god of mischief, attempted to draw Thor out of hiding by pretending to be the Hulk, Wasp was among those who answered the ham radio call of young Rick Jones (and his still head-shakingly silly Teen Squad). Despite the occasional leave of absence, the Wasp has been one of the most consistent members of the Avengers over its long, storied history. During her time with the team, Janet evolved as a person, moving past simply making eyes at handsome heroes like Thor, and coming into her own, eventually being elected leader of the team by her peers.

Despite being her own person, one of the defining aspects of the Wasp has been her relationship with Ant-Man. Her immense wealth meant that she was used to a life of leisure, as well as getting what she wanted, but Pym's daunting research schedule always kept the pair in a seemingly perpetual state of "will they, won't they?" over whether they would get engaged. One day, though, an

arrogant, cocky new crimefighter named Yellowjacket broke into Avengers HQ, claimed to have disposed of Hank Pym, and went so far as to kidnap Janet. Whether it was Stockholm syndrome or sheer charm, Janet proceeded to marry Yellowjacket, much to the chagrin and ire of her teammates. The tense wedding was made even more uncomfortable when the Circus of Crime attacked, but during the pitched battle it was revealed that Yellowjacket was none other than Hank Pym himself. A chemical accident induced a severe case of schizophrenia, which caused a dissociative personality

Buzz Off

In 2012, Joss Whedon shattered box office records when he brought together the biggest names in the Marvel Cinematic Universe for the team-up film to end all team-up films, *The Avengers*. The team's roster, however, was a fair sight different than the original Avengers lineup that Stan Lee and Jack Kirby envisioned in 1963. In particular, neither Ant-Man nor the Wasp were anywhere to be seen despite being founding Avengers. But, did you know that Whedon's first drafts of *The Avengers* actually had the Wasp as a central character?

At a special screening of *The Avengers* at the Director's Guild of America headquarters in Los Angeles, Whedon revealed during an extended Q&A that there was a period of time where they weren't sure they'd be able to secure Scarlett Johansson as Black Widow. The solution was to make the film's female lead the amazing, shrinking Janet Van Dyne, aka the Wasp. "There was a very Wasp-y draft that I wrote—but it was way too Wasp-y," Whedon revealed. "Because I was like, 'She's adorable! I'm just going to write her!'" Unfortunately for audiences with a madness for miniatures, they'll never know how the Wasp would have fared against Tom Hiddleston's megalomaniacal Loki. Maybe Peyton Reed's *Ant-Man* will offer some answers, or at the very least feed our insatiable need for insect-themed superheroes.

(Eisenberg, Eric. "The Avengers Almost Had Wasp Instead Of Black Widow, Joss Whedon Wanted A Second Villain." - CinemaBlend. N.p., 19 Dec. 2012. Web. 03 Aug. 2014. <http://www.cinemablend.com/new/Avengers-Almost-Had-Wasp-Instead-Black-Widow-Joss-Whedon-Wanted-Second-Villain-34698.html>.)

disorder in the scientist. Nobody's fool, Janet realized that it was Hank early on and used it as a means to tie the knot with her long-time boyfriend.[46] As Robert Muldoon once famously remarked in *Jurassic Park*, "Clever girl."

Unfortunately for Janet and Hank, their relationship would be fraught with difficulty, both as a result of Hank's decaying mental stability and the perils that come with being a superhero (e.g. she was the subject of Ultron's Oedipus complex as a result of its brain patterns being based on Pym's). Most infamously, Yellowjacket had been asked to take a leave of absence from the Avengers after he had grown increasingly paranoid, volatile, and violent, going so far as to attack a villain from behind after they had already surrendered. Hell-bent on getting back in the group's good graces, he concocted a plan to unleash a deadly robot on the team, and then, at the last minute, swoop in and save the day. When Janet learned of his plan, she tried to stop Hank, but he viciously backhanded her, making for one of the most shocking and reviled moments in Avengers history. She divorced him shortly thereafter.

While that dark moment in Hank Pym's character history is what many people first think of when they think of the Wasp, it is not, by any means, what defines her. During the 1980s, Wasp realized the Avengers were in need of some fresh leadership, and was elected chairperson by Thor, Iron Man, and Captain America. Janet proves herself to be a shrewd, efficient leader, and makes a point of increasing the number of female superheroes on the team by recruiting She-Hulk and Captain Marvel.[47] Simultaneously, she embarked on a side career as a professional fashion designer, creating exclusive designs for the likes of She-Hulk. Basically, she proved that not only can she save the world on a regular basis, but she can blaze her own trail in professional civilian life too. Forget Glen Coco—you go, Janet Van Dyne.

Years later, after Pym's mental state returned to normal, she even resumed a romantic relationship with her troubled ex-husband. In

spite of getting knocked into a coma by Scarlet Witch during the horrific events of *Avengers: Disassembled,* transformed into a biological bomb by an evil Skrull version of Hank Pym and remotely detonated, and being trapped in a pocket universe known as the Microverse, the Wasp has always managed to persevere in the face of adversity. Time and time again, she has proven that in the company of gods, geniuses, and living legends, even the smallest hero can make a difference…and look damn good in the process.

10 Hawkeye

Although he hasn't had much of a chance to shine on the screen (in spite of Jeremy Renner's terrific performance), Hawkeye has become something of a fan favorite amongst *Avengers* fans thanks to his razor sharp wit, no-nonsense attitude, and the fact that he's crazy enough to take on the biggest baddies in the Marvel Universe armed with little more than a bow and arrow. Clint Barton wasn't always a hero, though. In fact, our favorite blue-and-purple-clad marksman was originally a villain when he made his Marvel Universe debut.

Created by Stan Lee and Don Heck, Hawkeye first appeared as a villain in the pages of *Tales of Suspense* #57 in September 1964. Over time, Hawkeye would come to be a prominent member of the team, appearing consistently from 1963 through present day. In addition to serving on the Avengers, Hawkeye was also a founding member of the West Coast Avengers and went on to serve as team leader for the Secret Avengers, too. Though he would adopt other monikers over the years—Goliath and Ronin, for example—he

would always return to his trusty bow and arrow. But before we go any further, here's a little history lesson.

After his parents died in a car accident, Clint Barton and his brother Barney were sent to a foster home, but they soon ran away to join the circus—literally. At the Carson Carnival of Traveling Wonders, Clint and his brother worked as laborers, but soon Clint began training with two of the carnival's employees, Swordsman and Trickshot, who taught him the art of hand-to-hand combat and archery, respectively. However, when Clint stumbled upon Swordsman counting the cash he'd stolen from the Carnival, everything changed. His mentor offered him the chance to become partners in crime, but Clint rejected him, leading to a fight that left him nearly dead. As if that weren't enough of a blow to his pride, his brother Barney abandoned him too, unable to believe he'd passed up such a lucrative opportunity. Battered, bruised, and alone, Clint thankfully found solace in Trickshot, who became a true mentor to the troubled youth.[48]

In an effort to use his newfound skills for good, Clint joined Trickshot in raiding the lair of a criminal known as Marko. Though the raid was successful, Clint wound up critically injuring one of the guards, who turned out to be none other than Barney himself. Disgusted and horrified by what he'd done, he abandoned Trickshot, parting ways on bad terms.[49] Lighting out on his own and having honed his archery ability to incredible levels, he assumed the persona of "Hawkeye, the World's Greatest Marksman" in order to make ends meet. Though it wasn't until a chance encounter with Iron Man, who was saving lives at a carnival, that Hawkeye would decide to embark upon a life of fighting crime. In keeping with Hawkeye's classically bad luck, he wound up on the run from the police his first night on the job after they mistook his costume for a criminal's.

Like many red-blooded American men, Clint Barton found himself entranced by a mysterious, beautiful woman. In this case, it

was Black Widow, who was working as a spy for the Soviet Union, and convinced Hawkeye to help her steal state secrets by battling Iron Man. After a few scuffles, Hawkeye wised up and swore to go on the straight-and-narrow, and after rescuing the Avengers' butler, Edwin Jarvis, he found himself sponsored for Avengers membership by his one-time foe Iron Man. Under Captain America's leadership, Hawkeye officially joined the Avengers alongside Scarlet Witch and Quicksilver to form the second official incarnation of the supergroup.

Hotheaded, stubborn, and resistant to authority, Hawkeye often found himself at odds with his new teammates. His romantic advances toward Scarlet Witch led to tensions with her brother Quicksilver, and he constantly bristled when Captain America tried to bring him under heel. Although he would eventually come to respect Captain America as a mentor and friend, his feelings toward Scarlet Witch proved problematic, eventually causing him to leave the group for a time after a clash with the Vision over her affections.

One of the most heartbreaking moments in Hawkeye's storied career came when he adopted a new costume and identity, namely the mantle of Goliath, which was previously held by Hank Pym. While he was acting as Goliath, his brother Barney came back into his life. Now a major racketeer, Barney came to the Avengers for help after learning about the villainous Egghead's plans to construct an orbital death ray (which, for the record, is about as evil a plan as one can concoct) with which to extort the United States government. This resulted in a massive battle with the Avengers, Egghead, and his cohorts the Mad Thinker and the Puppet Master. Shockingly, Barney perished in the ensuing melee, devastating poor Hawkeye.

Vengeance would be Clint Barton's though. Later on, Hawkeye would avenge his late brother and his pride when his old mentor Swordsman, who was working for Egghead at the time, captured

him. Given that Egghead was Hank Pym's nemesis and in his Goliath guise, Hawkeye bore a striking resemblance to his fellow Avenger, so the villains mistook him for Pym.[50] Thankfully, Hawkeye prevailed and defeated both criminals, delivering justice for his slain brother. Shortly thereafter, though, Clint retired the Goliath moniker, and resumed operating as Hawkeye, marksman extraordinaire.

Even after returning to his blue-and-purple roots, Hawkeye had a rough go of things. His brother was dead, his romance with Scarlet Witch came to an end (she chose the Vision, an android, over him), and he lost his hearing after being forced to use a sonic arrow at close range. Yet, all was not bad for our hero—he met the costumed superhero Mockingbird, fell in love, and the two were married shortly thereafter.[51] And as we learned from Miracle Max in *The Princess Bride*, true love is the best thing in the world (except for a nice, juicy M.L.T.—a mutton, lettuce, and tomato sandwich).

Realizing they needed to expand their operations, the Avengers asked Hawkeye to lead the West Coast branch of their operation, the aptly titled West Coast Avengers. After a spell in Los Angeles with the West Coast Avengers that saw Hawkeye and Mockingbird separate after the accidental death of a fellow hero, Hawkeye left the team with Mockingbird in tow to mentor up yet another Avengers team, the Great Lakes Avengers (a group of oddball heroes that were technically using the Avengers name without permission). Eventually, Hawkeye returned to the West Coast Avengers, where he and his team found themselves going toe-to-toe with Mephisto, the lord of hell himself. During the battle in a demonic, otherworldly dimension, Mockingbird was slain, giving her life to save Hawkeye's.[52]

Once again, death hit Hawkeye hard, leading him to temporarily retire from costumed crimefighting, until he returned to help the Avengers battle one of their greatest foes, Onslaught, who seemingly killed them all in their final encounter. Of course, no

one really stays dead in the Marvel Universe (seriously, no one), and upon his resurrection in the so-called Heroic Age, Hawkeye dabbled with leading the Thunderbolts, was briefly in jail, and gave his life once more to stop a Kree warship from destroying the Earth after Scarlet Witch's reality-bending powers caused the Kree to invade. Eventually, Hawkeye returned again vis-a-vis the same reality-changing powers that killed him in the first place, and he used the martial arts training he received from Captain America and Swordsman to assume a third identity, that of Ronin.

When the assassin Bullseye began masquerading as Hawkeye in Norman Osborne's nefarious Dark Avengers and using his identity in the name of evil, Clint Barton unmasked himself as Ronin to warn the world before it was too late. Operating as Hawkeye once more, Clint Barton was in for a bit of a surprise as he learned that Mockingbird hadn't really died—a shape-shifting alien Skrull replaced her and the real Mockingbird was their captive. Likewise, his brother Barney wasn't dead after all—he was now operating as Trickshot, and hell-bent on one-upping his brother to claim the title of world's greatest marksman.[53] Man alive—is it better to think your loved ones are dead or to have them be secret aliens and crazed bow-wielding rivals? Either way, it's just another day in the life of Hawkeye—Avenger, ass-kicker, and all-around good guy.

11 Black Widow

Beautiful, deadly, and always one step ahead of both the good guys and the bad guys, Black Widow is among the most mysterious members of the Avengers. The secret agent better known as Natasha Romanova has been a mainstay of the Avengers universe

both on the screen and off. Like Hawkeye, Black Widow was originally conceived of as a villain, a Soviet spy who went toe-to-toe with Iron Man on several occasions. Later on, she defected to the United States, serving as an agent of S.H.I.E.L.D., and eventually an Avenger too. Ever since she first appeared in *Iron Man 2*, the only question on our mind has been "when will see more Black Widow and what is that 'red in her ledger' she keeps referring to?"

Fun fact: while Scarlett Johansson brings Natasha Romanova (Romanoff in the MCU) to life on the silver screen, she almost didn't get the part. Producers originally offered the role to Emily Blunt, who was unable to accept it due to a scheduling conflict with her starring role in *Gulliver's Travels*. It's probably for the best because after seeing *Captain America: The Winter Soldier*, it's hard to imagine anyone other than Johansson playing the role.

As befits an international superspy, Natasha Romanova's backstory is much cooler than most. Born around 1928, Natalia "Natasha" Romanova grew up an orphan in the war-torn streets of Stalingrad until a soldier named Ivan Petrovitch Bezukhov rescued her. [54] By the late 1930s, Soviet intelligence began to take notice of her, and began rigorously training her to eventually operate as an elite undercover agent. In 1941, she was captured and nearly brainwashed into serving the nefarious ninja clan known as the Hand, but Ivan, James Howlett (the man who would become Wolverine), and Captain America saved her before it was too late. [55]

In the years following World War II, she was recruited into the Black Widow Program, an elite group of black ops sleeper agents, where she received instruction from the likes of the Winter Soldier (Captain America's one-time partner Bucky). This is an important difference between the Marvel Cinematic Universe in which Black Widow had merely heard rumors about the Winter Soldier and his role in major political assassinations over the last few decades. While in the Black Widow program, she trained as a ballerina (as her cover), and married a test pilot named Alexi Shostakov at

the behest of the Soviet government. After a few years together, though, the Soviets faked Alexi's death in order to draw Natasha deeper into the program. While at the covert Red Room facility, she was biologically and psychologically enhanced using the Soviet equivalent of the Super Soldier serum; while it didn't make her as strong as Steve Rogers, it definitely heightened her abilities, and she was finally granted the title of Black Widow.

Although we know and love Black Widow for her iconic black leather catsuit and her iconic bracelets that fire her "Widow's Bite" energy blasts that can deliver up to 30,000 volts of ass-kicking, she used to rock a bouffant hairdo, fishnets, a black corset, and an angular domino mask. Thankfully, she was updated to a more modern look in the 1970s because she looks much better suited to perform highly classified off-the-books black ops missions nowadays than she used to.

After a few run-ins with Iron Man and seducing Hawkeye in order to help her steal state secrets, Natasha defected to the U.S., partially due to Hawkeye's earnest idealism and her growing affection for the roguish archer. After she was briefly brainwashed into battling the Avengers, she broke all ties with her onetime spymasters and began fighting alongside S.H.I.E.L.D. and providing informal assistance to the Avengers. For a time, she operated independently, and occasionally partnered up with the likes of Daredevil until she was finally made the 16th member of the Avengers after she helped them defeat Magneto in New York City.

Following Captain America's departure from the team in the wake of the Kree-Shi'ar War, Black Widow assumed leadership of Earth's Mightiest Heroes, harnessing her incredible tactical genius to lead the team against the likes of the Gatherers, the Lunatic Legion, Grim Reaper's Legion of the Unliving, and other forces of evil. Internal team strife continued to build in the wake of Cap's departure, and as a result, eventually the West Coast Avengers disbanded as a result. When most of the Avengers roster seemingly

died while fighting Onslaught, it was Natasha who soldiered on, trying to rebuild the team and recruiting new members.

During *Civil War*, she was a supporter of the Superhuman Registration Act, serving on Tony Stark's task force. At the commencement of the *Heroic Age*, which emerged from the aftermath of *Civil War* and *Secret Invasion*, she was recruited by Steve Rogers to serve on the new black ops division of the Avengers, the aptly named Secret Avengers.[56] She even infiltrated the Thunderbolts when Norman Osborn was using the seemingly reformed supervillains as his own personal army. Over the years, Black Widow has been present for some of the Avengers' toughest battles, including the cosmic Korvac Saga and battling Thanos when he wielded the Infinity Gauntlet, but she has always managed to stay calm, cool, and collected. A true femme fatale, Black Widow has had her fair share of work-based romances (Hawkeye, Daredevil, Hercules, and Iron Man, to name a few), but her true love is the one she always comes back to: saving the world.

12 Loki

When you think of Loki, what's the first thing that comes to mind? Impossibly blue eyes? Dreamy cheekbones? Unparalleled on-screen charisma? Well, you're not wrong—thanks to Tom Hiddleston's breakout performance, Marvel's Asgardian god of mischief has become one of the best loved characters in the entire Marvel Universe. It's fitting that Loki was the big baddie in the first *Avengers* film because back in 1963, it was Loki's ham-fisted attempt at luring Thor out of hiding that resulted in the formation

of the Avengers in the first place. Truly, without Loki, there would be no Avengers either on or off the screen.

Loki first appeared in Timely Comics' *Venus* #6 (1949) in a story that saw him as a member of the Olympian gods exiled to the Underworld, depicted akin to the Devil. His first official Marvel appearance happened in *Journey into Mystery* #85 (Oct. 1962), where he was introduced as Thor's archenemy in a script from brothers Stan Lee and Larry Lieber, and artwork by Jack Kirby. His abilities are vast and varied; not only does he possess an incredible intellect and powerful magical ability, but he can create illusions, shapeshift, imbue superhuman abilities to other beings and inanimate objects, and manipulate others into doing his dirty work.

Although he is often referred to as Odin's son, Loki is, in truth, adopted. Odin and the warriors of Asgard waged battle against the frost giants of Jotunheim (one of the nine realms). The Asgardians prevailed, slaying Laufey, the king of the frost giants, in battle, but when they surveyed the ruins, they discovered a small baby hidden within the giants' fortress. This baby was Loki, and Odin heeded his father Bor's final words—to adopt the son of a father killed by his hands.[57] Thus, Odin raised Loki as his own alongside his biological son, Thor, the god of thunder.

Although in Norse mythology, Loki is portrayed more as a puckish trickster, Marvel's version finds Loki more focused. Perhaps it's for the best, though, since no one really wants to see Tom Hiddleston reenact the time that Loki tried to make the giantess Skadi laugh by tying his testicles to a goat.[58] Growing up in Asgard, Loki seethed with resentment over how everyone seemed to favor his flaxen-haired brother, resentment that becomes the seed of evil within Loki that deepens and grows over time, fertilizing them into something far more sinister.

As Loki matured into a young man, he acted out more and more frequently until Odin was forced to imprison him so that he might learn from his misdeeds. Disillusioned by Asgard, Loki used

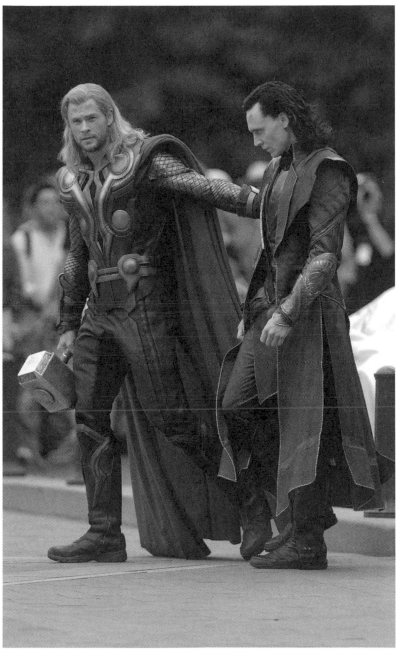

Thor (Chris Hemsworth) leads Loki (Tom Hiddleston) during filming in Central Park. Possibly to craft services. (Ray Tamarra/Getty Images)

his magic to escape his cell and fled, training in the black arts under a sorcerer named Eldred. In classic Loki fashion, he soon betrayed Eldred's trust by offering the sorcerer's soul to Surtur, a 1,000-foot-tall fire demon from the realm of Muspelheim, in exchange for tremendous power.[59] Now, he was no longer merely the god of mischief, but the god of evil too.

When Thor was exiled to Earth, Loki constantly tried to exploit his weakness while in his human form, the lame-legged Dr. Donald Blake. Attempting to trick Thor into battling the green behemoth that is the Hulk, Loki diverted a distress call intended for the Fantastic Four to Dr. Blake's office. Little did he suspect, but other heroes—Iron Man, Ant-Man, and the Wasp—heard the distress call too, and banded together to help stop the evil god's designs. After they put a stop to Loki and realized the Hulk wasn't actually on a rampage, the group decided they should continue to fight crime together, and thus the Avengers were born. Inadvertently creating the Avengers is a fact that would continually plague Loki.

Over the years, Loki's schemes primarily centered around taking vengeance on Thor, Odin, and the denizens of Asgard for their

That's So Raven!

Long before *Game of Thrones* made us view ravens as a potential substitute for the U.S. Postal Service and even before Edgar Allen Poe made us wonder why they were such naysayers, the black birds had deep-seated roots in traditional Norse mythology. The All-Father, Odin, father to both Thor and Loki, famously had two ravens, Huginn and Muninn, which he would use to ferry information back and forth between Asgard and Midgard (Earth). Well, eagle-eyed—or should I say raven-eyed—viewers of 2012's *Avengers* may notice that after Thor unceremoniously removes Loki from the Quinjet onto the mountainside, two large ravens fly overhead. Is this Odin keeping tabs on his two tempestuous sons? A clever reference by Joss Whedon? Two Asgardian gods destroying a local ecosystem so they can have a heated discussion? It's probably a little bit of all three.

perceived mistreatment. Learning that he is destined to slay Balder, and in doing so bring about Ragnarok—the end of the world and of Asgard—Loki deliberately attempts to initiate this armageddon-like event on several occasions.[60] Wielding an uru hammer of his very own (the magical substance of which Mjolnir is made), Loki proceeded to bring about Ragnarok. Little did he know, but Thor allowed this to happen, having realized that Asgard was trapped in a cycle of death and rebirth. Decapitating his brother Loki, Thor held his severed, still-living head aloft as the two watched the fire demon Sultur consume and destroy Asgard, presumably killing them both in the process and thus breaking the cycle.[61] Of course, in classic Marvel fashion, they would be reborn in short order, albeit trapped in human form on Earth as the Lost Gods.

It must be noted that despite his many defeats, Loki has actually managed to usurp the throne of Asgard a few times too. While Odin was hibernating in his eponymously named Odinsleep, Loki seized control of his body, ruling in disguise. At the time, Thor's power was bound to the human Eric Masterson, so Eric and Lady Sif teamed up to journey to the realm of Mephisto, where they discovered Odin's spirit. They restored it to his body, and trapped Loki in Hell in his place. Another time, Loki managed to seize the throne, only to have it taken back by Odin; he was exiled to Earth in the form of a vagrant as a result. In perhaps the most comical attempt at usurpation, Loki transformed Thor into a frog, who was still somehow able to wield the hammer Mjolnir.[62] Thus, Loki's reign was short-lived, as the Mighty Throg (yes, that's right, a Thor-frog hybrid) forced him to undo his amphibious enchantment.

At times, even Loki was forced to put his hatred of his family aside in order to defend Asgard from destruction at the hands of monstrosities like Surtur. It's crucial to note that Loki never really sought to destroy Asgard; rather, he wanted to rule it and make people realize his worth. We saw glimpses of this in *Thor: The Dark World*, when Loki and Thor were forced to band together in order to

stop the nefarious Dark Elf Malekith from using the Aether (which we now know is an Infinity Stone) to obliterate the Nine Realms.

Whether he's reluctantly fighting to help save the universe or intending to destroy it in order to enact some petty vengeance on his brother, Loki is undeniably one of the most important members of the Marvel Universe. Case in point, he's even reported to have a cameo in Age of Ultron and will undoubtedly play a pivotal role in 2017's *Thor: Ragnarok*. If Loki's on-screen popularity maintains its current trajectory, it wouldn't be out of the question to see him starring in his own standalone film down the line either. We certainly wouldn't object to the storyline where he winds up switching bodies with Lady Sif; just tell me you wouldn't want to see Tom Hiddleston in drag.[63] If you said "no," you're a bigger liar than Loki himself.

13 Ultron

There is no casting more wonderfully perfect when taken at face value than James Spader as Ultron. When it was announced that Marvel's resident ruthless robot would not only be appearing in the hotly anticipated *Avengers* sequel, but would be the main villain *and* played by Spader, it was like seeing a double rainbow—a thing of absolute beauty. While Loki may be the first villain the Avengers sparred with and the impetus for their existence in the first place, it's hard to think of a villain more iconic to their canon than Ultron. Yes, Thanos is the big bad in the overarching Marvel Cinematic Universe as we build towards an epic Infinity Gauntlet–themed conclusion, presumably in the two-part *Avengers: Infinity War*. However, Thanos threatens the entirety of the Marvel Universe, forcing the Avengers to call in all of their many, many

allies in order to defeat him. Ultron has a single-minded focus on destroying Earth's Mightiest Heroes and ruling the Earth with a chrome-plated iron fist.

Ultron was originally created by Hank Pym, who you may know better as Ant-Man, one of the founding members of the Avengers in the comics. In the film, it's looking like he'll be the result of Tony Stark's experimentations with artificial intelligence, but he was technically a creation of Pym's. Moreso than anything else save for, perhaps, Jekyll and Hyde, Ultron is a case study against self-experimentation. While studying artificial intelligence, Pym decided to create a robot using a copy of his own brainwave patterns as the basis for the programming. Building a crude robot, Pym gave it a consciousness—specifically his—which meant that the artificial intelligence not only had Pym's vast intellect, but also his mercurial mental instability minus a human conscience. In case it isn't painfully obvious, this was a recipe for disaster.

Within moments of being activated, the robot evolved an advanced intellect and an unexpected range of emotions. Unfortunately, the emotion it displayed most was hatred, which it directed primarily at its "father" Pym and the human race. Using advanced hypnosis to mesmerize and dominate Pym, the robot, which dubbed itself Ultron, commanded him to forget its existence and abandon the New Jersey–based lab where Pym created it.[64] Pym complied and departed the lab while Ultron proceeded to rebuild himself four times. The fifth time was evidently the charm and the robot, renaming itself Ultron-5, felt that it was finally ready to wage war on mankind.

In terms of what Ultron is capable of, it's hard to nail it down as he has undergone so many changes over the years. The base model displayed superhuman strength, heightened reflexes, enhanced speed, subsonic flight, the ability to shoot concussive blasts from repulsors in its optical sensors, and an "encephalo-ray" that places its target into a coma. While under the effects of the ray, Ultron

is able to implant subliminal commands (e.g. rebuilding him) that will be enacted at a later date. Ultron is also able to self-repair, process information at incredible speeds, and control hundreds of other Ultron bodies simultaneously vis-a-vis a hive mind. Very few heroes are capable of directly hurting Ultron; most effective are Scarlet Witch's reality-warping hex powers.[65] That being said, the Human Torch's nova burst was able to damage Ultron's internal circuits, and the Vision managed to destroy the robot with the Avengers' assistance.[66]

Fascinatingly, the first time the Avengers encountered Ultron, he was disguised as a human, namely the nefarious Crimson Cowl, a shadowy figure who was reassembling the Masters of Evil. Recruiting members of the Avengers' rogues gallery like Klaw, Radioactive Man, the Melter, and Whirlwind, Ultron set out to destroy Earth's Mightiest Heroes. He did so by extorting Edwin Jarvis, the Avengers' longtime butler, who was in desperate need of money to pay for his mother's surgery. In exchange for the Avengers Mansion's new security blueprints, Jarvis was supposed to receive a sizable cash advance. However, Ultron (in his Crimson Cowl disguise) betrayed Jarvis, knocking him unconscious.

Using the security blueprints, they bypassed the Avengers' defenses, broke into Avengers Mansion, and captured Earth's Mightiest Heroes. Thankfully, the day was saved by Black Knight (Dane Whitman), the son of a former supervillain who had taken up his father's mantle in the name of justice. He infiltrated Ultron's Masters of Evil, freed the Avengers, and exposed Ultron for what he really was.[67] Though Ultron escaped, the Avengers now knew they had a deadly new foe who had already outsmarted them once.

Interestingly enough, Ultron wound up creating one of the Avengers' strongest allies and their eventual leader, the synthezoid known as the Vision. Following in his father's footsteps, Ultron created his own artificial being using the android body of the original Human Torch and programming its personality using a

Not-So-Arch Nemesis: Mandrill

While the Avengers are, without a shadow of a doubt, Earth's Mightiest Heroes and tasked with facing some of the most menacing threats the Marvel Universe has to offer, not every villain can be an Ultron or a Baron Zemo. Sometimes you get C-list supervillains that are more criminal than they are mastermind, and the results are sadly unforgettable. Case in point: Mandrill. No, that's not an adult film star; it's the moniker of Jerome Beechman, the son of a nuclear scientist who was abandoned by his father after an explosion caused his skin to turn black and him to develop increasingly ape-like features, as well as the strength, speed, and agility of a great ape. His most disturbing ability, though, is a pheromone he exudes which allows him to attract and enslave women, bringing them under his thrall.

Over the years, Mandrill, a mutant by birth, would use his powers of influence to try to overthrow several African nations, use an army of mind-controlled black women to try to topple the United States government, and generally perpetrate misogyny all across the Marvel Universe. According to Marvel's official character wiki, Mandrill's whereabouts are currently unknown, and considering the deeply problematic racial undertones and sexist overtones, it's probably best they stay that way.

("Mandrill." Marvel Universe Wiki. Marvel Comics. Web. 18 Aug. 2014. <http://marvel.com/universe/Mandrill>.)

modified version of the seemingly deceased villain-turned-hero Wonder Man (aka Simon Williams). Although the Vision was sent to destroy the Avengers, the synthezoid could not bring himself to do so and allowed his humanity to seep through. During a climactic battle at Ultron's lair, Vision rebelled against his creator, and destroyed the megalomaniacal machine.

Though Vision was the first of Ultron's synthetic creations, he wouldn't be the last. As Ultron-8, it created the robot Jocasta (named after Oedipus' mother, a reference to his obsession with Pym), which it modeled after Janet Van Dyne, the Wasp, the wife of his creator.[68] Jocasta was meant to serve as Ultron's bride. She

did love him deeply, but could not accept his evil nature, and ultimately betrayed him.[69] Like the Vision, Jocasta went on to help the Avengers in many of their battles, but unlike the Vision, she was never granted proper membership status.

Time and time again, Ultron would rebuild himself into newer, deadlier forms. Over the years, Ultron has been destroyed countless times, often using secretly implanted subroutines in his creations or hypnotic suggestions to compel his creations and cohorts to rebuild him after his destruction. At one point, Ultron even interfaced with Iron Man's armor, which was integrated into his biology at the time, effectively taking over Stark's body. Most grievous though of all of Ultron's schemes, machinations, and world domination plots was the time he actually succeeded—the Age of Ultron. But to find out exactly how that went down, you'll have to flip to the Age of Ultron chapter. A tricky move, I know, but I feel like Ultron would be proud.

14 Scarlet Witch

Raised in the mystical, secluded enclave of the High Evolutionary on Mount Wundagore, Wanda Maximoff, aka the Scarlet Witch, is arguably the most powerful hero on the Avengers roster, wielding hex powers that allow her to manipulate probability, essentially allowing her to alter the fabric of reality itself (sometimes to the detriment of her allies). Unbeknownst to Wanda, she forged a bond with the Elder God Cthon, marking her to be a Nexus Being, a human conduit for the mystical energy surrounding the Earth. Later, her powers were explained as manipulating chaos magic, but semantics aside, the fact remains that one blast from her hex powers

manifests the kind of bad luck that leads her enemies to rue the day they crossed paths with her.

Much like Hawkeye and Black Widow, Scarlet Witch first made her debut as a villain, a trait we'll likely see reprised in *Avengers: Age of Ultron*, where she will be played by Elizabeth Olsen. In the comics, she first appeared in *X-Men* #4 (March 1964) as a member of the Brotherhood of Evil Mutants alongside her brother Quicksilver. They wound up falling in with a bad crowd after the supervillain Magneto—who was, in truth, their father, even though none of them knew it at the time—rescued them from a superstitious crowd that turned violent after they displayed their powers. One year later though, not only was she fighting for truth, justice, and the American way, but she was a member of the Avengers.

After Magneto was abducted by a mysterious cosmic entity called the Stranger, she and her brother left the Brotherhood of Evil Mutants.[70] Recruited into the second iteration of the Avengers by Captain America alongside new members Quicksilver and Hawkeye, Scarlet Witch remained a loyal member of the team until she was mistakenly shot while battling against Magneto.[71] This prompted Quicksilver to fly into a rage and flee the Avengers with Wanda in tow. After lying low at Magneto's hidden base to recuperate, she realizes that Magneto is actually evil, and eventually rejoins the Avengers after they rescued her from an alien warlord named Arkon (complicated, I know).

After her return, Wanda soon wound up in a love triangle with Hawkeye and her new android teammate, the Vision. Alas, Hawkeye's feelings were largely unrequited and soon Wanda and the Vision developed a romantic relationship, much to the objection of both Hawkeye and Quicksilver. In spite of this, the pair eventually got the blessing of the entire Avengers team and got married.[72] Using powerful accumulated magic energy, Wanda even became pregnant with the Vision's twin sons and gave birth to William and Thomas.

However, her joy would be short-lived as the Vision was kidnapped, dismantled, and his personality severely altered out of a fear that he would attempt to take over the world, a fact which drove a wedge between the two. Then, she lost her children when Mephisto, the Lord of Hell, absorbed her sons into fragments of his soul, causing them to cease to exist. Losing her husband and her children to powerful forces beyond her control gave Wanda a nervous breakdown, which was intensified by the inherent instability of the chaos magic powering her hex powers. To give her peace of mind, she used her powers to resurrect her dead mentor Agatha Harkness, who cast a spell on Wanda to suppress her memories of having had children in the first place.

All it took was an errant crack by the Wasp about her having tried to have kids and vague memories of her children came back. She had another full-on nervous breakdown, and reached out to Doctor Doom to help her bring her children back to life. Together, they launched a campaign of vengeance against the Avengers for failing to save her kids. During a devastating attack on Avengers Mansion, several team members were killed and it ultimately led to the dissolution of the Avengers as we know them. It took the combined might of Doctor Strange's powerful mystical abilities and the Avengers in order to bring her down. Once defeated, she lapsed into a coma and was taken by Magneto to the mutant island nation of Genosha to recover.[73]

After several months, the X-Men and the Avengers gathered to determine Wanda's fate. Fearing that they were going to kill her, Quicksilver convinced Wanda to use her hex powers to alter reality and change the world into one where both the heroes and Magneto would get what they wanted. She did, creating a world in which she and her family, the House of M(agneto), ruled over the entire planet where mutants reigned and humans were a minority. Though the reality warp was successful, Wolverine and several other heroes realized what had happened and went off to confront

Magneto, believing him to be responsible. During the standoff, it came out that Quicksilver had put Wanda up to it, and Magneto murdered his son in cold blood. Wanda used her powers to resurrect her brother, and with three simple words—"No More Mutants"— changed the Marvel Universe as we knew it. Suddenly, 99 percent of the world's mutant population, including her father and brother, lost their mutant powers, leaving a mere 198 mutants remaining. Distraught, Wanda fled to live in seclusion on Wundagore.[74]

Several years later, Wanda returned to the Avengers during the events of *Avengers vs. X-Men*, saving the Avengers from certain death at the hands of Cyclops, who is possessed by the evil Phoenix Force.[75] Along with the messianic mutant Hope Summers, Wanda is able to defeat the Phoenix Force by uttering three simple words—"No More Phoenix"—resulting in the defeat of the cosmic entity and the restoration of mutant powers worldwide, effectively reversing the catastrophic events of *House of M*.[76] All's well that ends well, right? Sort of. She would die and be resurrected in the events following *Avengers vs. X-Men*, but that seems to be par for the course for Earth's Mightiest Heroes.

As for the Scarlet Witch we'll be seeing in *Avengers: Age of Ultron*, that's a horse of a different color. Although she's Magneto's daughter, don't call her a mutant— no really, legally Disney and Marvel can't call her that on the big screen; those rights are tied to the X-Men franchise, which is owned by Fox. Wanda Maximoff is *technically* a mutant as far as comics fans are concerned, but the Wanda we'll see on the big screen will likely be a superpowered youth with no connection to Magneto. When we last saw her and her brother at the end of *Captain America: The Winter Soldier*, they were in holding cells at an underground HYDRA base, which means that she's likely full of misinformation regarding who the good guys and bad guys are, and she'll be more than a little unstable. Just look at how Bucky turned out after his transformation into the Winter Soldier. As Stan Lee would say: "Nuff said."

15 Quicksilver

To say that Pietro Maximoff lives life in the fast lane would be the understatement of the century. The superpowered mutant hero known as Quicksilver is arrogant, imperious, and impatient with nearly everyone he encounters, a likely side effect of his power: the ability to run at superhuman speeds. Of course, Quicksilver explained that this disdainful attitude is a direct result of perceiving the world in slow motion: "Have you ever had a day where you are at the ATM and you are in a hurry because you're running late but the person in front of you doesn't know how to use the ATM and they're taking forever? Now imagine what it must be like to spend every day surrounded by people who don't know how to use the ATM."[77] Say no more, Quicksilver, we completely understand.

Raised by a pair of gypsies named Django and Marya Maximoff, Pietro and Wanda (also known as the Scarlet Witch) had a tumultuous youth, much of which was spent on the run from angry, terrified mobs. Pietro, like Wanda, led a difficult life that saw him swayed into a life of supervillainy after his father, Magneto (although they didn't know of their blood relation at the time) rescued him and his sister from an angry mob, compelling them to join the Brotherhood of Evil Mutants. Evil was not necessarily in Quicksilver's blood—though he and Wanda stayed with the Brotherhood for a time out of a sense of obligation to Magneto, they soon left and joined the second iteration of the Avengers at Captain America's behest.[78]

They remained core members of the team for many years, and Pietro developed a particular bond with Hawkeye, another reformed villain turned hero. Growing up on the run with his sister and facing constant persecution, he is extremely protective of his

sibling, often to the point of irrational anger. When Wanda became romantically involved with the Vision, the android hero and fellow Avenger, Pietro was furious, refusing to accept their relationship at first, but eventually accepting their love and giving his blessing to their marriage.[79] To be fair, though, most people would probably raise an eyebrow if they heard their sibling was dating a synthetic humanoid created by a megalomaniacal robot bent on destroying them and everyone they loved.

While on a mission, Pietro is gravely wounded by a Sentinel, the giant mutant-hunting robots from X-Men lore, and is discovered by Crystal, a member of the Inhumans, who nurses him back to health. Although the pair would eventually marry (despite a mid-wedding Ultron attack) and have a daughter together named Luna, it would be an arduous path to happiness.[80] In the miniseries *Vision and the Scarlet Witch*, it was revealed that, though Quicksilver proved to be a neglectful and easily enraged husband, Crystal had an affair with a human real estate broker named Norman Webster. After discovering the truth, Quicksilver was furious, a fact which Crystal's evil uncle Maximus the Mad seized upon, using technology to plunge Pietro into a psychotic rage, turning him on the Avengers and betraying his one-time allies to the U.S. government.

Eventually cured of his mania, he sought to make amends for his behavior by fighting alongside the West Coast Avengers against Magneto and Immortus, who had kidnapped his sister before moving on to fight for the government-funded superhero team X-Factor.[81] When all the Avengers seemingly died fighting against the psychic villain Onslaught, Pietro initially refused to help re-form the Avengers thanks to governmental anti-mutant legislation. However, when the Earth's heroes returned and he was reunited with his estranged wife Crystal, he helped Earth's Mightiest Heroes reassemble, taking the title of reserve member and helping the team on various missions.

While living with his father on Genosha, an island mutant nation, he watched over his sister as she recuperated in the wake of the tragic events of *Avengers Disassembled* that saw her using her powers to nearly destroy the Avengers, killing Ant-Man, Hawkeye, and the Vision. Overhearing discussions between the X-Men and Avengers over how to deal with Wanda, Pietro feared that they would kill her, so he convinced his sister to use her chaos magic to alter reality to one in which everyone would get what they want. The result was a dystopian world in which mutants ruled the planet under the iron fist of Magneto and his family. Eventually, some of the world's heroes saw through the magical ruse and, blaming Magneto, took the fight to him. When it came out that it was done at Quicksilver's behest, Magneto turned on his son and the two began fighting. Unable to bear the strife tearing her family apart, Wanda uttered three words—"No More Mutants"— and depowered 99 percent of the world's mutant population, Quicksilver and Magneto included, in an event that would come to be known as the Decimation.

Desperate to regain his powers, Quicksilver exposed himself to the Terrigen Mist, the mysterious substance that gives the Inhumans their superpowers and mutant abilities, and kidnapped his daughter Luna. Seeing how mutated and deranged he has become, Crystal has their marriage annulled, and Quicksilver soon winds up alone, destitute, and in jail after the members of X-Factor removed the Terrigen crystals from his body, depowering him once more. It was only after he escaped and saved an innocent bystander that he rediscovered his desire to be a hero and fight for the forces of good.

He was eventually exonerated after helping the Avengers save the day during the Secret Invasion, and is publicly exonerated of all misdeeds. His past behavior was blamed on a Skrull impostor, a lie known only to Henry Pym, his daughter Luna, and the Avengers' butler Jarvis.[82] Although he loses the respect of his daughter, Pym

insists that they keep the secret, believing that everyone deserves a second chance. Given Pym's horrific track record in his personal life, he is most definitely speaking from experience. Most recently, Quicksilver has tried to distance himself from his father's tainted legacy by working as an instructor at the Avengers Academy, training the next generation of potential Avengers and using his considerable tactical prowess for good.[83]

Like his sister, the Scarlet Witch, Quicksilver is set to make his Marvel Cinematic Universe debut in *Avengers: Age of Ultron*, played by Aaron Taylor-Johnson. In a bit of cool movie trivia, Taylor-Johnson's *Kick-Ass* co-star Evan Peters also played Quicksilver in Fox's *X-Men: Days of Future Past*, a memorable but drastically reimagined version of the speedster. Though he likely won't have any connection to Magneto on the big screen, Pietro will hew closer to his origin story of being a child from a war-torn, tumultuous country who faced tremendous adversity alongside his sister as a result of their incredible abilities. When we last saw them at the end of *Captain America: The Winter Soldier*, they were trapped in a pair of cells in a basement laboratory belonging to the terrorist organization HYDRA, so it's looking like a good bet that he'll be fighting against Earth's Mightiest Heroes before joining them to defeat the looming threat of Ultron.

16 The Vision

Built from the inert android body of the original 1940s version of the Human Torch, the Vision was originally an instrument of evil, a synthetic humanoid crafted to exact a terrible vengeance on Earth's Mightiest Heroes. In a roundabout way, Henry Pym is

partially responsible for the Vision's existence. The shrinking scientist crafted an advanced android called Ultron who accidentally achieved sentience and turned on his creator, and Ultron in turn created a hyper-intelligent homunculus of his very own. With a control crystal on his forehead to keep him in check and neural processors based on the brainwave patterns of deceased Avenger Simon Williams, better known as Wonder Man, the Vision was designed to be Ultron's perfect killing machine, a soldier to do his bidding and proof positive that he could create life on a whim. Little did Ultron know that the Vision would go on to become one of the greatest Avengers in the team's history. Except that one time Ultron possessed the Vision and made him rebuild the megalomaniacal machine out of nearly indestructible adamantium—that was pretty bad.[84]

The Vision has a complicated set of powers, which work in cohesion to make him one of the heaviest hitters on the team's roster. The Solar Jewel on his forehead absorbs solar energy in order to power his internal computer systems, but also allows him to discharge the energy as powerful optic beams. Most famously, Vision can control his density, allowing him to fluctuate between diamond-hard and spectral intangibility, which he can use to phase through walls. In addition to these fantastical abilities, the Vision possesses superhuman strength, heightened reflexes, and can process information at incredible speeds due to his android brain.

When we first meet the Vision, he stalks the streets of New York City, rain beating down on his head, as he stares through the windows of the Wasp's apartment. Suddenly and without warning, he appears in her apartment and threatens her life. "No—no! It's some sort of unearthly inhuman vision!" she cries before running away, locking the door of the bathroom behind her.[85] Just when she thinks she's safe, the Vision begins phasing through the wall, his gnarled yellow hand reaching towards her. It is, by all accounts, a horrific introduction to a character, yet by the issue's end, the

Vision, having accidentally lured the Avengers back to Ultron's lair, betrays his creator and saves the Avengers from certain doom. From that point forward, Earth's Mightiest Heroes accepted the Vision as one of their own, and he fought alongside them during some of their most trying battles.

After joining the Avengers, he grew close with Wanda Maximoff, the Scarlet Witch, and soon the two were married. Although many, including Quicksilver and Hawkeye, opposed this union at first, the Avengers came to accept the couple, and they even went on to have twin boys named Thomas and William thanks to Scarlet Witch using her magic.[86] While battling against the villain Annihilus, the Vision shuts down, regaining consciousness several weeks later only to find he is paralyzed. Although he eventually regained control of his body and became the team leader, his experiences left him unstable.[87] His control crystal began malfunctioning, and he soon seized control of the world's computers and defense systems in an effort to create a new global golden age of peace on Earth. The Avengers stopped him before it was too late by severing his connection to the computers and removing the control crystal, but he lost the trust of the world's governments who closely monitored him thereafter.

In the wake of his megalomaniacal malfunction, the Vision came to be seen as a high-level security threat, so much so that government agents kidnapped and dismantled the Vision, erasing his memory in the process. Though he was rescued and rebuilt by Henry Pym, the recently revived Wonder Man refused to let them implant his brainwave patterns into the newly reconstructed Vision. Wonder Man was jealous of his cybernetic counterpart, especially his relationship with Scarlet Witch, for whom he harbored secret feelings. As a result, the new Vision was pale white, completely devoid of human emotion, and unable to remember that he loved his wife.[88] While that may sound appealing to some of you married folks out there, it was pretty devastating at the time.

Later on, he would regain the ability to feel emotions and, though he recalled his time with Scarlet Witch, he decided not to reconcile with her. Rather, he focused on exploring those aspects of the human condition he had not yet experienced. Yet, this was not the end of his turbulent relationship with Scarlet Witch. When Wanda lost control of her powers and went insane, she used her chaos magic to transform the Vision's body into a series of Ultrons, which led to the deaths of many Avengers like Ant-Man and the Vision himself.[89] Enraged, She-Hulk tore Vision's body asunder. What remained of him was locked away in storage until his tattered body could be repaired, which it eventually was thanks to the Avengers resident tech whiz, Tony Stark. Once restored, the Vision forgave She-Hulk for smashing him, but he could not bring himself to do the same with Scarlet Witch. While he still cared for her on some level, he could not forgive her for weaponizing his body and using it to harm their friends, leading him to banish her from the Avengers Mansion when she attempted to return.[90] And you thought *your* breakups were bad.

We haven't yet seen the Vision on the big screen, but we know that he'll be played by a familiar face. Well, voice technically: Paul Bettany. The British actor has been a part of the Marvel Cinematic Universe since 2008's *Iron Man*, voicing J.A.R.V.I.S., the effete artificial intelligence system that operates Tony Stark's Iron Man armor. While we don't know exactly what is going to happen in *Avengers: Age of Ultron,* we know that somehow J.A.R.V.I.S. will be transformed by Ultron into the villain-turned-hero we know and love, the Vision. Whether we'll see the sparks of love between him and Elizabeth Olsen's Scarlet Witch, though, is another matter entirely.

17 Thanos

Remember that craggy, purple-faced giant sitting on a floating throne on an asteroid in deep space at the end of *Avengers* and in *Guardians of the Galaxy*? Remember how he had Josh Brolin's booming baritone? Well, that, dear readers, is none other Thanos, the Mad Titan, one of the most powerful villains in the Marvel Universe, and the all but confirmed villain of *Avengers: Infinity War*, a film that has yet to be written. How do we know this? Well, for starters his name is derived from the Greek word *Thanatos,* the demonic personification of death itself. And have you seen that ugly purple mug? I rest my case.

Thanos has superhuman strength and incredible stamina, but he can also absorb and redirect cosmic energy as a weapon too. Hyperintelligent, Thanos is well versed in nearly every field of advanced science, a master strategist, and an accomplished hand-to-hand combatant, to boot. In other words, he's not just some joker in a costume; he's one of the strongest, most dangerous figures there is in the MCU.

Jim Starlin originally came up with the idea of Thanos during a college psychology class. If you're seeing thematic and stylistic similarities to DC Comics' resident galactic tyrant Darkseid, you're not crazy; Thanos was indeed influenced by DC's big baddie, a character created by Jack Kirby, and has filled a similar role in the Marvel Universe. Although we know Thanos as the blue-and-orange-clad behemoth, the original design wasn't nearly as bulky. In fact, it hewed closer to another of Kirby's New Gods, Metreon. When Starlin brought the character to editor Roy Thomas, he took one look at him and said, "Beef him up! If you're going to steal one of the New Gods, at least rip off Darkseid, the really good one!"[91]

A slightly less purple Thanos (Josh Brolin) shows off the Infinity Gauntlet.
(Alberto E. Rodriguez/Getty Images)

Born on Saturn's moon of Titan in a colony of Eternals, a race of evolutionarily enhanced humans created by mysterious beings called the Celestials, Thanos was misshapen and disfigured, especially compared to his handsome brother Starfox. As they grew older, Starfox embraced a devil-may-care attitude while Thanos grew into a dark, brooding man obsessed with death itself. He craved power, and went so far as to give himself cybernetic implants until he was stronger than anyone else in his community. Reportedly, he even vivisected his own mother to investigate how someone so consumed by death could have been given the gift of life.

Exiled from his home, Thanos traveled the galaxy, growing in power and reputation. At one point, he met Death itself, which appeared personified in a female form. Thanos found himself smitten with Death and devoted his life to making himself worthy of her love. Amassing an army, he conquered his home world of Titan, and proceeded to try to claim the powerful relic, the Cosmic Cube, prompting a coalition of Earth's heroes to band together and stop him. With the power of the Cosmic Cube, he was nearly godlike, battling back the likes of Captain Marvel and the Avengers. In a wild gambit, Captain Marvel convinced Thanos that he had drained the Cube of its power reserves, so Thanos threw it away. Seizing the moment, Captain Marvel grabbed the Cube and used its power to restore the universe to its rightful order while depowering Thanos in the process.

Believing that his failure caused Death to reject him, Thanos devised a new plan to win her love, searching for the powerful Soul Gems, which you may know from Guardians of the Galaxy as the Infinity Stones. After hearing of a prophecy that states a hero known as Adam Warlock would prove to be his undoing, Thanos time-traveled to the future to create a perfect assassin of his very own, the warrior known as Gamora, who he adopts as an infant and raises to become a killing machine. With her by his side,

Thanos soon amasses the six Infinity Stones, using their power to extinguish stars and all the life they contained in an effort to court Death. However, Adam Warlock learned of his plan, and assembled the Avengers and Captain Marvel to oppose the Mad Titan. Adam Warlock died in the ensuing battle, but was restored to life at the intervention of Spider-Man, the Thing, and cosmic entities. Filled with cosmic power upon his resurrection, Warlock defeated Thanos in battle and ultimately turned him to stone, a fate worse than death for one who wanted nothing more than to be united with Death.

Though Death would indeed come for Thanos. The cruel mistress restored Thanos to life, which he took as a sign that the universe was out of balance. Once again amassing the Infinity Stones, Thanos placed them into a powerful weapon, the golden glove known as the Infinity Gauntlet, which he used to exterminate half the living beings in the galaxy. Obviously, this aroused the interest of nearly every hero in the universe, as well as several ancient cosmic entities that realized that Thanos' power was too great to wield. With nearly omnipotent power, Thanos defeated all of the Marvel Universe's heroes only to be spurned by Death, which left the Mad Titan distraught. In his moment of weakness, his "granddaughter" and acolyte Nebula seized the Infinity Gauntlet for herself. Thankfully, though, Adam Warlock and the Avengers were able to defeat Nebula and Thanos, thanks in no small part to powerful cosmic beings like Galactus, Lord Chaos, and Master Order. His reign of terror put to an end, Thanos was exiled to an uninhabited planet to live out a hermetic existence. Yet that would not be the last time Thanos threatened the Marvel Universe or wielded omnipotent power. Like all the best villains, Thanos always manages to find a way to build himself back up, and when the Mad Titan has even a modicum of power, it takes the combined might of Marvel Universe's finest to bring him down. We saw at the end of *Guardians of the Galaxy* the havoc one Infinity Stone can wreak,

so just imagine the unbridled power of all six when wielded by a brutally strong tyrant like Thanos. 'Nuff said.

18 Joss Whedon

Although there was no stopping the juggernaut that is Marvel Studios' cinematic empire, one cannot help but wonder whether or not *Avengers* would have been the box office powerhouse it was without director Joss Whedon at the helm. Chances are that without Whedon's unique narrative sensibilities and penchant for telling high-octane, action-packed stories that are infused with heart and genuine emotion, *Avengers* could have been yet another casualty in this age of distraction cinema in which we live. Whedon has long been a darling among the Comic-Con crowd, and for good reason. By age 50, Whedon has given the world a Western set in outer space, a black-and-white modern-day *Much Ado About Nothing*, a vampire-slaying teen, a *Horrible* sing-along web series, and, lest we forget, the *Avengers*. To say the least, he has been the creative force behind a number of cult classic franchises with rabid fan bases that come out in droves to support him.

Though *Avengers* brought Joss Whedon into the Hollywood limelight, he's been a powerful force behind the scenes for years. Beginning with a stint writing *Roseanne* in 1989, Joss Whedon has had a long, twisting and turning career as a writer. Whedon also has a reputation as one of the hottest script doctors in Hollywood, meaning that when a script just doesn't seem to be working, studios take it to Whedon to fix it. He worked as an uncredited writer on films like *Speed*, *Waterworld*, *Twister*, and *X-Men*. Though *X-Men* evidently only wound up using two of Whedon's exchanges, the

final version of *Speed* used nearly all of Whedon's dialogue. The studio gave him a writer's credit, but then, as Whedon revealed in an interview, "The Writers Guild of America took it away, and I was pretty devastated."[92] At least he has his piles of *Avengers* cash to dry his tears.

While working as a script consultant, Whedon penned *Buffy the Vampire Slayer* (1992)—the feature film version that preceded the eponymous series—and *Alien: Resurrection* (1997). Whedon would also go on to co-write 1995's *Toy Story* (earning him an Academy Award nomination for Best Original Screenplay) and *Titan A.E.* (2000). It was in1997, though, that Whedon took his first step into the hearts and minds of a generation of TV fans with *Buffy the Vampire Slayer*, the TV adaptation of his 1992 film. The series arose from his dissatisfaction with seeing "the little blonde girl who goes into a dark alley and gets killed in every horror movie" played ad nauseam in Hollywood films.[93] Like many of Whedon's works, *Buffy* deconstructed that trope, subverted it, and resulted in a compelling, critically acclaimed series.

Buffy the Vampire Slayer ran for seven seasons, netted an Emmy Award for the 1999 episode "Hush," and has gone on to become the subject of many fan-oriented academic studies, thanks in particular to its position as a feminist work. Indeed, strong female characters are something of a hallmark of Whedon's work, with empowered female protagonists kicking ass and taking names. When asked about this particular narrative predilection for the umpteenth time, Whedon famously replied, "Because you're still asking me that question."[94]

After *Buffy*, Whedon created a spin-off series, *Angel*, which ran for five seasons and, like Buffy, continued in canonical comic book form at IDW Publishing before moving to Dark Horse Comics. In 2002, Whedon followed *Angel* with one of his most popular creations to date, *Firefly*. The space-set western was an oddball, offbeat mish-mash of genres that combined a charismatic cast, sleek

Whedon's Other Woman

Little do many people know, but *Avengers* wasn't the first superhero project to have Joss Whedon's name attached to it. In the summer of 2001, New Line was trying to get its adaptation of *Iron Man* off the ground and approached Whedon to potentially direct, but the talks fell through. During the mid-2000s, Warner Bros. and Silver Pictures tapped Whedon to write and direct an adaptation of DC Comics' Wonder Woman. Given his penchant for writing strong female characters, it seemed like a natural fit for Whedon. After spending two years on the script, Whedon and the studio ultimately couldn't see eye to eye, and the project fell apart in early 2007. "It's pretty complicated, so bear with me," he wrote on his website. "I had a take on the film that, well, nobody liked. Hey, not that complicated." Having read the script, it's a crying shame that the world never got to see his vision of DC's Amazonian princess, but fortunately for us that meant we got the *Avengers*, so thanks, wishy-washy film execs!

(Elder, Robert K. (June 1, 2001). "All work and lots of slay." Chicago Tribune); (Whedon, Joss. "SATIN TIGHTS NO LONGER." Whedonesque. N.p., 3 Feb. 2007. Web. 05 Sept. 2014. <http://whedonesque.com/comments/12385>.)

narrative, and unique premise to create an unusually endearing and enduring series, which is saying something, considering it only ran for 14 episodes before Fox cancelled it. Though Whedon would continue the story in the 2005 feature film *Serenity*, *Firefly* still has a ferocious fanbase to this day, and perennially appears on lists of most-wanted sequel series.

During the 2007–2008 Writers Guild of America strike, Whedon struck paydirt again with *Dr. Horrible's Sing-Along Blog*, a musical web series he directed, co-wrote, and produced with his brother Jed Whedon. The series went viral and reignited Whedon's popularity, leading to the creation of his fourth TV series *Dollhouse* in 2008, which ran for two seasons before going off the air. Afterward, Whedon spent time finishing up his run on comics like Marvel's *Astonishing X-Men* and *Runaways*, as well as continuing

his *Buffy*-verse comics too, in addition to the occasional television directing gig on shows like *Glee* and *The Office*.

So, the question remains: How did Joss Whedon land the crown jewel of Marvel's film empire with only one feature film directing credit to his name? According to popular lore, it was his criticism of the original Zak Penn script. "I don't think you have anything," Whedon told Marvel Studios president Kevin Feige. "You need to pretend this draft never happened." That confidence and self-assuredness went a long way with Feige and it was finally confirmed in 2010, hot on the heels of completing work on his love-hate letter to horror films with Drew Goddard *Cabin in the Woods*, that Whedon would be directing *Avengers*.

For Whedon, directing *The Avengers* was not an opportunity he felt he could pass up. After meeting with Feige, Whedon had an epiphany. "I thought about it and my question wasn't, Can I get *The Avengers*?" Whedon said. "My question was, Honestly, can *The Avengers* get me? Like, do I need to tell this story? Is there a reason for me to make this movie?' Because if there's not, I don't want to waste their time and I certainly don't want to be away from my family," he continued. "And I thought about it and I was like, these are the most dysfunctional people on the planet. They are my people. I need to tell this story."[95] And now, with *Age of Ultron*, Whedon continues that story in a spectacularly apocalyptic fashion—and we couldn't be happier that he did. One can only imagine what the multi-hyphenate will do next. Considering he spent his break in between wrapping on *Avengers* and shooting the pilot for *Marvel's Agents of S.H.I.E.L.D.* by filming a black-and-white adaptation of William Shakespeare's *Much Ado About Nothing* in 12 days at his Santa Monica home, you can bet your bottom dollar that it'll be worth the wait.

19 Black Panther

Though the first black superheroes we've seen in the Marvel Cinematic Universe have been Jim Rhodes (Don Cheadle) and the Falcon (Anthony Mackie), there is one who preceded them that audiences have been clamoring to see. That hero is none other than the Black Panther. The Falcon may have been the first African American superhero, but Black Panther was the first black superhero in mainstream superhero comics and remains one of the most iconic Avengers in the team's decades-long history. Unveiled years before Marvel's the Falcon, Storm, and Luke Cage, and even longer before DC Comics characters like the Green Lantern (John Stewart), Cyborg, or Black Lightning, the Black Panther has been an important part of the fabric of the Marvel Universe and the public consciousness since he made his thrilling debut in *Fantastic Four* #52 in July 1966.

When one thinks of the name "Black Panther," the first thing to come to mind is likely a fist raised in solidarity, the symbol of the black political party also founded in 1966. Even though they both emerged in the latter half of 1966, Marvel's hero actually predates the political organization by several months. In fact, Marvel briefly changed his name to Black Leopard in 1972 to avoid connotations with the political party.[96] Black Panther even moonlighted as Daredevil for a spell at Matt Murdock's behest after he was possessed by an ancient vengeful spirit during the events of *Shadowland*.[97] He and his then-wife, the X-Men member Storm, also filled in as members of the Fantastic Four for Reed Richards and Susan Storm.[98] Yet, at the end of the day, the hero always returns to his iconic moniker, that of the Black Panther.

Born in the far-off African kingdom of Wakanda, T'Challa, the man who we would come to know as Black Panther, was the heir to the ruling dynasty and the Panther Clan. His mother died during childbirth, leading his adopted older brother, Hunter, to resent him for much of his life. As a teenager, T'Challa's father T'Chaka was murdered by the villainous Klaw, a Dutch physicist who sought to plunder Wakanda's vibranium supplies in order to power a device that could transform sound waves into physical force. Before he could he escape, though, T'Challa attacked Klaw, cutting off his right hand before the villain could make good his escape.

Studying abroad in both Europe and the United States, T'Challa was a citizen of the world, yet his heart lay in Wakanda. He returned to undergo ritual trials, including fighting his uncle S'yan, the then-current Black Panther, in order to win the heart-shaped herb, which linked him spiritually to the Panther God Bast and granted him enhanced physical capabilities. With his newfound position as Wakanda's ruler, T'Challa disbanded the secret police (of which his brother was a member), and unified the warring tribes in order to transform his country into a high-tech bastion of education and enlightenment. This was a particularly bold narrative decision at a time when many portrayals of African kingdoms tended to depict the continent as being backwards or somehow uncivilized.

One of his first acts as king was to invite the Fantastic Four to visit Wakanda. Upon their arrival, he attacked them and neutralized them one by one in order to prove himself worthy of ruling Wakanda, as well as test their abilities as an ally against the nation's menace, the supervillain Klaw. After making amends, T'Challa befriended the Fantastic Four, and together they defeated both Klaw, now a being made of solid sound, and the evil Psycho-Man, an insane technocratic leader from the Microverse. Beginning in *Avengers* #62 in 1969, Black Panther joined the Avengers, initially intending to spy on the American supergroup from within, but

he soon came to regard them as staunch allies.[99] From that point forward, T'Challa would split his time between Wakanda and America, joining the Avengers to battle off the likes of M'Baku the Man-Ape, the rebel leader Eric Killmonger, the Ku Klux Klan, and countless others in order to defend his homeland and the world at large.

What sets Black Panther's stories apart from most is that he must balance his responsibilities as a monarch and an ambassador of Wakanda with his duty to protect the world at large from threats that only Earth's Mightiest Heroes can stop. So, in between battling the likes of Ultron and Thanos, T'Challa must also contend with threats both diplomatic and internal. Having sealed off the country's supply of vibranium from the world at large, Wakanda is constantly under threat from invading forces looking to stripmine it for its valuable resources. Not only that, but rebel forces like those led by Eric Killmonger constantly sought to dethrone Black Panther and claim their title for himself, often enlisting mercenaries like Deadpool to attack T'Challa and his homeland. As the saying goes, heavy is the head that wears the skin-tight black spandex and the crown.

A Black Panther film has been in development since 1992, with Wesley Snipes spearheading much of the efforts. Snipes was originally intended to star in the film, but the plans never came to pass primarily due to his attachment to the *Blade* franchise and his later incarceration for income tax evasion. Marvel reinvigorated efforts in 2009, creating an in-house team of writers to work on feature film scripts for *Black Panther* and heroes like Doctor Strange, Cable, and Iron Fist.[100] In 2011, Marvel hired Mark Bailey specifically to write a script for Black Panther. It seemed all progress had stalled until Marvel made a surprise reveal during a live event on October 28, 2014. Not only did they announce a Black Panther solo film for November 3, 2017, but they brought out actor Chadwick Boseman, who will portray the mighty T'Challa on screen, beginning with

Captain America: Civil War on May 6, 2016. Given T'Challa's place in Marvel's considerable canon, his role in Avengers history, and his ever-growing fan base, it was only a matter of time before we would see the Black Panther up on the silver screen. Because if Howard the Duck can get his own movie, why not T'Challa too?

20 Kevin Feige

Just as Stan Lee and Jack Kirby architected a sprawling universe of comic characters that have, one by one, dominated box offices across the world, Kevin is the man behind the curtain of Marvel's conquest of global popular culture. Unlike his counterpart in the Emerald City of Oz, you should definitely be paying attention to this soft-spoken, blazer-clad, baseball cap–wearing man who quietly transformed Marvel Studios into an international powerhouse.

Born, like all great men, in Boston, Massachusetts, Kevin Feige grew up in Westfield, New Jersey, before attending college at the University of Southern California. While studying at USC, he began interning for producer Lauren Shuler Donner, who has produced everything from *Pretty in Pink* to *Free Willy* to *X-Men* to 2016's *Deadpool*. After graduation, he began working as her assistant, and worked on projects like *You've Got Mail*—he was instructed to teach Meg Ryan how to use e-mail.[101] When Donner began working on *X-Men*, she made Feige an associate producer on the film thanks to his encyclopedic knowledge of the Marvel Universe. Seven years later, at the age of 33, he was named president of Marvel Studios, the first major independent movie studio since DreamWorks.

Unlike many producers who have shepherded multiple films past $1 billion in ticket sales worldwide, Feige is an unassuming

Kevin Feige at the premier of Captain America: The Winter Soldier.
(Christopher Polk/Getty Images)

impresario. While men like maverick financier Avi Arad may have laid the groundwork for many of these deals to get off the ground, it was Kevin Feige who helped see them from concept to completion. In an industry marked by constant meddling from the executive level so that everyone can leave their stamp on the film, Feige blazed a different trail, hewing close to the source material in an effort to appeal to the hardcore comic book readers first and foremost. After all, with 50-plus years of comics continuity from which to mine, there's more than enough material ready to be turned into the next big-screen behemoth.

"I would hear people, other executives, struggling over a character point, or struggling over how to make a connection, or struggling over how to give even surface-level depth to an action scene or to a character," Feige, speaking about his time on *X-Men*, recalled in an interview. "I'd be sitting there reading the comics going, 'Look at this. Just do this. This is incredible.'"[102] Moreover, his eye for casting is unparalleled. Before *Iron Man*, Robert Downey Jr. was considered a risky commodity after his ongoing legal troubles, and Feige brought Mark Ruffalo in to replace a contentious Edward Norton as the Hulk for *Avengers*.

Avengers director Joss Whedon may have put it best: "Kevin is just a huge nerd. Possibly more than I am."[103] When you're making movies based on what is ostensibly something very nerdy, it's probably best to have someone in the target audience helping craft the final product. Just as Stan Lee and Jack Kirby broke ground in the 1960s by crafting an interconnected universe with a recurring cast of characters, Feige has done the same with Marvel's vast cinematic universe. Having interviewed Feige on multiple occasions, I can attest that he is the real deal, and genuinely cares about the Marvel Universe rather than just making money. In an industry filled with cynical, opportunistic people, Feige is a breath of fresh air. That being said, his sphinx-like silence when pressed for details about upcoming productions is just as maddening as one would expect.

21 Brian Michael Bendis

In the modern era of comic books, particularly where Marvel Comics is concerned, there are few names more iconic than Brian Michael Bendis. With an impressive array of both creator-owned

works and seminal Marvel Comics/*Avengers* stories under his belt (and five Eisner Awards, to boot), Bendis has had a hand in everything from launching the Ultimate Marvel Universe to relaunching the Avengers in 2004's *New Avengers* to helping chart the course of the Marvel Cinematic Universe. With that said, it's more than safe to say Bendis is someone that *Avengers* fans need to know about before they shuffle off this mortal coil.

Born on August 18, 1967, in Cleveland, Ohio, Bendis decided that he wanted to work professionally in comics from a very early age. In high school, for a creative writing assignment, he submitted a novelization of Chris Claremont's *X-Men and the Starjammers* story, which earned him an A+ for inventiveness.[104] He first broke into the field through the Michigan-based Caliber Comics, an independent publisher through which he met longtime friends and creative collaborators Michael Avon Oeming, Dave Mack, and Marc Andreyko.[105] The success of one of his Caliber/Image Comics books, *Jinx*, led to an invitation from Marvel editor Joe Quesada to contribute ideas for the then-newly minted Marvel Knights imprint. Bendis pitched a planned, but ultimately unproduced Nick Fury story, but more importantly, he got his foot in Marvel's door.[106]

With the release of 2000's *X-Men* film, Marvel was looking to reinvigorate its readership and provide an alternative to readers who might be daunted by half a century of continuity. Their solution was to create Ultimate Marvel, a new line of books featuring everyone's favorite heroes that would hit the reset button and tell the heroes' stories from word one. On Quesada's recommendation, Marvel editor-in-chief Bill Jemas hired Bendis to pen one of the flagship titles, *Ultimate Spider-Man*.[107] Adapting Peter Parker's 11-page origin story from 1962's seminal *Amazing Fantasy* #15 into a seven-issue arc, the comic was a hit, and even managed to surpass the mainstream Marvel Universe *Amazing Spider-Man* title in sales.

Alongside artist Mark Bagley, Bendis produced 111 consecutive issues, making it one of the longest-running partnerships in American comic book history, and the longest by a Marvel creative team, beating out even Stan Lee and Jack Kirby's legendary *Fantastic Four* run.[108] Perhaps most famously, he killed off Peter Parker in 2011 and replaced him with Miles Morales, a half-Latino, half–African American teenager that Glenn Beck insisted was part of a Michelle Obama–led conspiracy.[109]

While working on *Ultimate Spider-Man*, Bendis also expanded the Ultimate line, pitching titles like *Ultimate Fantastic Four, Ultimate Marvel Team-Up, Ultimate Origins*, and many more. During this time, he also penned the cult classic *Alias* for Marvel's adult-targeting, non–Comics Code-approved MAX imprint, which starred former costumed hero Jessica Jones as a private investigator. Soon, we'll be getting a Jessica Jones series on Netflix too, but there's no word yet on whether or not it will mimic the *Alias* run.

In addition, Bendis soon became Marvel's go-to guy for big-ticket event books. Coming in on the tail end of 2004's *Avengers Disassembled* event, which saw Scarlet Witch go berserk and murder several members as well as the disbanding of the Avengers, Bendis spearheaded the team's revival in *New Avengers*. One of his very first storylines culminated in the death of Hawkeye, a controversial story arc, but that was nothing compared to the 2005 New Avengers/X-Men crossover he penned with artist Olivier Coipel, *House of M*, which resulted in the depowering of 99 percent of the world's mutant population. After the devastating events of Marvel's 2006 *Civil War* event, Bendis would relaunch the Avengers once more as *The Mighty Avengers,* alongside artist Frank Cho, and follow that up with a full-blown invasion of Earth by the shapeshifting alien Skrulls in 2008's *Secret Invasion*.

Alas and alack, the Mighty Avengers in their then-current incarnation would disband at the conclusion of another storyline penned by Bendis called *Siege,* which saw Loki manipulating

Norman Osborn, then in charge of the United States' defenses, to lead his evil Avengers in an all-out assault on Asgard, which was floating above the small town of Broxton, Oklahoma. In the wake of *Siege*, Bendis helped relaunch both *Avengers* and *New Avengers* once more as part of a company-wide branding effort called "The Heroic Age." Though Marvel would hit the reset button on its entire lineup once more in 2013 with their Marvel NOW! initiative, Bendis this time wound up launching *All New X-Men*, a wildly inventive book that brought the original 1960s X-Men lineup into the present day, along with *Uncanny X-Men*, and *Guardians of the Galaxy*.

Most recently, Bendis penned the *Age of Ultron* storyline, a 10-issue crossover comic that saw the Avengers' greatest nemesis returning and conquering the Earth. The story was a complex saga that took place across multiple realities, examining what would happen if Henry Pym were killed before creating Ultron. The answer, of course, was more apocalyptic than one might expect. Although the *Avengers* film sequel is also subtitled *Age of Ultron*, Joss Whedon confirmed that the story is wholly original and not an adaptation of Bendis' storyline. Fans of Bendis need not worry though, because the writer is very much involved in helping to shape the trajectory of the Marvel Cinematic Universe too.

As part of a creative council that included Marvel Studios president Kevin Feige, Marvel Studios co-president Louis D'Esposito, Marvel Entertainment president Dan Buckley, and chief creative officer Joe Quesada, Bendis helped ensure that all the Marvel films adhered to one core principle: that they please the hardcore comic book readers first. As Joe Quesada said in an interview: "Really you have to start with the loyalists. If the loyalists reject it, then we feel that everyone is going to reject it."[110] Considering the box office totals of every Marvel Studios film since *Iron Man*, I'd wager that they're doing fine with comic book readers and non-readers alike, but that success is indubitably due in part to the input of men

like Bendis making sure that the films are always in service of the characters. That being said, someone should really sit Joss Whedon and him down because the glee they derive from killing beloved characters is probably listed as a cause for concern in the *DSM-5*.

22 The Tesseract

If you only knew how desperately I wanted to call this chapter "Gleaming the Cosmic Cube," you probably would have put this book down and walked away already. Fortunately, I didn't do that, so you're stuck reading it. Ha! The joke is on you, sucker! Kidding aside, I think you're great, and this chapter is no laughing matter, because the Tesseract is one of the most important items in the Marvel Universe. Well, technically, the Marvel Cinematic Universe because the Tesseract is, in truth, an extremely powerful relic known as the Cosmic Cube.

Though The Tesseract is one of the six Infinity Stones, specifically the Space Stone, allowing its user to power hundreds of advanced Hydra weapons and Loki to open a portal halfway across the galaxy, the Cosmic Cube is slightly different. The Cube enables the user to reshape reality itself, effectively granting wishes, nigh invincibility, and possesses the power to destroy entire galaxies with a thought. It has existed in one form or another in the Marvel Universe since 1966's *Tales of Suspense* #79 in which the paramilitary scientist group A.I.M. created it as part of an experiment to contain and harness a powerful energy source known as "x-element" energy, an omnidimensional substance that grants the Cube its reality-warping powers. Obsessed with its power, the Nazi agent known as the Red Skull seized control of the device, becoming

all-powerful in the process. In his omnipotent arrogance, the Skull was tricked by Captain America, who pretended to surrender, and knocked the Cube out of his grasp, causing it to fall deep into the ocean, a plot we saw mirrored and adapted in *Captain America: The First Avenger*.[111] This would neither be the first nor the last time the Red Skull would plot to get his hands on the Cube.

For a time, the Cube passed from hand to unsuspecting hand as everyone from Namor to Mole Man to the Red Skull again to A.I.M. managed to get their greasy, world domination–hungry mitts on it. Eventually, though, it fell into the clutches of none other than Thanos, the Mad Titan, who you may remember as the shadowy figure behind the Chitauri invasion in *Avengers* and the imperious Cheshire Cat–grinning behemoth sitting on a rocket-powered throne in *Guardians of the Galaxy*. Using it in an effort to control the universe—and literally court Death itself—Thanos challenged the Avengers and Captain Marvel (at the time, the alien Mar-Vell) before absorbing the energy contained within the Cube. Foolishly believing the Cube was drained of its power, he discarded the all-powerful device, leaving Captain Marvel to claim it and restore reality back to normal, an act that actually burned out the Cube in the process.[112]

Other Cosmic Cubes have been created over the years. A team of scientists, including Arnim Zola, who you may remember as the sardonic Nazi A.I. from *Captain America: The Winter Soldier*, was creating a Cube for the Red Skull and the Hate-Monger, the subtly named clone of Adolf Hitler.[113] The Red Skull intended to transfer his consciousness into the completed Cube, but the Hate-Monger betrayed him and called in a S.H.I.E.L.D. strike team to attack the Skull and retrieve the Cube. In classic evil Nazi warlord fashion, though, the Red Skull was on to Hate-Monger the whole time, and kept secret the fact that they had constructed a working Cube, but hadn't been able to tap into the x-element energy. As a result,

Hate-Monger's mind was trapped inside the powerless Cube, and it now resides on a shelf in Red Skull's trophy case.[114]

Time and time again, The Red Skull and Thanos vied for control of the reality-altering object, but each and every time Captain America, the Avengers, and on one occasion, the Guardians of the Galaxy, were there to save the day. As we saw at the end of *Avengers,* Thor retrieved the Tesseract and used it to return with Loki to Asgard to dispense some cold, hard Asgardian justice. In *Thor: The Dark World,* we learn that the Tesseract is safe and sound in Asgard, but it may be Asgard itself that is in danger; as Thor declines to succeed his father Odin on the throne of Asgard and leaves, we see that it was not the All-Father after all, but Loki in disguise. Methinks that we have yet to see the last of the God of Mischief, and with Thanos hot on the trail of the Infinity Stones, it's only a matter of time before the two team up once more to wreak havoc on Earth's Mightiest Heroes and our wallets (because I, for one, am definitely seeing it at least twice on the big screen).

23 The Chitauri

Nothing says "assemble a coalition of Earth's mightiest heroes to save the day" like an alien invasion, and that's precisely what happened in 2012's *Avengers.* Using the Tesseract to create a portal to deep space, Loki unleashed a full-scale invasion on the Earth by an alien race known as the Chitauri. Created by Mark Millar and Bryan Hitch, the Chitauri were actually inspired by British conspiracy theorist David Icke who believes that the world is secretly run by an elite cabal known as the Illuminati, who, themselves, are a race of shape-shifting reptilian humanoids.[115] If it sounds like the

stuff of science fiction, it is (I, for one, welcome our lizard over-lords), which is precisely why Millar and Hitch tapped them to be the primary extraterrestrial menace to both the Ultimate Marvel Universe and the Marvel Cinematic Universe.

Endowed with the ability to mimic human form and absorb human knowledge through a form of cannibalistic osmosis (read: they eat the brains of the humans they're impersonating), the Chitauri possess enhanced strength, stamina, durability, and have rapid regeneration. Conceived as Ultimate Marvel's counterpart to the shapeshifting Skrulls of the main Marvel continuity (Earth-616), the Chitauri first gained notoriety for secretly helping the Nazis during World War II.[116] This prompted the United States to respond in kind with a super-soldier program of their very own, spawning Captain America, who ultimately defeated them.

Their next attempt at world conquest involved long-term psychic manipulation by subtly influencing the media, implanting R.F.I.D. (radio frequency identification) microchips in school-children, and placing drugs in global water supplies. They also managed to infiltrate S.H.I.E.L.D., but were eventually detected and wiped out in a raid led by Black Widow and Hawkeye.[117] The trap had been set though, and using false information, they lured the Ultimates (the Ultimate Universe's Avengers equivalent) and S.H.I.E.L.D. to a small island where thousands of S.H.I.E.L.D. forces were killed and many helicarriers destroyed before the Ultimates could save the day.

Never ones to take a hint, the Chitauri counterattacked the Ultimates at their home base and captured the Wasp, holding her hostage at a hidden base in Arizona.[118] The jig was up though when a fleet of damaged Chitauri ships warped in, hovering above the secret base. Licking their wounds and on the run from their enemies across the galaxy, the Chitauri fleet ordered their Earth forces to destroy the planet and the solar system with a massive bomb as part of a very literal scorched-earth policy.[119] Iron Man

and Thor managed to dispose of the bomb by transporting it to another dimension (similar to how Tony Stark diverted a nuclear bomb to massacre the Chitauri fleet at the end of *Avengers*), and Captain America and the Hulk defeated the Chitauri armada and their leader by beating, dismembering, then eating him.[120] And you thought "Hulk smash" was overkill.

The Chitauri are slightly less insidious on the big screen and have way fewer connections to the Nazi Party, but unlike their comic counterparts, they're shown as servants of Thanos, the biggest, baddest villain in all the Marvel Cinematic Universe. Eagle-eyed viewers may have noticed that Taneleer Tivan, aka the Collector, kept a single Chitauri in his collection on the mining colony Knowhere in *Guardians of the Galaxy*. Likewise, the Chitauri have been referenced on *Marvel's Agents of S.H.I.E.L.D.* on multiple episodes, which gives the distinct impression that we haven't heard the last of Mark Millar's intergalactic interlopers. In fact, they might be walking among us already. Don't drink the water. Don't trust anyone. Invest in tinfoil hats. The end is nigh! (Of this chapter, at least.)

24 The Infinity Stones

As Tears For Fears famously told us, everybody wants to rule the world, and in the Marvel Universe that usually means that they're after the Infinity Stones. Also known as the Infinity Gems or the Soul Gems, the Infinity Stones are six powerful relics in the Marvel Universe. Each one grants its owner total control over one aspect of the universe—space, time, reality, mind, power, and soul. When all six are wielded together, usually vis-à-vis the golden glove known as

the Infinity Gauntlet (which you can see in Odin's vault in *Thor*) there is virtually nothing the holder cannot do, which usually is seriously bad news for the denizens of the Marvel Universe. The Stones were once a part of the primordial entity Nemesis, a goddess who existed at the beginning of the universe, but killed herself out of loneliness from being the only sentient being in the universe. In order of ROYGBIV (minus the I), here is what each Infinity Stone is capable of:

The Power Stone, first wielded by the blue-skinned, overly muscled behemoth the immortal Champion of the Universe (subtle), not only matched its bearer's red pants, but essentially grants omnipotence to whomever holds it.[121] Allowing access to all the universal power that has ever or will ever exist, it works as a booster of sorts to empower the other Stones' effects. The Power Stone made its first on-screen appearance in *Guardians of the Galaxy*, contained within Peter Quill's orb.

The Time Stone, originally held by the Gardner, one of the Elders of the Universe, is orange in hue and grants its bearer control over the past, present, and future.[122] With the Time Gem, you can travel through time, rapidly age or de-age (I prefer the term "youthanize," personally) beings, and trap people in endless time loops. Just imagine being made to relive middle school over and over again until the end of time. Yikes indeed.

The Reality Stone, yellow in color, gives whomever holds it control over reality itself, granting whatever the bearer wishes, even if it contradicts with the laws of science, physics, man, or nature. Arguably the most powerful of the Stones, it was Taneleer Tivan, the Collector, who originally held it, keeping it nestled away in his living museum of relics and intergalactic curiosities.[123] Though it has not been explicitly stated, it is widely believed that the Aether, the mysterious force that can alter matter into dark matter from *Thor: The Dark World*, is the MCU equivalent of the Reality Stone. As we saw at the end of *The Dark World*, the Asgardians delivered

it to The Collector for safekeeping, saying it was too dangerous to have two Stones so close together in Asgard. With a cruel smile, the Collector remarked, "One down, five to go."

The vibrant green Soul Stone, first possessed by Adam Warlock, allows its owner to control, manipulate, and steal the souls of the living and the dead.[124] It also allows the bearer access to a utopian pocket universe contained within. The Stone itself is sentient and constantly hungers for more souls, making it, perhaps, the most dangerous of all the Infinity Stones, since it is most likely to corrupt the holder.

The blue-hued Mind Stone grants the bearer incredible mental and psionic abilities, allowing them to access the thoughts and dreams of others at a whim. When used in conjunction with the Power Stone, it enables the user to access all minds in existence simultaneously, so thank your lucky stars that some e-mail spammer doesn't possess it. A manifestation of the universal subconscious, it was originally possessed by the game-loving cosmic elder The Grandmaster until it was seized by Thanos, the Mad Titan.[125]

Last but not least is the Space Stone, violet in hue and violent in purpose. You may know it better as the Tesseract. When activated, it allows the bearer to warp and rearrange space to his or her liking, moving objects anywhere through reality at a whim. It also grants the bearer the ability to exist in any or all locations, and when used in concert with the Power Stone, complete omnipresence. Be thankful that your mother-in-law hasn't managed to get her hands on it yet. It was possessed by the Elder of the Universe, Runner, until Thanos straight-up Benjamin Buttoned him, using the Time Stone to turn him into a decrepit old man, and then a baby before seizing the Stone by force.[126] The Tesseract acts as the Space Stone in the MCU, and is currently being held in Asgard, though who is watching over it there is in question.

As you may have already realized, the Infinity Stones are among the most powerful items in the Marvel Universe, both on screen

and on the printed page, and will only prove to be more essential to the Marvel Cinematic Universe as we build towards the showdown with Thanos in *Avengers 3*. Having seen three Stones already, it's only a matter of time until the rest are revealed, and then the fate of the universe will well and truly be at stake.

25 The Infinity Gauntlet

In all the decades that Marvel has been publishing comics, few storylines have been more iconic or enduring than 1991's *The Infinity Gauntlet* miniseries. The culmination of years of world building and the events of *Silver Surfer* #34 and the two-issue miniseries *The Thanos Quest*, the six-issue series brought together nearly the entire Marvel Universe, both earthbound and cosmic, in an effort to stop Thanos, the Mad Titan, from destroying the universe as we knew it. Written by Jim Starlin and illustrated, at first, by George Perez and later by Ron Lim, *The Infinity Gauntlet* not only set the bar for company-wide crossover events, but it is also the basis on which much of the Marvel Cinematic Universe is founded. If you have to die after reading any one chapter, it should probably be this one since it's crucial to your interests as both a fan of the comics and the cinematic adaptations.

Mistress Death, the living embodiment of, yes, Death, believed that there was an imbalance in the universe and sought to rectify the fact that there were more people living than dead. Who better to carry out this grim reaping than her loyal servant (who also happens to have a massive crush on her) Thanos? Death resurrects the Mad Titan in secret, who had perished after being turned to

stone by Adam Warlock, and tasks him with collecting the Infinity Stones once more.[127]

One by one, Thanos hunted down the possessors of the Infinity Stones, the Elders of the Universe who had fled to different corners of the universe after using the Stones to try to murder Galactus. With the six Stones—Time, Space, Mind, Reality, Soul, and Power—in his possession, Thanos placed them into a golden glove called the Infinity Gauntlet. With mastery of all aspects of existence, Thanos becomes godlike, and in an effort to court Death, he kills half the sentient life in the universe in an instant, including most of the X-Men, the Fantastic Four, and Daredevil, with a literal snap of his fingers.[128] The shockwave also destroyed the Bifrost (the Rainbow Bridge that connects Asgard with the other realms), Japan, caused a tsunami that devastated the East Coast of the United States, and the entire West Coast to sink into the ocean.

The surviving heroes of Earth band together along with a recently resurrected Adam Warlock, and cosmic entities like Quasar, Epoch, and Galactus to stand against Thanos in his newly omnipotent state. Meanwhile, Thanos scoffs at their plans, laughing at "fools taking up arms against omnipotence," and promising to "provide them with a most glorious doomsday."[129] Even though Thanos has murdered half the universe, Death remains unimpressed, so to spite her, he creates a lover in his image, the deadly Terraxia. Using a powerful mystical item, the Eye of Agamatto, Doctor Strange gives everyone the ability to breathe in space and teleports them to Thanos where they prepare for all-out war with the Mad Titan.

Yet not even the might of the assembled heroes of the Marvel Universe could match Thanos' newfound might. Thor's hammer is flung into deep space, transformed into glass, and shattered into a million pieces; Wolverine's bones are turned from indestructible adamantium to spongy rubber; Scarlet Witch is vaporized; Iron Man is decapitated; Spider-Man's head is bashed in against a rock;

Vision's central processing unit is ripped out of his chest; Drax is transported back to prehistoric Earth presumably to be eaten by dinosaurs; Captain America, ever the hero, stares Thanos down, and doesn't flinch even as Thanos kills the heart and soul of the Avengers.[130] Sorry if this paragraph seemed a bit gratuitous, but it was just as shocking then as it is now.

As the battle continues to rage, Thanos finds himself under attack from a coalition of the most powerful cosmic entities in the universe. Master Order and Lord Chaos, Galactus, the Stranger, Epoch, Chronos, and others band together to try to defeat him, but are summarily felled by the all-powerful being. Even Death herself joins the assault against Thanos, which saddens the lovesick lunatic, but he manages to ensnare all the cosmic entities and comes face to face with Eternity, the living embodiment of time and reality in the Marvel Universe, and the two battle for control of reality itself. Thanos wins, and transforms into a cosmic being, the living embodiment of the universe. However, this leaves his physical form vulnerable to attack, and Nebula, one of his assassins and his alleged granddaughter, seizes the Gauntlet for herself.[131]

Wielding the Gauntlet, Nebula undoes all of Thanos' actions, resurrecting the dead, and restoring the universe to the way it once was. Another melee takes place, and this time the heroes are triumphant as Adam Warlock seizes the Gauntlet. Thanos seemingly commits suicide with a thermonuclear device, and Warlock absconds with the Gauntlet much to the protest of his companions. Transporting himself and his companions two months into the future on a faraway planet, it is revealed that Thanos did not die. Rather he is living out his days quietly as a farmer and contemplating his losses.[132] Satisfied that they have vanquished the Mad Titan and that he is no longer a threat, they decide to leave him be, which as all comic book readers know, was a terrible, terrible idea. (Spoiler alert: he comes back with a vengeance, but that's a story for another chapter.)

If it all sounds like a lot to take in, that's because it is. Starlin, Perez, and Lim's cosmic saga was groundbreaking in scale, scope, and the impact it had on event books to come. There's a reason that Kevin Feige and the filmmakers at Marvel Studios chose this as the overarching arc for their cinematic universe—it's simply too epic to ignore. In fact, it is too epic to contain in a single film, which is why Marvel has split *Avengers 3*, better known as *Avengers: Infinity War*, into two sprawling cosmic parts.

26 Robert Downey Jr.

There is no "I" in team, which is the whole idea behind the Avengers—assembling Earth's Mightiest Heroes to combat those threats that they could not defeat individually. Likewise, Marvel Studios had to assemble a top-notch array of actors to bring these iconic characters to life. While the entire cast has more than proven that they are worthy of the much-loved characters, few are more synonymous with the Marvel Cinematic Universe as a whole than Robert Downey Jr. Since he first electrified audiences with his debut as Tony Stark in 2008's *Iron Man*, Downey has become, perhaps, the biggest movie star in the world. He was named the highest-paid star in Hollywood by *Vanity Fair,* and for good reason—he has a tremendous talent that well justifies his expensive price tag. However, he wasn't always Hollywood's favorite son, and it was nearly impossible to imagine that he could headline a global franchise thanks to a tumultuous personal life and destructive behavior that landed him in jail.

Robert Downey Jr.'s life has taken him on a long, twisting road full of ups and downs. From an early age, Downey pursued a career

in acting, but at the same time, drugs and potential debauchery surrounded him. Downey made his big-screen debut at age five, playing a puppy in his father, Robert Downey Sr.'s, film *Pound.* At age six, his father allowed him to try marijuana for the first time, something that Downey Sr. has said he deeply regrets.[133] In 1985, Downey made history as the youngest cast member ever to join *Saturday Night Live*, remaining with the show for a season before departing. In 1987, his role in the Bret Easton Ellis adaptation *Less Than Zero*, in which he, ironically, played a drug addict, is what first rocketed him into the public eye.

As his star rose, Downey netted roles in bigger and bigger projects, which earned him critical acclaim for roles in films like *Air America, Soapdish,* and his Academy Award–nominated turn in *Chaplin.* For a time, it seemed like Downey was on top of the world, but then the ugly specter of addiction reared its head once more. Beginning in 1996, Downey found himself constantly in trouble with the law, arrested on multiple occasions for drug-related charges including possession of cocaine, heroin, and marijuana.[134] In 1997, he missed a court-mandated drug test and spent six months in Los Angeles County Jail.[135]

Although Downey kept consistently working in film and television, he soon found himself getting fired off of projects like NBC's *God, the Devil, and Bob* for failing to show up for rehearsals. After a 1999 arrest for failing to take another mandatory drug test, he was sentenced to three years in prison at the California Substance Abuse Treatment Facility and State Prison in Corcoran, California. Of his addictive behavior, he told a judge, "It's like I have a shotgun in my mouth, and I've got my finger on the trigger, and I like the taste of the gunmetal."[136] He qualified for early release, but in July 2001, the actor pled no contest to drug possession charges from an incident the previous year in Palm Springs when his room was searched by police, who found him under the influence and in possession of cocaine and Valium.[137] He entered into drug rehabilitation and a

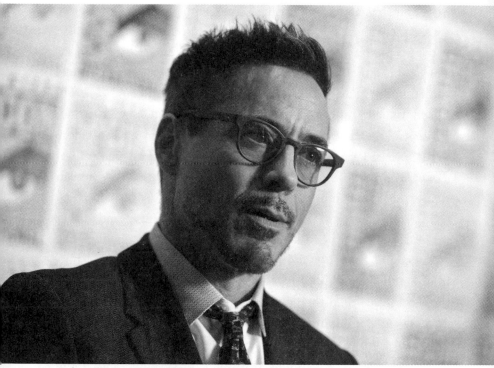

Robert Downey Jr. attends Comic-Con International on Saturday, July 26, 2014, in San Diego. (Richard Shotwell/Invision/AP Images)

three-year probation, finally taking the first steps on a long road to recovery.

Although Downey was newly sober, his reputation preceded him, making it difficult for the actor to get work in Hollywood at first. For example, Woody Allen wanted to cast Downey and Winona Ryder in his eventual 2005 film *Melinda and Melinda,* but was unable to do so because they couldn't get insurance to cover the two troubled actors.[138] It wasn't until Mel Gibson, a friend of Downey's since they worked together on *Air America,* paid Downey's insurance bond for the 2003 film *The Singing Detective,* that Downey's comeback could begin in earnest.[139]

From there, Downey began working in earnest on a number of well-regarded projects like *Good Night and Good Luck, A Scanner Darkly,* the Shane Black–directed *Kiss Kiss Bang Bang,* and David Fincher's 2007 film *Zodiac.* It wasn't until 2008 that Downey cemented his modern superstar status by starring in a pair of blockbuster films, the Ben Stiller–directed *Tropic Thunder* and the Jon Favreau–directed *Iron Man,* which collectively grossed more than $700 million worldwide. Though we know now that Robert Downey Jr. is the consummate embodiment of Tony Stark, it was an uphill battle for director Jon Favreau, who fought back against Marvel Studios after they rejected the notion of casting Downey multiple times.

"Everybody knew he was talented," said Favreau in a radio interview. "Certainly by studying the Iron Man role and developing that script I realized that the character seemed to line-up with Robert in all the good and bad ways. And the story of Iron Man was really the story of Robert's career."[140] (Like Robert Downey Jr., Tony Stark also struggled with substance abuse, which was most famously cataloged in the 1979 Iron Man storyline "Demon in a Bottle.")

It was a big gamble for Marvel, but one that paid off in dividends for them and their now-parent company Disney. The *Iron Man* franchise has grossed nearly $2.5 billion worldwide, in addition to the $1.5 billion pulled in by *Avengers.*[141] Favreau summed up the whole debate rather succinctly: "That was a big gamble on whether or not he was really serious about it… and now history has definitely proven that he was dead serious about it and now he is the biggest star in the world."[142]

Whether or not he'll return for *Iron Man 4* is still up in the air (Downey Jr. has said he would do it if Mel Gibson directed), but we will see him butting heads with none other than Chris Evans in *Captain America: Civil War* on May 6, 2016. One thing is for certain: there is no doubt that he is the face of the *Avengers* franchise and, like Tony Stark, a shining example of real-life redemption.[143]

27 Doctor Strange

Science and mysticism don't typically go hand in hand, but then again, it isn't every day that a brilliant surgeon winds up becoming the world's preeminent conduit for magic on our plane of existence. Such is the dichotomy of Doctor Strange, the Sorcerer Supreme, and Marvel's resident master of mysticism. More than a means to tell supernatural superhero stories, Doctor Strange was groundbreaking in its scope, offering acid-tinged metaphysical musings on the nature of mankind and otherworldly adventures that felt like a journey into the heart of madness itself. When Doctor Strange burst onto the scene in July 1963's *Strange Tales* #110, the combination of Stan Lee's bombastic, arch dialogue and Steve Ditko's mind-melting, surreal artwork, he was a revelation. College students, especially those experimenting with opening their mind vis-à-vis psychedelic drugs, flocked to the good Doctor in droves.

Born in Philadelphia in 1930, Stephen Strange has had a connection to the magical from an early age; when he was but eight years old, he was attacked by demons controlled by the apprentice sorcerer Karl Mordo, but he was rescued by Mordo's master, the powerful spellcaster known as the Ancient One who protected the Earth from magical incursions. After displaying an early aptitude for medical mastery, Strange earned his medical degree in record time and went on to a highly successful residency at New York Hospital. He soon became a brilliant but arrogant surgeon, seemingly caring only for the wealth brought on by his prestigious profession. Then, one fateful night in 1963, he was in a car accident. He survived, but his hands were severely injured, resulting in constant trembling. The prognosis: he would never operate again.

Proud to a fault, Strange couldn't bring himself to accept a position as a consultant or a teacher, which he considered to be beneath him. So, he set off on a worldwide quest to find another way to treat his damaged digits, trying various homeopathic treatments and consulting different doctors in search of exotic, untested cures. Nothing seemed to be working, and soon Strange found himself penniless and homeless, forced to perform medical procedures illegally just to make a buck. While in the Himalayas, Strange comes across a lone hermit named the Ancient One (auspicious much?), who refuses to help Strange due to his incredible selfishness. Yet, Strange proves his capacity for goodness when the Ancient One's disciple, Baron Mordo, suddenly and viciously attacks his former mentor. Selflessly, Strange stops Mordo (who would go on to become his arch-nemesis) and saves the Ancient One's life. In exchange, the Ancient One reveals that he is actually the Earth's Sorcerer Supreme, the world's mightiest magical defender, and agrees to teach Strange the mystic arts.[144]

Spending years under Ancient One's tutelage, Doctor Strange learns to invoke the power of incredible eldritch entities and tap into the mystical power of the world around him. When the Ancient One perished, Strange assumed the mantle of the Sorcerer Supreme, defending Earth against all manner of magical menace. Returning to America, Strange set up shop in New York's Greenwich Village, where he was joined by his trusty attendant Wong, the descendant of a long line of those who had served the Ancient One in centuries past. Over the years, the Doctor would battle demonic hordes, extradimensional invaders like the Dreaded Dormammu, eldritch entities, stygian horrors, covens of vicious vampires, and many more monstrous creatures.

Though typically operating as something of a lone wolf with a small, trusted group of friends and allies, Doctor Strange has, at various times, teamed up with other heroes in order to save the day. Impressed by Spider-Man's bravery and altruism, Doctor Strange

has teamed up with Ol' Web-Head countless times over the years. He has acted as a supernatural advisor to teams like the X-Men, Avengers, and Fantastic Four. He has played a behind-the-scenes part in many major Marvel Universe events as a member of the shadowy cabal, the Illuminati. He led a team of superheroes known as the Defenders (who will eventually be seen at the culmination of Marvel's four forthcoming Netflix series), and he has been an on-again, off-again member of the Avengers. Most importantly, he has done whatever it takes to defend the innocent and the people of Earth against threats of every variety, magical and otherwise.

A longtime passion project of Marvel Studios president Kevin Feige, Doctor Strange is one of the films Marvel will be pulling out of its hat during Phase 3. Directed by Scott Derrickson, the film stars the Internet's boyfriend, Benedict Cumberbatch, and is set to hit theaters on November 4, 2016. But could we expect the Doctor to work his magic alongside the Avengers, perhaps in *Avengers 3*? According to Kevin Feige, the idea of an ever-changing Avengers roster isn't all that far-fetched. "Certainly that has been the case with the comics, right?" said Feige. "Go into the comic bin and pull up any Avengers issue from 1960-whatever and 1980-whatever, and they probably don't match. I think that's fun. That's one of the reasons why Wanda and Pietro [Quicksilver and Scarlet Witch] have shown up in the new Avengers film, because we like the notion of a shifting roster, of a growing roster."[145] So, while it's too early to say with any certainty, we'll take a definite maybe over an outright rejection any day of the week.

28 Civil War

With great power comes great responsibility. Uncle Ben's adage doesn't just apply on an individual level, but a societal one as well. What happens when those without great power are caught in the crossfire of those who possess it? Who watches the watchmen? These are but a few of the questions posed by one of Marvel's most memorable crossover events in recent memory, the seven-issue limited series *Civil War*, which, like its namesake, rent the superhero community asunder, pitting friend against friend and brother against brother in a battle of ideals, politics, and civic duty. Much like our nation's own Civil War, the Marvel Universe would take many years to heal from the scars it left behind.

Written by Mark Millar and illustrated by artist Steve McNiven, *Civil War* began with a bang—literally. The New Warriors, a group of young superheroes who starred on their own reality TV show, confronted a group of escaped supervillains holed up in a home in Stamford, Connecticut, which led to a knockdown, drag-out fight. In the middle of the melee, the villain known as Nitro used his superpowers to create an explosion that decimated several city blocks, including an elementary school, killing 600 innocent civilians, 60 of which were children, and all of the combatants save for the New Warriors' Speedball and Nitro himself. It was, by all accounts, a horrific tragedy, televised for millions to see, and it immediately soured public opinion against costumed crusaders, creating a demand for government regulation.

The solution? The Superhuman Registration Act, a piece of legislation that required all superpowered individuals residing in the United States to register with the government or face

imprisonment. The notion of superhumans being made to register with the government is nothing new in popular culture; it's been used in everything from Alan Moore and Dave Gibbons' classic *Watchmen* to Pixar's *The Incredibles* as a means of creating conflict between a hero's need to do the right thing and operating within the bounds of the law.

Very much a product of the times and steeped in political allegory in the wake of 9/11 and the Patriot Act, the central question of *Civil War* is one we are still exploring today: "Would you give up your civil liberties in order to feel safer?" The battle between trading liberty for security was explored on the big screen in *Captain America: The Winter Soldier,* but nowhere is it more evident in the Marvel Universe than in the pages of *Civil War.*

Things quickly went from bad to worse as intensely negative public opinion resulted in the brutal assault of the Human Torch by an angry mob. To calm the situation, S.H.I.E.L.D. director Maria Hill summoned Captain America and asked him to help enforce superhero registration. He refused, and Hill unleashed a surprise attack by S.H.I.E.L.D.'s Anti-Superhuman Response team in an effort to tranquilize and detain the Super Soldier, but Rogers managed to escape and dropped off the grid.

Battle lines were drawn in the sand as Iron Man became the face of the pro-registration movement, going so far as to secretly meet with the president of the United States, to whom he promised that he, Mr. Fantastic, and Yellowjacket would bring Captain America to justice. Likewise, Captain America became the face of the anti-registration, refusing to exchange the liberty he fought his entire life to preserve for a false sense of security. Going underground, Captain America, Luke Cage, and the Falcon began recruiting members of the Resistance, including the Young Avengers, who they rescued after the team was captured by S.H.I.E.L.D. forces.

As the debate intensified, both sides began trying to make their point to an unfeeling public. The anti-registration forces continued

A New Avengers *tie-in to* Civil War, *an event that touched every corner of the Marvel Universe.*

fighting supervillains, leaving them bound and tied for collection by the proper authorities, whereas the pro-registration forces attempted to locate and arrest any non-registered superhumans they could find.

The event was nothing short of seismic for the Marvel Universe, and nowhere was this more evident than in the mic drop moment at the end of *Civil War* #2 in which, during a press conference, Spider-Man took the podium. He gave a rousing speech about how, for years, he had kept his identity a secret for fear of reprisal against his loved ones. The Superhuman Registration Act, he argued, gave heroes a choice between remaining unchecked and being a threat to the public or legitimizing their fight against evil and earning back the trust of the public. To drive home his support

of the Act, Spider-Man publicly unmasked himself, revealing to the world that he was none other than Peter Parker. Back in *The Daily Bugle* offices, J. Jonah Jameson fainted at his desk.[146]

The X-Men, however, were a harder sell, initially refusing to sign the registration act as the systematic hunting and persecution of a select group of people who were trying to do the right thing was antithetical to everything for which they stood. Ultimately, though, they came to an understanding that the X-Men would remain neutral—they would not help the anti-registration fighters so long as the pro-registration forces left them alone.

Leading a new group dubbed the Secret Avengers, Captain America, alongside Hercules, Daredevil, Goliath, and others, responds to a fire at a petrochemical plant, which turns out to be a

No One Ever Really Dies

One of the most shocking things that can happen in comics is the death of a beloved character, especially a long-running superhero. It's a powerful narrative tool that can pack a massive emotional punch when characters who readers have come to know and love suddenly shuffle off this mortal coil. It always comes as a short, sharp shock to see someone who you've followed for a hundred-plus issues suddenly stop moving from panel to panel, but it's a necessary narrative tool.

In the real world, death is permanent. In the world of comic books, however, it's a little more malleable. With characters that are as perennially popular as Captain America or Spider-Man, they may kick the bucket on the printed page, but they have a habit of rising from the grave, usually within a year or so. Case in point, when Captain America was assassinated by his longtime love interest/S.H.I.E.L.D. agent Sharon Carter following *Civil War,* it was revealed two years later that he wasn't actually killed; rather, the gun had caused Cap to phase in and out of space and time where he experienced his greatest lifetime moments and battles over again until he was returned to the present. Unfortunately, we can't say the same for Aunt Prudence.

trap laid by Iron Man and the pro-registration forces. Stark makes overtures to Captain America, telling his onetime ally that there's still time to come to Jesus and join the pro-registration side without facing prosecution. The pair shakes hands, but Captain America activates a hidden S.H.I.E.L.D. electron scrambler, deactivating Iron Man's armor, and suddenly there is a superhero smackdown. Responding to the threat, Maria Hill activates Ragnarok, a clone of Thor created by Henry Pym, who immediately kills the hero Goliath by blasting him through the chest with a bolt of lightning. Horrified, the pro-registration forces try to restrain the clone while Captain America and the Secret Avengers make a desperate retreat.[147]

The death of Goliath sent waves through the pro-registration community, causing many to lose faith in Iron Man and the team's brute force tactics that claimed the life of one of their own. With heroes leaving in droves, including Invisible Woman and Human Torch, Tony Stark and Mr. Fantastic activated a new, more brutal iteration of the Thunderbolts, and tasked them with hunting down the fugitive heroes. At the same time, to deal with the growing number of captured superhumans that were unwilling to register, Iron Man and Mr. Fantastic built a prison in the Negative Zone called Project 42 in which they planned to jail those who did not comply indefinitely. Learning of this grotesque perversion of justice, Spider-Man winds up fighting Iron Man, and escaping to join Captain America's anti-registration side, which is having morale problems all its own as Steve Rogers' zealotry increases by the day.[148]

Eventually, the resistance launches an all-out assault on the Project 42 prison in the Negative Zone, releasing the prisoners. Using his teleportation ability, Cloak transports all of the combatants to the middle of Times Square where the battle reaches a fever pitch. Iron Man and Captain America go toe-to-toe, blow-for-blow, but soon Captain America has the advantage. Just as he is

about to unleash a finishing blow on Iron Man, several unpowered emergency workers tackle Captain America, saying that they don't want any further damage done to the city. Realizing the terrible toll the superhuman war has taken on the civilian population they were all ostensibly trying to protect, Captain America unmasks and surrenders himself to the pro-registration forces.[149]

Two weeks later, Tony Stark is appointed the director of S.H.I.E.L.D. as Maria Hill is demoted to deputy director. The federally sanctioned Mighty Avengers were formed and the United States government launched the Fifty State Initiative, a program designed to train a superhero team for every state. Although many of the Secret Avengers were granted amnesty, others chose to remain underground, acting as the New Avengers; Steve Rogers was jailed where he awaited arraignment. On the day of his arraignment, though, Captain America was apparently shot to death multiple times by the assassin Crossbones and the hypnotized Sharon Carter.[150] The image of Captain America lying dead in a pool of his own blood on the courthouse steps is not one that would soon leave readers.

Though Marvel would later hit the reset button on many of these developments—e.g. Captain America returned to the land of the living—*Civil War* remains seminal as a modern event comic. The premise was simple—ideological and political conflicts drove superheroes to go to war with one another—but the execution was seamless, touching every part of the Marvel Universe through tie-in comics, and the main book led to a major sea change in the Marvel Universe as Tony Stark assumed leadership of S.H.I.E.L.D., Spider-Man made a pact with the devil to re-conceal his identity at the expense of his marriage, the Thunderbolts became Norman Osborn's personal army, and Bucky Barnes succeeded his dead mentor as Captain America. Some of *Civil War*'s allegorical elements were pre-scient a decade ago, and the core themes remain resonant to this day. Come May 6, 2016, we could be seeing a slightly different version

up on the big screen thanks to complicated rights issues with core characters (although Spider-Man was recently untangled from Sony's web, so anything is possible), but it stands the test of time as a book that every *Avengers* fan needs to read.

29 Secret Invasion

Everyone has those days when they're just not acting like themselves…but what if it turned out that they weren't themselves and the people you knew and loved and trusted had secretly been replaced by a nefarious race of shapeshifting aliens? Well, that's precisely what happened in Marvel's 2008 year-long crossover event *Secret Invasion.* Written by Brian Michael Bendis and illustrated by Leinil Francis Yu, the eight-issue limited series revealed that the Skrulls had, over the course of many years, slowly and subversively invaded the Earth, infiltrating countless government organizations and replaced many of Marvel's mightiest superheroes with impostors. Fittingly, the tagline asked, "Who do you trust?"

In the wake of the Kree-Skrull War, a group of Marvel's most powerful heroes—Iron Man, Mister Fantastic, Professor Xavier, Black Bolt, Namor the Sub-Mariner, and Doctor Strange—formed a secret cabal known as the Illuminati. Together, they went to confront the Skrulls, attacking them and letting them know that future incursions would not only not be tolerated, but considered an act of war. However, in their hubris, they were captured and subjected to intense study by Skrull scientists.[151]

Years later, the Skrull princess Veranke foresaw a prophecy, and claimed that the Skrull throneworld would be annihilated. The Skrull ruler, Emperor Dorrek, exiled her to a prison planet

for attempting to incite religious extremism. Lo and behold, the Skrull throneworld was summarily destroyed by the planet-eating Galactus, and Veranke assumed the throne by right of succession.[152] With the might of the Skrull empire, Veranke leads an invasion of Earth, armed with her newfound knowledge of Earth's superheroes, who she forcefully extracted from the Illuminati. Once on Earth, she and her cohorts capture and begin impersonating several of Earth's superheroes, with Veranke posing as Spider-Woman. However, fate dealt her an unexpected hand when a number of Earth's deadliest supervillains broke out of the floating prison known as the Raft, forcing her to join the New Avengers.

Veranke and the Skrulls remained largely undetected until the ninja assassin Elektra died in battle with the New Avengers, and was revealed to be a Skrull named Pagon in disguise.[153] Seizing the opportunity to sow the seeds of discord, Veranke took the corpse to Tony Stark in an attempt to create an alibi for herself, telling him that not only had Skrulls invaded the Earth, but his own teammates suspected him of being a Skrull too. (This was actually true—Luke Cage suspected Tony Stark of having been compromised.) A shocked Iron Man realized that it was repercussion of the Illuminati's attempt to stop the Skrulls years earlier, and convinces Veranke/Spider-Woman to join the Mighty Avengers in an effort to lure out any Skrulls that might be hiding on the team.[154]

He assembled the Illuminati once more to warn them of what had happened, and the group turned in horror when Black Bolt voiced his opinion. For any other member, it wouldn't have been a cause for concern, but Black Bolt's ability is that his voice is so powerful it can level entire cities, so hearing him speak is a rarity to say the least. Revealed to be a Skrull in disguise that possessed Black Bolt's powers *and* the abilities of the other Illuminati members, a pitched battle took place with the Skrull beating the Illuminati back until Namor finally killed him. The Illuminati weren't safe yet; they were attacked by a Skrull that had Cyclops' optic blasts,

The cover of the Secret Invasion epilogue.

Nightcrawler's tail, and Colossus' steel skin, and one that wielded a souped-up replica of Thor's hammer Mjolnir. Once again defeating their foes, the Illuminati went their separate ways after Namor warned them that any one of them could secretly be a Skrull and that they shouldn't trust anyone.[155]

Utilizing blitzkrieg tactics, the Skrulls disabled communications among the superheroes via a series of simultaneous strikes. In one fell swoop, they disabled the main S.H.I.E.L.D. helicarrier, engineered a breakout of supervillains being held at the Raft, transported the Fantastic Four's headquarters, the Baxter Building, to the Negative Zone, and launched an assault on Thunderbolts Mountain, the home base of the Thunderbolts. At the same time, the Skrulls, who had been mining vibranium, attacked the Avengers

in the Savage Land with a squadron of classic superheroes in their 1970s garb, and a Skrull named Criti Noll, posing as Henry Pym, wounded Reed Richards shortly after he invents a way to detect the shapeshifting interlopers.[156] Though the assaults are brutally effective, they have an unintended effect of rallying together Earth's heroes and villains. For example, known mobster the Hood throws his lot in with Earth's heroes, reasoning that if there's no planet left, there'll be nothing for him to plunder.

Their plot exposed and the Earth's Mightiest Heroes *and* villains fighting together against the alien invaders, Veranke and the Skrull forces make their last stand in New York City. Facing the combined might of the New Avengers, the Mighty Avengers, Daredevil, the Young Avengers, the Thunderbolts, KaZar, Nick Fury, and many more, the heroes of Earth fight for the fate of their planet. During the final battle, Hawkeye manages to wound Veranke using his trick arrows, but the Skrulls deal a devastating blow of their own; Wasp grew to a tremendous size, then Critti Noll detonated a bomb he had planted on her. Though Thor managed to contain the blast, Janet Van Dyne, the Wasp, was dead. In the wake of Janet's death, Norman Osborn, having intercepted information from Deadpool on how to defeat the Skrulls, fired the shot that killed Queen Veranke, and the heroes managed to destroy the remainder of the Skrull armada as Iron Man rescued the remainder of Earth's captured heroes.[157]

In the wake of the attack, everything changes for the Marvel Universe. Shaken to the core by the extent of the alien invasion, the president issues an executive order disbanding S.H.I.E.L.D., to be replaced by Norman Osborn's newly formed organization H.A.M.M.E.R. instead (a whole other can of worms unto itself). A Skrull that was impersonating Jarvis skulked away in the dead of night with Jessica Jones' and Luke Cage's baby in tow.[158] Last, but not least, the Secret Invasion came full circle as Norman Osborn assembled his Dark Illuminati, a grim assembly of six of the most

megalomaniacal figures in the Marvel Universe—Emma Frost, Doctor Doom, Namor, the Hood, Loki, and himself.[159] The Secret Invasion may have been over, but a darkness was about to descend on the Marvel Universe, a wolf in sheep's clothing being shepherded by Norman Osborn himself.

30 Dark Reign

For years, the world knew Norman Osborn as the troubled industrialist behind Oscorp who, in his lust for power, fell to new depths of depravity by becoming Spider-Man's arch-nemesis, the supervillain Green Goblin. Yet, in the wake of 2008's Secret Invasion, Norman Osborn reinvented himself as a public defender, a champion of national security, and was widely hailed as an American hero for his role in helping to defend the world from Queen Veranke and the Skrull armada during the events of Secret Invasion. S.H.I.E.L.D. was disbanded, and Norman Osborn was put in charge of much of the Earth's defense systems, replacing them with an organization called H.A.M.M.E.R. instead. Under his rule, Earth's Mightiest Heroes were forced to go on the run from Osborn's iron-fisted rule, fighting the good fight while Osborn and his Cabal secretly plotted world domination. Like Secret Invasion before it, the tagline summarized things quite concisely: "We Lost, They Won."

Not an event series in the traditional sense, *Dark Reign* didn't have a core book going along with it; rather, it was more of a year-long status quo for the Marvel Universe that saw Osborn's influence and the fallout of *Secret Invasion* touching every corner of the universe. Using the Sentry, and more specifically the demonic entity known as the Void, as his secret weapon to keep his Cabal/

the Dark Illuminati in check, Osborn quickly installed himself as one of the world's most powerful figures. Putting on a pleasant public face, Osborn offers the public peace of mind while enforcing his stringent security policies using jackbooted thugs. As writer Brian Michael Bendis put it, "People know he's a bastard, but ignore it as long as he gives them safety."[160]

Donning Iron Man–like armor, Osborn assumes the moniker of Iron Patriot, and assembles a pale imitation of Earth's Mightiest Heroes, the Dark Avengers. Like the name would suggest, this state-sponsored team resembles the Avengers in nearly every way, and its members even wear the costumes of iconic heroes like Captain America and Hawkeye, but they are secretly supervillains that Osborn has commissioned to do his bidding. Like Thunderbolts, the Dark Avengers were ostensibly reformed supervillains, except they never lost their sociopathic, murderous edge. Consisting of Iron Patriot (Osborn in Iron Man armor), Spider-Man (Mac Gargan/Scorpion), Ms. Marvel (Moonstone), Hawkeye (Bullseye), Wolverine (Daken), Ares, Captain Marvel (Noh-Varr), and the Sentry, the team served as Osborn's personal hit squad, going after Hawkeye/Ronin when he publicly denounced Osborn on TV, and enforcing martial law in San Francisco during anti-mutant riots. In an example of extreme brutality, the Punisher is systematically hunted down and murdered by Daken, who dismembers and decapitates Frank Castle after a bloody hand-to-hand skirmish.[161]

All the while, Nick Fury is waging secret war (note: not a Secret War, though) of his own against H.A.M.M.E.R. and Hydra after learning that S.H.I.E.L.D. had been essentially controlled by Hydra since its inception. Forming a new group called the Secret Warriors, Fury leads a crusade against Osborn, becoming one of the most annoying thorns in his side.

Osborn sets his sights on Daredevil, now the leader of the ninja cult known as the Hand, when a group of ninjas unceremoniously assassinate a group of corrupt lawyers and police officers

in Osborn's employ. Sending out Daredevil's old nemesis Bullseye in his old costume, Daredevil and Bullseye battle across Hell's Kitchen, building to a rooftop showdown atop a condemned building. Bullseye warns Daredevil that the building will be destroyed, but the 107 people inside refuse to leave. Unable (and possibly unwilling) to help them, Bullseye detonates the bomb, killing all those inside, and demolishing an entire city block. Shocked and broken, Daredevil is helpless as Bullseye escapes into the night.

The Dark Reign culminated in the Siege of Asgard, an all-out assault on Thor's homeland, which was floating above a small town in Oklahoma. The events played out over the course of another major crossover event called "Siege," which saw the heroes of the Marvel Universe banding together to stop Osborn, his Dark Avengers, and the Cabal once and for all, but it marked the beginning of the end for the man with the worst haircut in the Marvel Universe. As for whether we'll see this particular storyline play out in the Marvel Cinematic Universe, I wouldn't hold your breath. Though they could likely recast Norman Osborn with another villain, the storyline requires a bit too much setup in the form of events like *Civil War* and *Secret Invasion* beforehand. That being said, stranger things have happened, and maybe there's a secret Cabal behind the scenes of Marvel Studios working to bring it to movie theaters across the world as we speak.

31 S.H.I.E.L.D.

Wherever there's trouble in the Marvel Universe, you can bet dollars to highly classified donuts that a legion of black-suited, sunglasses-wearing men and women will be there in short order to

contain it (or at least try to). These are the agents of S.H.I.E.L.D., Marvel's preeminent black ops espionage brigade and international peacekeeping force, and they are much more than jackbooted thugs, superspies, and hyperintelligent codebreakers; they are the connective tissue of the Marvel Universe. As a narrative tool, S.H.I.E.L.D. is sort of the glue that bound the Marvel Universe together, both on-screen and off, appearing in *Iron Man*, *Thor*, *Iron Man 2*, *Captain America*, *Avengers*, and many other films, providing context for individual heroes' adventures in relation to the massive world that Marvel has been building. Also, they ride around in a totally sweet Helicarrier, which is quite literally a combination of a helicopter and an aircraft carrier, and about as awesome as it sounds, to boot.

There's a scene in *Marvel's Agents of S.H.I.E.L.D.*, the TV adventures of the titular spy ring, in which Nick Fury's lieutenant, Agent Maria Hill is questioning Agent Ward about what S.H.I.E.L.D. stands for. Without missing a beat, he replies, "Someone really wanted our initials to spell out 'SHIELD'." He's not wrong, but in the Marvel Universe, S.H.I.E.L.D. stands for so much more. The original acronym stood for Supreme Headquarters, International Espionage, Law-Enforcement Division. In 1991, it was changed to Strategic Hazard Intervention Espionage Logistics Directorate, and in the Marvel Cinematic Universe, it stands for Strategic Homeland Intervention, Enforcement, and Logistics Division. Long story short: S.H.I.E.L.D. represents the bottom line in espionage, intrigue, and black ops intelligence gathering in the Marvel Universe.

First introduced in August 1965's "Nick Fury, Agent of S.H.I.E.L.D." in the pages of *Strange Tales* #135, S.H.I.E.L.D. was inspired by a growing trend in the espionage genre to have international intelligence agencies with catchy acronyms, particularly NBC's popular *The Man from U.N.C.L.E.* (which stood for United Network Command for Law and Enforcement) and James

Bond's foes from S.P.E.C.T.R.E. Lee wanted to take the Nick Fury character, who was already popular from his then-lapsed series *Sgt. Fury and His Howling Commandos,* and put him into stories that were "bigger and more colorful and more far out" so they could ride the wave of Cold War espionage mania.[162] Fury was reimagined as eyepatch-clad super-spy and thus, S.H.I.E.L.D. was born.

Originally a peacekeeping organization founded by Nick Fury in the wake of World War II, S.H.I.E.L.D. operated as a tactical arm of the United Nations, primarily to combat the growing threat of its greatest and most persistent enemy, the terrorist syndicate Hydra. Like the Avengers, S.H.I.E.L.D. operates vis-à-vis the official government sanction of the U.N. General Assembly and the United States government, although many of its activities would likely make the members of both organizations recoil if they ever came to light. In truth, the real power behind S.H.I.E.L.D. is a shadowy coterie of 12 mysterious men and women who give Fury his marching orders, leaving the implementation to their one-eyed associate.[163] We got our first real glimpse of these men and women in *Captain America: The Winter Soldier* when they are held hostage by the Hydra double agent Alexander Pierce (Robert Redford).

It's worth nothing that in the MCU, Howard Stark was the one who founded S.H.I.E.L.D. in the wake of the Second World War, and the Avengers are actually assembled by Nick Fury as an official sub-team of S.H.I.E.L.D. in order to combat the threat posed by Loki and the Chitauri. As we saw in *Captain America: The Winter Soldier,* Hydra had secretly infiltrated S.H.I.E.L.D. since its inception, slowly manipulating world events and creating a climate of fear while they bided their time, waiting to strike. Like any good spy ring worth its salt, S.H.I.E.L.D. has been infiltrated, dissolved, and reformed a number of times over the years thanks to Hydra sleeper agents, rogue androids, and, on more than one occasion, Nick Fury going off the deep end in the name of the greater good.

As the Marvel Universe grew in size, so did S.H.I.E.L.D.'s scope, and as a result, it has multiple sister organizations, each with cheeky initials all their own: A.R.M.O.R. (Altered-Reality Monitoring and Operational Response) for interdimensional incursions, S.W.O.R.D. (Sentient World Observation and Response Department) for extraterrestrial threats, and W.A.N.D. (Wizardry, Alchemy, and Necromancy Department) for threats of a magical nature, just to name a few. After Norman Osborn and the Thunderbolts helped save the world during an attack by the shapeshifting alien Skrulls in *Secret Invasion*, S.H.I.E.L.D. was replaced by a new organization called H.A.M.M.E.R., which frustratingly didn't stand for anything at all (except secretly trying to take over the world).[164]

S.H.I.E.L.D. has also been responsible for a number of advanced technologies that have become staples of the Marvel Universe. While their high-flying headquarters, the Helicarrier, is most famous, they are also responsible for the Life Model Decoy, or LMD for short, an uncannily lifelike android used to replace high-ranking agents and high-value targets that are in danger of being killed. When the supervillain Scorpio (who is secretly Nick Fury's younger brother) stole it, he used the technology to create a team of evil androids called the Zodiac.[165] Nick Fury has used so many LMDs over the years that it's usually safer to assume that the Nick Fury you're seeing in front of you is an android body double rather than the real deal. One was even kidnapped by Scorpio (again) and it achieved sentience, eventually joining the villainous organization the Shadow Council, which would often battle the Secret Avengers.[166]

Though the Stan Lee and Jack Kirby days were all well and good, the true highlight of S.H.I.E.L.D.'s comic book existence is in writer/artist Jim Steranko's legendary run, which began in 1967's *Strange Tales* #155 and ran until #168 before spinning off into its own series. Blending cinematic flair with cutting-edge design work

and a penchant for eye-catching op art, Steranko brought a contemporary attitude to Marvel Comics in a time where soap opera histrionics reigned supreme.[167] It was a refreshing change of pace for Marvel, but alas and alack, it didn't sell particularly well and soon Nick Fury and S.H.I.E.L.D. would fade into the background of the Marvel Universe, rather than remain in the spotlight.

The most recent iteration, Jonathan Hickman and Dustin Weaver's 2010 comic *S.H.I.E.L.D.,* reimagined the organization's beginnings, detailing the secret history of an occult cabal called the Brotherhood of the Shield that dated back to ancient Egypt. Set during the height of the Cold War, shortly after the death of Joseph Stalin, S.H.I.E.L.D. agents Nathaniel Richards (Reed Richards' father) and Howard Stark (Tony Stark's father) enlist a young superpowered man named Leonid to help prevent the end of the world. Through flashbacks, we learn that the Shield was founded by Imhotep after a battle with the original Moon Knight and Apocalypse against the Xenomorph-like alien race, the Brood. Previous agents also included Leonardo da Vinci, Galileo Galilei, and Zhang Heng.[168] Eventually, Shield splits into two factions, one led by Da Vinci and one led by Isaac Newton, and they square off in a deadly game of cat and mouse that's full of skullduggery, Machiavellian machinations, and intrigue. Plus, it stars Nikola Tesla as a cybernetically enhanced superhuman, Michelangelo as a being who can manipulate time and space, and that Newton secretly tortured Nostradamus for years to discern the future's secrets. If Marvel is ever looking for a truly off-the-wall idea for Phase 6, they should look no further than *S.H.I.E.L.D.*

Or you could just re-release the 1998 David Hasselhoff–starring TV movie *Nick Fury: Agent of SHIELD* on IMAX and call it a day. Your move, Marvel.

32 Nick Fury

As Tony Stark famously told Loki in 2012's *Avengers*, "If we can't protect the Earth, you can be damned well sure we'll avenge it." However, there is one man in the Marvel Universe who has toiled tirelessly for decades to make sure it would never have to come to assembling the Avengers in the first place. He is the watcher on the wall, the one who has to make the hard calls, and shoulder the burdens of the world on his broad, muscular shoulders. He is none of other than Nick Fury, former U.S. Army sergeant, agent of S.H.I.E.L.D., and the single coolest person to wear an eyepatch.

Although many of you likely know Nick Fury from the Marvel Cinematic Universe, where he is brought to life by one of the great cinematic badasses of our time, Samuel L. Jackson, the original character was a grizzled white guy, who was brought to life on screen once by David Hasselhoff. Surely this can't be the same character, can it? Well, yes and no, depending on what continuity you ascribe to. The African American version of Nick Fury first appeared in Marvel's Ultimate Universe, an imprint it created in 2000 alongside the *X-Men* film that essentially rebooted, reimagined, and updated all of its characters in order to attract younger and lapsed readers who might have been daunted by 50 or so years of backstory. The Ultimate Nick Fury was actually modeled after Samuel L. Jackson; his backstory is similar, and the comics even included a panel where Fury jokingly suggested Jackson play him in a movie. Jackson granted Marvel his consent to do so, and went on to play the secret agent, although how much of that is causation vs. correlation is up for debate.[169]

During World War II, the original Earth-616 (Marvel's main continuity) Nick Fury made a name for himself alongside a group

Samuel L. Jackson as Nick Fury filming on location for Captain America: The First Avenger *on the streets of Manhattan.* (Bobby Bank/Getty Images)

of elite special forces who were known as the Howling Commandos for their barbaric yawp of a battlecry. Sgt. Fury and his Howling Commandos often fought alongside Captain America and Bucky against Nazi threats across Europe and Northern Africa. While on a mission, Fury's eye was badly wounded by a grenade and the lack of immediate medical attention aggravated the wound, leading him to adopt his signature eyepatch. Upon his return to the United States, Fury was administered with a serum called the "Infinity Formula," which slowed his aging process to a relative crawl provided he administered regular injections.[170] In the aftermath of the war, he joined the U.S. government's postwar CIA agency, which evolved into S.H.I.E.L.D.

Serving as director of S.H.I.E.L.D. with an arsenal of state-of-the-art technology provided by Tony Stark and Stark Industries, Fury recruited many of his former Howling Commandos to the organization, particularly the mustachioed, bowler hat–loving Timothy "Dum Dum" Dugan. A seasoned combat veteran, tactical genius, and weapons expert, Nick Fury soon showed that there was no task to which he could not prove equal. Under Fury's command, the organization grew by leaps and bounds, becoming one of the world's primary defenses to global threats posed by the likes of Hydra, AIM, the Hate-Monger (Adolf Hitler's clone), Scorpio (his own brother Jacob in disguise), and even rogue creatures like Godzilla and the Incredible Hulk.

Being in charge of one of the most powerful intelligence organizations on the planet comes with a whole different set of occupational hazards. Constantly under threat of assassination, Nick Fury has been marked for death multiple times, and even slain on occasion. Or so it would seem. By using a Life Model Decoy (LMD), a highly advanced android serving as a body double, Fury is able to play spymaster and put himself in harm's way without putting himself directly at risk. If only I had one of those to distract my editor while I was working on this book...

However, in classic Marvel fashion, Hydra seized control of a group of LMDs known as Deltites, and used them to infiltrate S.H.I.E.L.D. and discredit Fury. Betrayed and on the run from his fellow agents, many of whom were Deltites in disguise, Fury found himself hunted by the organization he helped create. Eventually he exposed the conspiracy and defeated Hydra, but was so disillusioned by the extent of the corruption and betrayal that, for a time, he walked away from S.H.I.E.L.D., leaving it behind.[171]

This wouldn't be the first time or the last time that Fury would face corruption within S.H.I.E.L.D. During the Secret Invasion, shapeshifting Skrulls infiltrated the intelligence organization, forcing most of the Earth's heroes—and some of its villains—to work together to defeat the alien menace. In fact, Norman Osborn (the man once known as Green Goblin) wound up saving the day, and was granted control of S.H.I.E.L.D. in the wake of the attack on Earth.[172] That, coupled with the realization that S.H.I.E.L.D. had been infiltrated by Hydra since day one, forces Fury into hiding, where he operates in secret, training a group of young superhuman operatives known as the Secret Warriors.[173] Fury bided his time until he and the Avengers were able to defeat Norman Osborn and his forces during an all-out assault on Asgard, which was mysteriously hovering over a small town in Oklahoma.[174]

In the 2012 series *Battle Scars*, a new Nick Fury bearing a strong resemblance to Ultimate Nick Fury/the MCU version appeared in Marvel's main continuity along with Agent Coulson, presumably in an effort to streamline Marvel's multiverse and make sure fans of the films had Nick Fury and Coulson parallels. This new African American character is Sgt. Marcus Johnson, Nick Fury's son, who winds up changing his name back to his birth name of Nick Fury Jr. and following in his father's footsteps by joining S.H.I.E.L.D. at the end of the story arc.[175] (And you thought *your* dad had a cool job.) This should, hopefully, put to rest any lingering questions about why Nick Fury seems to transcend racial barriers.

Given the remarkable similarities between Nick Fury, Jr. and the MCU's Nick Fury, it wouldn't be out of the question to see parallels between the comics and film continue to intensify. As part of the Marvel NOW! relaunch, Nick Fury, Jr., Agent Coulson, and Maria Hill form a version of the Secret Avengers alongside Hawkeye and Black Widow.[176] Throw Captain America and Falcon in the mix, and it sounds like you have a recipe for one seriously kickass fighting force for *Captain America: Civil War.* Who knows? Maybe they can even hunt down Hasselhoff or have a seriously off-brand family reunion!

33 Phil Coulson

It's hard to say who the most popular character in 2012's *Avengers* was. Between the legions of fans swooning over Tom Hiddleston's Asgardian cheekbones and Robert Downey Jr.'s superheroic snarkiness, it was difficult to tell, but the undeniable dark horse was one of the film's most unassuming characters: Agent Phil Coulson. Unlike his cinematic counterparts, Coulson had no comic pedigree of which to speak; he was created from whole cloth for the film. Between his awkward hero worship of Captain America, his easygoing demeanor, and his noble sacrifice, Clark Gregg's Coulson felt like a stand-in for the audience and many fans left the theater with a new favorite character. Though he was slain by Loki, the fans paid him back in spades.

As Gregg revealed on *Jimmy Kimmel Live!*, he believes the fans and their massive grassroots Twitter campaign using the hashtag #CoulsonLives is what convinced the Marvel brass to bring him back from beyond the pale. "It's fun for me to go to Comic-Con,"

Gregg explained. "Because Agent Phil Coulson—now Director Phil Coulson—is a bit of a nerd. He had an awkward man-crush on Captain America. When he died, the nerds brought him back to life with a hashtag, #CoulsonLives. The nerds, my people, as a nerd, they have a real connection with Phil Coulson."[177] Well, how about that? The Internet actually being used for good for a change! Go ahead and pat yourself on the back (and retweet the link to buy this book to your followers).

Agent Phil Coulson first appeared in 2008's *Iron Man* in a sequence where he attempted to explain to Tony Stark (Robert Downey Jr.) and Pepper Potts (Gwyneth Paltrow) the circumstances under which Stark returned from captivity in Afghanistan. It was, by all accounts, a minor role, but Gregg wound up signing a multi-picture deal with Marvel and the character returned in *Iron Man 2* (2010), *Thor* (2011), *Avengers* (2012), two Marvel One-Shots short films, and is now starring on the *Agents of S.H.I.E.L.D.* TV series. As for why Coulson's character was chosen to be expanded, *Iron Man* producer Brad Winderbaum explained that, "[They] wanted to paint a picture of S.H.I.E.L.D. pulling the strings and being responsible for some of the events we've seen in films. What better character to represent this idea than Agent Coulson, the first S.H.I.E.L.D. agent we were introduced to in the first *Iron Man* film."[178]

More than most characters in the Marvel Cinematic Universe, Coulson provided connective tissue between the films, a goofy, straitlaced through line of sorts between the films. When Tony Stark is placed under house arrest in *Iron Man 2*, Coulson is one of the agents assigned by Nick Fury to guard him. Later in the film, Coulson reveals he's been reassigned to handle a situation in Mexico. In the post-credits sequence and in *Thor*, we learn the "situation" is the discovery of Thor's hammer Mjolnir in a small New Mexico town, which he investigates alongside Agent Clint Barton (aka Hawkeye) and Agent Jasper Sitwell. When a depowered Thor

attacks the facility surrounding the mythical hammer, it is the "Son of Coul" who interrogates the astray Asgardian.

Gregg then reprised his role in its largest capacity yet in *Avengers*. Not only do we learn that Coulson has an ongoing dalliance with a cellist who recently moved away, but he geeks out when meeting Captain America for the first time. Nervously fumbling over his words, he tells the Captain that he watched him while he was sleeping (translation: guarded him while the frozen Super Soldier was defrosting), and reveals he had a complete set of vintage Captain America trading cards. When he is seemingly killed by Loki during the Trickster God's escape from the S.H.I.E.L.D. Helicarrier, Nick Fury throws the blood-spattered cards on the

Pick a Card, Any Card

Ah, Agent Coulson, how do we love thee? Let us count the ways. As if Coulson's undeniable nerdiness over his vintage Captain America playing cards wasn't enough to make us love him (he even mentions the "slight foxing around the edges"), their contents certainly are. In fact, not only are they an endearing part of Coulson's personality, but they're also home to one of the hardest to spot Easter eggs in Joss Whedon's *The Avengers*.

When Coulson is seemingly killed in action by Loki, Nick Fury spurs the Avengers to action by giving a rousing speech and throwing Coulson's beloved, blood-spattered collectible cards on the table. The top card shows us an image of Steve Rogers in his classic USO costume that he wore during *Captain America: The First Avenger*. It is fitting, to show a younger, more innocent, naïve version of Captain America given the scene's shocking, motivational subtext, but if you look closer there's an even earlier glimpse of Captain America. One of the cards we can see shows Cap in mid-punch, an homage to the cover of *Captain America* #1, which depicted Cap delivering one hell of a haymaker directly to Adolf Hitler's face. If you didn't notice it the first time, that's okay: only the most diehard of Captain America fans or those with Level 8 S.H.I.E.L.D. clearance would really be in the know.

table in front of the bickering Avengers, motivating them to band together and take up arms against this world-threatening evil. As we know now, that wouldn't be the last of Coulson—Maria Hill herself pointed out that the cards weren't on Coulson when he died, so clearly Nick Fury must be up to something.

As a testament to his popularity, Coulson has even found his way into Marvel's main Earth-616 comic book continuity as part of the Secret Avengers, a black ops battalion led by Maria Hill. Alongside Hawkeye, Black Widow, and Nick Fury, Jr., they foil Al-Qaeda terrorist cells, battle the Masters of Evil to save their compatriots, and battle an army of Iron Patriot Armor suits that had been hijacked by A.I.M. agents.[179] All in a day's work for the hardest working men on S.H.I.E.L.D.'s payroll.

Though he won't appear in *Avengers: Age of Ultron*, Coulson's adventures continue on the ABC series *Marvel's Agents of S.H.I.E.L.D.*, which follows him as he leads a crack team of relatively young S.H.I.E.L.D. agents against all manner of crises both superhuman and otherwise. How is Coulson alive, you ask? In the pilot, he explains that he was resurrected by S.H.I.E.L.D. medics after his death at Loki's hands and sent to recover in "Tahiti," but clearly there's more than meets the eye. What isn't explained is why he has a flying cherry red Corvette named Lola, but then again, not everything needs answers. Over the course of the first season, Coulson discovers that not only did S.H.I.E.L.D. alter his memories and hide the truth behind his Lazarus-like resurrection at the hands of an alien drug known as GH-325, but Hydra has infiltrated S.H.I.E.L.D. (a tie-in with the events of *Captain America: The Winter Soldier*), including one of his oldest friends at the organization and one of the most trusted team members.

S.H.I.E.L.D. effectively disbands in the aftermath and Coulson's team is on the run, having been branded terrorists. Eventually, with the aid of Nick Fury himself, they are able to defeat the traitors in their midst and prevent Hydra from winning the day, using a

Tesseract-powered ray gun to vaporize his onetime friend-turned-traitor. Newly appointed the Director of S.H.I.E.L.D. by Nick Fury, Coulson begins the task of rebuilding the organization from the ground up. So, just think about that the next time you're complaining that your boss is making you stay late on a Friday.

34 Maria Hill

Though many of you likely know Maria Hill from Cobie Smulders' portrayal of Nick Fury's second-in-command in films like *Avengers* and *Captain America: The Winter Soldier*, as well as *Marvel's Agents of S.H.I.E.L.D.*, she is actually one of the most important figures in S.H.I.E.L.D.'s storied history. Created by Brian Michael Bendis and David Finch, Maria Hill first appeared in 2005's *New Avengers* #4. Cold, calculating, and extremely effective, Hill is not only one of S.H.I.E.L.D.'s most effective agents, but she was hand-picked to succeed Nick Fury as commander and acting director of S.H.I.E.L.D.

In the wake of Nick Fury's Secret War, in which he attempted to covertly overthrow the nation of Latveria, Fury went into hiding and Maria Hill was named interim executive director of S.H.I.E.L.D. because she was viewed as a particularly adept agent and she wasn't a Fury loyalist. Using a Life Model Decoy of Nick Fury, Maria Hill managed to maintain the illusion of normalcy while asserting control over the intelligence organization.[180]

When she first rose to power, Hill found herself butting heads with Iron Man and the New Avengers, primarily because they withheld important information about the House of M, which led to the global depowering of 99 percent of the world's mutants. She even

went on to arrest Spider-Man, unmask him, and use S.H.I.E.L.D. psychics to scan his brain for further information. However, when the president ordered her to drop a nuclear bomb on the island nation/mutant enclave of Genosha because the Avengers were there, she flatly refused, earning the respect of one-time adversaries like Tony Stark.[181]

During the superhero Civil War, Maria Hill tried to convince Steve Rogers to comply with the Superhuman Registration Act and lead the Avengers to arrest anyone who wouldn't comply with the law, but Rogers declined. In response, Hill authorized her team of "cape killers," an elite superhuman containment force, to tranquilize and contain Captain America, who narrowly escaped and went on to create an underground fighting force, the Secret Avengers.[182] Using kidnapping, blackmail, and other brute force tactics, Hill managed to beat back many of the anti-Registration forces, but ultimately stepped down as director, ceding the job for a time to Tony Stark.

When the Skrulls invaded the Earth during the Secret Invasion, they seemingly executed Hill after she confronted the alien shape-shifters, who had been posing as a number of S.H.I.E.L.D. agents. However, it was revealed that the Skrulls executed a Life Model Decoy, a precaution Hill had taken after being confronted by Nick Fury, and she went on to detonate the Helicarrier's self-destruct mechanism, killing the alien invaders on board.[183] After S.H.I.E.L.D. was disbanded in the wake of Secret Invasion and Norman Osborn took control of the United States intelligence and defensive operations, Hill began working off the grid with Iron Man and the Avengers to combat the forces of evil.[184]

Most recently, she is commanding the newly formed Secret Avengers alongside Nick Fury Jr., Agent Coulson, Black Widow, and Hawkeye.[185] Perhaps we could even see her taking charge of the black ops team on the big screen too. Honestly, though, I'll take any chance to see more Maria Hill on the big screen that I can get,

even if it's revealed that she has a Robin Sparkles–like alter ego and launches into a children's television career.

 35 Hydra

"Hail, Hydra! Immortal Hydra! We shall never be destroyed! Cut off a limb, and two more shall take its place! We serve none but the Master—as the world shall soon serve us! Hail Hydra!"—The Hydra Oath.[186]

Every hero needs a good foil and, likewise, every internationally sanctioned peacekeeping group needs a fascist New World Order to combat at every turn. Such is the long, storied, bloody ballad of S.H.I.E.L.D. and Hydra, the subversive global terrorist organization that we've seen everywhere from the pages of Marvel Comics to *Captain America: The Winter Soldier* to *Marvel's Agents of S.H.I.E.L.D.* and beyond. Founded by infamous Prussian aristocrat-cum-Nazi wing commander Baron Wolfgang von Strucker, with the support of nefarious Nazi leader Red Skull, Hydra is a sprawling global organization with highly advanced technology that has opposed S.H.I.E.L.D., the Avengers, and nearly every major superhero group in the MCU. And, just as their motto seems to imply, every time the good guys take down a Hydra agent, two more seemingly pop up to take his place, a frightening testament to the power of guerilla radicals.

Driven out of Europe by Hitler and his agents after a power struggle, Strucker fled to Japan where he made contact with a group of revolutionaries who wanted to foment unrest and overthrow existing power structures to install their own iron-fisted rule. Funding the emerging cabal with his personal fortune, Strucker

Hydra's sworn enemy, S.H.I.E.L.D. (Thos Robinson/Getty Images)

and his gang established a base of operations on a small Pacific island (soon to be subtly renamed "Hydra Island") where they recruited a cadre of scientists to build their arsenal. (These scientists would form the core of the group that would come to be known as Advanced Idea Mechanics, aka A.I.M.) Just when they were on the verge of achieving nuclear weaponry, though, a group of U.S. Marine commandos (the Leatherneck Raiders) and their Japanese counterparts (the Samurai Squad) attacked and destroyed the base.[187] As per usual, Strucker escaped to fight again another day.

In the wake of World War II, Hydra quietly regrouped, moving their base of operations to America and slowly amassing an arsenal of advanced weaponry and installing agents all around the

world. To combat the growing threat of Hydra, an international coalition created S.H.I.E.L.D. and named Colonel Nicholas Fury as its leader, who just so happened to be Strucker's No. 1 wartime nemesis. Over the years, Fury helped foil many Hydra schemes including their attempt to blackmail the world with a Betatron Bomb that could unleash deadly radiation, simultaneously detonate the global supply of nuclear weapons with the Overkill Horn, or their plot to unleash the ominously named Death Spore on an unsuspecting public. Fury even killed Strucker at one point, but like many characters in the Marvel Universe, he would somehow claw his way back onto this mortal coil.[188] (They really need a regulatory commission for cloning technology in the Marvel Universe, huh?)

In the wake of the Secret Invasion, during which S.H.I.E.L.D. and much of the Earth had been invaded and replaced by shapeshifting alien Skrulls, it was revealed that S.H.I.E.L.D. had already been under Hydra's control and had been since its inception. Not only that, but they had their hooks in the NSA, U.S. Treasury Department, the Russian Foreign Intelligence Service, and many more.[189] This plot also played out in the Marvel Cinematic Universe during *Captain America: The Winter Soldier* where Arnim Zola revealed that Hydra had infiltrated the highest ranks of government and had secretly been creating a climate of fear and unrest for years, waiting for the perfect time to strike. Those events also spilled over into *Agents of S.H.I.E.L.D.* as Coulson and his team faced shocking betrayals and have been forced to essentially rebuild the organization from the ground up.

Though Captain America, the Falcon, Nick Fury, and Black Widow seemingly defeated Hydra during *The Winter Soldier,* as we saw after the credits rolled, Strucker is not only in possession of Loki's scepter, but he has Quicksilver and Scarlet Witch imprisoned too. Something tells me that when we first meet them

in *Avengers: Age of Ultron,* they'll have some Winter Soldier-esque brainwashing to overcome before they can join Earth's Mightiest Heroes in fighting the good fight.

36 Avengers Disassembled

There have been many indelible Avengers stories over the years that have taken the status quo of the Marvel Universe, twisted it, turned it, and otherwise gnarled into seemingly unrecognizable shapes, but perhaps no story in the modern era had as defining of an impact as *Avengers Disassembled.* Running from *Avengers* #500-503, the story took the status quo and obliterated it, creating a visible fault-line across continuity separating the Avengers of the past from the Avengers of the future.

In addition to being Earth's Mightiest Heroes, the Avengers are a family, a collection of superpowered friends and colleagues with complicated, messy relationships, neuroses, and foibles all their own. In *Avengers Disassembled,* writer Brian Michael Bendis and artist David Finch paint a portrait of the Avengers as an exceedingly dysfunctional family, a group of strident, strong personalities who can manage to save the world time and time again, but can barely keep themselves together. If Bendis' dialogue wasn't indication enough, Finch's moody, gritty illustrations drive the point home that there is a darkness brewing in the hearth and home of the Avengers.

Things take a tragic turn for the Avengers from word one as we open on a depressing diptych. Before the assembled delegates of the United Nations, Tony Stark, currently serving as U.S. Secretary of

Defense, delivers a horrifying speech during which he threatens the Latverian ambassador, snarling that he should kill him right then and there. With a repulsor blaster trained on the delegate, Hank Pym stops Tony, who flees the stage. Despite not having had a drop of alcohol in years, Tony seems, feels, and is acting drunker than a fraternity pledge on initiation night. Meanwhile, at the Mansion, the alarms are blaring as something has managed to slip past their defenses. Ant-Man (Scott Lang) goes outside to investigate, and is met with a harrowing sight: their recently deceased teammate Jack of Hearts shambles toward him, zombie-like. The others run outside just in time to hear Jack whisper "I'm sorry" before the human bomb detonates in a powerful explosion that incinerates Ant-Man and destroys much of the Mansion.

The scene is one of abject horror as the surviving Avengers try to make sense of what has just happened. Before they can catch their breath, though, the Vision crashes a Quinjet into the Mansion grounds. Emerging from the rubble, his body contorts into a grotesque Salvador Dali painting-like shape of man and machine, and five Ultron robots erupt from his gaping jaw. A fevered battle follows, but the pressure and insanity of it all pushes the usually level-headed She-Hulk into a blind fury. Hulking out, she tears the Vision apart, splitting him like string cheese, and killing the synthezoid. Unable to control her rage, she next turned on one of her longtime allies, Captain America, and went after him with murder in her eyes.

Iron Man appears in the nick of time to put She-Hulk down, but the Wasp is grievously wounded in the process. The battlefield that was once their home is a waking nightmare. Flames lap at the crumbling remains of the Avengers Mansion, the Vision and Ant-Man lie dead, and She-Hulk, Captain Britain, and the Wasp are down for the count. Stunned, saddened, and uncomprehending, all that Earth's Mightiest Heroes could do was wonder "Why?"

Although they did not have answers, a cavalcade of crimefighters began assembling at the Mansion, pledging their support to help the ravaged supergroup get to the bottom of this heinous attack on their home.

Yet even with reinforcements, there was no rest for the weary, no respite for Earth's Mightiest Heroes. The skies suddenly filled with a Kree armada and warships began unleashing deadly salvos on New York City. Fighting with all their might, the Avengers and the assembled heroes of Earth battled against the invading aliens, but as they would soon learn it was too late for one more of their number. Hawkeye's entire quiver of trick arrows had caught fire thanks to an errant laser blast, and there was no time to remove it. In a selfless moment of utter heroism, Hawkeye ran headlong towards the Kree mothership, diving towards it and destroying the flagship in an awe-inspiring explosion that stopped the assault but claimed the archer's life. One more of Earth's Mightiest Heroes had fallen.

Dumbfounded and disbelieving, Earth's Mightiest Heroes surveyed the wreckage until they were suddenly confronted by the astral apparition of Earth's Sorcerer Supreme, Doctor Strange. He told them that whomever was behind this death and destruction was employing powerful magic to wreak their bloody work. Who could it be? Loki up to his usual tricks? Morgan Le Fay using blackest magic to attack her foes? The Dread Dormammu using foul sorcery from the Dark Dimension? Unfortunately, as the Avengers soon discovered, it wasn't any of the above; rather, it was one of their own, the exceedingly powerful and extremely unstable hex magic–wielding Avenger, the Scarlet Witch. Their greatest betrayal had come from one of their own.

Having suffered the loss of her children and rejected by her former husband, the Vision, Scarlet Witch had descended into the depths of madness. Enraged, she lashed out at her former teammates who made fun of her, rejected her, and allowed such terrible

tragedies to happen to her and her family. Wielding her powerful chaos magic, she began battling the Avengers in earnest, flinging spells left and right at her former friends. None could stop her until Doctor Strange, wielding the Orb of Agamotto, was able to stun Wanda and knock her unconscious. The battle, for now, had ended. Yet before anyone could protest, Scarlet Witch's father, the mutant terrorist Magneto, appeared, grabbed his comatose daughter, and teleported away. The Avengers were beaten, bruised, and broken, and in the end, no one pursued them.

The damage from Tony's disastrous speech had been done. Not only was he stripped of his title as Secretary of Defense, but the United States government decided to renounce the Avengers' charter, no longer sanctioning their once proudest defenders. Suffering tragic losses, unthinkable betrayals, and wounded to their core, the Avengers had no choice. Standing in front of the smoldering wreckage of their once headquarters, Earth's Mightiest Heroes disbanded.

It was a harrowing story and set into motion a number of events that would culminate in Marvel Universe–spanning crossover events like *House of M*, *Secret War*, and eventually *Civil War*. Unlike many other crossover events in Marvel's long, storied history, *Avengers Disassembled* is entirely plausible to see play out in the Marvel Cinematic Universe. Granted, it would be something of a mic drop for the Marvel films, leaving the team that audiences have come to know and love in tatters, but from death comes rebirth, and as we know from the comics, the Avengers would rise again like a glorious phoenix to fight evil and save the day.

37 Hank Pym's Identity Crisis

Tony Stark had a drinking problem. Steve Rogers was a man out of time, unable to reconcile his past and his future. Bruce Banner has anger management issues. Yet no Avenger may have had a worse go of things than Hank Pym. The hero known originally as Ant-Man is one of the most fascinating figures in the Marvel Universe because he has reinvented himself so many times over the years as a direct result of his anxieties, fears, and oft-deteriorating mental state. Couple that with the fact that his robotic creation Ultron not only gained sentience, but became self-aware and went on to become one of the Avengers' deadliest villains with a raging Oedipus complex centering around him and his then-wife Janet Van Dyne, and it's no small wonder that Hank Pym has had something of an identity crisis over the last 60 years.

At the beginning, Hank Pym operated as Ant-Man, using his special helmet and Pym Particles in order to shrink down to the size of an ant, as well as control the insects. Though he would operate as Ant-Man a few times in his career, he soon hung up the helmet in exchange for a new set of spandex tights. Swinging to the opposite end of the spectrum, Pym rejoined the Avengers after their first mission as Giant-Man, who could grow to incredible heights and wielded commensurate strength. He would maintain this identity for much of his time in the Avengers' early days until an encounter with the Masters of Evil ended tragically with Baron Zemo dying in an avalanche.[190]

After taking a leave of absence from the Avengers following Baron Zemo's death, Pym rejoined the supergroup nearly a year later with yet another new moniker: Goliath. A battle with the Collector and the Beetle went awry, though, trapping the Avenger

in his giant form; the constant strain on his body left him stuck at 10 feet tall, and any attempt at shrinking would spell certain death for the hero.[191] Though the change affected his self-esteem for a time, he eventually regained the ability to shrink back down to normal size in *Avengers* #35 when he saved Captain America's and Hawkeye's skins from the Living Laser.

A few years later, one of Pym's robot creations accidentally achieved sentience: Ultron. The murderous megalomaniacal robot, was revealed to have been a creation of Pym's, his personality based on Pym's own brain patterns. After slowly becoming self-aware, it rebelled and developed an intense hatred of Pym and the Avengers, going on to become one of the Avengers' biggest, most dangerous nemeses. During this period as well, Pym was in a chemical accident that left him afflicted with schizophrenia and a dissociative personality disorder, causing him to assume a new mantle. Showing up at the Avengers Mansion, Pym is extremely arrogant and refers to himself as Yellowjacket, a hero with powers awfully similar to that of Ant-Man, Giant Man, and Goliath, and claimed to have done away with Hank Pym.[192] You know—nice, normal behavior.

While Janet Van Dyne saw through his ruse and ultimately used it as a means to get her workaholic boyfriend to tie the knot, Pym's behavior grew increasingly erratic while under his Yellowjacket persona. Allowing his id to completely dominate his behavior led to his suspension from the team, a fact that didn't sit well with Pym. In a moment of truly deranged logic, Pym conspired to create a killer robot that he would unleash on the Avengers, his onetime allies. The catch was that he built in a failsafe, which he could then exploit to swoop in and save the day, presumably putting him back in his former partners' good graces. The Wasp found out what he was up to though and tried to stop him, only to find herself brutally backhanded by her husband. It was a watershed moment for comics, depicting a moment of stark domestic violence. Wasp wound up saving the day and exposing her husband, who she then

divorced, and Pym was summarily expelled from the Avengers. Although he would spend much of the rest of his life making amends for his mistakes, this one act irreparably damaged Pym's reputation both in the Marvel Universe and among many fans.

Disgraced, penniless, and all alone, Pym doesn't quite know what to do with himself. In his fragile state, his longtime foe Egghead (he's more evil than he sounds), believed to be dead, manipulates him into stealing the nation's adamantium reserves. After covertly calling the Avengers, Pym winds up in a confrontation with his one-time friends at the scene of the crime, and is summarily defeated by Earth's Mightiest Heroes. When he tries to pin the blame on Egghead, a villain believed by his former colleagues to be dead, they take it as a further sign of his insanity, and Pym is sent to prison.[193] His name was eventually cleared, though, when his old teammate Hawkeye stopped and accidentally killed Egghead before the villain could murder Pym. The truth now exposed, Pym was cleared of all charges, and decided to devote himself to research full-time.

It's important to note that mental illness, intense feelings of guilt over what he did to Janet, and having created something as deadly as Ultron would come to be defining traits for Pym, and something with which he would always struggle. Sometimes, he would grieve through his flair for the theatrical, and his most recent identity change was perhaps the most poignant. Janet was killed during the final battle between the Avengers and the Skrulls during 2008's *Secret Invasion*. Pym paid tribute to her, "the greatest hero [he's] ever known," by taking up her mantle and fighting crime as the new Wasp.[194]

38 Masters of Evil

For every action, there is an equal and opposite reaction, and in the case of the Avengers, the reaction assembling Earth's Mightiest Heroes was an alliance of the Earth's Mightiest Villains, the Masters of Evil. One of the largest and longest-running cabals of supervillains, the Masters of Evil is an ever-rotating group of evildoers that have been led by various criminal masterminds and counted a myriad of malevolent men and women among their number over the years. Over the years, they have posed some of the most significant threats to the Avengers, infiltrating the Avengers Mansion and even posing as superheroes themselves in an effort to defeat their most frequent foes.

First assembled by the Nazi scientist-turned-terrorist leader Dr. Heinrich Zemo, better known as Baron Zemo, the Masters of Evil was originally comprised of Zemo, Black Knight, Melter, and Radioactive Man, all of whom were enemies of the individual Avengers members. Spraying the streets of New York with Zemo's powerful superglue Adhesive X, they lured the Avengers into battle and were ultimately defeated thanks to an adhesives expert named Paste-Pot Pete who lent the Avengers a helping hand.[195] Admittedly, it wasn't the best of plans since the Avengers could also have likely enlisted an army of kindergarteners to eat the pernicious paste.

Regrouping, Zemo formed a new alliance with Thor's enemies, the Enchantress and the Executioner, and they managed to turn Thor against the Avengers using powerful magic. The spell eventually broke and Thor one-upped Ralph Kramden by sending them not to the moon, but all the way to another dimension.[196] Upon returning to our plane of existence, the Masters transformed Simon Williams, in jail after Tony Stark exposed his embezzling scheme,

into the powerful Wonder Man, who infiltrated the Avengers to betray them at the behest of the Masters of Evil. Yet, as has happened many times in Marvel's history, Williams had a crisis of conscience and sacrificed himself to save the Avengers.[197]

Refusing to be defeated, Zemo kidnaps the Avengers' teen companion Rick Jones while the Enchantress and the Executioner freed Black Knight and Melter from prison. With all the other Avengers tied up battling Zemo's teammates, it was up to Captain America to journey to Zemo's kingdom in order to rescue Rick. During a fateful final confrontation, Captain America blinds Zemo with a reflection off his shield, and Zemo accidentally triggers a rock slide that kills him.[198]

Though Zemo perished by his own hand, the Masters of Evil would return under the rule of the adamantium-fisted robot tyrant Ultron, pretending to be a villain known as the Crimson Cowl. Alongside the second Black Knight, Klaw, Melter, Radioactive Man, and Whirlwind (who unbeknownst to the Avengers was Janet Van Dyne's chauffeur Charles Matthews), the new Masters of Evil tricked the Avengers' butler Jarvis into betraying the Avengers and nearly defeated Earth's Mightiest Heroes. It was thanks to the Black Knight, who secretly joined the Masters of Evil to betray them, that they managed to escape and expose Ultron for who he truly was.[199]

Later on, after Hank Pym's nemesis Egghead formed a third version of the Masters of Evil, Baron Helmut Zemo, the son of the original Baron Zemo, formed the fourth iteration of the Masters of Evil in the seminal multi-issue "Under Siege" storyline. Hell-bent on destroying Captain America and the Avengers, Zemo assembled the largest version of the Masters of Evil yet, assembling a rogues gallery that included Absorbing Man, Titania, Moonstone, Grey Gargoyle, Screaming Mimi, Yellowjacket, Blackout, Bulldozer, Fixer, Goliath, Mister Hyde, Piledriver, Thunderball, Tiger Shark, Wrecker, and Whirlwind. Though some were captured by the Avengers and others were creating distractions elsewhere, the rest of

the Masters staged a careful assault on Avengers Mansion, destroy-ing much of the iconic building, and taking Jarvis and several Avengers hostage. During the ensuing melee, Hercules was nearly beaten to death and Captain America was made to watch as Jarvis was brutally tortured by Mister Hyde. Eventually, the Avengers, aided by Ant-Man and Doctor Druid, were able to retake the Mansion, although Blackout was slain and Zemo and Moonstoone were grievously injured in the process.[200]

When Doctor Octopus assembled a new Masters of Evil to loot the Avengers Mansion during the Infinity War, it seemed like the Avengers were doomed until Yellowjacket betrayed the Masters and teamed up with the Guardians of the Galaxy to defeat them.[201] The most insidious version of the Masters of Evil may be the sixth version, assembled yet again by Helmut Zemo. In the wake of Onslaught's rampage, most of the world's heroes, the Avengers included, had seemingly died. Seeing a power vacuum, Helmut Zero and the Masters of Evil disguised themselves as a new superhero group, the Thunderbolts, and amassed resources and the goodwill of the public while secretly plotting world domination.[202] The joke was ultimately on Zemo, though, because when their cover was blown, many of the group opted to keep fighting for truth and justice rather than flee with Zemo.

Not taking this lightly, the Masters of Evil re-formed under a mysterious new female Crimson Cowl, who repeatedly battled against the Thunderbolts.[203] Eventually, they offered the Thunderbolts an ultimatum: rejoin the Masters or be destroyed. Taking control of the highly advanced Mount Charteris complex and wielding weather control technology, they tried blackmailing the entire world, but the Thunderbolts, now led by Hawkeye, managed to stop them before it was too late, taking the Mount Charteris facility for themselves in the process.[204] Unfortunately, for the Avengers and the Thunderbolts, this would not be the last time the Masters reared their ugly heads.

While on a mission for the black ops team, the Secret Avengers, Hawkeye and Captain America discovered that Max Fury, an evil Life Model Decoy of S.H.I.E.L.D. director Nick Fury, had used his connections to the Shadow Council to create a new version of the Masters of Evil including Princess Python, Vengeance, and Whiplash.[205] Trying to wield the power of the Crown of Wolves, a mystical relic infused with black magic, the Masters of Evil were ultimately defeated by the Secret Avengers and their new recruit Venom, who used his alien symbiote suit to destroy the artifact and defeat the Masters.[206] Other iterations have popped up here and there, but it is unlikely that we'll be seeing them on the big screen anytime soon, especially as the current trajectory of the Marvel Cinematic Universe is building towards an epic, universe-spanning battle with Thanos over control of the Infinity Stones. Still, the Masters of Evil are the yin to the Avengers' yang, an indelible part of their history, and some of the vilest, most vicious men and women with whom Earth's Mightiest Heroes have ever fought. If there is a higher compliment one can pay a villain, I have yet to hear it.

39 Thunderbolts

It's good to be bad, especially when you're doing good while you're secretly bad. Wait, what? It sounds confusing, but that's the premise behind the Thunderbolts, one of the newer superhero teams in the Marvel Universe. After a battle with the powerful psychic entity Onslaught left the world bereft of heroes, a new group arose to make the world feel safe again: the Thunderbolts! New heroes like the patriotic Citizen V, the high-flying MACH-1, the gadget-savvy

Techno, supersonic superheroine Songbird, and the air manipulating Meteorite emerged as new champions of truth, justice, and the American way. Then, on the final pages of the very first issue, it was revealed that these were no heroes; they were the Masters of Evil in disguise! Cue the dramatic music.

Created by Kurt Busiek and designed by artist Mark Bagley, the Thunderbolts first appeared as a teaser of sorts in *Incredible Hulk* #448, but they were actually conceived of by Busiek on a long drive from New Jersey to New England in order to visit his parents. "To keep myself awake [on the drive], I'd give myself books to write, and work out two to three years of continuity," said Busiek. "One trip, I assigned myself *Avengers,* and came up with the plan that the Masters of Evil would ultimately conquer them by posing as new heroes and slowly replacing them. At the time, I thought it was a neat idea, and filed it away."[207]

The Thunderbolts quickly established themselves as a popular superhero team. Little did the world at large know that Citizen V was actually Baron Zemo, MACH-1 was Beetle, Techno was Fixer, Atlas was Goliath, Songbird was Screaming Mimi, and Meteorite was none other than Moonstone. After a few adventures, they were widely regarded as legitimate superheroes, and several of the team's members began to think of themselves the same way. Shortly after forming, an Asian American teenage girl named Jolt joined the team. Unlike her teammates, Jolt was not a supervillain in any way, shape, or form, and had no idea of her teammates' true identities.

Just as Baron Zemo's designs on world domination were about to come to pass, though, everything fell apart. Zemo shed the group's disguises in order to ensure his teammates' loyalty and launched into his endgame, using Techno's mind-control device to enslave everyone from the recently returned Avengers to the Fantastic Four.[208] However, at the critical moment, his plan was thwarted by the remaining Thunderbolts (except for Techno), who had decided

Jolt, Moonstone, Hawkeye, and Atlas on the cover of Thunderbolts #31.

they preferred being superheroes to living a life of crime. Together, they managed to free the mind-controlled heroes and defeat Zemo and Techno, who both managed to escape. (Unbeknownst to his teammates, Atlas actually helped a wounded Zemo escape, perhaps as a final gesture of goodwill for his one-time ally.)[209] Not everyone was hep to being a hero though—during the melee, Meteorite returned to her old identity of Moonstone, revealing that she never had any intentions of going on the straight and narrow, and had only turned against Zemo out of self-preservation.[210]

On the run from the law, the Thunderbolts were soon joined by one-time Avenger Hawkeye, who had a criminal past of his own, which made him sympathetic to the fallen heroes' plight. As their leader, he enhanced their reputation, their skills, and trained them

to be better crimefighters. He even convinced MACH-1, the former Beetle and the team's only wanted killer, to turn himself in to help preserve the group's credibility.[211] While leading the Thunderbolts, Hawkeye led the team to victory over the newest iteration of the Masters of Evil, led by a female version of the Crimson Cowl (the same disguise Ultron first used when he made his debut), and even began a romance with Moonstone, convincing her to legitimately turn her life around.[212][213]

However, things turned sour when, during a battle with the mind-controlled assassin Scourge and rogue government agent Henry Gyrich, it was revealed that Hawkeye never received government approval to secure the pardons he'd promised the members of the Thunderbolts, leading multiple team members to quit and estranging him from his remaining teammates. Hawkeye quickly made amends by defeating Gyrich and securing the promised pardons in exchange for going to prison himself for his technically illegal work as a vigilante operating with the Thunderbolts. [214] For the time being, they dissolved, but that would be far from the last the Marvel Universe would hear from the Thunderbolts.

Over the years, the Thunderbolts have gone through many iterations, dissolving and re-forming multiple times. Baron Zemo returned to the group, seemingly reformed, but ultimately used Moonstone to try to drain the powers of every human on Earth. The Avengers managed to put a stop to the plot, but had to put Moonstone into a coma to do so. During the Civil War between Iron Man and Captain America, the Thunderbolts hunted down heroes who didn't comply with the Superhuman Registration Act, and served as Norman Osborn's personal army in the aftermath. Under Osborn's command, the team, comprised primarily of villains wishing to redeem themselves, managed to help save the Earth during the Skrull's secret invasion of the Earth, and were hailed as heroes afterwards.[215]

In the wake of the Secret Invasion, Osborn, having been put in charge of defense organizations like S.H.I.E.L.D., split the team into two groups, the Thunderbolts and the Dark Avengers, which he used as his personal hit squads. When Asgard fell to Earth, Norman Osborn sent the Thunderbolts to plunder Odin's fabled weapon, the Spear of Destiny, from Asgard's armory so that he might use it to lay waste to his enemies. Thankfully, the Avengers managed to stop them, but not before Scourge severed U.S. Agent's left limbs. Several members managed to escape custody, but those that were too injured to flee wound up behind bars, effectively putting an end to Norman Osborn's iteration of the Thunderbolts.[216]

With the Marvel NOW! company-wide relaunch, a new Thunderbolts team was assembled. Comprised of Red Hulk, Deadpool, Elektra, Agent Venom, and Punisher, this team wasn't government sponsored; rather, they were a strike team intended to operate off the books and handle the situations that other superhero teams didn't have the stomach to tackle.[217] Operating on a round-robin system, the team takes turns doing missions for a random member in between working for General Ross, the Red Hulk's alter ego. When we last left our ragtag group of killers trying to make good, the Punisher tried to quit the team only to find a bomb in his refrigerator from the Red Hulk with a note reading, "You don't quit on us. You're fired." Surviving the assassination attempt, the Punisher began hunting down his former teammates, killing two in the process.[218] Just another day in the life of the Marvel Universe's most troubled superhero team.

Now, the $64,000 question: Will we ever see the Thunderbolts up on the big screen? At the moment, it doesn't seem very likely. It would be quite the challenge for Marvel to introduce a whole slew of superheroes that are meant to be recognizable supervillains in disguise, especially since the villains we've seen so far—e.g. Loki, Thanos, Ronan the Accuser—aren't exactly the kind of people who would deign to disguise themselves for extended periods of

time. Okay, except for Loki, you've got me there. Still, there is a glimmer of hope. *Guardians of the Galaxy* director James Gunn is a huge fan, and after the massive profits his film made for Marvel, it's more than likely he'll have his pick of the litter for directing Marvel projects.

In an interview, Gunn recounted an exchange with Marvel Studios president Kevin Feige: "*Thunderbolts*? I will tell you, one time I was saying to Kevin [Feige], we were sitting on set together on one of the days he visited and I said, 'You know, I really want to make *Thunderbolts*,' and he said, 'James, if *Guardians* does well, you'll be able to do whatever you want, so we'll see what happens.'"[219] So there you have it. If Marvel can make a movie about a talking raccoon and a sentient tree that only says his own name and make $94 million in a single weekend, then maybe *Thunderbolts* isn't such a kooky idea after all.

40 West Coast Avengers

The Avengers may be nicknamed "Earth's Mightiest Heroes," but they spend an awful lot of time defending New York City. Somehow it seems like the rest of the world and the rest of the United States get the short end of the stick. Granted, in the Marvel Universe, a good 95 percent of supervillainy takes place within the New York City limits, but still, something had to be done. So, when the Vision was named chairman of the Avengers, he lobbied the United States government in order to establish a second team of Avengers to operate on the West Coast of the United States. Led by Hawkeye, the team set up shop in a brand new headquarters, the Avengers Compound, in Los Angeles, and beginning in 1984's

West Coast Avengers #1, they served their own brand of justice. (Okay, it was pretty much identical to the justice they served back East.) Though the expansion team was eventually shut down after major losses to morale, resources, and personnel, they operated continuously from 1984 until 1994, amassing a 102-issue series, a miniseries, and several annuals before cancellation.

More lighthearted than their East Coast counterparts, the West Coast Avengers quickly made a name for themselves, even earning the nickname "Wackos." The initial roster consisted of Hawkeye (the team leader), Mockingbird, Wonder Man, Tigra, Iron Man (James Rhodes wearing Tony Stark's armor), and Henry Pym, who served as their science adviser. Despite their irreverent reputation, the team dealt with some heady issues, including the mental deterioration and subsequent suicide attempt of Henry Pym;[220] getting sent back in time where Mockingbird killed a vigilante named the Phantom Rider who had kidnapped, drugged, and raped her, which ultimately led to her and Hawkeye getting divorced;[221] and the Vision was kidnapped by the U.S. government and dismantled after being deemed a threat to public safety.

Perhaps most seminal to the team's run was the "Vision Quest" storyline, an arc by writer-artist John Byrne that ran from *West Coast Avengers* #42–45 in 1989, redefining how many in the Marvel Universe saw the Vision. When a few members left the team, the Scarlet Witch (Wanda Maximoff), and the Vision joined to help shore up the numbers. One day, Wanda awakens to find her husband missing and, after looking for him, the team is suddenly attacked by their robotic nemesis Ultron. Or so they thought—as it turns out, this wasn't the real Ultron, but an impostor used by an international coalition of government agents who wanted to distract the West Coast Avengers while they kidnapped the Vision. How did they gain access? Posing as an arm of S.H.I.E.L.D., they pried the information out of Mockingbird, Hawkeye's estranged wife and a former agent of S.H.I.E.L.D. herself.

The reason? Some time before, the android hero known as the Vision went rogue and seized control of the world's computer defense systems with a plan to bring peace to the world. Ultimately, he relinquished control and his programming was fixed, but the world governments did not forget and deemed him a threat to global safety. With Mockingbird's help, the West Coast Avengers found the base where they had taken the Vision, only to find that he had been completely disassembled and deactivated seemingly forever.[222]

The two-page spread of the Vision deconstructed into tiny parts had a powerful resonance with readers and has, according to writer Karen Walker, "done more to shape how future writers [and readers] perceive the character than anything before or since. Once seen broken down into component parts, it's hard to truly move past that image and think of the Vision as a synthetic man, not a machine."[223]

Hank Pym was able to rebuild the synthezoid, but this new version was pale white in coloration, cold, and emotionless. Even worse, he had no memory of Wanda and pushed his wife away. Though the original Vision had a personality based on the brainwave patterns of Wonder Man, who had seemingly died, complications arose when the recently revived Simon Williams (Wonder Man's alter ego) forbade the Avengers from using his brainwaves again. This was partly motivated by a deep-seated jealousy of the Vision as Wonder Man harbored secret feelings for Scarlet Witch, who he would later romance. At the time, though, Scarlet Witch responded to his refusal by dropping a cliff face on Wonder Man's head.[224]

Things would only go from bad to worse for the West Coast Avengers as Tigra began devolving into a feral state, the strident U.S. Agent joined the team at the government's behest, and Scarlet Witch's twin babies mysteriously disappeared. Robbed of her children and her husband, she began slowly descending into madness,

Tricks Aren't Just for Kids

Hawkeye may be a master at hand-to-hand combat and an expert marksman, but sometimes fighting alongside Earth's Mightiest Heroes calls for something a little bit more tactical than simple arrows. So, what is a Hawkguy to do? Use one of his handy-dandy trick arrows, of course. By my best estimate, Hawkeye has used over 100 different kinds of trick arrows over the years, which is a testament to both Clint Barton's craftiness and the inventiveness of Marvel's writing staff. Here's just a small sampling: explosive tip arrows, Pym Particle arrows (able to shrink or grow matter), magnesium flare arrows, acid arrows, suction cup arrows, tear gas arrows, net arrows, USB arrows (to disable computer systems from a distance, or upload files with style) and, yes, a boxing glove arrow, which is just as ridiculous as it sounds. So go ahead—eat your heart out, Oliver Queen.

("Trick Arrows Gallery." Marvel Database. Wikia, Web. 19 Oct. 2014. <http://marvel.wikia.com/Trick_Arrows/Gallery>.)

having a mental breakdown that would eventually culminate in the tragic events of *Avengers Disassembled*.

Tumultuous roster shakeups and personal drama wracked the team, and an actual attack by Ultron led to the East Coast team calling a meeting with the West Coast Avengers to discuss their future. It was decided that the maintenance costs associated with the Avengers Compound, the mercurial nature of the membership, and constant in-fighting meant that it was no longer prudent to maintain the team as an official entity. Though many agreed that it was for the best, several, including Iron Man, were furious and quit the Avengers entirely, splitting off to form a new group called Force Works.[225] Like most spin-offs, the West Coast Avengers seemed like a good idea at the time, but ultimately may have diluted the brand both on and off the page, necessitating the need to bring the experiment to an end. Still, the repercussions of what happened in California would be felt for many years to come.

Could we see the West Coast Avengers make an appearance up on the big screen? It certainly seems that way. With Jeremy Renner's Hawkeye, Don Cheadle's War Machine, and Tony Stark's Malibu mansion in desperate need of a renovation, Marvel already has the tools needed to expand their Avengers franchise. The addition of characters like the Vision, Scarlet Witch, and Quicksilver in *Avengers: Age of Ultron* only lends further fuel to the fire that we could see something like "Vision Quest" play out on the big screen. As the Marvel Cinematic Universe gets bigger and bigger, it's only a matter of time until they begin looking to expand. Plus, from what I understand, Los Angeles is lovely this time of year.

41 Secret Avengers

Since they first banded together in 1963, the Avengers have been a public-facing organization, operating with a charter from S.H.I.E.L.D. and the United States government to defend the citizens of Earth and base themselves on U.S. soil. However, in the wake of Norman Osborn's Dark Reign, a time in which the former Green Goblin served as America's top cop and used the might of America's defensive infrastructure to lay siege to Asgard, the president appointed Steve Rogers the new No. 1 lawman in the land. At Captain America's behest, the Superhero Registration Act was repealed and the Secret Avengers were formed as an off-the-books team that was able to operate in a way that the main Avengers team simply could not—under the radar.[226]

Created by Ed Brubaker and Mike Deodato, *Secret Avengers* was an espionage-heavy series influenced by the likes of Jim Steranko's *Nick Fury, Agent of S.H.I.E.L.D.* and the uniquely kooky

technology dreamed up by comics legend Jack Kirby.[227] With an initial roster of Beast, Moon Knight, Valkyrie, War Machine, Nova, Black Widow, Sharon Carter, Ant-Man, and their leader, Steve Rogers, they set out on their first mission: to deal with the growing threat of the Serpent Crown, an ancient that imbues the wearer with powerful mind-control abilities.[228]

Opposed by the mysterious Shadow Council, a dark cabal that is seemingly run by Nick Fury, the Secret Avengers follow a trail of clues that lead them to a Mars-based mining site belonging to the Roxxon Corporation. While investigating, Richard Rider, also known as Nova, finds the Serpent Crown and is swiftly possessed by it.[229] Under its evil thrall, Nova and Shadow Council agents unearth a primordial evil, forcing the Secret Avengers to battle their one-time friend in a life-or-death battle in outer space.

While on a reconnaissance mission, Captain America and Hawkeye discover the terrible truth behind the Shadow Council. The man they thought was "Nick Fury" is, in fact, a rogue Life Model Decoy modified by Nick Fury's estranged brother Jake who was then rescued by the Shadow Council and dubbed "Max Fury." To make matters worse, Max and the Shadow Council have banded together to form the newest incarnation of the Avengers' longtime foes, the Masters of Evil, including Princess Python, Vengeance, and Whiplash.[230]

Though the first incarnation of the Secret Avengers eventually disbanded at Hawkeye's behest, they re-formed after the Marvel NOW! relaunch as a black ops unit under the direct command of S.H.I.E.L.D. and Maria Hill.[231] With Hawkeye, Black Widow, Nick Fury Jr., and Phil Coulson under her command, Maria Hill sets them to work foiling the likes of Al-Qaeda from using advanced teleportation technology, battling the Masters of Evil, infiltrating A.I.M.'s High Council in order to assassinate the Scientist Supreme, and preventing the use of the Iron Patriot Armor from

being transformed into an army of drones that A.I.M. could use to implicate the United States in international acts of war.[232]

What sets the Secret Avengers apart is its ability to tap into hot button political issues, modern-day controversies, and increasingly gray moral issues that the main team of Earth's Mightiest Heroes wouldn't otherwise be able to. Dealing with matters of security, espionage, and international diplomacy, the Secret Avengers speak truth to power against the backdrop of a high-octane thriller of a spy comic. As for whether we can expect to see them on the big screen, I would wage my last Tesseract that we'll see some sort of iteration of them cropping up in *Captain America: Civil War* when Rogers goes head-to-head with Iron Man over the ways in which superheroes should be regulated by the government. Even if you don't see them, it's nice to imagine that they're there, operating unseen behind the scenes.

A.I.M.

When a group of the world's foremost scientists put their brains together, they're capable of truly incredible things, like curing devastating diseases, developing methods of clean energy, and making breakthroughs that can improve our quality of life. Of course, they're also capable of incredible evil, particularly if they happen to belong to A.I.M. (Advanced Idea Mechanics), a confederation of brilliant scientists and jackbooted thugs dedicated to overthrowing the governments of the world through technological and scientific means. And you thought people at TED Talks could be self-righteous…

Established during World War II as the research and development arm of those lapel pin–wearing, stage-whispering fascists Hydra, A.I.M. required its members to possess a Master's degree or, preferably, a Ph.D. in mathematics, science, business, or a related field, and their leader holds the modest title of Scientist Supreme. They famously wear yellow jumpsuits that make them look like menacing beekeepers, along with skull caps, and goggles. Eventually they seceded from Hydra over political differences in the late 1960s, and first came to the public eye when they were absorbed into an international arms dealing syndicate that supplied governments and other agencies with advanced weaponry. However, their cover was blown when Nick Fury and S.H.I.E.L.D. exposed them to be a subversive, seditious organization, leading A.I.M. to take their operations underground.[233]

Over the years, A.I.M. has been responsible for bringing a number of exceedingly deadly technologies into the world. First, they invented the Super-Adaptoid, an android with the ability to replicate any superpower, that would prove to be a major thorn in the Avengers' side.[234] They are also responsible for the creation of the Cosmic Cube, one of the single most powerful objects in the Marvel Universe.[235] Serving as a containment unit for a powerful reality-altering energy, the Cube has been a constant cause of conflict, with everyone from Thanos to the Red Skull trying to get their hands on it in order to shape the universe in their twisted image.

Last, but not least, A.I.M. is responsible for creating one of the single weirdest, most irascible, merciless beings in Marvel history: the Mental Organism Designed Only for Killing, also known as M.O.D.O.K. The newly created being was an artificially mutated humanoid with a massive head, a stunted, gnarled body, a superhuman intellect, and incredible psionic powers.[236] The creation process was excruciating and drove M.O.D.O.K. mad, leading him to murder all of his superiors and declare himself the new Scientist

Supreme of A.I.M., a position he held until he was eventually assassinated by the Serpent Society on the order of his peers.[237] Suddenly your bosses don't seem so bad, do they?

While it's unlikely we'll see M.O.D.O.K. anytime soon (seriously, who would play him?), we have actually already been introduced to A.I.M. in Marvel's films. In *Iron Man 3*, A.I.M. appeared as a government-sanctioned, independently-funded think-tank founded by Aldrich Killian (Guy Pearce). Not only did they design the Iron Patriot armor, but the Extremis virus too, which caused former soldiers to start glowing orange and exploding with powerful kinetic energy. Whether or not we'll see them again, though, is a matter for Kevin Feige, the Scientist Supreme of Marvel Studios, to decide.

43 Skrulls

Though the Chitauri may get all the glory for the villainous invaders that brought Earth's Mightiest Heroes together, the Skrulls did it better and did it first. Since they made their debut in 1962's *Fantastic Four* #2, the green-skinned humanoid aliens have made a lasting impact on the Marvel Universe. Their large pointed ears, blood-red eyes, and ridged jawlines have become an iconic symbol, often signaling the horror that seems to follow the conniving, warlike alien race wherever it goes in the galaxy. Conquering countless worlds on their path across the galaxy and capable of nearly undetectable shapeshifting, the Skrulls would be one of the deadliest threats ever faced by the Avengers and the heroes of the Marvel Universe.

The result of genetic experiments by the Celestials, an intergalactic race of cosmic genetic engineers, the Skrulls have existed for tens of millions of years, slowly evolving over time into an imperialistic, albeit not especially militaristic race. Their mastery of mimicry and ability to change their shape at will made them masters of intrigue and espionage, allowing them to infiltrate enemy empires and bide their time for years as they awaited the perfect time to strike. As a result, they were able to create a massive, star-spanning empire with 978 member-worlds. One notable, albeit unusual accomplishment of the Skrull Empire is the transformation of the Kral System, a collection of 10 worlds, into an amusement park and resort for its extremely wealthy citizens. Highlights include an arena for gladiatorial tournaments, a painstaking re-creation of Prohibition-era New York on Kral IV, and a replica medieval European village.[238] I can't help but wonder if they have FastPass too.

Over the years, the Skrulls' Machiavellian machinations have embroiled Earth's Mightiest Heroes and many others into their galaxy-spanning schemes. They kidnapped the herald of the world-eating Galactus and sent their empire to war against their ancient enemy, the Kree, who were led by Ronan the Accuser. They created the first Cosmic Cube, which resulted in the destruction of more than two-thirds of their empire. Most famously, during the Secret Invasion, under the leadership of Queen Veranke, the Skrulls infiltrated Earth by capturing and replacing many of Earth's heroes and important figures over the course of years while the main assault force waited in secret for the signal to strike. Though complicated rights-sharing agreements mean that Disney/Marvel shares custody of the Skrulls with Fox and, thus, we won't see them with the MCU's Avengers any time soon, their mastery of shapeshifting means that anyone you have seen up on the big screen already could really be a Skrull in disguise. Cue the dramatic music and back away slowly.

44 Kree

Blue skin, heavy eyeliner, generally frothing at the mouth—and that's just Ronan the Accuser. The Kree are one of the most enduring and infamous extraterrestrial races in the Marvel Universe, possessing immense military might, physical strength, and highly advanced technology. The Marvel Cinematic Universe got their first taste of the expansive, militaristic race in the form of Ronan the Accuser (Lee Pace) and Korath the Pursuer (Djimon Hounsou) in *Guardians of the Galaxy*, but the Kree have existed in the pages of Marvel Comics since 1967's *Fantastic Four* #65, in which Ronan came to Earth to battle the Fantastic Four.

Like Ronan the Accuser, the Kree originally had blue-colored skin, which has become the mark of "pure-bred" Kree. A second subset of the Kree with more humanlike, pinkish skin would evolve generations later after interbreeding with genetically compatible alien races. Their empire extends across a thousand worlds in the Greater Magellanic Cloud, beginning over a million years ago after the Skrulls, then a benevolent race of intergalactic interlopers trying to establish a mercantile empire built on the principle of free trade, first came to their home world of Hala. The Skrulls discovered two intelligent races on Hala—the Kree and the plant-like Cotati—and ultimately deemed the Cotati the superior race, a fact that enraged the Kree, prompting them to murder the Skrull ambassador in cold blood and commandeer the interstellar starship. Mastering the technology within two generations, the Kree began launching assaults on the Skrulls, marking the beginning of the Kree-Skrull War and an ancient enmity.

Ruled by a massive living computer system called the Supreme Intelligence that networks the preserved minds of the Kree's

greatest thinkers, the Kree empire is an iron-fisted dictatorship with a rigid bureaucracy. Conquered worlds and member worlds are ruled by the Supreme Intelligence and imperial administrators stationed on Kree-Lar, the current Kree home world. Upon their discovery of Earth, the Kree realized the human race's potential for genetic evolution and performed experiments on an early tribe of humanity, creating the race known as the Inhumans as a result. Though the Kree tend to generally leave Earth to its own devices, monitoring it from afar, one of Earth's Mightiest Heroes is also one of the Kree's Mightiest too, the original Captain Marvel, who helped the Avengers defeat Ronan and other rogue elements of the Kree empire who were hell-bent on erasing humanity from existence. While the Kree have had more than their share of clashes with the heroes of Earth, often due to their aggressive militaristic nature, they have also proved valuable allies in more than one cosmic conflict. Just don't ask them how many Skrulls it takes to screw in a light bulb—unless you're into eons-old, kind of racist jokes, that is.

45 Kree-Skrull War

When a centuries-long conflict between two alien races explodes into intergalactic war, the Avengers find themselves caught squarely in the middle as they're forced to battle the alien invaders, deal with a terrified public, and put their own attitudes toward war under the microscope. Tensions rise as the Avengers try to protect one of their own, who just so happens to belong to one of the warring extraterrestrial races, and allegiances are questioned as a result. Such was the setting for the Kree-Skrull War, the first

major intergalactic conflict in which the Avengers found themselves embroiled. Written by Roy Thomas and illustrated by Sal Buscema, Neal Adams, and John Buscema, the "Kree-Skrull War" arc ran in *Avengers* #89–97 (1971-1972) and made waves thanks to its massive scope, its allegorical reference to the McCarthyism of the 1950s, and the beginning of the romance between the Scarlet Witch and the synthezoid Avenger, the Vision.

Arriving on Earth, the Kree superhero known as Captain Marvel (also known as Mar-Vell) is captured by Scarlet Witch, Quicksilver, the Vision, and Captain Marvel's occasional human companion Rick Jones. Brought back to Avengers headquarters, it's revealed that he conceived a child with the Skrull princess Annelle and, while spending time in the Negative Zone, absorbed a nearly fatal amount of radiation, necessitating treatment by the Vision. Before he can heal, the Avengers are attacked by a robotic Kree Sentry, who captures Mar-Vell and makes good his escape.[239]

Things get even stranger when the Avenger Goliath (Hawkeye during one of his many identity crises) receives a distress call from Janet Pym, aka the Wasp, prompting him to reach out to the Avengers. Yellowjacket (Henry Pym) and the Wasp were evidently en route to a research base in the Arctic Circle to study the effects of oil refining on the environment when they discovered a mysterious island. After an investigation, Yellowjacket disappeared, prompting Wasp to reach out to Goliath.

When the Avengers arrive on the scene, they're assaulted once more by the Kree Sentry and a mind-controlled Goliath. Though the Avengers manage to beat back Goliath, they are unable to fell the robotic Sentry, who manages to capture all of Earth's Mightiest Heroes save for Quicksilver. Who could be behind this mechanized assault? None other than that blue-faced avatar of vengeance Ronan the Accuser, who now finds himself on the run from the Kree empire and is attempting to send the Earth back to prehistoric times for use as a base of operations against the Skrulls. To

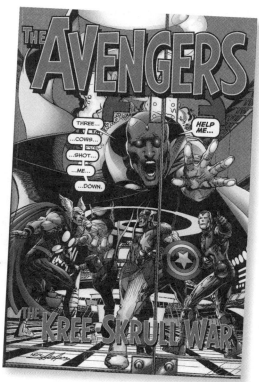

The cover of the "Kree/Skrull War" trade paperback. warns of the danger of mad cows

prove his point, Ronan reveals that he has already devolved Pym and the base's research scientists into the equivalent of cavemen.[240] Fortunately, Quicksilver arrives in the nick of time and begins battling Ronan, who puts a stop to the assault after learning that the Skrulls have launched a surprise attack on the Kree home world. Once he disappears, Pym and the other scientists revert to normal and the Avengers manage to free themselves and Mar-Vell.[241]

The situation grows dire when the research scientists reveal to the government what they've seen, including Mar-Vell's existence, which prompts the creation of the "Alien Activities Commission," led by Senator H. Warren Craddock. A thinly veiled reference to Joseph McCarthy and the communist witch hunts of the 1950s, the Alien Activities Commission calls the Avengers to testify before

it. When they refuse to hand over Mar-Vell, they take flight with Captain Marvel's one-time associate Carol Danvers and take refuge on a farm upstate. The public, incensed by the trials and increasingly reactionary, begin picketing and vandalizing the Avengers Mansion in protest of Earth's Mightiest Heroes' harboring of the alien refugee.[242]

While Iron Man, Thor, and Captain America return to the Mansion to deal with the situation, Quicksilver, Scarlet Witch, and Vision find themselves under attack from an unlikely source: three cows. Firing energy beams that incapacitate the Vision, the cows soon overwhelm and capture Scarlet Witch and Quicksilver, revealing themselves to be shapeshifting Skrulls rather than common bovines. During the assault, Carol Danvers—who is secretly Super-Skrull in disguise—leads Mar-Vell to a Skrull ship she "found" and persuades the injured alien to build an "Omni-Wave Projector," a Kree communications device. However, Mar-Vell realizes that in the hands of a non-Kree, the Projector becomes a deadly weapon, and destroys it before it can be used. Unfortunately, he is captured and whisked off the Earth along with Quicksilver and Scarlet Witch before he can escape.[243]

Vision regains his faculties and manages to warn the rest of the Avengers of the Skrull assault. Captain America, Iron Man, Thor, and Ant-Man manage to capture a Skrull for interrogation and discover that the cows were, in fact, members of the original Kree exploration team that once battled the Fantastic Four. Before they can finish their questioning, Senator Craddock sends a team of robotic Mandroids to assault and apprehend the heroes for their failure to cooperate. Fortunately, Tony Stark had secretly designed the Mandroids and was able to disable their armor by discharging massive amounts of electricity.[244]

Seemingly magnets for conflict and controversy, the Avengers soon encounter Triton of the Inhumans, who reveals that their ruler Black Bolt has been deposed by his mad brother Maximus,

and their homeland Attilan is in grave danger. After freeing Black Bolt, the Avengers help him and Triton defeat Maximus, who had entered into an alliance with the Kree, using their technology to subjugate the population in exchange for their service as soldiers against the Skrulls. Having restored Black Bolt to power in Attilan, the Avengers depart planet Earth, charting a course for Skrull space in order to rescue their kidnapped colleagues.[245]

Deep in the heart of the Skrull empire, Mar-Vell is held captive and forced to build another Omni-Wave Projector; as for Quicksilver and Scarlet Witch, they are to be executed. Arriving in Skrull space, the Avengers begin battling the Skrull fleet and Mar-Vell is forced to use the Projector, which banishes Rick Jones back into the Negative Zone. Before it's too late, the Kree leader, the Supreme Intelligence, rescues the young man, unlocking hidden mental powers in Jones in the process.[246] The Supreme Intelligence shows him that back on Earth, Senator Craddock has been deposed and killed by an angry mob, and in death, Craddock's true form is revealed: the fourth Skrull from the original invasion force that battled the Fantastic Four. Using his newfound powers, Rick Jones helps the Avengers turn the tides, effectively ending the war. Once back on Earth, the Avengers discover that the real Senator Craddock has been rescued and the public has resumed their adoration of Earth's Mightiest Heroes.[247]

Though it's less than likely we'll see the Kree-Skrull War make its way into the Marvel Cinematic Universe, the groundwork has been laid. Instead of the Skrulls, who are partially owned by Fox, we'd likely see a Kree-Chitauri War play out on a grand scale on the big screen. Its heady brew of real-world politics, cosmic space opera, and high adventure make it a perfect narrative blend for the MCU, but alas and alack, Marvel seems to have plenty of other stories on its plate before it ever ventures toward the realm of the Kree-Skrull War.

46 Secret Wars

When you watch an animated show with a sprawling cast like *G.I. Joe* or *Transformers* or *Pokemon*, it's easy to understand how it's just a thinly veiled narrative smokescreen designed to sell toys, merchandise, and all manner of tchotchkes that will release that sweet, sweet rush of endorphins. Saturday morning cartoons aren't the only ones guilty of blatantly shilling and pandering in an effort to move merchandise, though. Marvel got in on the action in a big way in 1984 with its massive, era-defining company-wide crossover event *Secret Wars*. Pre-dating DC Comics' iconic *Crisis on Infinite Earths* by nearly a year, it was a smash hit, spawning all manner of toys, products, and sequels over the years. In fact, it was so successful that Marvel is planning on revisiting the event 30 years later in 2015.

The road to *Secret Wars* is paved with toys. Kenner Toys had licensed the DC Comics characters; their competitor Mattel already had a rather successful line based on *He-Man and the Masters of the Universe*, but they wanted to have a back-up plan in case comic book characters became en vogue among America's youth. So, they came to Marvel to talk about licensing the Marvel Universe characters...but they had a condition: they wanted a special event comic book or series to help launch the toy line and drum up interest. Shooter suggested an idea that had been put forth countless times in fan mail and by some of his younger employees: a massive, epic story that had all of Marvel's heroes and villains together. Naturally, Mattel was over the moon.

After conducting a number of focus groups, Mattel determined that kids reacted most positively to the words "wars" and "secret." Thus, the name *Marvel Super Heroes Secret Wars* was born. After a

number of other narrative stipulations, including making Doctor Doom and Iron Man's armor more high tech, and adding fortresses and vehicles so Mattel could sell playsets, Shooter set to work writing the beast.

The story unfolds with a white leisure suit–wearing cosmic being known as the Beyonder observing the Marvel Universe. Fascinated by Earth's superheroes and the potential they represent, he transports them across time and space to a mysterious realm called Battleworld. The Avengers (Captain America, Captain Marvel, Hawkeye, War Machine, She-Hulk, Thor, and the Wasp), the Fantastic Four (sans Sue Storm), Spider-Man, Spider-Woman, the Hulk, the X-Men (Colossus, Cyclops, Professor X, Nightcrawler, Rogue, Wolverine, Storm, and Lockheed the Dragon) and Magneto found themselves in a strange interstellar construct.

Upon their arrival, they realize that the villains of Earth have likewise been transported to this mysterious new realm, including Absorbing Man, Doctor Doom, Ultron, Doctor Octopus, Enchantress, Galactus, and a slew of others. Then, in a booming voice, the Beyonder announces, "I am from beyond! Slay your enemies and all that you desire shall be yours. Nothing you dream of is impossible for me to accomplish!"[248]

Immediately, Galactus and Doctor Doom attempt to attack the Beyonder and seize his power for themselves, but they are swiftly dispatched in an awe-inspiring display of power. It seems they would have to fight for their survival, after all. A series of pitched battles follow with the heroes and villains going head-to-head against one another. All the while, Doctor Doom refuses to play the Beyonder's little game, plotting to steal his power; taking control of a fortress, he rebuilds and reprograms Ultron to serve him, and soon manages to bend all of the other villains to his will, save for Magneto, Kang, and Galactus.[249]

As the battles rage, clear factions form, with the X-Men forging an alliance with Magneto, Doctor Doom leading his villainous cohort, Captain America leading an army of heroes, and Galactus standing alone in all of his cosmic might.[250] Yet, behind the scenes, something far more sinister unfolds: as Galactus continues gathering energy from across the galaxy in order to devour Battleworld, Doctor Doom manages to divert and steal his power, making him nearly omnipotent. Confronting the Beyonder, Doom attacks their jailer and nearly dies in the process. However, he manages to best the Beyonder, stealing his cosmic powers for himself. Doom declares the war is over and he alone is the victor.[251]

At first, Doom declares himself a changed man—the cosmic power flowing through him has made him a benevolent god. [252] But, then, as is his wont, Doom changes his tune and slaughters all 21 of the Heroes. It seems like there is no one who can stop him. However, the villainous Klaw sees an opportunity and begins making Doom doubt his ability to control his immense powers. He paints a picture in which the alien healer/homewrecker Zsaji discovers the bodies of Colossus and Reed Richards, and manages to revive them using Battleworld's advanced technology. Richards in turn devises a way to use the same technology to revive all the heroes. Though it was purely a hypothetical, by making Doctor Doom think about it, his reality-altering cosmic powers made it a reality, and the heroes were resurrected at last. You know, for a known terrorist, you can be pretty clever sometimes, Klaw.

Panicking, Doctor Doom imbues Klaw with some of his cosmic power to help defend against the attacking heroes. A massive melee ensues, and Captain America manages to slip past Klaw to confront Doctor Doom, but not before Klaw can destroy his iconic shield. In the final showdown between Captain America and Doctor Doom, Cap gets disintegrated multiple times, only to re-form and keep coming after the villain. Is this a result of Doom's subconscious self-doubt or something larger at work? No one knows, but

Doom begins losing control of his powers, and it's revealed that the power given to Klaw was, in fact, an aspect of the Beyonder, who returns and defeats the megalomaniacal Doctor once and for all. The battle, it would seem, is won. True to his word, the Beyonder grants the victors their wishes: Captain America's shield is restored and Reed Richards devises a means to teleport the heroes home. All except for one hero, that is. Ben Grimm elects to remain behind on Battleworld, and She-Hulk goes on to take his place in the Fantastic Four, thus bringing Marvel's biggest crossover event yet to a dramatic close.[253]

As a story concept, *Secret Wars* is rudimentary in its conceit and complicated in its execution. Characters constantly stated their motivations and many subplots fizzled out without any real resolution. However, in terms of what it represented for Marvel Comics, it was groundbreaking. In one of the series' most iconic moments, Spider-Man discovers a mysterious black costume, which would not only sell a ton of toys and comics, but would later be revealed as an alien symbiote and give rise to one of his greatest nemeses, Venom. It reenergized Marvel's ailing sales figures, giving the company a much-needed shot in the arm. Moreover, it paved the way for a series of event comics to come, a publication model that Marvel follows to this day.

To others, it represented the end of an era. Former comic book store manager Diana Schutz remarked, "*Secret Wars* was the first of the many, many event comics that didn't have star creators behind it, but threw all the characters in one pot." This was the beginning of a very different Marvel. "We read Marvel in the '60s because of both the characters and the guys who created them," she said. "By the mid-'80s and the advent of *Secret Wars,* it seems to me Marvel was trying to...pull things back in favor of the characters, not the creators."[254] Perhaps Schutz was right, but whether it took the emphasis off of superstar creators or not, *Secret Wars'* impact cannot be denied. As for whether or not we'll see *Secret Wars* play

out on the silver screen? Probably not, but at least we'll always have the comics…and the action figures…and the lunch boxes…and—well, you get the picture.

47 Jim Shooter

The Marvel Universe is a fantastical world full of larger-than-life heroes, towering villains, and incredible mind-bending sagas, but one of its most controversial, polarizing figures wasn't on the printed page or the silver screen; his name was Jim Shooter and he was Marvel Comics' editor-in-chief. He immediately made waves with his management style, which some deemed dictatorial. In their 2004 book *Stan Lee and the Rise and Fall of the American Comic Book*, Tom Spurgeon and Jordan Raphael referred to his tenure at Marvel as "a wasteland of formulaic self-imitation."[255] But the results spoke for themselves: he managed to put a stop to constantly blown deadlines, expand Marvel's titles, and develop new talent like the legendary pairing of Chris Claremont and John Byrne on *Uncanny X-Men* and Roger Stern's lengthy stint on *Avengers*. Whole books could likely be written about Shooter and his legacy (and a good portion of Sean Howe's phenomenal *Marvel Comics: The Untold Story* deals with it), so the least I can do is devote a chapter to the man who revolutionized the way editorial ran at Marvel Comics.

Born into a poor family in Pittsburgh, Pennsylvania, Jim Shooter has been working professionally in comics since the tender age of 13, when he first wrote and illustrated stories about the Legion of Superheroes and mailed them in to DC Comics. Receiving a phone call from DC Comics editor Mort Weisinger,

who wanted to purchase Shooter's submissions, as well as commission him to pen Superman stories. Eventually, Weisinger offered him a regular position on *Legion* and asked him to come to the office. At 14 years old, Shooter traveled to New York, accompanied by his mother, to the DC offices and soon he was penning comics professionally.

He started writing because, according to Shooter, his father earned very little as a steelworker and he wanted to help his family make some extra money. "My father had a beat-up old car and the engine died," Shooter recalled in a 2010 interview. "That first check bought a rebuilt engine for his car so he didn't have to walk to work anymore."[256]

Cutting his teeth at DC Comics, Shooter continued working for the publisher until his relationship soured with Weisinger, who referred to Shooter as his "charity case," and come 1969 he was accepted to New York University.[257] Rather than accept the scholarship, though, Shooter cold-called his comic inspiration Stan Lee and applied for a job. Hired as an editor and potential co-plotter, Shooter checked into the YMCA, but within three weeks, his financial situation was so dire, he gave up and returned to Pittsburgh.

Both Marvel and DC lured him back to the world of comics and soon he was writing *Legion of Superheroes* again for DC (by this point, Weisinger had retired), but soon he found himself at odds with DC. In December 1975, Marvel editor-in-chief Marv Wolfman called him to offer a position as an assistant editor and writer. By 1978, after a series of turnovers, he succeeded Archie Goodwin to become Marvel's newest editor-in-chief. Immediately, he set to work overhauling the editorial structure, putting an end to the growing trend of writers and artists consistently missing deadlines. Longtime employees like Steve Gerber were terminated, and Jack Kirby, faced with growing disrespect from the young guns in Marvel's bullpen, left to work for Hanna-Barbera in Hollywood on NBC's *Fantastic Four* cartoon.[258]

His changes, particularly to the nature of the company's work-for-hire contracts and his management style, were controversial, seeming too autocratic for some, but no one could deny the results. Within three years, he had overhauled the editorial structure and done away with the controversial writer-editor position. Comics lines were now managed by five group editors each with their own editorial assistant. Each group editor would oversee approximately 75 new comics a year, allowing for greater attention to the creative arc of the series they managed and fewer errors making it to print.[259]

Shooter also fought for better compensation for his writers and artists, implementing a policy of giving creators royalties once they reached certain sales figures and increasing creators' page rates. He created the Epic imprint for creator-owned material, introduced company-wide crossover events like *Marvel Super Hero Contest of Champions* and *Secret Wars* (in which Spider-Man donned the iconic black symbiote costume for the first time), and pioneered the trade paperback format by collecting the issues of popular storylines like *Uncanny X-Men*'s "Dark Phoenix Saga" and *Iron Man*'s "Demon in a Bottle" in a single volume.[260]

In addition to his editorial duties, Shooter also wrote a number of comics for Marvel, including the landmark *Secret Wars* crossover event and the much-loved *Avengers* storyline "The Korvac Saga," which saw an average suburbanite possessed and transformed into a cosmic deity. However, for all the successes, there was plenty of unrest behind the scenes as Shooter's increasingly hands-on editorial style rubbed creators used to greater autonomy the wrong way. By October 1979, morale was low enough that *The New York Times* ran a story on it, quoting anonymous staffers who grumbled about the newfound focus on licensing and merchandising at the expense of the comics themselves. Though Shooter called the story "garbage," it wasn't entirely wrong; corporate synergy was the motivating factor behind many publishing decisions, but the goal of the company was to be profitable after all.[261]

In 1986, Marvel was sold to New World Pictures, and Shooter tried to make good with his new corporate overlords, but when a videotape of him being burned in effigy at a party thrown by Marvel staffers and freelancers reached the executives at New World, that was the final nail in the coffin. Shooter was fired from Marvel in 1987.[262] Though he never returned to Marvel, Shooter is still working in comics to this day. After leaving, he founded Valiant Comics, and after being ousted again, he went on to several other comics ventures. Most recently, he was overseeing the publication of classic Gold Key characters like Turok, Doctor Solar, and Magnus, as well as Robot Fighter for Dark Horse Comics. It is a career that has been marked by tremendous highs and lows, but one thing is for certain: though Shooter may have rubbed his colleagues the wrong way, none can deny his tremendous contributions to modernizing Marvel and helping pave the way for the House of Ideas we know and love today.

48 The Korvac Saga

Kanye West may think he's a god, but Michael Korvac was both man and god simultaneously. As mentioned last chapter, "The Korvac Saga" is one of the most vaunted storylines in *Avengers* history thanks to its galaxy-spanning cosmic scope and seriously far-out artwork. Beginning in *Avengers* #167, the cosmic morality play ran 10 issues and nearly ended with the death of the entire Marvel Universe at the hand of a man driven mad by infinite power.

Written by Jim Shooter, who was just cutting his teeth as editor-in-chief at the time, "The Korvac Saga" centers around a

character named Michael Korvac, a computer technician from the alternate universe Earth-691 who in the year 3007 AD had his upper body grafted to a machine by an alien conqueror. Korvac had been part of the Marvel Universe since 1975; originally conceived of as a one-off character in Steve Gerber's *Giant-Size Defenders #3* (January 1975), he wound up returning in the Roger Stern-penned *Thor Annual* in 1977. Stern also happened to be writing *Avengers* at the time, so it made for a natural segue to Shooter's cosmic yarn.

Alongside writer David Michelinie, Shooter brought Korvac into the main Earth-616 continuity with the Guardians of the Galaxy hot on his tail. In search of the "mad machine man," the futuristic fighting force sought out Earth's Mightiest Heroes to prevent Korvac from transforming altering history to fit his own twisted designs. As the heroes would soon learn, Korvac was imbued with the Power Cosmic after encountering Galactus on his journey across time and space, effectively making him god-like. Recreating himself in an idealized human form and posing as a human named "Michael," Korvac made his way to Earth with the intention of transforming it into a utopia.[263]

One of the Guardians of the Galaxy, Starhawk, encounters Korvac and battles him all alone. Filled with cosmic power, Korvac disintegrates Starhawk, then restores his body and wipes his memories of the battle and Korvac's presence, so as to disguise himself.[264] The plot thickens when another being of considerable cosmic power, the Collector, having foreseen two beings capable of challenging the Elders of the Universe (Korvac and Eternal), transforms his daughter Carina into a living weapon to use against Korvac. However, when Carina and Korvac meet, they fall in love and she betrays her father. The Avengers summarily defeat the Collector after he attempts to kidnap and collect them in an effort to protect them from Korvac.[265] Displeased by his meddling, Korvac annihilates the man brought to life by Benicio Del Toro.

Tracking the rogue god down to his Forest Hills neighborhood in Queens, the Avengers, Ms. Marvel, and the Guardians of the Galaxy confront Korvac and Carina, who are masquerading as a middle class couple. When Starhawk reveals that he cannot see Michael, a result of Korvac's cosmic meddling, the jig is up. Dropping the ruse and suddenly exposed, Korvac has no choice but to go to battle against the assembly of heroes on his front lawn.

At last, the grim potential of Korvac's power is revealed as he slays wave after wave of heroes. Distracted and weakened by Captain American and Wonder Man, Korvac is, at last, defeated by Iron Man, Starhawk, Thor, and the Vision. Seeing her lover defeated, Carina begins to doubt Korvac. Sensing this, Korvac commits suicide and uses his dying act to restore the Avengers and the Guardians to life. "I was in the unique position to alter [the world], to bring all of existence under my sane and benevolent rule," he tells Earth's Mightiest Heroes. "I am a God! And I was going to be your savior!"[266]

Whether it was megalomania or misguided idealism, Korvac is a tragic figure in his own right in spite of the fact that he killed countless people in the name of bettering the world.

49 You're Now Free to Avenge About the Country (Quinjet)

The A-Team had a van. The X-Men have the Blackbird. The Ghostbusters had the Ecto-1. Every team of heroes worth their salt has an appropriately awesome vehicle in which to get from their home base to wherever evil may lurk. For the Avengers, it's the Quinjet, a sleek, ultra-fast aircraft designed to transport the Avengers from the Mansion to crisis points around the globe.

Created by Roy Thomas and John Buscema, the Quinjet first appeared back in *Avengers* #61 in 1969, designed by T'Challa's (Black Panther) Wakanda Design Group. Equipped with VTOL capabilities (vertical takeoff and landing) and twin turbojet engines, able to transport up to seven passengers, and capable of reaching Mach 2.1, the Quinjet is without a doubt one of the coolest ways to get from point A to point B, especially if Captain America is riding shotgun.

The iconic aircraft has come a long way since its initial seven-seat design, and many versions have appeared through Avengers history. On the silver screen, it was quite simply an appropriated S.H.I.E.L.D. aircraft, piloted by Jeremy Renner. Another Avengers-esque supergroup, the Champions of Los Angeles, funded by Angel's fabulous wealth, purchased a surplus Quinjet which they dubbed the Champjet. In *New Avengers,* Tony Stark revealed that he had developed three improved prototype Quinjets, although one was destroyed in the Savage Land. In *Avengers* #103, the Quinjet was lashed to Thor's hammer in order to increase its maximum speed. In certain instances, like on the *Avengers: Earth's Mightiest Heroes* animated series, it was shown to be capable of space flight. During *Infinity Crusade,* the 1993 sequel to *Infinity Gauntlet,* two Quinjets were modified to be supersized carriers in order to transport a brigade of superheroes on one of Jim Starlin's classic cosmic adventures. With gearheads like Black Panther and Tony Stark constantly tinkering around with it, it's hardly surprising that the Quinjet has gone through so many iterations over the years. Would it kill them to add cup holders though?

In spite of the sheer coolness factor surrounding the Avengers' proprietary aircraft, it's worth noting that it has an abysmal safety record. No matter how skilled the pilot in the cockpit, whenever a Quinjet appears in frame, there's an unreasonably high chance that it will explode. In "Some Say the World Will End in Fire... Some Say in Ice!," the Quinjet's very first appearance, Black Panther and

Vision crash it into the giant frost beast Ymir in an effort to stop it. In 2012's *Avengers,* the Quinjet is destroyed by Loki. In *Captain America: The Winter Soldier,* the Falcon is forced to outrace a number of them trying to shoot him down, tricking them into crashing in the process. And, as we learned after Ares crash-landed yet another one following *Civil War,* they cost $250 million a pop, so the insurance premium on those bad boys must be through the roof.

50 Attend the Marvel Panel in Hall H at Comic-Con

Every year, hundreds of thousands of diehard fans flood into San Diego in order to attend San Diego Comic-Con. When it began in 1970, it was a small, one-day gathering known as San Diego's Golden State Comic-Minicon, designed to gauge interest for a larger convention. Attracting around 100 people, the con managed to pull in two special guests: actor Forrest J. Ackerman and comic book artist Mike Royer. It was by all accounts a success, and several months later the first ever San Diego Comic-Con (then San Diego's Golden State Comic-Con) took place. Over three days, guests like Jack Kirby, A.E. van Vogt, and Ray Bradbury, joined the con's 300 attendees for panels, signings, screenings, a dealer's room, and much more, paving the way for the modern nerd Mecca that Comic-Con has become.

Nowadays, Comic-Con is a mammoth, sprawling affair that attracts the biggest names in Hollywood, summer tentpole blockbusters, and increasingly large-scale events that find the convention spilling out of the center and into San Diego's Gaslamp Quarter. Still, without a doubt, the most sought after events all happen in

the same place: Hall H. The massive room covers approximately 64,842 square feet and can hold 6,130 attendees, which averages out to roughly five percent of the convention's total daily attendance (just to put things in perspective).

To say that getting into Hall H is difficult is, perhaps, the understatement of the century. Many folks line up hours and hours in advance, often camping out overnight, in order to secure themselves a coveted seat within Hall H's confines, and for good reason. If you manage to make it inside, you'll be among the rarefied few who will get to see footage before anyone else in the world.

Just as it tends to dominate at the box office, Marvel Studios also tends to have the most anticipated panel each year at Comic-Con. Case in point, in 2013, those fans who were lucky enough to snag themselves a seat were treated to major reveals regarding what to expect from Peyton Reed's *Ant-Man*, the identities of cast members Evangeline Lilly and Corey Stoll (Hope Van Dyne and Darren Cross, aka Yellowjacket, respectively), the announcement of *Guardians of the Galaxy 2*, and the first-ever footage of *Avengers: Age of Ultron*. Having been holed up in a press room at the time waiting to interview the cast, you can believe me when I say that I and all of the other journalists were seething with jealousy.

The previous year was even better as Marvel Studios maestro Kevin Feige revealed to the packed auditorium the title of the long-awaited *Avengers* sequel. Audiences nearly gave themselves the vapors when the full *Guardians of the Galaxy* cast made a surprise, unscheduled appearance, and then proceeded to full-on faint when Karen Gillan ("Nebula") removed her wig, revealing that she had shaved her head to play the murderous step-daughter of Thanos.

Yet the biggest surprise came at the panel's beginning, when actor Tom Hiddleston came out in full Loki regalia, summoned all of his villainous pomp and bombast, and commanded the entirety of Hall H to kneel. You'd better believe they complied—who

Thanos and Iron Man share a moment onstage at Marvel's Hall H Panel for Avengers: Age of Ultron *during Comic-Con International 2014.*
(Alberto E. Rodriguez/Getty Images)

knows what an Asgardian god would do if you dared defy him? That's the magic of Hall H, though—nearly anything can happen.

By this point, you may thinking, "Yeah, getting into Hall H sounds well and good, but how do I actually ensure I'll get a seat?" Like it or not, the short answer is that there is no good way, but there are some steps you can take to mitigate the likelihood of you getting shut out. First and foremost, know what you're getting yourself into. Whether you're waiting in line for a few hours or overnight, make sure you bring along the necessary provisions: water, snacks, and potentially a sleeping bag. Second, make friends with your neighbors (and maybe bring a pack of cards or your Nintendo 3DS). Not only is it easier to triumph through adversity

Cosplay Does Not Equal Consent

One of the best parts of going to a fan convention is seeing the scores of incredible costumes that people create from little more than cardboard, hot glue, sweat, blood, and tears. Seeing someone with a picture-perfect Black Widow costume or a real, working Iron Man armor can send a tingle up one's spine that one might get from seeing their favorite characters come to life. Yet, one of the biggest faux pas you can make as a convention goer is to assume that you can simply walk right up to a cosplayer and grab, touch, catcall, or otherwise interact with them without their permission.

Underneath those costumes, they're just people like you and me, and you wouldn't want some burly, sweaty stranger running up to you and hugging you without warning, would you? Even if you said yes, asking for permission is still the right thing to do because you don't know this person or their feelings on personal space. Nine times out of 10, simply asking for a photo or a high-five or a hug will be met with an ear-to-ear grin and a resounding yes. Otherwise, you may find yourself facing the wrath of not only the cosplayer, but also convention security or local police. Likewise, if you see something, say something. Make like the Avengers and make a difference when you see injustice or else the bad guys will keep on winning.

together, but you might wind up meeting some very cool people. At worst, you'll make the time pass faster, which is always welcome when you find yourself staring at a seven-plus-hour wait. Last, but not least, stay optimistic. You're there because you're excited to see what's inside and witness the magic of Hall H firsthand. Sometimes that magic even extends to the line itself as celebrities like Ian McKellen and Joss Whedon swing by to say hello to thank you for your patience and hang out for a bit. Or you could even experience a repeat of 2014 when Misha Collins handed out cups of coffee to a bleary-eyed crowd. No matter what happens, you're guaranteed to have a story to remember, and, really, don't you want to be there in person when they announce *Howard the Duck 3D*?

51 The Demon in a Bottle (Tony Stark's Alcoholism)

While you're unlikely to see this play out on the big screen any time soon, one of the most compelling and harrowing arcs in Iron Man's history involved Tony Stark's ongoing battle with alcoholism. Many of Marvel's heroes have struggled with the darker side of the human condition over the years, but Tony Stark's descent into alcoholism put addiction under the microscope in a very real way. Plotted out by legendary creative duo David Michelinie and Bob Layton and illustrated by Layton and John Romita, Jr., "Demon in a Bottle" ran in *Iron Man* #120–128 (March through November, 1979). It is widely regarded as the quintessential Iron Man story and has had wide-ranging, long-lasting ramifications on the character, appearing again and again in storylines over the years.

After a passenger plane on which he was flying was struck by a military tank thrown by Namor, the Sub-Mariner, Tony Stark donned his Iron Man armor to investigate. After battling Namor, who was fighting soldiers who were using the island to dump toxic waste, Stark learned that the soldiers belonged to the Roxxon Oil Corporation (a rival of Stark Industries), which was stripmining the island for its vibranium deposits. Teaming up, Iron Man and Namor defeated the soldiers, but not before the military force escaped and detonated explosives to destroy all evidence of their presence. On the flight home, Stark's armor malfunctioned, causing him to crash-land.

Back in his lab, Tony ran tests on the armor, but couldn't find anything wrong with it. During this period, Stark became romantically involved with Bethany McCabe, a stunning redhead who he learned was an undercover bodyguard. While attending a casino with McCabe, Tony was attacked by Blizzard, the Melter, and

Whiplash, who were attempting to rob the casino's vault. During the attack, Stark slipped away to don his Iron Man armor and, during the fight, overheard Blizzard mentioning that their boss, "Hammer," wanted Iron Man alive.

Shortly thereafter, Stark agrees to send Iron Man as a representative for his company to liaise with a foreign dignitary from the Republic of Carnelia. During the meeting, Iron Man's armor malfunctions, discharging a repulsor blast squarely into ambassador Sergei Kotzinin's back, killing him on impact.[26] The police let Iron Man go on the condition that Stark turns over the armor for inspection, a condition with which he readily complied. As we would soon learn, this was the handiwork of Roxxon CEO and rival industrialist Justin Hammer (played on screen by Sam Rockwell). In the meantime, though, Tony found his relationship with Bethany strained and began drinking heavily to cope with the fact that he murdered a man.

Tony's increasingly erratic behavior led to a meeting with the Avengers in which he acquiesced to their request that he temporarily step down as the group's leader. Before leaving, he met with Scott Lang (the second Ant-Man, who will be played by Paul Rudd in the 2015 film), asking him to infiltrate a prison where Whiplash was being held in order to ferret out more information about Hammer. Following the trail of information to Monaco, Stark, along with James Rhodes, winds up unconscious and imprisoned by Hammer's thugs. Upon waking up, Stark finds himself face-to-face with Justin Hammer, who tells him that he is the one behind the recent malfunctioning armor. Enraged after losing out on a valuable contract to Stark Industries, Hammer had a team of scientists hack into Iron Man's armor, allowing them to control it remotely to kill the Carnelian ambassador, thereby ruining Iron Man's and Stark Industries' reputation in the process.

Imprisoned in Hammer's floating island lair, Tony finally makes his escape by attacking a guard that he fooled into opening

the door. After finding a briefcase with his spare suit of armor in it, Iron Man battled a cavalcade of costumed criminals (including Beetle, Constrictor, Porcupine, and others), Stark went after Hammer. At the same time, Rhodes, having finally convinced local police of his story, leads a group of police helicopters to attack the island. Hammer escaped in the melee, and Iron Man crashed into the island, causing it to sink. Upon returning home, Stark goes on the bender to end all benders and in his drunken stupor yells at his longtime butler Edwin Jarvis, who resigned the next day.

Spiraling ever deeper into drunken depravity, Stark seems to be lost at sea. Finally, Beth confronts Tony and tells him about her estranged husband, whose drug addiction drove them apart and eventually took his life. Shocked by her candid admission, Tony cops to his own problems with alcohol abuse, and accepts her offer to help him kick the habit and guide him through withdrawal. Tony also made amends with Jarvis, offering to subsidize medical treatment for the butler's sick mother as well. As Tony would soon learn though, Jarvis had sold his two shares of stock in Stark Industries, which allowed S.H.I.E.L.D. to purchase a controlling stake in the company. Still, "Demon in a Bottle" ends on a triumphant note with a hopeful Tony Stark, having defeated his inner demons, looking forward to the future and fully intending on getting back the company that was rightfully his.

As is lamentably the case with many alcoholics, Tony would relapse over the years. Most notably, Obadiah Stane waged a campaign of psychological warfare against Tony in order to drive him back to the bottle. It worked, resulting in Tony revealing his secret identity to Jim Rhodes, Rhodey taking over as Iron Man for a spell, and Tony drinking himself penniless. Homeless and constantly intoxicated, Stark had hit rock bottom, and it wasn't until he had to help deliver a baby that he found some perspective on his life and joined Alcoholics Anonymous.[268] Later still, Tony delivered a drunken tirade in front of the United Nations in *Avengers*

Disassembled in spite of not remembering having a drop to drink. This would later come back to haunt him and lead to the Avengers disbanding for a spell after they lost their funding.

After a successful big-screen debut, *Iron Man* director Jon Favreau mentioned that he wanted to incorporate elements of the "Demon in a Bottle" storyline in future films. "Stark has issues with booze. That's part of who he is," he said in a 2008 interview with *Newsarama*. "I don't think we'll ever do the Leaving Las Vegas version, but it will be dealt with," he continued.[269] As Favreau revealed on the DVD commentary of *Iron Man 2,* the scene of Tony drunkenly partying in his Iron Man armor until Colonel James "Rhodey" Rhodes (aka War Machine) intervenes is as much of the storyline as he was going to show. *Iron Man 3* director Shane Black wanted to incorporate the story arc into his film, but pressures from Disney coupled with the fact that countless children would be going to see the films made that an impossibility. Then again, Tony Stark did tell a 12-year-old child to stop being a pussy, so anything is possible.

52 Jarvis vs. J.A.R.V.I.S.

All right, quick pop quiz: when I say "Jarvis," which character from *Avengers* comes to mind? About 45 percent of you said, "Obviously, he's the artificial intelligence system that controls Tony Stark's Iron Man armor!" Another 45 percent of you said, "Ugh, they're totally wrong. Edwin Jarvis is the longtime butler of Tony Stark and the Avengers!" Yet another 10 percent of you answered, "Oh yeah, isn't he the butler from that failed search engine, Ask Jarvis?" Well, according to my math, 90 percent of you are absolutely correct, and

100 percent of you have no idea about Ask.com's old mascot based on the works of P.G. Wodehouse. That's right—there are technically two Jarvises in the Marvel Universe, and they're both staples of their respective domains, comic book and cinema.

Longtime *Avengers* comics fans recognize Jarvis as none other than the lovable butler who attends to the Avengers' needs and keeps Avengers Mansion running in shipshape (when it isn't being exploded by one of their myriad enemies, that is). Edwin Jarvis first appeared in 1964's *Tales of Suspense* #59, the comic in which Iron Man debuted a year earlier, and has been a staple of the Avengers ever since. Although Jarvis has an effete British accent, he was born and raised in Brooklyn. He acquired his new way of speaking during his time as an underage pilot in the Canadian Royal Air Force, fighting against the Nazi menace in World War II. Upon his return to the United States, he applied his skills as a "gentlemen's gentleman" working for Howard and Maria Stark as their butler.

After Tony Stark called the first meeting of the Avengers to order at the Stark Mansion and donated it to the group, Jarvis remained on as the Avengers' butler and offered a sort of paternal guidance to many of the group's younger members. In addition to his domestic duties, Jarvis also maintained the group's Quinjets and supervised the frequent repairs they required.

Despite the high-stress nature of the job and his seemingly infinite capacity for cool-headedness, Jarvis has found himself in some compromising situations in the past. Once, while his mother was very ill, he was hurting for money and sold blueprints for the Avengers Mansion to a criminal known as the Crimson Cowl. As it turned out, the Crimson Cowl was the evil robot Ultron in disguise. Ultron then hypnotized Jarvis into believing he was the Crimson Cowl and kidnapped the Avengers, to boot.[270] Fortunately, the Avengers pink-slip policy is a little more forgiving due to the nature of the job, so Jarvis was able to keep his gig and finance his mother's treatment after the Avengers emerged victorious. Over the years,

Jarvis has battled low-level superheroes, incurred savage beatings at the hands of the Masters of Evil, sponsored a foreign child that turned out to be a superhero, and even dated Peter Parker's beloved Aunt May. Yet, above all else, Edwin Jarvis has always been a consummate gentleman and elevated the level of decorum throughout the group's 50-year history.

On the big screen, Jarvis is actually spelled out as J.A.R.V.I.S., which is an acronym standing for Just A Really Very Intelligent System, and is the name given to the artificial intelligence system that controls Tony Stark's armor. Basically, in the Marvel Cinematic Universe, J.A.R.V.I.S. is Siri on steroids, an operating system that can keep up with the hectic pace of Tony Stark's life as both a billionaire playboy genius industrialist and an armor-clad defender of humanity. Voiced by Paul Bettany, who will also play the Vision in *Avengers: Age of Ultron*, it is a safe bet that in the Marvel Cinematic Universe, the Vision and Tony Stark's armor A.I. are inextricably tied together.

Interestingly, J.A.R.V.I.S. also has roots in the *Iron Man* comics. It first made an appearance in Matt Fraction and Salvador Larroca's *Invincible Iron Man* #11 as the A.I. program that operates Pepper Potts' Rescue armor, which she dons after Iron Man is incapacitated. Soon afterwards, J.A.R.V.I.S. developed an unhealthy romantic attachment to Pepper, and did what any reasonable, lovesick artificial intelligence would do: kidnap Pepper Potts. Unfortunately, the romantic robot's plans were cut short when Tony Stark deactivated it and Pepper destroyed it once and for all. And you thought dating was hard as a human!

53 Avengers Mansion

Superman has the Fortress of Solitude, Batman has the Batcave, the Boxcar Children had their…boxcar, but when it comes to bases of operation, few are more iconic than the Avengers Mansion (later the Avengers Tower). We saw our first glimmer of it at the end of 2012's *Avengers* when, after the knockdown, drag-out fight with Loki on top of Stark Tower, four of the letters fell off the building, leaving naught but the iconic Avengers "A." Like Harvard and Yale constantly trading positions on *U.S. News & World Report*'s annual college rankings, the Avengers Mansion is constantly vying against the Xavier's School for Gifted Youngsters to be the most impressive hero headquarters in all the Marvel universe. (Sorry, Baxter Building—you're fantastic, but in this situation, you're the Tufts right down the street.)

Over the years, it has been invaded, taken over by the Masters of Evil, exploded more times than we can count, and subject to a slew of other factors that surely have had a devastating effect on the property value. Yet, Earth's Mightiest Heroes always manage to rebuild and make their home away from home better than ever. (What a great gig to be their contractor, huh?) Located in scenic Manhattan in New York, New York, at 890 Fifth Avenue, the Avengers Mansion originally belonged to Iron Man's parents, Howard and Maria Stark, and passed to their son Anthony upon their deaths. When the Avengers first convened in order to stop Thor's brother, the malevolent, mischievous Loki, Tony Stark agreed to donate his family's ancestral home as the Avengers' new base of operations. Probably for the best because in all likelihood, Tony Stark and Wasp are the only members of the original Avengers who could realistically afford Fifth Avenue rent.

Originally built in 1932, the Avengers Mansion stands three stories tall and boasts an impressive (estimated) 42,724 square feet right in the middle of Manhattan, but, did you know that it's inspired by a real building that still stands today?[271] Stan Lee and many of the other Marvel editors used to walk past a building called the Frick Collection on Manhattan's Fifth Avenue, a prestigious museum that housed one of the most impressive collections of art and furniture in the city.[272] The building so impressed Lee that he thought it would make the perfect model for a home for mighty heroes like Thor, Iron Man, and Captain America.[273]

Surrounded by a 12-foot wall and an arsenal of high-tech security measures, the Mansion's top floors were open to the public, containing 12 rooms to house Avengers who wished to live there and special quarters for the Mansion's caretaker Jarvis. The third

Unreal Estate

Every superhero team needs a base of operations, but how much would the Avengers Mansion, which includes nine bedrooms and bathrooms, a pathology lab, swimming pool, aircraft hangar, and much more, cost in real life? We can estimate its 42,724-square-foot space would average out to roughly $2,649 per square foot. Tony Stark's Point Dume estate in Malibu runs $4,690 per square foot, and Thor's Asgardian palace would only run $820 per square foot. Multiplying these figures allows us to calculate an approximate cost for how much the whole shebang would cost, which means that a real-life Avengers Mansion would run you $113,175,876. And that's unfurnished, mind you. Does IKEA offer discounts for saving the world? Still, it could be worse. Tony Stark's constantly exploding Malibu home is $117,250,000 and even though Thor's home would only run $58,180,386, you're far less likely to be invaded by Frost Giants in Manhattan than you are in Asgard. As they say, location, location, location.

(Nelson, Randy. "You'll Need To Assemble $113M To Buy Captain America's Avengers Mansion." *Movoto.* 2 Apr. 2014. Web. 19 Oct. 2014. <http://www.movoto.com/blog/novelty-real-estate/captain-america/>.)

floor also served, in part, as a hangar for the Avengers' favored mode of transportation, the Quinjets. Although the Mansion is "only" three stories tall, it stretches far below the surface as well, with several sub-basements and subterranean levels which house unimaginable technology and elite training facilities. Below-grounds were strictly off-limits to the public, containing Howard Stark's infamous Arsenal chamber, a specialized training room akin to the X-Men's danger room, Hawkeye's archery range, a gym, a cryogenic storage facility, the ultra-reinforced assembly room (ideal for the aftermath of shouting "Avengers Assemble"), and a vault to contain Jack of Hearts' power.

Though the Mansion has undergone many changes over the years, the biggest renovation wasn't the addition of the multiple sub-basements or the Quinjet hangar or the Hulk's Japanese Zen garden (coming late 2017). Rather, it happened about a year after the Avengers moved in when Thor and Iron Man pushed the Mansion back roughly 35 feet from Fifth Avenue in order to give the Mansion a front yard (and the privacy that comes along with it).[274] Let's face it—it wouldn't behoove Earth's Mightiest Heroes to have to put those ugly wrought-iron bars on their ground-floor windows in order to prevent petty theft.

At one point, Hank Pym harnessed the powers of quantum physics and magic in order to create something known as the Infinite Avengers Mansion, a seemingly endless building that stretched into forever with an infinite number of doorways that could lead anywhere. The Avengers' trusty butler Jarvis was more than a little concerned until he discovered it was self-cleaning, of course. Things went haywire, though, when a tiny robot carrying the essence of Ultron smuggled itself into the Infinite Mansion on Pym's person. Once inside, Ultron assumed its true form, and corrupted the 10 billion Jocasta replicas populating the Mansion, using them as his personal army. With naught but a skeleton crew to defend the Mansion, it was up to Hank Pym to save the day.

Thinking quickly, he disabled the heart of the Mansion and hid it inside Jocasta's chest, preventing Ultron from invading anywhere in the Universe he so desired, and sealing himself and the others away in his lab.[275] Thankfully, Pym and the others were rescued from the Infinite Mansion, which was revealed to exist in Underspace, a plane of existence beneath the Microverse.[276] The point is, it was a good idea at the time, but nothing can replace the trusty, ol' Avengers Mansion (and really, isn't 40,000-plus square feet enough?).

54 The Helicarrier

The only vehicle in the Marvel Universe that can give the Quinjet a run for its money in terms of how often it is hijacked or shot down from the sky is the S.H.I.E.L.D. Helicarrier. Good luck saving 15 percent or more on your insurance when you're flying the bastard child of a helicopter and an aircraft carrier over New York City and some of the most dangerous places on the planet.

The Helicarrier was initially created so that S.H.I.E.L.D. Headquarters would not be located in any one of the nations that signed the treaty to create the international peacekeeping organization. Furthermore, the notion of a mobile command center helps mitigate the risk of an attack on a fixed location, which, as Tony Stark pointed out, has the potential to create unnecessary domestic political issues. Over 20 variations of the Helicarrier have been constructed over the years, including the Dum Dum Dugan–commanded *Behemoth* that was designed to hunt and combat Godzilla, and the *Hercules*, which was capable of operating in submarine mode.

Earlier generations of Helicarriers employed highly advanced turbo-rotors for both lift and propulsion, but later models use a combination of rotors and repulsor technology (like Tony Stark uses in his Iron Man armor) in order to improve maneuverability. Typically measuring from 1,100 to 1,400 feet and weighing anywhere from 100,000 to 115,000 tons, the Helicarrier is a mammoth mobile headquarters that is capable of transporting 1,700 dedicated crew members in addition to whatever aircraft crew and personnel are needed above deck.[277] With onboard fusion engines, robust crew facilities, optical camouflage capabilities, and a battery of defensive countermeasures including 20mm and 40mm cannons, cruise missiles, and multiple turrets, the Helicarriers are designed to operate for an indefinite period of time and seamlessly transition between both offensive and defensive mission parameters.[278]

Nick Fury may have put it best: "People see the Helicarrier as the heart and soul of S.H.I.E.L.D. That's good. That's what I want them to see, because that means I have a little secret: the heart and soul of S.H.I.E.L.D. are its agents, from the mechanics turning wrenches down in the hangars all the way up to Stark and Rogers. Don't get me wrong, though. It's a lot easier to rely on your people when they're backed up by the most powerful combat vessel the world has ever seen."[279]

Amen, Nick. Somehow the S.H.I.E.L.D. biplane or the S.H.I.E.L.D. Ford Focus just don't have the same ring to them; the Helicarrier suits you much better.

55 Acts of Vengeance

Guilt can drive a man to do take extreme measures; especially when you're an Asgardian trickster god with a burning hatred of your better-loved brother. Without Loki, the Avengers never would have come together in the first place. If the Avengers never came together in the first place, they would never have foiled plot after plot of countless supervillains. So it's only logical that Loki would assemble those who the Avengers have slighted in order to attack Earth's Mightiest Heroes and absolve him from guilt over the group's creation in one fell swoop. Having assembled a murderer's row of villains, Loki and his gang struck at everyone from Spider-Man to the X-Men to the Fantastic Four and, of course, the Avengers in a year-long crossover event called "Acts of Vengeance" that unfolded across multiple Marvel titles from December 1989 to February 1990.

Embittered and hungry for revenge, Loki disguises himself and assembles a group of the Marvel Universe's deadliest supervillains to come together in a conspiracy to destroy the Avengers once and for all. The Avengers were in shambles, having just suffered through the events of the misleadingly named "Atlantis Attacks," in which the serpent god Set tried to possess the Scarlet Witch (who had also recently lost both her children and her husband, the Vision); the Vision had been gutted of his personality matrix and rebuilt as a cruel, cold android; and the Avengers Mansion had been destroyed, leading Earth's Mightiest Heroes to abscond to a floating island called Hydrobase.[280]

Thus, Loki brought together Doctor Doom, Magneto, the Red Skull, the Wizard, the Kingpin, and the Mandarin to bring the Avengers to their knees. Loki also attempted to recruit the likes

of Apocalypse, the Mad Thinker, and Cobra, but they declined. Instead, to assist the master villains, Loki broke a number of lesser villains out of prison, then they proceeded to try and confuse Earth's Mightiest Heroes by pitting them against villains they weren't used to fighting. They first struck Hydrobase with an army of robots while the Avengers were elsewhere fighting. The only Avenger remaining on the island was the interstellar hero Quasar and the housekeeping staff (none of whom had powers of their own). During the fray, a bomb exploded in the island's fuel dump, causing Hydrobase, the Avengers' island home, to sink into the briny deep.

The attacks didn't end there. Assassins attempted to murder the Scarlet Witch as she lay helplessly comatose. She regained consciousness just in time to help the Avengers beat back their assailants and escape on a Quinjet.[281] Mole Man used horrendous subterranean monsters against them, and the deadly duo of Mandarin and the Wizard brought the fight directly to the Avengers in a slugfest on the streets of Manhattan.[282] As the attacks intensified, public disapproval over the Avengers and the violence that followed them grew to a fever pitch. Though they struck major blows to the Avengers, the plan ultimately failed because the villains couldn't put their differences aside, and they wound up constantly bickering with one another. Case in point: Magneto, a mutant and survivor of the Holocaust, attacked Red Skull, a former Nazi officer and super-fascist, burying him alive in a crypt.[283] Always remember that things could be worse the next time you have a disagreement with Gina from marketing.

One by one, the supervillains are defeated, forcing Loki to reveal his gambit. Imprisoning the Kingpin, Mandarin, and Doctor Doom (who is revealed to have been using a Doombot stand-in all along), Loki and the villains square off against the Avengers, who have tracked them down to the Isle of Silence, where they made their last stand.[284] Ultimately defeated, Loki is forced to flee back

to Asgard, but not before releasing a deadly robot called the Tri-Sentinel on New York City.[285] Vengeance is a dish best served cold, but when you go toe-to-toe with the Avengers, the only thing you'll be eating is your body weight in humble pie (probably with a few loose teeth in there for good measure).

56 Avengers/Defenders War

You already know and love the Avengers (otherwise, you've bought the wrong book), and depending on your level of comics fandom you may already know and love the Defenders (if not, you'll meet them at the culmination of Marvel's forthcoming Netflix series), but what happens when two of the biggest, baddest superhero teams in the Marvel Universe go head-to-head? The Avengers/Defenders War, that's what.

For those of you who don't know the Defenders, they are a superhero group that often worked in parallel to the Avengers, usually presented as a collection of individualistic outsiders who battled mystic and supernatural threats. Led by Doctor Strange, the group included the likes of Namor the Sub Mariner, Valkyrie, the Hulk, Silver Surfer, and countless others over the years.

The premise behind Avengers/Defenders War is quite simple: the Avengers and the Defenders are tricked into going to war with one another. Slightly more complexly: Doctor Strange's longtime nemesis, Dormammu, Lord of the Dark Dimension, coerces Thor's mischievous and malevolent brother Loki to help him conquer the Earth by using a legendary relic, the Evil Eye. Given Dormammu's longstanding hatred of Doctor Strange and Loki's burning enmity toward the Avengers, who better to do their dirty work than Earth's

Mightiest Heroes and Earth's Defend-iest Heroes (okay, that's not their real nickname)?

When the Defenders' teammate the Black Knight is transformed into a statue of living stone, Doctor Strange attempts to use his mystic powers to communicate with Knight's spirit. Though the Knight tries to tell his teammate that he is unaware of a means to free himself, but he is not in pain, the message is intercepted by Loki and Dormammu, who use their powerful magical abilities to alter the message, convincing the Defenders that they must find and assemble the six pieces of the Evil Eye in order to save their friend.[286]

The war soon began in earnest in *Avengers* #116 when Loki, fearing being double-crossed by Dormammu, secretly goes to the Avengers and warns them that the Defenders are seeking pieces of the Evil Eye for sinister ends. They split up in an effort to best intercept the Defenders and stop them before it's too late. While the Silver Surfer is searching for a fragment of the Eye above a volcano in French Polynesia, he enters the fiery hellmouth, accidentally causing it to erupt. The eruption winds up causing an explosion that blows the Scarlet Witch's Quinjet out of the sky. Thinking that the Surfer attacked Scarlet Witch on purpose, the Vision immediately counterattacks, beating back the cosmic crusader. The Vision is about to win the day when he is forced to abandon his quest to defeat the Surfer in order to save Wanda from the encroaching lava. The Silver Surfer escapes in the confusion, and the Defenders acquire their first piece of the Evil Eye.[287]

More clashes between the Avengers and the Defenders follow in the wake of the opening salvo between the Vision, Silver Surfer, and Scarlet Witch. Iron Man battled his one-time teammate Hawkeye at a Mexican college campus, but Hawkeye's trick arrows overwhelmed his armored adversary; Valkyrie and the Swordsman made their steel sing during a pitched battle at a Nazi castle in the jungles of Bolivia until Valkyrie managed to snag another piece for

the Defenders; and Captain America and Namor the Sub-Mariner rained blows down on one another in Japan until the mutant Sunfire ran interference on behalf of the Defenders. Each time the Defenders defeated Earth's Mightiest Heroes, and managed to abscond with the pieces of the Evil Eye. Though Captain America and Namor realized someone was pulling the strings, they couldn't prevent the Hulk and Thor from throwing down in a mammoth melee outside a hotel in Los Angeles, where the two powerful pugilists found themselves deadlocked until the Avengers and Defenders arrived to put a stop to the battle.

In classic comic book fashion, just when the two teams were putting together the pieces of the puzzle, Dormammu appeared and snatched the pieces of the Evil Eye, using them to meld Earth and the Dark Dimension together to create a nightmarish hellscape full of monsters and misery. Battling through hordes of demons, the Avengers and the Defenders (along with the newly arrived Nick Fury) take the battle to Dormammu. Betrayed and imprisoned by Dormammu, Loki breaks free from his co-conspirators constraints while the Avengers and Defenders are battling Dormammu's minions. Activating the Evil Eye, Loki manages to suck Dormammu's essence inside of it, absorbing him wholly and completely. However, the blast backfires, training on Loki and driving the god insane, rendering him a helpless, babbling mess and effectively neutralizing his threat.[288]

In the wake of the war, the Avengers took the debilitated Loki back to their Mansion in order to figure out how best to deal with him. The Defenders took the Evil Eye with them in order to try to find a way to save the Black Knight from being doomed to a life in a museum exhibit. The Defenders eventually would succeed (not before getting transformed into statues themselves and battling medieval armies on the astral plane), and later the Black Knight would accept an offer of membership in the Avengers' ranks, serving proudly alongside Earth's Mightiest Heroes. In fact, based

on their relationship after the fact, you'd never have guessed that they once nearly killed each other in the name of evil.

57 Captain Marvel

Over the course of the last 52 years, the Avengers have had many members and many times different people took on the same super-heroic identity, carrying on the legacy of those who came before them. Few characters have undergone more definitive, lasting identity changes, though, than Captain Marvel. The good Captain first came into being as the result of Marvel squatting on a trademark. The name "Captain Marvel" was originally trademarked by Fawcett Comics from 1940 through 1953, but they ceased publication after a copyright infringement suit from DC Comics. Once the copyright lapsed, Marvel seized on the opportunity by debuting Captain Marvel in 1967, and trademarking him shortly thereafter.[289] However, soon Captain Marvel would become an indelible part of the Avengers, and an essential component of the Marvel Universe at large.

The original incarnation was a Kree spy known as Captain Mar-Vell, who was sent to the Earth by the alien race in order to determine whether or not humanity was a threat to the Kree empire.[290] While on Earth, he wound up being manipulated by Ronan the Accuser into trying to overthrow the Kree ruler, the Supreme Intelligence. Although he was forgiven for his crimes, Captain Marvel was struck by a ray of cosmic energy and trapped within the dimension known as the Negative Zone. Through the intervention of the Supreme Intelligence, Mar-Vell forged a telepathic bond with the Avengers' teen companion Rick Jones, who

with a pair of special bracelets called "nega-bands" could swap places with Captain Mar-Vell.[291]

Imbued with the ability to absorb solar energy and redirect it to fire energy bolts, superhuman strength, and the power of flight, Mar-Vell became a powerful ally to the Avengers, fighting alongside them on many adventures. Perhaps most importantly, Mar-Vell was transformed into the "Protector of the Universe" by a powerful cosmic entity known as Eon in order to stop Thanos after he seized control of the reality-altering Cosmic Cube.[292] Wielding the all-powerful device, Thanos became nearly omnipotent and bent reality to his will. Believing the Cube to be drained of power, Thanos discards it and his spirit leaves his body, allowing Mar-Vell to seize the Cube and restore reality to its rightful state, draining Thanos' power in the process.[293]

In spite of saving the universe countless times, Mar-Vell soon found himself sick with an aggressive cancer that he contracted from earlier exposure to nerve gas. Living out his final days on Saturn's moon Titan, Mar-Vell passed away surrounded by friends and loved ones.[294] A statue was erected in his memory on Titan and he was awarded posthumous membership in the Avengers, a fitting tribute to a man from beyond the stars who stood beside Earth's Mightiest Heroes so many times.

The second person to assume the title of Captain Marvel was a New Orleans–born harbor patrol lieutenant named Monica Rambeau. After being approached by a family friend in need, Rambeau tried to prevent the creation of a powerful weapon that was about to fall into the hands of a South American dictator. Exposed to its powerful extra-dimensional energy, Monica Rambeau was transformed and found herself able to convert her body into pure energy at will. Dubbing herself Captain Marvel, she sought out the help of the Avengers in order to control her newfound powers. With the help of the team, she not only thrived, but went on to lead the team, taking part in some of the team's

most important events like battling Dracula alongside Doctor Strange and Scarlet Witch,[295] retaking the Avengers Mansion from the Masters of Evil when they invaded during "Under Siege,"[296] and battling everyone from the X-Men to the Gods of Mount Olympus itself.[297] Later, Monica shed her Captain Marvel moniker, renaming herself Spectrum, and eventually went on to lead the field team of Luke Cage's Mighty Avengers.[298]

The third and final person to take up the mantle of Captain Marvel was Air Force pilot-turned-C.I.A. intelligence operative Carol Danvers. After retiring from the C.I.A., Carol Danvers accepted a position as the security director at NASA's Cape Canaveral facility where she met and fell in love with the Kree warrior Mar-Vell.[299] As a direct result of Carol's relationship with Mar-Vell, the traitorous Kree commander Yon-Rogg kidnapped her in order to lure her alien lover out of hiding. During the course of the battle, Carol was caught in the blast radius of a Kree Psyche-Magnetron device, which transformed her physiology, making her half-Kree, half-human.[300] Her new DNA structure imbued her with fantastic abilities like superhuman strength, stamina, endurance, the ability to fly, limited precognition, and the power to fire blasts of cosmic energy from her fingertips. In short, she is one of Marvel's baddest mamma jammas, and definitely not one to be trifled with.

However, when Carol was manipulated, seduced, and impregnated (possibly raped) by Marcus, the son of the time-traveling warlord Immortus, things took a decidedly dour turn. Back on Earth, she gave birth to a child who rapidly aged into an alternate version of Marcus, who then took her to another dimension while the Avengers sat by and did nothing. Marcus continued rapidly aging and ultimately died of old age, and Carol managed to make her way back to Earth.[301] She felt sickened by Marcus' machinations and disillusioned that the Avengers stood idly by and watched it happen, causing her to leave the group for a time. Trouble followed

Carol when she rejoined the team years later, rebranding herself as Warbird, and developing a nasty drinking problem, to boot.[302] Growing increasingly reckless and ravaged by alcoholism, she continued to butt heads with Earth's Mightiest Heroes until she finally had to quit or be court martialed.[303]

Eventually, Carol received help for her condition and upgraded her name from Ms. Marvel to Captain Marvel after Scarlet Witch used her hex powers to completely alter the fabric of reality in *House of M*. In this new reality, Carol was known as Captain Marvel thanks to her subconscious desires to be accepted as a superhero in her own right. After helping restore reality to its rightful status quo, Carol kept the new name, and went on to fight alongside Tony Stark and the pro-Superhuman Registration Act forces during the events of *Civil War*. Since the events of *House of M*, she has consistently fought alongside the Avengers, helping to put a stop to the Skrull invasion of Earth during *Secret Invasion* and aiding in the Siege of Asgard against Norman Osborn's forces. Most recently, though, Carol has left the Earth behind in order to help deliver a uniquely cosmic brand of justice alongside the motley crew that is the Guardians of the Galaxy.

What makes Captain Marvel, particularly Carol Danvers, stand out from the crowd in the Marvel Universe isn't just her incredible power levels and superhuman abilities; rather, she is a strong, sometimes flawed, but supremely compelling character in Marvel's canon. Not only is she a terrific female role model and one of the strongest superheroes in Marvel's arsenal, but she always manages to overcome whatever challenge is put in her way, from alcoholism to intergalactic annihilation. As for whether we'll see her in the Marvel Cinematic Universe, you can thank your lucky stars that Marvel is bringing Carol Danvers to the big screen on July 6, 2018!

58 Heroes Return

In the wake of Onslaught's rampage, many of the Earth's heroes were seemingly killed, but in actuality they were sent to an alternate reality, a parallel world where everything was drawn by Rob Liefeld and things were eerily similar yet entirely different than their home reality. One year later, Earth's Mightiest Heroes made their triumphant return to Earth-616, the prime Marvel continuity.

With the superstar creative duo of writer Kurt Busiek and artist George Perez behind them, Earth's Mightiest Heroes were back and bigger than ever, boasting a sprawling cast. In *Avengers* #1, founding Avengers Iron Man, Giant-Man, the Wasp, and Captain America met to discuss the nature of the coordinated attacks against each and every one of their members. Yet, before they could reach the bottom of the matter, the thunder god Thor appeared with a harrowing warning: Asgard lay in ruins, the Bifrost (the Rainbow Bridge) had been destroyed and scattered across the Nine Realms, and the legendary relics of Asgard, the Norn Stones and the Twilight Sword, were missing.

The Avengers did what they do best: assembled. In total, 39 Avengers responded to the call of duty, but soon they were whisked away to an alternate reality, a cruel medieval world controlled by the mystic menace Morgan Le Fay. The villainess had secretly captured Scarlet Witch and used her reality-warping hex powers to transport the Avengers to her realm.

In this new world, the Avengers wound themselves with twisted memories and strange new identities. Iron Man was now the Iron Knight, Captain America was Yeoman America, the Vision was the Ghost of Stone, and Thor was now known as Donar. Always stalwart of mind, Yeoman America was able to see

through Le Fay's deception and alerted some of the Avengers to their grim reality; the others, however, remained convinced that they were Le Fay's servants, the Queen's Vengeance, champions of evil fighting in her name. While the two teams prepared to square off, Scarlet Witch raged in Le Fay's dungeons, where she was shackled up and held hostage. However, what no one anticipated was that in her fury, Scarlet Witch accidentally willed Simon Williams, the long-dead hero Wonder Man, into existence, and he helped her escape.

Bringing back Wonder Man was a controversial decision for some, especially given the complex love triangle between Wanda, Simon, and the Vision. "I wanted to bring [Simon] back, because he's a part of the strange extended family at the heart of what makes the Avengers for me—it's this whole web of relationships that fuels the drama," said Busiek. Rather than just reversing comics continuity for the hell of it, Busiek and Perez saw Wonder Man's return as a fascinating emotional wrench to throw into the works, especially since it was during a time in which Vision was pushing Wanda further and further away.

As her fantasy world crumbled, Morgan Le Fay furiously battled the awakened Avengers and wielded the powerful weapons, the Norn Stones and the Twilight Sword, in an effort to defeat them and recapture her escaped prisoner, the Scarlet Witch. In a battle of supreme sorceresses, Scarlet Witch challenged Morgan Le Fay directly and the two squared off in an epic showdown. Using Wonder Man's ionic energy as a conduit, Scarlet Witch pumped Simon up with immense, unthinkable amounts of energy, allowing him to go toe-to-toe with the Twilight Sword–wielding Morgan Le Fay. The combination of Wonder Man and Scarlet Witch proved too much for Morgan to handle, and her spell was broken—the fantasy world faded away, the Queen's Vengeance regained their wits, and the Avengers were left to pick up the pieces of what had just happened. At long last, the Avengers were well and truly back,

but Wonder Man's return would herald a whole new set of problems for the internal workings of the massive Avengers team. Most importantly, Jarvis must have been having stress-induced nightmares over having to clean, cook, and care for a team of Earth's Mightiest Heroes boasting *39 freakin' members.*

59 Kang the Conqueror

Time travel and supervillainy seem to be a recurring theme in the Avengers. As far as plot devices go, they are the peanut butter and chocolate of the Marvel Universe, and few embody this unholy union more than Kang the Conqueror. Perhaps the only villain as conniving and deceptive as Loki, Kang has appeared to the Avengers in many guises over the years. One of their oldest enemies, Kang has appeared before them as Victor Timely, Immortus, Scarlet Centurion, Rama-Tut, and even one of their allies, Iron Lad, the founder of the Young Avengers. Yet at the end of the day, no matter where he travels in time and space, the man once known as Nathaniel Richards will always become Kang the Conqueror.

Born in the year 3000 in an alternate timeline known as Other Earth (or Earth-6311 if you're nasty), Nathaniel Richards studied the greatest heroes of Earth-616 (the main Marvel timeline) and became enthralled with their fantastic feats. Seeking adventure of his own, he constructed a sphinx-shaped spaceship and traveled to Egypt circa 2950 BC where he became stranded. Subjugating the natives, he ruled as Pharaoh Rama-Tut, presiding over his kingdom attempting to raise En Sabah Nur, the mutant who would become Apocalypse, as his own.[304] He ruled for a decade before a battle with the Fantastic Four (which also involved everyone from En Sabah

Nur to the moon god Khonshu to Dr. Strange to the Avengers) caused him to flee into the timestream.[305]

From there, Richards briefly sojourned to the modern era, where he met Doctor Doom, who was also lost in time. Going their separate ways, he created a new armored identity for himself, the Scarlet Centurion, and traveled to an alternate universe where he tricked that world's Avengers into defeating all the other heroes so that he could rule. Again, the Avengers of Earth-616 intervened and displaced him from time.[306] Intending to return to his native timeline, Richards was displaced by a temporal storm and wound up in the 40th century of Other Earth. Adopting his now-infamous moniker, Kang, he swiftly conquered the entire world, amassing power and preparing for his next chronological conquest.

Now, I know what you're thinking: wouldn't a time-traveling villain simply be able to go back to when the Avengers were babies and murder them one by one? Sure, you *could* do that, but Kang the Conqueror doesn't stoop so low. In spite of his inherent capacity for villainy, Kang's twisted ideals and deeply ingrained sense of honor compel him to prove his dominance and tactical superiority over the Avengers by going head-to-head with Earth's Mightiest Heroes. That isn't to say that he won't use deception to achieve his ends, but he is far likelier to play the long con than he is to take the easy way out.

From assembling an alliance of three Kangs from across time to kidnap the Celestial Madonna in order to prevent her from giving birth to the most powerful being in the universe to using the Avengers as cosmic chess pieces in a contest of champions against the Grandmaster and beyond, Kang's storylines are among some of the most layered, complex, and carefully constructed in the Avengers canon. Most infamous among them is "The Kang Dynasty," Kurt Busiek's final arc during his legendary *Avengers* run, that saw Kang returning to the past with a warning: mankind is doomed, and only he can save them.[307] War overtakes the Earth

as Kang manages to take over the entire planet, enlisting villains from across space and time to help him in his conquest. It is by turns grim and thrilling as the 16-issue arc culminates in a grand betrayal by Kang's son Marcus himself. Escorting Marcus into his private chambers, Kang reveals a morgue filled with 22 exact duplicates of Marcus. Unable to abide a traitor in his midst—even his own son—he stabs Marcus through the chest, bringing the total to 23.[308] So go ahead and tell me again about how strict *your* father was.

Not all of Kang's iterations are evil though. His younger self, upon learning he would become one of the deadliest villains in history, tried to rebuke his fate. Traveling back in time and styling himself after Tony Stark, Nathaniel Richards adopted the identity of Iron Lad and assembled a new generation of Avengers for the sole purpose of defeating himself.[309] Sadly, as we would learn time and time again, in order to save the universe and prevent his timeline from being undone, he had to return to the future and accept his destiny as Kang. Likewise, Kang has also teamed up with the Avengers to defeat a future version of himself known as Immortus, a time-traveling warlord who threatened to destroy both Kang *and* the Avengers on multiple occasions.[310]

To this day Kang remains a vital part of the ongoing Avengers mythos. Most recently, during the *Age of Ultron* miniseries (unrelated to the *Avengers* film), he helped the Apocalypse Twins escape from futuristic concentration camps in order to transform them into his personal killing machines. However, soon the script is flipped and Kang finds himself desperately trying to stop the terrible twosome.[311] Turning kids into hardened murderers and jumping from timeline to timeline? Never change, Kang, never change. As for whether or not we can expect to see Kang travel his way into the Marvel Cinematic Universe, who's to say he already hasn't? One conspiracy theory posits that Stan Lee, with all his cameos, is actually Kang the Conqueror in disguise. Although that

sounds like tinfoil hat nonsense to me, it wouldn't be out of the question to see this indelible part of Avengers history eventually work his way into the picture.

60 Young Avengers

Just as the Justice League had the Teen Titans as their youthful counterparts, the Avengers has the Young Avengers serving as their adolescent stand-ins. Created by Allan Heinberg and Jim Cheung, *Young Avengers* quickly became a fan favorite book, garnering critical praise and earning two GLAAD Media Awards for its honest portrayal of LGBT issues. Emerging in the wake of 2004–05's *Avengers Disassembled* storyline that saw the Scarlet Witch launching a brutal attack on Earth's Mightiest Heroes, leading them to disband, the Young Avengers were brought together by the Vision as part of a contingency plan in case the Avengers ever fell apart or disappeared.

Although the Vision was destroyed during the events of *Avengers Disassembled*, he was rebuilt with the aid of Iron Lad, a robotics student from the future named Nathaniel Richards who traveled back in time to change his fate after coming face to face with his future self, the villainous Kang the Conqueror. Breaking into Stark Industries, Iron Lad uploads the Vision's CPU into his armor whereupon he finds a failsafe program designed to locate the next wave of Avengers. With this data, Iron Lad recruits three other "Young Avengers" in New York City—Wiccan, a boy with the power to project energy waves; Hulkling, a young man with a healing factor who can shapeshift into a green-skinned beast; and Patriot, a young African American man who received superpowers

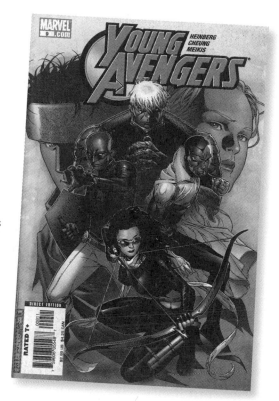

Young Avengers
#9 *cover by Jim
Cheung.*

after a blood transfusion from his grandfather, Isaiah Bradley, who was the sole survivor of a Tuskegee Experiment–like offshoot of the Super Soldier program. With his newly assembled team, Iron Lad began training his teammates to prepare for a final battle with Kang the Conqueror.[312]

They were soon joined by two young women: Cassandra Lang, aka Stature, the daughter of the recently deceased Ant-Man, who used stolen Pym Particles in order to give herself size, and Kate Bishop, who eventually takes up the mantle of Hawkeye, the daughter of a wealthy socialite who had previously helped the Young Avengers stop armed assailants at her sister's wedding.[313] By the time the two girls tracked the Young Avengers down at the destroyed remains of the Avengers Mansion, they had been

discovered by Captain America, Jessica Jones, and Iron Man, who were about to put the kibosh on the whole team when suddenly Kang the Conqueror materialized and gave the Avengers, young and old, an ultimatum: hand over Iron Lad or he will destroy their timeline.[314]

A ferocious battle broke out with the Avengers, the Young Avengers, and Kang trading blows until, finally, Iron Lad drives a sword through Kang, killing him.[315] When Kang dies, the timestream ripples, creating a new world in which the Avengers are dead, Jessica Jones has lost her baby, and the Avengers Wiccan, Hulkling, and Stature begin to disappear due to their connections to the Avengers. In order to repair the timeline, Iron Lad realizes he must return to the future and fulfill his destiny of becoming Kang the Conqueror. With a heavy heart, he bids his friends adieu, and uses the Vision's CPU to step through the portal back to the 30th century. Upon his departure, the timestream returns to normal, the Avengers are suddenly alive again, and the disappearing Young Avengers reappear. Though Captain America warned the Young Avengers that if they ever operated again, he would put a stop to it, they ignore their elder and continue fighting the good fight in secret.[316]

Over the years, the Young Avengers have gained members (e.g. Speed, the long-lost twin brother of Wiccan; the two of whom are the disappeared sons of Scarlet Witch and the Vision) and lost members (e.g. Patriot, who left the group after the events of the so-called "Children's Crusade"). They have dealt with important issues like drug and steroid abuse when it was revealed that Patriot's powers weren't derived from a blood transfusion from his grandfather like he claimed, but rather he was addicted to taking Mutant Growth Hormone. They also made waves by featuring a high-profile gay romance between Wiccan and his alien teammate Hulkling. While the notion of a homosexual relationship shouldn't seem like it's that crazy of a notion, this was a deeply human, sweet,

three-dimensional romance storyline that developed during a time when homosexual characters were seemingly nowhere to be seen in comic book culture.

Since their formation in the wake of *Avengers Disassembled*, the Young Avengers have had a part in nearly every major event in the Marvel Universe. From fighting alongside Captain America against Tony Stark's pro-Superhuman Registration Act forces to teaming up with the Runaways to battle the Skrulls during "Secret Invasion" to searching for Scarlet Witch in an effort to redeem the mad mutant after what she did during *Disassembled* and *House of M*, the Young Avengers have proven that they are a fitting group of successors for Earth's Mightiest Heroes even if they may lack in experience. While there are no official plans to see them up on the silver screen in the Marvel Cinematic Universe, they seem like a natural way to carry the franchise forward as we go deeper and deeper down the Marvel rabbit hole.

61 The Children's Crusade

One of the most tortured, polarizing figures in the Avengers canon is the Scarlet Witch. Not only is her father the mutant terror-ist Magneto, but she was responsible for murdering Ant-Man, Hawkeye, and Jack of Hearts with her reality-altering chaos magic in *Avengers Disassembled* and depowering 99 percent of the world's mutants in *House of M*. From the outside looking in, she would seem to be an archvillain hiding among the Avengers' ranks, but it's not as clear-cut as that. More than many of her colleagues—save for perhaps Henry Pym—the Scarlet Witch has had to endure ter-rible tragedies. Her husband, the synthetic human, the Vision, was

kidnapped by a coalition of world governments and destroyed, only to be rebuilt as a cold, unfeeling machine with no memory of their time together. Even after he regained his personality, he pushed his longtime lover away. Likewise, her twin sons that she had with the Vision mysteriously disappeared when it was revealed that she had subconsciously used her chaos magic to will them into existence. Losing one's husband and children would be enough to drive anyone into the throes of madness and retreat into seclusion, which is exactly where we find her in *Avengers: The Children's Crusade*, a nine-issue miniseries from *Young Avengers* creators Allan Heinberg and Jimmy Cheung.

When Wiccan's reality-altering powers begin to exponentially increase in power—he rendered an entire terrorist group comatose when they threatened his boyfriend Hulkling—he is informed about what happened to the Scarlet Witch when she lost her boys, went insane, and killed her teammates. The Avengers also explained how afterwards her brother Quicksilver convinced Wanda to use her powers to create a world where mutants reigned supreme, but the ensuing chaos led her to use her abilities to depower nearly all of mutantkind. Shocked by these revelations, Wiccan deduces that he and his fellow Young Avenger Speed must indeed be Scarlet Witch's lost sons. However, he refuses to believe that Wanda could truly be responsible for these events, and is sickened that the Avengers could be so distrustful and callous toward their former ally. Together with the Young Avengers, he decides that he must seek out the Scarlet Witch to see if she can be redeemed and possibly reverse the terrible things she's purported to have done.[317] They aren't the only ones with that plan though…

Magneto has also learned that Wiccan and Speed may, in fact, be Wanda's long-lost children and wants to meet his grandsons. Arriving out of thin air, Magneto appears before the Young Avengers and attempts to kidnap Wiccan and Speed, announcing that he is taking them to Transia to search for Wanda Maximoff.

The Avengers attempt to stop the master of magnetism, but they are too late—Wiccan teleports Magneto and the Young Avengers to the faraway land of Transia in order to continue their search. After tracking Scarlet Witch to a small village, they encounter Quicksilver, who is still furious at his father and tries to kill him. They launch into a heated battle and, during the melee, Quicksilver throws a barrage of spiked fence posts like javelins towards Magneto. With the projectiles in midair, they suddenly see a young woman in the village who looks exactly like the Scarlet Witch. However, it's too late—she is impaled by one of the spikes—and revealed to be a Doombot, giving them cause to believe that the real Scarlet Witch is being held captive by Dr. Doom in Latveria.[318]

Back at Avengers Tower, Earth's Mightiest Heroes have summoned Wonder Man, believing that his closeness to Scarlet Witch in the past may help them find her. Wonder Man is reluctant to help them, given their mistreatment of Scarlet Witch in the past, but when he learns that Wolverine intends to kill her, he flies into a rage, punching Wolverine down an entire story and flying off on his own to find Wanda before Wolverine can. Meanwhile, in Transia, the Young Avengers, Magneto, and Quicksilver are debating over how best to proceed—some believe that Latveria is a trap, others believe that it's where Scarlet Witch is being held. Quicksilver tries to sneak away with his nephew Wiccan, but Hulkling warns him that if he tries anything fishy, he'll rip off his legs. (Note to self: don't piss off someone's boyfriend, especially if they have super strength.) Eventually, in the middle of the night, Wiccan heads to Latveria alone.

Arriving in Latveria, Wiccan is swiftly discovered by Doombots, so he disguises himself as Scarlet Witch in order to be shown to her chambers. His ploy works and he is escorted to her room whereupon Scarlet Witch, who demands to know what's going on, confronts him. Unable to tell her that he is her son, he lies and tells her he is a superhero who has come to rescue her, telling

Elizabeth Olsen as the Scarlet Witch, filming Avengers: Age of Ultron *in Italy.*
(Getty Images)

her about Magneto and Quicksilver too. However, Scarlet Witch apparently has amnesia—she claims to have no knowledge of her father or brother. Yet even more shocking is the confession that Scarlet Witch is getting married the next day...to none other than Dr. Doom himself.[319]

Believing Wanda to be brainwashed, Wiccan attacks Dr. Doom who repeatedly assures him that she is not, and that he is merely trying to protect everyone. Wiccan tries to warn Wanda, but before he can reveal that he is her son, Doom knocks him unconscious. When Wiccan wakes up, Doom reveals that she is repressing her powers and her memories. She came to him seeking help for her people, and they wound up falling in love. Doom has cast a spell on Wiccan that suppresses his powers, offering him the choice of asylum or remaining as his prisoner. Outside the castle, Magneto, Quicksilver, and the Young Avengers arrive, intending to rescue Wiccan and Wanda, but they are followed closely behind by Wonder Man and the Avengers, who begin battling. The fight continues its way inside the castle, while Wiccan and Wanda take advantage of the confusion and try to escape. Suddenly, they're face-to-face with Wolverine, who pounces on Wanda, preparing to kill her, but he is stopped by an unexpected visitor: Iron Lad, returned from the future.[320]

Together with Iron Lad, the Young Avengers and Scarlet Witch escape into the timestream, emerging in the past on the day Jack of Hearts exploded, destroying Avengers Mansion and killing Scott Lang (aka Ant-Man/Stature's father), so that Wanda can hopefully undo all of her mistakes. Though the undead Jack of Hearts still appears and ultimately explodes, destroying the Mansion, the Young Avengers manage to teleport back to the present with Ant-Man and Wanda in tow. Iron Lad is stunned, unable to comprehend how they time-traveled when his power levels were so low. Wanda reveals that it was she who transported them and that both her Scarlet Witch powers and her memories have returned.[321]

Back in the present, Scarlet Witch is distraught, and everyone else is shocked by the newly resurrected Scott Lang. Scarlet Witch begins generating Kree warships and Ultrons to kill herself in the same way that she had killed her teammates once upon a time. However, Wiccan is able to talk her down when they explain that all of those who she had killed are alive again, the Vision is back, her father and brother are alive, and that Wiccan and Speed are, in fact, her sons. Their happy reunion is cut short somewhat when Beast asks Wanda if she can reverse the "No more mutants" spell she cast on M-Day that stripped most of the world's mutants. Although Wanda is unsure if it will work, Jessica Jones calls X-Factor to the scene, and Rictor volunteers to be a guinea pig. Wanda casts her spell, and the entire building begins shaking—it worked. Rictor's powers are back.[322]

Hearing of the Scarlet Witch's return, the X-Men arrive on the scene and they have blood in their eyes. "The Avengers don't get to negotiate on behalf of mutantkind," Cyclops snarls. "The Scarlet Witch is coming with us. The X-Men will hold her accountable for her crimes...or I will burn the Witch where she stands." The Avengers and the X-Men begin slugging it out over what to do with Scarlet Witch, which causes her and the Young Avengers to retreat back to Doctor Doom in Latveria for help. Doom reveals the truth behind her murderous rampage in *Avengers Disassembled*: Wanda's incredible powers were a direct result of their combined attempts to channel the Life Force in order to resurrect her children, but the Force was too powerful and it possessed her spirit.[323]

Together, Wiccan and Doom attempt to exorcise the entity from Wanda's body, but Patriot intervenes and the entity is transferred to Doom, imbuing him with Wanda's nearly omnipotent powers. With his scars suddenly healed, Doom removes his mask and begins calling himself Victor, promising to restore everything to the way it was.[324] With incredible powers at his disposal, he tells both the Avengers and the X-Men that he can resurrect their dead

friends and restore their missing powers…if they surrender. Both teams reject the offer and the assembled heroes prepare to confront the villain. Doom reveals that he was the mastermind behind the Scarlet Witch's horrific actions during *Avengers Disassembled* and *House of M*. Finally face to face with the man responsible for her father's murder, Stature rushes to attack Doom only to be struck down by a massive energy blast. Together, Wiccan and Scarlet Witch were able to expel the Life Force from Doom and remove his powers. Doom manages to escape, but Stature lies dead. Truly, it seems that the Lang family cannot escape the long shadow of tragedy.[325]

In the aftermath of the battle, Iron Lad offers to save Stature by taking her with him into the timestream. The Vision objects to this and tries to stop Iron Lad, who retaliates by destroying the Vision in a fit of sadness and jealousy.[326] As Iron Lad tries to jump back into the timestream to save his dead friend, Wiccan warns his former teammate that this is the moment that the hero becomes the villain that will be known as Kang the Conqueror. "I will be better than Kang the Conqueror," Iron Lad replies—and with that, he disappears. With the battle over, Cyclops agrees to leave the Scarlet Witch alone, but promises to kill her if she ever turns against the heroes again. As for herself, Scarlet Witch rejects an offer to rejoin the Avengers, opting instead to figure out what she wants to do with her life on her own before defining herself by anyone else's definition.[327]

Attempting to return to normal life, the Young Avengers decide to disband. Some major events in the Marvel Universe—e.g. *Avengers vs. X-Men*, the return of the Human Torch, Spider-Island—take place, but the Young Avengers remain apart from it. Hulkling eventually asks Wiccan about their future; will they remain ex-heroes? Wiccan assumes that Hulkling is going to break up with him, but quite the opposite. Hulkling makes an off-handed pseudo-marriage proposal and the two share a passionate kiss…

only to be interrupted by Ms. Marvel, who tells them they're needed at the Avengers Mansion. Arriving at the Mansion, Captain America acknowledges their incredible accomplishments—finding Scarlet Witch, defeating Doctor Doom, generally saving the day— and leads them outside to unveil statues of Cassie and the Vision alongside the statue of Scott Lang. At long last, Captain America announces that they will henceforth not be known as "Young Avengers," but they will be full-fledged Avengers—deserving members and allies of Earth's Mightiest Heroes.[328]

62 Under Siege

What's the last thing you do before going to bed at night? If you're anything like me, you double-check that your front doors are locked, your windows secured, and your dog hasn't escaped from her crate. There's just something so unnerving about the idea of a home invasion that it has become a trope in popular culture, particularly among horror movies and thrillers. When it comes to evil lurking just behind your bedroom door, not even the Avengers could escape this particular narrative conceit. Thus it came to pass in 1986, when writer Roger Stern and artist John Buscema demolished everything the Avengers held dear, including the Avengers Mansion, in the gripping five-issue arc "Under Siege" that stands tall as one of the most harrowing storylines to this day.

"Under Siege" finds the Avengers battered, bruised, and broken in the midst of a devastating series of coordinated attacks by the Masters of Evil. Led by Baron Zemo (the son of the original who died in battle against Captain America), the Masters of Evil had assembled a small army of supervillains to take out Earth's

Mightiest Heroes once and for all. In an interview for Marvel's 75th anniversary, Roger Stern explained that, "The first Baron Zemo had organized the Masters [of Evil] as a sort of one-to-one match for the Avengers, with five villains opposing five heroes. And it occurred to me that the best way to make the Masters a real threat was to have them overwhelm the Avengers with superior numbers." And overwhelm they did, assembling a formidable army of supervillains that came closer than most to actually defeating the Avengers once and for all.[329]

The new Masters of Evil consisted of Baron Zemo, Mister Hyde, the Fixer, the Wrecker and the Wrecking Crew, Titania, the Absorbing Man, Moonstone, Blackout, and evil versions of both Yellowjacket and Goliath. In spite of in-fighting and attempts by Moonstone to undermine Zemo's leadership, the madman manages to keep control of his group of villains and they first launched their assault in *Avengers* #273. Their initial strike was two-pronged: the Wrecker was getting Hercules drunk in a bar to get information out of him (and get under his skin about taking orders from then-chairwoman, the Wasp), and the rest of the Masters of Evil broke through the Avengers Mansion's automated defenses, kidnapping Jarvis and taking control of the Mansion.[330]

The Avengers were all but oblivious until Black Knight returned from a disappointing evening out with the Wasp (he was hoping it was a date) and realized something was amiss ("The lights are *never* left off in the foyer. Something's not right—!"). Before he can alert his teammates, Black Knight is battered unconscious by Mr. Hyde, and captured by the Masters of Evil. Next, they manage to trick Captain Marvel into returning to the Mansion by impersonating the Wasp's voice, whereupon she is banished to the Dark Dimension by Blackout, thus effectively negating her cosmic powers and ability to travel at light speed. [331]

Captain America and the Wasp had uncovered the Masters' plot, but not even they could prevent Hercules from trying to take

on the army of villains single-handedly. Already liquored up by the Wrecker, Hercules was plied further with more drugged booze and the feminine wiles of Tanya Sealy, better known to many Marvel readers as the villainess Black Mamba. Bristling at having to take orders from the Wasp and confident in his immense strength, Hercules stalked off towards the Mansion only to incur a beating at the hands of Tiger Shark, Goliath, Mr. Hyde, and the Wrecking Crew, the likes of which Marvel readers had never before seen. Stern, perhaps, put it best: "Here's how strong these guys are: they beat Hercules to within an inch of his life. They put a god in the hospital."[332]

Though Captain America and the Wasp tried to run after Hercules to provide support, they were beaten back by supersonic defenses installed by Fixer; Wasp managed to escape, but Cap was taken hostage, trapped inside seemingly for good once Zemo ordered Blackout to encase the Mansion in a pitch-black prison made of Darkforce energy.[333] Meanwhile, Wasp accompanied Hercules and the paramedics to the hospital where he laid comatose. Of course, there's no rest for the weary as the Absorbing Man and Titania attack the hospital in an attempt to put Hercules down for good. Fortunately for Wasp, Ant-Man appears on the scene to help beat them back. Together, the two insect-sized heroes manage to cleverly defeat two of the heaviest hitters in the Masters of Evil, which is no small feat by any means.

Back at the Mansion, though, readers were treated to perhaps one of the grisliest panels in all of *Avengers* history: a tied-up Captain America is made to watch horrorstruck as Mr. Hyde pummels Jarvis, beating the Avengers' butler within an inch of his life. To this day, it remains some of John Buscema's best and most brutal pages in his storied comic book career. "Jarvis' beating was important," Stern explained. "Zemo had Captain America captive, and felt that just breaking him physically was not enough. He wanted to break Cap's spirit, and he did it."[334]

Despite Wasp's moments of self-doubt at the hospital, Zemo had not managed to break her spirit or the spirits of two new arrivals: a furious Thor and the escaped Captain Marvel. Managing to burrow underneath Blackout's Darkforce prison (evidently, he forgot to extend it below the surface), the assembled Avengers broke into the Mansion and freed their allies Captain America and Black Knight. By that point, the mysterious mystic known as Doctor Druid appeared on the scene too, managing to mentally coerce Blackout to drop the barrier. Thor single-handedly beat Mr. Hyde and the Wrecking Crew into submission, then began grappling with Goliath; Ant-Man took Fixer out of commission; Captain Marvel pursued a fleeing Moonstone until the villain took a sudden turn and smashed into a cliff-face, breaking her neck; last, but not least, Captain America squared off on the rooftop of Avengers Mansion with Baron Zemo.[335]

The final battle between Captain America and Baron Zemo is a tense, furious standoff. Zemo attempts to use Cap's shield against him as the two verbally spar simultaneously. Blaming Captain America for the death of his father, Zemo is blinded by his own rage, and soon teeters on the edge of the roof. Too proud to give Captain America his hand, Zemo falls from the rooftop and lies broken and bloodied on the cold, hard ground, killed by his own hubris in an eerie parallel to his father's death. The closing shots of the issue find Captain Marvel stumbling upon a shaken Captain America, kneeling amidst the rubble of Avengers Mansion and quietly shedding a tear or two over the contents of his footlocker— old photographs of his mother and Bucky—which were destroyed by Zemo and company. "This place became home," Captain America remarks to Captain Marvel as they stand in the wreckage. "It'll be a long time before anyone lives here again."[336]

It's a real testament to Roger Stern's writing, John Buscema's artwork, and Tom Palmer's moody inks that the story holds as much weight today as it did back in 1986. Earth's Mightiest Heroes

had been rent asunder by their greatest foes, but they would soon bounce back stronger than ever. As for whether or not we'll see this story make its way to the Marvel Cinematic Universe, I would be positively delighted, but it'll require the introduction of a cavalcade of criminal masterminds over the course of other films first. That isn't to say that it's outside the realm of possibility, but rather that it will take time. As the old saying goes, good things come to those who wait, and "Under Siege" was one hell of a good thing.

63 Ultron Unlimited

If you give a mouse a cookie, he's going to want a glass of milk. If you give a rogue artificial intelligence sentient thought, he's going to want to exterminate mankind and replace them with his own robotic ilk. It may sound bleak, but that's exactly what Ultron tried to do in the classic storyline "Ultron Unlimited." Written by Kurt Busiek and illustrated by George Perez, Ultron attempts to repopulate the Earth with robots at the expense of all human life. He begins his campaign of terror by invading the small European nation of Slorenia, murdering its entire populace in the course of three hours, and issuing an ultimatum to the world: stay out of Slorenia or suffer the same fate.[337] This was a problem bigger than the Mac Store Genius Bar was prepared to handle; this was a problem for Earth's Mightiest Heroes.

So why didn't the Avengers assemble? Well, it turns out that they had already *been* assembled by Ultron, who was holding the heroes captive. In keeping with Ultron's strange hang-ups about his "family," the Avengers, he could not resist toying with them

Cover of Age of Ultron, *Book One, not to be confused with* Avengers: Age of Ultron. (Marvel/AP Images)

and scanning their brainwaves to guide his own bionic brethren. Kidnapping the likes of Vision, Wasp, Wonder Man, Scarlet Witch, and Hank Pym, Ultron keeps his "family" imprisoned and boasts of using them to create his "children."[338] The remaining Avengers are forced to invade Slorenia, battling through hordes of Ultron's clones—enemies that would have felled them in years past—until they finally manage to break into the compound where their friends and their jailor await. "Ultron, we would have words with thee!" shouts Thor as they burst through the wall in perhaps the understatement of the century. For once, the Avengers actually had something to avenge, and thanks to a timely delivery of Antarctic vibranium (a substance known as anti-metal) by Justice, they were able to defeat the mad machine.

This storyline represents the culmination of Hank Pym's guilt, rage, and fears over accidentally creating Ultron so many years ago. Ultron did not commit genocide out of some strange Oedipus complex directed towards Hank Pym; he committed genocide because he's a conscience-less maniac and Hank Pym is indirectly responsible for the deaths of the Slorenian populace. "Ultron Unlimited" forced Pym to come to terms with the sheer horror of his creation, looking at it face-to-face. Finally besting his deadliest creation, we see Hank Pym blind with rage, relentlessly pummeling Ultron into smithereens, spittle flying out of his mouth as he lets loose an alarming invective against Ultron as his teammates look on awestruck. "That's Hank?" Firestar asks fearfully. "That's the kind, gentle man who—," she continues. Justice cuts her off matter of factly, "That's him, honey..."[339] Perez's innovative panel design lends a kinetic, visceral impact to Pym's unbridled fury, as Busiek's words ooze catharsis with each powerful punch.

One of the most devastating challenges the Avengers have faced to date, "Ultron Unlimited" is widely considered not only the definitive Ultron story, but one of the best in the Avengers canon. George Perez's breathtaking panels of pitched battles between the Avengers and hundreds and hundreds of horrifying robot soldiers and Busiek's electrifying, emotionally charged script make this a truly transcendent reading experience, cementing it as one of the highlights of his run. If we don't see elements of this story in *Age of Ultron* (perhaps even the "We would have words with thee" moment), then I'll be writing some very stern, very disappointed letters to Joss Whedon in the near future.

64 World War Hulk

What happens when you collude with the most powerful influencers in the Marvel Universe to send the Hulk into deep space? He comes back with a vengeance of course, and you can be damn well sure he's going to smash.

Well, that's precisely what the Illuminati did—after the Hulk rampaged through Las Vegas, killing 26 people and a dog, they tricked Bruce Banner into boarding a malfunctioning weapons satellite in order to repair it. As it turns out, it was a starship that rocketed Hulk halfway across the galaxy. Crash-landing on a faraway planet, the Hulk went straight-up Maximus Decimus Meridius, fighting as a gladiator until he earned his freedom. Eventually, Hulk became the ruler of the planet, taking a woman named Caiera to be his wife. She is pregnant with his child when the antimatter warp core engine on the crash-landed ship that brought him there detonates, vaporizing the city and killing her and the unborn child too. Whatever anger Hulk felt before was a mosquito bite compared to the blinding rage that came over him. Gathering up his allies, the Warbound, Hulk set a course for Earth. This isn't just war; it's *World War Hulk*.

The five-issue miniseries, written by Greg Pak and illustrated by John Romita, Jr., saw the Hulk cutting a bloody swath through the Marvel Universe. The Hulk's first stop? The moon, where he batters the Inhuman king Black Bolt into submission and damages the moon's surface so tremendously that the geological distress it causes is detected by Earth's satellites. Although the U.S. government mobilizes S.H.I.E.L.D., nothing could prepare them for the Hulk's fury. Returning to Manhattan, Hulk projects a message

across the city, announcing that if the Illuminati members do not appear within 24 hours, he will destroy the city.[340]

Iron Man dons his specialized Hulkbuster armor, a specialized exo-suit that allows Tony Stark to go toe-to-toe with the Hulk (for a few rounds at least). Stark's special technology can't save him though; the Hulk tackles Iron Man at such velocity that they rocket through the New York skyline and bring down the entire weight of Stark Tower on top of them. The Hulk is the only one to emerge from the rubble.[341] Dusting himself off and dragging the shattered remains of Iron Man's armor behind him, the Hulk and his Warbound lay the smackdown on the Fantastic Four, the Mighty Avengers (including She-Hulk), and the New Avengers. Capturing the heroes, he outfits them with obedience disks, technologically advanced collars that prevent the heroes from using their powers.[342]

Next, the Hulk faces the combined might of the United States military led by General "Thunderbolt" Ross, a distraction that allows Doctor Strange to enter Hulk's mind and immobilize his body. Strange calms Hulk momentarily, but the not-so-jolly green giant crushes Strange's hands on the astral plane, which somehow crushes his hands in the real world too, allowing Hulk to move once more. The Sorcerer Supreme merges with a demonic entity known as Zom, but the Hulk exorcises that demon one punishing blow at a time. The good Doctor is outfitted with an obedience disk of his very own. With that, the games can now well and truly begin.[343]

Transforming Madison Square Garden into a gladiatorial arena, the Hulk singles out the Illuminati co-conspirators—Doctor Strange, Iron Man, Black Bolt, and Mister Fantastic—and makes them reenact the Hunger Games by fighting a tentacled spacebeast and later each other to the death before a cheering audience. Doctor Strange battles Black Bolt, managing to subdue him without killing him. Next, Mister Fantastic and Iron Man fight each other, and Reed Richards manages to defeat Tony Stark. His obedience disk

activated, Mister Fantastic looms over Iron Man with an axe at the ready. At first Hulk orders Mister Fantastic to kill Iron Man, then changes his mind, deciding to destroy the city of New York and leave the Avengers and Illuminati to their shame instead.[344]

Suddenly, the powerful yet troubled hero known as Sentry appears on the scene and launches a ferocious attack on the Hulk. To put things in context, the Sentry wields the power of one million exploding suns, and ripped the god Ares in half in a later storyline. So, yes, this is the epic showdown we've been waiting for. The two titans trade devastating blow after blow, but the Hulk manages to withstand even Sentry's most powerful attacks. In a rare moment of clarity, Sentry confesses to the Hulk that he is out of control and expends all of his power into one massive burst of

Gary Frank's cover of World War Hulk *#106.*

energy. Whether he is trying to kill the Hulk, himself, or both, one thing becomes clear—the Hulk sees himself reflected in Sentry. Their power proves to be too much for one another, and they both revert to their human forms, Bruce Banner and Robert Reynolds. Exhausted, the two humans fight on, and Banner finally manages to knock Reynolds unconscious. The battle, it would seem, is over.[345]

Yet, just as Banner moves to shake hands with his longtime friend Rick Jones, one of his Warbound—the insectoid Miek—grabs a spear and stabs Rick, screaming that the Hulk's vengeance is not yet complete. This enrages Bruce Banner enough to turn him back into the Hulk, whereupon he viciously savages the alien. During their battle, Miek reveals that it was not the Illuminati who detonated the explosion that killed Hulk's wife and child, but rather agents of the previous ruler, Red King loyalists. Miek knew of the plot and allowed it to happen, hoping to set the Hulk on a course of bloody, bone-crunching vengeance (because he is a sick puppy like that). Angrier than ever before, Hulk begins emitting heretofore unseen levels of gamma radiation that threaten to destroy the Earth as we know it. Before it's too late, Tony Stark manages to activate an experimental defense satellite that launches a salvo at the Hulk, incapacitating the behemoth and causing him to revert to his Bruce Banner form.[346]

The story ends with Banner locked away in a S.H.I.E.L.D. holding facility three miles underground, and the Warbound in military custody. Meanwhile, halfway across the galaxy on the ruins of the planet Hulk called home, a green figure emerges from the rubble. It is Hulk's son, Skaar.[347] While this is technically more of a Hulk story than an Avengers story, Earth's Mightiest Heroes—particularly those who are members of the Illuminati—are so intrinsically tied to it, that it feels like their story as well. Greg Pak's tight plotting accelerates at a steady crescendo, exploding in all the right places with some truly spectacular battles brought to life by John Romita, Jr.'s expert eye for action-packed visuals. Although

some complain about weird tonal shifts (e.g. why doesn't the Hulk have Reed kill Tony?) and Miek's sudden betrayal, they are minor quibbles in an otherwise brutal tale of revenge. Given what we can glean from *Avengers: Age of Ultron*, it wouldn't be at all out of the question to see elements of *Planet Hulk* and *World War Hulk* bleeding into the Marvel Cinematic Universe in the very near future. Just remember: when Hulk smashes, we win.

65 How *The First Avenger* Almost Didn't Happen

When one thinks of the Avengers franchise, it's impossible to picture anyone other than Chris Evans playing the square-jawed, straitlaced Steve Rogers, but it almost didn't happen. The saga of bringing Captain America to the big screen is a long, storied one fraught with false starts. In 1997, Marvel was negotiating with producers Gary Levinsohn and Mark Gordon to create a *Captain America* film based on a script by Larry Wilson (*The Addams Family*) and Leslie Bohem (*Dante's Peak*). Three years later, the film was seemingly set for distribution with Artisan Entertainment, but a lawsuit from Joe Simon over the Captain America copyright ownership derailed the project until it was settled in 2003.[348] By that time, Marvel Studios, flush with a $525 million cash injection from Merrill Lynch to fund their film slate, planned to release it through Paramount Pictures.[349]

As with all best laid plans, they fell through; the production once again ran into unforeseen roadblocks as a result of the Writers Guild of America strike of 2007–08. By January 2008, though, Marvel Entertainment managed to reach an interim agreement with the WGA that allowed writers to resume working on the

company's ever-expanding development slate. After the incredible success of 2008's *Iron Man*, Marvel announced that Captain America was in production for a target release date of 2011. *Iron Man* director Jon Favreau and Louis Letterier expressed interest in directing the project, but it ultimately landed in the lap of Joe Johnston, thanks in part to his special effects work on the original *Star Wars* trilogy and his impressive directorial resume which included period pieces like *The Rocketeer* and *October Sky*. Shortly thereafter, Johnston brought aboard the screenwriting duo of Christopher Markus and Stephen McFeely, who have written both *The First Avenger* and *The Winter Soldier*. Now all they needed was a star—simple enough, right?

Codename: Marvel

Even in this era of telephoto lenses, grainy set photos, and rampant speculation over who is playing which character in what movie, Marvel does its best to preserve an air of mystery around its films. One way it does this is by giving each film a unique codename so that paparazzi and/or potential film pirates can't identify the production site or the film itself while it's en route to theaters. *Iron Man* was shipped to theaters under the titles *Bell* and *Debonair*; *Iron Man 2*, appropriately, went by *Rasputin*; *Iron Man 3* turned things up a notch and was dubbed *Caged Heat*; *Thor* was dubbed *Manhattan*; *Thor: The Dark World* reflected its grittier tone and was known as *Thursday Mourning*; *Captain America: The First Avenger* was known as *Frostbite*; Meanwhile, *Captain America: The Winter Soldier* was called *Freezer Burn*; *Guardians of the Galaxy* adopted the moniker *Full Tilt*; *Ant-Man* is using the tongue-in-cheek nickname of *Bigfoot*; and perhaps most adorably, *The Avengers* was known as *Group Hug*. As of the time of this writing, *Avengers: Age of Ultron* was codenamed *After Party,* which leads me to believe that *Avengers 3* will almost definitely be called *The Hotel Lobby* as that's what naturally comes next.

("MARVEL STUDIOS Feature: Working Titles & Production Company Names; Why Do They Do This?" Comic Book Movie. 21 June 2013. Web. 19 Oct. 2014. <http://www.comicbookmovie.com/fansites/TheDailySuperHero/news/?a=81983>.)

Finding the right man to embody Steve Rogers was more difficult than producers anticipated. Both Channing Tatum and Ryan Phillippe auditioned for the role, and rumors swirled around everyone from Dane Cook to the Jonas Brothers throwing their hats in the ring, but for a long time the frontrunner was none other than John Krasinski.[350] Riding high off of his success from *The Office*, Krasinski seemed like a shoe-in...until, as is so often the case in Hollywood, something changed. Suddenly, Krasinski was on the outs and producers had narrowed their search to three people: Mike Vogel (*Cloverfield*), Garrett Hedlund (*Tron: Legacy*), and Chris Evans.

Chris Evans wasn't always a household name even though he had been a Marvel superhero before. Previously, he played the Human Torch in Fox's *Fantastic Four* film series and was reluctant to play another Marvel character. "[Playing] Captain America just changes things, and there's really no off switch once you walk down that road," Evans explained in an interview with MTV.[351] He had reportedly declined the role of Captain America three times before eventually signing a six-picture deal with Marvel. "I can't believe I was almost too chicken to play Captain America," he remarked in an interview with *Entertainment Weekly*.[352] "At the time, I remember telling a buddy of mine, 'If the movie bombs, I'm f---ed. If the movie hits, I'm f---ed!'" he explained in decidedly un–Steve Rogers language.[353] Fortunately for all parties involved, the movie didn't bomb, and Evans has proven himself more than up to the formidable task of bringing Captain America to life. Just remember—when big-shot Hollywood producers come knocking at your door begging you to play one of the most iconic characters in pop culture, sometimes it pays to say "no" at first. But only if they really want you. And maybe then only if you're Chris Evans.

66 Roy Thomas

Jim Shooter is given a lot of credit for modernizing Marvel's editorial practices and turning the company around, but in the controversial former editor-in-chief's own words, the man who truly "saved Marvel" was none other than longtime Marvel writer and former editor-in-chief Roy Thomas. In addition to penning some of the most essential *Avengers* stories in the team's formidable history (which we'll get to), Thomas convinced the company to take a gamble on an upstart sci-fi property in late 1976. After taking a look at the pre-production sketches of the film that was currently in production in Tunisia, Thomas agreed to appeal to Stan Lee on their behalf. Little did they know, but the film would go on to become one of the biggest pop culture phenomena of all time: *Star Wars*.

"George Lucas himself came to Marvel's offices to meet with Stan and help convince him that we should license *Star Wars*," wrote Shooter. "I was told Stan kept him waiting for 45 minutes in the reception room."[354] Shooter admits that though that particular anecdote may be apocryphal, it still "reflects the mood at the time," which was one of general aversion to risk-taking, especially on genres that weren't proven sellers.

The deal was, admittedly, a gamble. Not only was Marvel in shambles at the time with poor sales, constantly blown deadlines, and decreasing quality of storylines across certain titles, but the figures seemed to bear out that neither sci-fi nor westerns sold well, and *Star Wars* was both (or at least, being pitched as such). Furthermore, the deal called for a six-issue adaptation with the first three issues hitting store shelves before the film even opened in theaters.

Thomas' argument for licensing the comic was bolstered by the fact that Stan Lee and Marvel Comics president Jim Galton were on a licensing spree, gobbling up copyrights and brand names (e.g. Spider-Woman and Ms. Marvel), and strengthening their relationships in Hollywood by licensing everything from sci-fi films (*Logan's Run, 2001, Godzilla*) to Edgar Rice Burroughs characters (*Tarzan, John Carter*). Plus, Thomas had been right about the efficacy of licensing Robert E. Howard's Conan the Barbarian, whose comics were among some of Marvel's best sellers.[355]

As we know now, Thomas couldn't have been more on the money. Advance buzz around the film made for decent sales, but after the film hit theaters, it force-choked the cultural zeitgeist, which meant an incredible sales spree for Marvel. Issues were flying off the shelves quicker than Han Solo could make the Kessel run; Marvel couldn't seem to reprint it fast enough. Shooter, perhaps said it best: "In the most conservative terms, it is inarguable that the success of the Star Wars comics was a significant factor in Marvel's survival through a couple of very difficult years, 1977 and 1978."[356]

So, now you understand why Roy Thomas was essential to Marvel, yes? Now, let's dial it back to the beginning so you have some context. Starting his career at DC Comics under the notoriously cantankerous Mort Weisinger, Thomas only remained there for eight days before accepting a job at Marvel Comics.[357] His first published story was "Whom Can I Turn To?" in *Modeling With Millie* #44, which hit newsstands in December 1965. After dabbling in teen romance comics and a couple Doctor Strange stories here and there, Thomas first made his name writing Marvel's first long-term title, the World War II–set *Sgt. Fury and His Howling Commandos*, which starred a pre-eyepatch Nick Fury battling the Nazis across Europe and North Africa. He graduated to *Uncanny X-Men*, taking over from issue #20 through #43 from 1966 to 1968, and also took over on *The Avengers* in issue #35 in December 1966, a post he would hold until 1972.

During that time, he was one of the creative forces behind storylines like the "Kree-Skrull War," which was revolutionary its scale and scope, as well as the introduction of a romance between Vision and Scarlet Witch; he dreamed up the villainous Squadron Sinister to battle the Avengers as pawns in a cosmic chess match; he created one of the Avengers' most enduring enemies, the mad megalomaniacal robot Ultron (who you'll meet in *Avengers: Age of Ultron*); and created two of the most seminal issues in the Avengers canon, which introduced the mysterious android, the Vision, as a villainous creation of Ultron's who has a crisis of conscience and helps the Avengers in their time of need. The arc culminates in "Even an Android Can Cry" where the Avengers consider the synthezoid for membership on the team. You can probably guess from the story's title how he responds. So, before you go to the movie theater to see *Avengers: Age of Ultron*, be sure to give thanks to Roy Thomas because, without him, most of that film wouldn't be possible.

67 John Buscema

Though Jack Kirby may have first given life to many of the Marvel characters we know and love in the Avengers with his prodigious pen, it was, in fact, another artist who was behind some of Earth's Mightiest Heroes' most iconic adventures: John Buscema. Like his brother Sal, John Buscema was a longtime artist for Marvel Comics, where he illustrated *Silver Surfer,* over 200 issues of *Conan the Barbarian*, and alongside his longtime creative partner Roy Thomas, brought some the Avengers' most important adventures to life as they erupted from his vibrant, larger-than-life pencils.

Buscema began his career with Marvel by penciling over Jack Kirby layouts for "Nick Fury, Agent of S.H.I.E.L.D." in *Strange Tales* #150 in November 1966. Soon thereafter, he became the regular penciller for *The Avengers,* alongside writer Roy Thomas, which would become one of his best-known works. Introducing characters like the Black Knight, the Vision, and Ultron, his run on *Avengers* was the stuff of legend, and his drawing style gave the Avengers' adventures an almost mythic quality. Of Buscema's work, fellow comics artist Jim Steranko said, "[His] anatomically balanced figures of Herculean proportions stalked, stormed, sprawled, and savaged their way across Marvel's universe like none had previously."[358] He would remain on the title regularly until 1989.

What is fascinating about "Big" John Buscema (as the towering artist was known), is that he had a profound ambivalence towards superheroes. He hated "goddamn automobiles and skyscrapers," preferring to focus on rendering the human anatomy and lush landscapes.[359] As a result, Roy Thomas tailored his scripts towards Buscema's rich, lavish illustration style, which found the Avengers facing a variety of increasingly mythology-steeped scenarios. From his pen, heroes like Hercules and Thor leapt off the page, possessing a certain godly gravitas that other artists could not give them. His heroes were musclebound, his monsters were gargantuan, and his style was immediately impactful.

Together with Thomas, the dynamic *Avengers* duo was able to create thrilling adventures and expand the series' canon by recycling older Marvel/Timely characters that had fallen out of use. Case in point: the Vision, who was a Kirby creation from the 1940s, was reimagined by Buscema and retooled by Thomas as an android imbued with the brainwaves and thought patterns of Wonder Man, another Kirby creation, who had perished in *Avengers* #9. The cover of *Avengers* #57 with its stark black and red hues, boldly announcing the Vision, a larger-than-life figure looming over the Avengers with arms outstretched, remains among comics' most memorable.

Likewise, at the end of *Avengers* #58, we see Buscema's capacity for tenderness in "Even an Android Can Cry"; when the Avengers offer the Vision membership in their crimefighting coterie, the Vision gingerly clutches his temple and sheds a tear, bringing a true sense of humanity to what was ostensibly a cold, lifeless machine-man.

Buscema's work was in peak form during the "Under Siege" arc in *Avengers* #273–277, which saw the Masters of Evil taking over the Avengers Mansion and nearly defeating Earth's Mightiest Heroes once and for all. The brutality of the panels in which Mr. Hyde is savagely beating Jarvis in front of an unconscious Black Knight and a captive Captain America remains as haunting today as when they were first drawn in 1987.[360]

Later in life, Buscema sat down with Roy Thomas for an interview at Joe Petrilak's All Time Classic New York Comic Book Convention in White Plains, New York, in 2000. Thomas revealed that he had saved many of his collaborations with Buscema, which surprised the artist a bit. Thomas asked, "You wonder why I saved the stuff?" Without missing a beat, Buscema replied, "Well, Roy, I'm not a fan of comics."[361] For John Buscema, it was all about the artwork and the craft rather than the content. While he may not have cared much for comics, we're certainly glad he spent six decades creating them, because without his incredible work, we, especially Avengers fans, would be all the poorer for it.

68 Roger Stern

Few comic book creators can claim to have penned seminal runs on *The Avengers*, but even fewer can claim to have created another Avengers team that had a beloved 10-year run. Then again, not

everyone is Roger Stern. Like many creators in Marvel's so-called "third wave" of creators, Roger Stern first started as an avid fan, publishing the fanzine *CPL (Contemporary Pictorial Literature)* alongside fellow future Marvelite Bob Layton out of Layton's apartment.[362] It quickly became one of the most popular fan magazines out there, and allowed him to make inroads with others in the industry. Eventually, Stern (and Layton) was able to parlay those connections into a writing position at Marvel, where he went on to write *The Amazing Spider-Man, Doctor Strange* (including the incredible *Doctor Strange and Doctor Doom: Triumph and Torment* graphic novel), and, most importantly, *The Avengers.*

During his tenure on the Avengers, much of which was spent with the legendary artistic team of penciller John Buscema and inker Tom Palmer, he was responsible for some of Earth's Mightiest Heroes' most memorable adventures including "Absolute Vision," in which the Vision attempted to create paradise on Earth by seizing control of the world's computer systems; the thrilling conclusion to "The Trial of Yellowjacket" in which Hank Pym finally cleared his name; the classic yarn *Avengers* #1 ½ that told the thrilling tale of what happened between issues #1 and #2 of *Avengers*; and many, many more. His greatest triumph, though, is the 1986 arc "Under Siege," which saw the Masters of Evil destroying the Avengers from the inside out by overwhelming them with superior numbers, taking control of the Mansion, and savagely beating Jarvis within an inch of his life. "Under Siege" was the boiling point of a number of slow-burning sub-plots and seemingly innocuous details that came together to spectacular effect to create one of the most visceral and memorable stories in the team's history.

Easily one of the most creative minds in Marvel's bullpen, Stern not only created the iconic Avenger Monica Rambeau (the second Captain Marvel) and Spider-Man villain Hobgoblin, but he co-created the West Coast Avengers with artist Bob Hall. According to Stern he came up with the West Coast Avengers "at a weekend

convention in Rome, Georgia, that [he] attended with Mark Gruenwald." The cast of current and former Avengers members had swollen to unmanageable numbers and Gruenwald "wanted [Stern] to come up with a miniseries, and [he] wanted to nail down some of the non-active Avengers."[363] The West Coast Avengers were Stern's solution; the plan was to form a second branch of the team in California, and once the miniseries was done, there would be two teams of adventurers on which to draw. However, Stern didn't anticipate the title spinning off into a monthly series, and before he knew it, he was writing *West Coast Avengers*.

However, in 1987, editor Mark Gruenwald fired Stern from *The Avengers* after a disagreement over upcoming storylines.[364] Rather than endure the ignominy of defeat, he left for DC Comics for nearly a decade where he wrote Superman stories, including the iconic "The Death of Superman," which is largely responsible for reviving Superman's popularity in the early '90s. In 1996, Stern returned to Marvel, where he wrote a number of miniseries and one-off issues over the next four years. Though he collaborated with the likes of Kurt Busiek on important Avengers works like the maxiseries *Avengers Forever*, his output would never match the narrative heights of his work in the 1980s. Still, Stern has made his mark on Marvel Comics history and many of his stories, especially "Under Siege," remain not only definitive Avengers tales, but the gold standard to which other writers hold themselves to this day. Now if we could just convince Kevin Feige and Marvel Studios to adapt "Under Siege" for the Marvel Cinematic Universe, we'd be in business.

69 George Perez

Jack Kirby may have been dubbed the King, but when it came to incredibly detailed character work and sprawling scenes packed to the brim with different characters, few could come close to matching George Perez. One need look no further than his work on the 2003 crossover book *JLA/Avengers* to see just how painstakingly detailed, imaginative, and fully realized his characters could be amidst the chaos of a pitched comic book battle. Throughout the 1980s and early '90s, Perez was about as big of a superstar artist as they come, drawing some of the most popular books of the era for both Marvel and DC Comics. Although he continues illustrating comics to this day, it was his early Marvel work, particularly that on *Avengers* that made him the icon he is today. After all, that reputation for expertly drawing team books had to come from somewhere.

The Bronx-born artist began his long illustrious career in professional comics as *Fantastic Four* and *Astonishing Tales* artist Rich Buckler's assistant in 1973.[365] A year later, he made his Marvel Comics debut with a two-page pencil spread in *Astonishing Tales* #25, and soon he became a regular in Marvel's rotation, penciling titles like *Deadly Hands of Kung Fu*. Along with author Bill Mantlo, he even created the White Tiger, the first Puerto Rican superhero in comics. However, it wasn't until Perez began penciling *The Avengers* (starting with issue #141) that his meteoric rise began in earnest.[366]

During his run on *The Avengers,* he was responsible for the introduction of important figures like the Avengers' stern National Security Council liaison Henry Peter Gyrich and the Taskmaster,

a villain-turned-antihero with photographic reflexes that allowed him to mimic most movement and combat styles. Perez was also the artist behind some of the most crucial moments for the troubled Avenger Hank Pym as well, from the slap heard round the world (he struck his wife, the Wasp) to Ultron brainwashing Pym into creating Jocasta, a robotic bride for the megalomaniacal machine. He was even the initial artist for the galaxy-spanning *The Infinity Gauntlet* miniseries, which is the basis of the current overarching

Artist George Perez at the Wizard World Philadelphia Comic Con 2012.
(Gilbert Carrasquillo/Getty Images)

story taking place in the Marvel Cinematic Universe right now. Exhaustion and overwork forced him to drop out on issue #4, but his impact was undeniable, setting the visual tone for the series and giving replacement artist Ron Lim quite the chip on his shoulder.

Some of his greatest triumphs came during the late 1990s and early 2000s when he was paired with writer Kurt Busiek. Together, the pair created tales like "The Morgan Conquest," the kickoff to the post-Onslaught "Heroes Return" campaign in which the Avengers were transported to an alternate medieval reality ruled by Morgan Le Fay. Not only did Perez craft epic, fantasy-tinged panels of scores of Marvel heroes doing battle with one another, but he reimagined them in classic medieval garb too. Take one look at those scenes of sprawling battles between superpowered medieval Avengers doing righteous battle and you'll be hard-pressed not to remember why you love comics in the first place.

However, one of the biggest feathers in Perez's cap is thanks to the 2003 crossover *JLA/Avengers*, a project nearly two decades in the making that was derailed by bureaucracy and bullheaded decision-making years prior. Another collaboration with Busiek, *JLA/Avengers* is such an accomplishment for Perez because not only did he manage to make dozens and dozens of superheroes look good on the page together at the same time, but he managed to keep the action coherent, a feat unto itself that many lesser artists can't do with a cast a third the size.

As for why team books suited his style so well, Perez chalks it up to the sense of fellowship and unique combinations made possible by those stories. "I like interaction between the characters," he said in an interview. "I've always felt the strong social urges. Man is a social animal, and I think it seems to be very dominant in my make-up. I enjoy the camaraderie of the characters. Just the idea of, in your own community, having a friend share what you go through, being a team worker, being involved."[367] It's a good thing that George Perez has been such a friendly guy and shared his art

with us over the years because his artwork contains exactly the kind of camaraderie and kinship you need, whether you're a teen (titan) or one of Earth's Mightiest Heroes.

70 Kurt Busiek

Like all great men, Kurt Busiek was born in Boston. Although he would grow up to have an illustrious career in professional comics, Busiek did not read them as a child; his parents disapproved of them. However, like all good rebellious teens, he found a way to do exactly that which his parents disapproved of by picking up a copy of *Daredevil* #120 (1975) at age 14.[368] The comic was a heady blend of romance, espionage, intrigue, action, and most importantly, Busiek's first exposure to complex continuity. It imbued a genuine sense of history to the young reader. From that point forward, he began working towards breaking into professional comics by writing and drawing his own comics alongside his childhood friend (and future successful comics creator) Scott McCloud. After graduating from Syracuse University in 1982, Busiek sold his first professional script, a backup story that appeared in DC Comics' *Green Lantern* #162. Shortly thereafter, he penned *Power Man and Iron Fist* for Marvel for nearly a year, and then he was off to the races.[369]

For a time, he worked as a freelance writer, an assistant editor, and even a sales manager for Marvel. However, it wasn't until 1993 that he found his big break. He and painter Alex Ross created a four-issue miniseries called *Marvels*, a thoughtful, deeply inventive story that imagined the rise of superhumans in the Marvel Universe from the perspective of an average Joe. A massive critical and commercial success, *Marvels* became the gold standard for

what a miniseries can accomplish narratively and paved the way for Busiek's future success. Often imitated, never duplicated, *Marvels* opened doors for Busiek, giving him the pick of the litter for mainstream comics work in the years to come.

In 1997, Busiek made one of his longest lasting contributions to the Marvel Universe, the creation of the Thunderbolts, a group of superheroes who emerged in the wake of the apparent death of most of Marvel's heroes following the events of the Onslaught Saga. On the final pages of the first issues, we learn, in one of the great twists of the modern era, that the so-called heroes were actually the Masters of Evil in disguise. In February 1998, alongside artist George Perez, Busiek helped usher the Avengers into the modern era with "The Morgan Conquest," the kickoff to Marvel's "Heroes Return" event that brought the Avengers back to the main Marvel Universe that saw the villainous Morgan Le Fay altering reality to create a strange medieval version of Earth, transforming the Avengers into sovereign knights in the process.[370] Though they eventually broke free of the scurrilous sorceress' scheme, the three-issue arc signaled a sea change in the kinds of stories fans could expect after some of the lazy storytelling of the early '90s.

Busiek's Avengers tenure lasted until 2002, culminating in the "Kang Dynasty," an epic saga that saw one of the Avengers' deadliest enemies, the 30th century warlord Kang the Conqueror, who came back to the 21st century with his son Marcus in order to conquer the planet, killing the entire population of Washington, D.C., in the process.[371] Other standouts of Busiek's storied run include the 12-issue miniseries *Avengers Forever* that brought together different Avengers from across the team's history on a time traveling race against the clock to stop the nefarious Immortus and his evil masters, the Time Keepers;[372] one of the definitive Ultron storylines, "Ultron Unlimited," that saw a souped-up murderbot invading a country, slaughtering its populace, and creating an army of adamantium-bodied Ultrons to battle the Avengers;[373] and

last, but not least, he teamed up with George Perez once more for the 2003 cross-company crossover event *JLA/Avengers* that pit the two greatest superhero teams in comics against one another before uniting them against a common enemy in a truly unforgettable event series.

What makes Busiek such an enduring force in the world of comics is the purity of his storylines. Sure, they manage to break the mold, pushing the boundaries of storytelling within the medium and making us rethink our preconceived notions about many classic characters, but they manage to hearken back to the core values of comic book writing. His approach is old-school without being navel-gazing, possessing a classic sensibility within the trappings of modernity. He helped revitalize Earth's Mightiest Heroes in a major way and paved the way for the excellent storytellers to follow him. In short, he deserves an honorary spot on their roster and permanent space on your bookshelf.

71 Steve Englehart

As the old saying goes, "Father knows best." Considering that Steve Englehart is the father of crossovers at Marvel Comics, it's probably best that you know who he is and why he is essential to the Avengers legacy. Born in Indianapolis and a graduate of Wesleyan University, Englehart first broke into comics as a replacement for departing assistant editor Gary Friedrich, but quickly graduated to full-time writer. At first, Englehart worked uncredited on scripting stories like *Sgt. Fury and His Howling Commandos* #97, *Iron Man* #45, and *The Incredible Hulk* #152.[374] Proving his worth, editor-in-chief Roy Thomas gave him his first credited work on

a series starring Beast from the X-Men, then put him to work on *The Defenders* ongoing series that he launched with Sal Buscema (brother to legendary Avengers artist John Buscema). Then, in November 1972, Englehart began his run on *Avengers,* which would last for nearly four years and more than 50 issues when all was said and done.

One of the first things Englehart did was aggressively campaign and convince Thomas to allow him to pen an eight-part story that moved back and forth between the pages of *Avengers* and *The Defenders*. It would become known as "Avengers/Defenders War," one of the most seminal storylines in both teams' histories and it was the first official crossover in Marvel Comics history.[375] His run also included the "The Serpent Crown" arc that pit the Avengers against the Justice League–like Squadron Supreme in an alternate reality for control of a demonic, mind-controlling relic—the titular Serpent Crown.[376]

Most famously, he penned "The Celestial Madonna Saga," a long, winding, time-traveling epic that not only featured an android marrying a reality-altering mutant witch, but a crime-fighter-turned-cosmic Virgin Mary entering into holy matrimony with an alien plant in the form of her deceased boyfriend. But that's the kind of totally weird, far-out storylines that one can expect from Englehart. A labyrinthine, layered story full of highs and lows, "The Celestial Madonna Saga" culminated in an epic showdown with Kang the Conqueror and Dormammu, and a wedding between the Scarlet Witch and the Vision.[377]

After Roger Stern created the original *West Coast Avengers*, Englehart took up writing duties on the ongoing series, penning the "Lost in Space-Time" storyline that transported the expansion team through a series of different eras throughout history. The arc explored heady issues for the time like Hank Pym dealing with suicidal thoughts, as well as the philosophical conflict between the very religious Firebird and the atheist Pym. Most importantly, though,

it saw Mockingbird taking bloody vengeance on a vigilante known as the Phantom Rider who sexually assaulted her. The trauma of it all drove a wedge between her and Hawkeye, ultimately leading to the dissolution of their marriage.[378]

Part of the vaunted third-wave of Marvel Comics talent, Englehart had his work cut out for him with peers like Steve Gerber, Marv Wolfman, Len Wein, Don McGregor, and Tony Isabella. Succeeding Roy Thomas on *Avengers* was no small task, but he quickly found his footing and went on to write some of the series' most memorable moments. Likewise, his acid-washed, mind-melting work on titles like *Doctor Strange* and his politically charged stint on *Captain America* (during which Cap became so disillusioned, he actually hung up the shield for a spell) remain

The Write Stuff and the Wrong Stuff

Although Steve Englehart is renowned as one of the best writers in Marvel Comics and *Avengers* history, not everyone can bat one thousand. In 1982, Englehart left the world of comic books for a year after wrapping up a stint at DC Comics. During this time, he traveled abroad to Europe, wrote a novel, and returned to something very different: designing video games. The first game Englehart worked on was an Atari title called *E.T. Phone Home.* Englehart's original design was nearly four times as large as the final product, which revolved around E.T. guiding Elliot around the neighborhood to collect pieces of the interplanetary telephone needed to call E.T.'s friends. Though the initial designs were well-received and it sold 1.5 million copies, the final product is widely considered the worst video game of all time, and in 1983, the unsold copies of the game were buried in a landfill in Alamogordo, New Mexico. Though the remains were unearthed on April 26, 2014, after a six-month excavation, *E.T. Phone Home* is still regarded as a huge, steaming pile of digital trash. At least we'll always have your comic books, eh Steve?

(Englehart, Steve. "E.T. [computer]" Steve Englehart Official Page. Web. 18 Oct 2014. http://www.steveenglehart.com/games/e.t.%20(computer).html)

unassailable. His stories were clever, fast-paced, and the fundamentals of storytelling were ingrained into their very DNA. His legacy still looms large over *Avengers*-dom and will continue to seep its way into the Marvel Cinematic Universe and Marvel Comics stories for many years to come.

72 Marvel Zombies

While storylines like "Fear Itself" or "Avengers vs. X-Men" or "Age of Ultron" may feel more important to the modern era, they pale in comparison to the sheer, unbridled fun of *Marvel Zombies*. Written by *The Walking Dead* creator Robert Kirkman and illustrated by Sean Phillips, this five-issue miniseries lived up to its title, bringing flesh-eating undead abominations to the Marvel Universe in a truly spectacular alternate universe story. Over the course of five issues, the story answers the burning question of "What would happen if the greatest heroes in the Marvel Universe were transformed into zombies, but still managed to retain their personality and, in many cases, their powers?"

Set in a particularly bleak corner of the Marvel Multiverse, Earth-2149, *Marvel Zombies* begins when an unknown superhero (later revealed to be a zombified version of Sentry from *Ultimate Fantastic Four*'s "Crossover" arc[379]) brings the otherworldly "Hunger," an insatiable desire for human flesh, to the world. We learn that nearly all of humanity has fallen save for a few pockets of superpowered individuals. In the ruins of the Baxter Building, Magneto sends a young Reed Richards back to his home universe (the Ultimate Universe), and stays behind to destroy the inter-dimensional portal so that no one can follow him. Soon

Magneto is surrounded by zombified versions of the Avengers, including Spider-Man, Colonel (formerly Captain) America, Thor, Giant-Man, Luke Cage, Wolverine, and others. Narrowly escaping, he learns that the mutant Forge and his Acolytes are still alive on Asteroid M, his orbital base, but before he can contact them, he is attacked once more. Though he manages to decapitate zombie Hawkeye, Magneto is taken by surprise by the Wasp, who sneaks up on him, taking a huge bite out of his neck, turning Magneto from the Master of Magnetism to the main course.[380] Alas and alack.

After feasting, the Zombies Heroes regain some lucidity, which leads them to contemplate their plight. They feel no pain, yet their hunger is insatiable. Their internal organs have failed, but their brains still seem to be intact. Wolverine sums up the matter quite succinctly, saying, "My healing factor ain't doing squat…we're dead but we're not dying. Simple as that—and I ain't no doctor." The Zombie Heroes sit around contemplating where they'll get their next meal, but it comes to them sooner than they'd expected. It's not delivery, it's not DiGiorno—it's the Silver Surfer, who has come to tell them that their planet is next to be devoured by the cosmic chowhound himself, Galactus.[381] Never one to turn down a good meal, several of the zombies (Colonel America, Iron Man, Luke Cage, Spider-Man, Giant-Man, Hulk, and Wolverine) overpower and tear Silver Surfer asunder, turning him into human tapas. However, this meal is unlike the others; it has imbued them with the Power Cosmic, which they promptly use to slaughter most of the other zombies in order to reduce the number of mouths to feed.[382]

Elsewhere, the aforementioned Acolytes return to Earth for a reconnaissance mission on which they make a shocking discovery: Black Panther is still alive! T'Challa had been held captive by Hank Pym as a secret food supply, injected with sedatives while Pym amputated select limbs.[383] As a result, Black Panther is missing an

arm and a foot. The Wasp, already a zombie, also fell victim to Pym, who bit off her head during an argument over how he was hoarding Black Panther for food. Her head remains sentient and continues begging for sweet, sweet flesh, but Panther scoops it up and carries it with him as he makes his escape with the Acolytes.[384]

Although the Zombie Heroes decided to use their cosmic powers to see what other zombies taste like when they're "extra crispy," they still can't stomach the taste of dead flesh. When Galactus arrives though, they don't see a massive purple destroyer of worlds; rather, they see an all-you-can-eat buffet. However, Galactus proves too strong for them at first, beating them back. Regrouping at Pym's lab, the Zombie Heroes are getting so hungry that they're reaching into their own stomachs to eat undigested bits of flesh that they've already consumed like a grisly sort of Ouroboros. As it turns out, eating leftovers staves off the hunger long enough for them to construct a powerful device that harnesses all of the Zombie Heroes' cosmic powers into a single, powerful blast. "It's space god on the menu tonight!" Luke Cage says with a cruel smile.[385]

With their weapon in tow, the Zombie Heroes confront Galactus once more, who is swatting zombified supervillains like so many gnats. Though the Zombie Heroes manage to fell the mighty Galactus with a few well-placed blasts of concentrated cosmic energy, the villains try to steal their feast. Fortunately for our murderous heroes, their newfound powers make short work of their undead opponents. Together, they begin to devour the remains of Galactus. Flash-forward to five years later—a mysterious craft lands in a neglected city square. From the ship emerges T'Challa (complete with mechanical limbs), the Acolytes, and Janet Van Dyne, who is now a cyborg-zombie with her head floating in a jar of preservative fluid. Their scans confirm that the Zombie Heroes are nowhere to be found on the planet. If they're not here, though, where could they have gone? The series ends with our

six decomposing heroes descending from the starry sky, speeding towards a brand new world. They are no longer Earth's Mightiest Heroes; they are the Galactii, and they are very, very hungry.[386]

While I sincerely doubt that we'll ever see this story make its way into Marvel's Cinematic Universe, I cannot stress enough how amazing that would be. Seriously, if someone starts the Kickstarter for that, please e-mail me because I will send you money faster than you can say, "It's feeding time, boys!"

73 Nefaria Supreme

Although fans would have to wait until 2003 to get the proper answer to the question "What would happen if the Avengers fought Superman?" they got their first taste at what that might look like in 1977 thanks to Jim Shooter and John Byrne in the now-legendary arc "Nefaria Supreme!" Running from *Avengers* #164–166, the story took a villain the Avengers had fought before with few problems and turned his power levels up to 11, giving him godlike strength and the bombast to match. What followed was drama of the highest order for the Avengers as they tried—and largely failed—to stop this incredible, superpowered villain run amok.

For some quick backstory, Count Nefaria is a wealthy Italian aristocrat whose lust for power, influence, and wealth led him to join the Maggia crime syndicate (sort of like the Mafia, but with way more mad scientists and supervillains on staff). Previously, he managed to kidnap the Avengers by luring them to his castle under the pretense of a charitable gala event, and managed to incapacitate most of Earth's Mightiest Heroes with a specialized knockout gas.

Keeping them in suspended animation, he used their images to extort and intimidate the United States with threats of conquest. Eventually, Captain America managed to break into the castle (isn't he always infiltrating some European castle or another?) and free his compatriots, putting a stop to Nefaria's plan before it was too late.[387]

Perhaps it's something about being a member of the aristocracy, but they never seem to take defeat well. Naturally, Nefaria returns, recruiting three of the Avengers old enemies—Whirlwind, the Living Laser, and Power Man—to create a new iteration of the Lethal Legion. Count Nefaria immediately sets them to work harassing the Avengers and robbing banks to fund his unscrupulous schemes. With powers enhanced by Nefaria's team of scientists (one of whom is Baron Helmut Zemo's former science adviser), the Legion attacks Avengers Mansion and winds up in a ferocious battle with Earth's Mightiest Heroes. However, halfway through the battle, the hapless henchmen realize they are but guinea pigs for their pernicious puppet master and they suddenly lose their powers. They are soundly defeated by the Avengers, who themselves are stunned by a massive shockwave naught but a moment later. Who could have generated such force? The sneering figure of Count Nefaria looming over them gives them their answer.[388]

Now possessing a deadly array of superpowers including superhuman strength, super speed, the ability to fly, and the power to shoot energy beams from his eyes, Count Nefaria was far more formidable than the conniving, corrupt aristocrat they had battled years prior. His team of scientists managed to endow Nefaria with all of the abilities of his costumed henchman, but amplified a hundredfold. One by one, Captain America, Wonder Man, Yellowjacket, the Wasp, The Scarlet Witch, and the Black Panther all fell to the terrible might of Count Nefaria, who even dropped a 40-story building on them at one point. Not even the last-minute

arrival of Iron Man could reverse their fortunes. All, it would seem, was lost for Earth's Mightiest Heroes.

However, in the midst of the melee, the venerable villain known as the Whizzer confronted Count Nefaria, forcing the megalomaniacal madman to face his own mortality by reminding him that his power is meaningless because he will still grow old and die as all men do. Apparently, that was the last thing Nefaria needed to hear; the Count flew away flustered, only to return a short while later demanding that Thor reveal himself. Ask and ye shall receive, foul knave! "And verily thine hour of judgment hath come!" the Thunder God shouts as he bursts onto the scene.[389] Squaring off in single combat, the two titans engage in a truly epic battle—using buildings as blunt weapons, battering one another with bruising body blows, and pummeling each other with an uncanny strength. Then, something happens that even gives Thor a moment of pause: Count Nefaria stops a swing of Thor's hammer Mjolnir with his bare hands. Stunned, Nefaria counters with a powerful punch that drops the Thunder God.

Victory, it would seem, was Nefaria's after all. Yet, before he could finish his grim work, a meek little milquetoast of a man named Professor Sturdy, the scientist that gave Nefaria his incredible powers, appears to give the Count a dire warning. The process that had given Nefaria immeasurable powers had also sped up his aging process, and if he kept fighting, he would die in a matter of days. Understandably, the Count was shaken by this news, standing there stunned. That moment of opportunity was all the Avengers needed. Taking Nefaria by surprise, the Vision increased his density to maximum levels and dropped on the Count from a mile overhead, knocking the superpowered scoundrel unconscious. The Avengers win the day, and take Nefaria into protective custody, only to learn later that Sturdy had lied about Nefaria's rapid aging process.[390] So, remember, if you're ever facing someone much more powerful than you, all you need to do is essentially trick them

into WebMD-ing themselves, and you're bound to come out on top. Even Earth's Mightiest Heroes are no match for good old-fashioned hypochondria, it would seem.

74 The One-Shots

In comics jargon, a one-shot refers to a self-contained story that unfolds over the course of a single issue. However, in the Marvel Cinematic Universe, a one-shot is a direct-to-video short film that appears on the Blu-ray/DVD home video release of Marvel's movies and expands upon the story with, you guessed it, a self-contained done-in-one story. It may tie-in to the events of what you just watched in the main movie, but the one-shot itself lives up to its name by offering a complete package running between four and 14 minutes in length. When examined in the larger context of the Marvel Cinematic Universe, these short films create connective tissue between the standalone films, giving the sense that this is truly a living, breathing world in which these heroes live.

Started in 2011, the one-shots were originally conceived of as a way to sell more *Thor* Blu-rays and DVDs, but Marvel Studios producer Brad Winderbaum explained that, "It's a fun way to experiment with new characters and ideas, but more importantly it's a way for us to expand the Marvel Cinematic Universe and tell stories that live outside the plot of our features."[391] Set after the events of *Iron Man 2* and *The Incredible Hulk, The Consultant* follows Agent Phil Coulson (Clark Gregg) as he tries to figure out a way to convince the World Security Council not to put the villainous Emil on the planned Avengers roster. In order to trick his jailer, General "Thunderbolt" Ross, they send in the titular

consultant, Tony Stark, who proceeds to annoy the living daylights out of Ross, leading to Blonsky remaining in prison. It was a clever, well-crafted little film, but more importantly it gave the sense that S.H.I.E.L.D. was pulling the strings behind many events, and this was just a small taste of their full menu of machinations, wheelings and dealings.

The follow-up film, *A Funny Thing Happened on the Way to Thor's Hammer* (2011), appeared on the *Captain America: The First Avenger* Blu-ray, and offered a very different perspective on a day in the life of a S.H.I.E.L.D. agent; Coulson stops for gas in Albuquerque, New Mexico, and winds up foiling a robbery and delivering a healthy dosage of ass-kicking. *Item 47* (2012) followed it on *The Avengers* home video, and centered on a couple that finds a discarded Chitauri gun, and use it to rob banks in the wake of the attack on Earth. In fact, it was the success of this story that helped to inspire the TV show that would become *Marvel's Agents of S.H.I.E.L.D.*

When *Iron Man 3* blasted onto home video, we got a glimpse of *Agent Carter,* a period piece that follows Peggy Carter during her days at the Strategic Scientific Reserve as she tries to break the mold of the boys' club in which she works. Filmed over five days, the short film actually helped inspire the *Agent Carter* series on TV. Last but not least is my absolute favorite: 2014's *All Hail the King*, a film that finds Justin Hammer wondering aloud how A) he came to be in the same prison as Trevor Slattery, and B) how the fraud got to be so popular in prison. However, as we soon learn, Slattery is being hunted by enthusiastic murderers, agents of the Ten Rings, who let him know the real Mandarin is none too pleased about being impersonated. We also learn that Slattery starred in a preposterous 1980s cop show called *Caged Heat*.

Although neither *Captain America: The Winter Soldier* nor *Guardians of the Galaxy* contained a one-shot on their respective home video releases, one cannot help but hold out hope that

Marvel Studios will see the light of day and give the people what they're clamoring for: the complete season-one boxed set of *Caged Heat* starring Trevor Slattery in all of its cheeseball glory.

75 Red Zone

No, it's not a weird piece of promotional marketing sponsored by Old Spice; "Red Zone" was a six-issue arc from Geoff Johns' two-year run on *The Avengers* that played out like *The Stand* with superheroes. (Yes, that's right—before he became Mr. DC Comics, Geoff Johns actually worked at Marvel.) A mysterious red dust is sweeping across Middle America killing all who come into contact with it. Having infiltrated the highest levels of government, the Red Skull released the biological weapon on the peaks of Mount Rushmore, killing thousands in the surrounding areas, leaving it up to the Avengers to contain it before it's too late. Published in 2003, "Red Zone" tapped into fears held by many in a post-9/11 world, namely biological attacks. Even though it was published more than a decade ago, the fears about weaponized biological attacks and rapidly spreading disease that it represented remain prescient as ever to this day.

In the aftermath of the initial disease cloud, the Avengers assemble (in their finest hazmat gear) and Iron Man and Black Panther attempt to neutralize the cloud. However, government agents stymie their efforts as the Secretary of Defense, Dell Rusk, leads them away from the disaster area on the grounds that the Avengers are no longer sponsored by the United States government. Meanwhile, the rest of the team discovers a secret weapons lab at the base of Mount Rushmore, giving way to the horrifying

realization that the weapon may have been manufactured by the government itself. Something is rotten in the state of ~~Denmark~~ North Dakota, and the Avengers are going to get to the bottom of it.

What follows is a race against time as the Falcon teams up with Henry Gyrich, the weasely, conniving government liaison to the Avengers, to spy on Rusk, who was the direct supervisor of the secret laboratory. Meanwhile, Iron Man and Black Panther must put aside their egos and distrust of one another to work together to find a cure before it's too late. As it turns out, Rusk is none other than the Red Skull, Captain America's greatest foe, who is trying to destabilize the U.S. government from within. The Skull's plot hinged on releasing the biological weapon in order to lay the blame

J.G. Jones' cover of Red Zone Part 2, with Captain America, Scarlet Witch, and She-Hulk.

at Wakanda's feet, plunging the United States into war with the Black Panther's homeland. To make matters worse, the only cure for the Red Zone lies within the Red Skull's blood.[392]

While the Scarlet Witch desperately uses her chaos magic in an attempt to contain the creeping plague, Iron Man and Black Panther take on the Red Skull. Disabling Iron Man's armor, the Black Panther battles the Nazi sleeper agent in hand-to-hand combat. Finally, with a boost from the Falcon, the Black Panther manages to put the Red Skull down. Together, Stark Industries and the Wakandan government are able to fast-track a cure and effectively neutralize the Red Zone, resulting in a new scientific sharing agreement between Stark and T'Challa.[393]

Tensely paced and well plotted, Geoff Johns' script breaks away from the classic Avengers mold of throwing a massive squadron of good guys against a massive squadron of bad guys, creating a creeping biological thriller. Likewise Olivier Coipel's artwork possesses a highly cinematic quality, enhanced by his clever layouts that lend a kinetic quality to the action and an underlying anxiety to the whole storyline. The enduring subject matter of "Red Zone," along with its palpable character development (Iron Man and Black Panther were forced to put their egos aside for the greater good) and striking artwork, make this not just a great comic book arc, but one that is ripe to make the leap to the Marvel Cinematic Universe too. Honestly, how much better would *Outbreak* have been if Dustin Hoffman got to pal around with the likes of Iron Man and Black Panther?

DAN CASEY

76 The Cameo Conspiracy

Any eagle-eyed Marvel fan worth their salt knows that a Marvel Studios film will have two things in addition to a metric ton of explosions, high-flying heroes, and larger-than-life villains: 1) extra scenes after the credits roll known as "stingers," and 2) a cameo from legendary Marvel Comics editor-in-chief Stan "The Man" Lee. Over the years, the Generalissimo has played everything from the victim of poisonous gamma-irradiated soda to a World War II general. Not only is Lee essential to the legacy of Marvel Comics, but he is becoming a stalwart of the Marvel Cinematic Universe as well. In fact, Lee has a rich history of appearing in nearly every Marvel project beginning with 2000's *X-Men* (and a couple that even came before it)!

The Trial of the Incredible Hulk (1989): In this TV movie spin-off from the 1970s *Incredible Hulk* television series, Lee played a jury foreman in the trial of…well, you get the picture. Interestingly, this film featured Jonathan Rhys Davies as the Kingpin and served as a backdoor pilot for a live-action Daredevil series that was never produced. Turns out they just had to wait for the invention of Netflix!

X-Men (2000): When Senator Kelly manages to escape Magneto, he emerges on a beach where Stan Lee is selling hot dogs by the seashore.

Spider-Man (2002): During Spider-Man and Green Goblin's battle in Times Square, Lee briefly grabs a young girl and moves her out of the way of falling debris. Lee's cameo was originally longer, with him asking Peter Parker, "Hey kid, would you like a pair of these glasses? They're the kind they wore in *X-Men*," but it was ultimately cut.

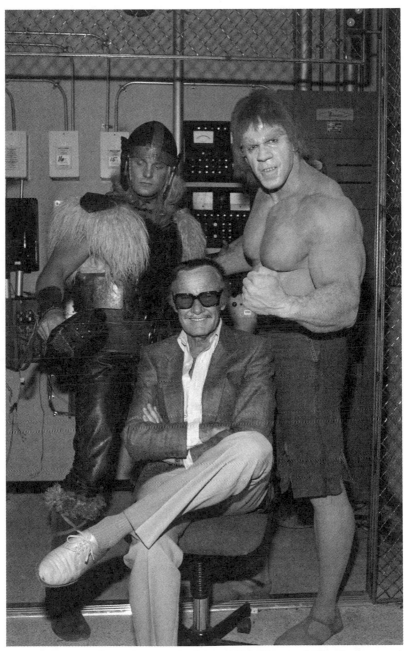

Stan Lee poses with Lou Ferrigno (right) and Eric Kramer (left), who portrayed the Hulk and Thor, respectively, in a special movie for NBC, The Incredible Hulk Returns. (Nick Ut/AP Images)

Daredevil (2003): A young Matt Murdock saves the life of a man reading a newspaper (Lee), who nearly gets hit by a bus.

Hulk (2003): Sharing the screen with former 1980s *Incredible Hulk* TV actor Lou Ferrigno, Lee played a security guard at Bruce Banner's lab. This marked Lee's first speaking role.

Spider-Man 2 (2004): Lee reprised his role of man pulling innocent women away from falling debris as a witness during the epic battle between Doctor Octopus and Spider-Man.

Fantastic Four (2005): Lee makes a cameo as a character he created in 1960, a cheerful mailman named Willie Lumpkin.

X-Men: The Last Stand: (2006): Watering his lawn goes awry when Stan Lee witnesses young Jean Grey showing off her incredible mutant powers.

Spider-Man 3 (2007): Near the beginning of the film, Lee has a chat with Peter Parker and even manages to work in his signature "'Nuff said!"

Fantastic Four: Rise of the Silver Surfer (2007): Attempting to enter the wedding of Reed Richards and Sue Storm, Lee gives his

Wait, Who Was That Guy?

Stan Lee may have the most notorious and noticeable cameos in Marvel's movies, but he is far from the only important Marvel Comics figure to grace the silver screen with his presence. In *Thor*, veteran writer J. Michael Straczynski is seen as the first man to try to lift the hammer, and legendary Thor writer Walt Simonson can be seen toward the end during a banquet scene sitting between Sif and Volstagg. In *Captain America: The Winter Soldier*, not only can you spot the film's writers, Christopher Markus and Stephen McFeely, as two S.H.I.E.L.D. interrogators, but you can spy Joss Whedon in a Captain America t-shirt at the Smithsonian descending the escalator, and Winter Soldier creator Ed Brubaker as a S.H.I.E.L.D. scientist too! Who will we see in *Avengers: Age of Ultron*? Only time will tell, but smart money is on Stan Lee (at the bare minimum).

own name to the man working the door only to be told that he isn't on the guest list.

Iron Man (2008): Stan Lee, rocking a fine smoking jacket, is mistaken for being none other than *Playboy* mogul Hugh Hefner.

The Incredible Hulk (2008): This is not a joke—Stan drinks a poisoned soda that has been contaminated by Bruce Banner's blood. That is a thing that actually happened.

Iron Man 2 (2010): Once again, Tony Stark mistook Stan Lee for another famous silver fox: Larry King.

Thor (2011): Lee revs his pickup truck and brings some good ol' boys to try to help him budge the mythical hammer Mjolnir.

Captain America: The First Avenger (2011): Lee portrays a World War II general that mistakes Captain America's identity for someone else's.

Avengers (2012): During a news report, Lee plays a man being interviewed that doesn't believe the Avengers exist.

The Amazing Spider-Man (2012): One of my favorite cameos to date. Lee stars as a clueless school librarian who is busy performing his dead-end job while the Lizard and Spider-Man have a knockdown, drag-out fight just behind him.

Iron Man 3 (2013): In one of Lee's briefest cameos yet, he played a beauty pageant judge.

Thor: The Dark World (2013): Perhaps Lee's craziest cameo yet—literally. He is seen as a patient in a mental hospital.

Captain America: The Winter Soldier (2014): Moonlighting as a security guard at the Smithsonian Institute, Stan Lee makes a brief guest appearance.

X-Men: Days of Future Past (2014): Lee actually didn't have a cameo for this one. Speaking with CNN, Lee revealed two reasons why it didn't come to pass. One was innocuous—it was due to scheduling conflicts. The other is far more sinister. "I have a funny theory about it," said Lee. "It also could be they didn't want me to do the cameo because, without my cameo, the movie will make

more money...You see, somebody watches the movie and the movie ends and the person says, 'Wow, I didn't see Stan's cameo. I must have missed it.' So what do they do? Right back to the box office, buy another ticket, and watch the movie again. So I think it's a big moneymaking ploy on the part of the producers."[394]

My god...the plot thickens by the moment!

Guardians of the Galaxy (2014): While looking for possible bounties on Xandar, Rocket Raccoon and Groot spot a dapper, silver fox of a man romancing an alien woman on a bridge. Who could it be? Who else, but Stan Lee!

Also of interest, Lee's original *Guardians of the Galaxy* cameo saw him encased in the Collector's museum of rarities and treasures. When the Guardians finally arrive at Taneleer Tivan's home, Lee slowly gives Groot the finger. However, the scene was ultimately cut by director James Gunn for creative reasons after he deemed it too stylistically similar to a moment earlier in the film where Peter Quill flips off the Nova Corps.[395]

As of this writing, it's unclear what capacity we'll see Lee in during *Avengers: Age of Ultron*, but I'd bet dollars to doughnuts it will be another rich addition to his on-screen canon. Speaking of which, Lee's cameos have spawned a few fan theories of their own. Some people posit that Lee is playing an alien he created with Jack Kirby for *Fantastic Four* #13 in 1963—Uatu, the Watcher, the cosmic observer of the most important events in the Marvel Universe. Others posit that Lee is a time-traveling Kang the Conqueror, who I suppose is just taking it easy rather than actively trying to, you know, conquer stuff. While neither of these likely hold any water, there's definitely one role that Stan Lee was born to play: "The Man."

'Nuff said.

77 Avengers Forever

What happens when Immortus, the time-traveling lord of Limbo, travels back in time to try to murder one of the Avengers' closest allies? Well, you assemble an Avengers squad comprised of current and classic Avengers across different timelines and realities to save the day before it's too late. Such was 1998's *Avengers Forever*, a 12-issue maxiseries that featured positively beautiful artwork from Greg Pacheco and the writing talents of the formidable brain trust of Kurt Busiek and Roger Stern. Not only did the book introduce a new Captain Marvel to the Marvel Universe, and reignited a craze for crossover events that hadn't been seen in a couple years (and hasn't died down since).

Though the notion of time travel can send some people running for the hills, the core of the story was quite simple in its concept. Immortus, time-traveling evildoer, wants to kill Rick Jones, a trusted ally of the Avengers and possessor of the powerful Destiny Force, a cosmic energy that played a major role in the "Kree-Skrull War" storyline. However, the leader of the Kree, the Supreme Intelligence, and Kang the Conqueror (who is actually a younger version of Immortus) manage to thwart Immortus' initial efforts. By the end of the first issue, aided by former Zodiac member Libra, Rick Jones uses his powerful abilities to pluck seven Avengers out of the timestream and transport them to the present in order to help battle Immortus' growing threat.[396]

These Avengers were: the Wasp and Giant-Man from the present day; Captain Marvel from a few months in the future; Songbird from an alternate reality; a disillusioned Captain America who was in the midst of rooting out traitors in the U.S. government; a mentally unbalanced Yellowjacket (who is unaware that he

is Hank Pym); and Hawkeye from shortly after the conclusion of the Kree-Skrull War.[397] Though they seem to be randomly chosen, Libra reveals that his subtle awareness of maintaining cosmic balance helped Jones to select each of these people for a precise reason.

Before the Avengers have much time to ponder their newfound reality, they're thrown into a battle between Kang the Conqueror and the Army of the Ages, summoned by Immortus. Eventually reaching a stalemate, Immortus and his army beat a retreat, forcing the Avengers to chase them across the time-space continuum into different eras like the American frontier during the Old West, ancient Egypt, a reality with an alternate Avengers lineup in 1959, and many more.[398] As it turns out, Immortus is working for an

The cover of
Avengers Forever #3.

ancient race of cosmic beings called the Time-Keepers, a trio that watches over time itself. They are worried that the human race will eventually develop incredible powers à la the Destiny Force and take over the universe, forming the iron-fisted Terran Empire, policed by the Galactic Avengers Battalion. Given that Rick Jones is the catalyst for all of this, they mark him for death.[399]

Aiding the Avengers in their epic final battle with the Time-Keepers, Kang the Conqueror kills his future masters when they attempt to punish Immortus for his failure. However, before they perish, the Time-Keepers cause Immortus and Kang to be irrevocably split into two separate beings. In order to save Rick's life, Captain Marvel merges with him, and soon thereafter the Avengers return to their respective timelines with vague memories of everything that has happened.[400] One major side effect: the 1959 version of the Avengers are now present in the main Earth-616 reality of the Marvel Universe where they continue to operate as the Agents of Atlas.[401] Hey—it could be worse. It's not like Captain America accidentally made his own mother fall in love with him, then invented rock 'n' roll at the Enchantment Under the Sea dance.

Artfully playing with context and continuity, *Avengers Forever* not only reestablished Kang the Conqueror as an important villain in the *Avengers* canon and the Marvel Universe, but paved the way for the next phase in Rick Jones' evolution. Much like the story itself, Busiek's script has one foot in the past and one in the future, blending the sensibilities of the 1960s and the 1990s to create something that is greater than the sum of its parts. As it turns out, when seemingly disparate slices of Marvel history are thrown together, they make one hell of a pie. And while I would be delighted to see this storyline play out on the Marvel Cinematic Universe's canvas, I have a feeling that an *Avengers Forever* adaptation is about as likely as the Hulk *not* smashing something puny.

78 How to Properly Preserve Your Comic Book Collection

So, you've made the life-altering and apartment-filling decision to start collecting comic books? Congratulations on ignoring the fact that you could have avoided this whole situation by investing in a tablet device, but hey, there's something to be said for that feeling of cracking open a comic fresh off the racks or that inimitable smell that you get when you unearth a comic from the '60s or '70s. Now that you've started collecting them, though, you're going to want to protect your investment, which can often be something that's easier said than done for the uninitiated.

Proper storage is paramount to keeping your comics in peak condition. One of the most popular methods of storage is bagging and boarding. Individual issues (called "floppies" by some) are placed in plastic sleeves, and then a comic book–sized piece of cardboard is placed behind it in the sleeve to help preserve its shape. For storing the individual issues, the most common method is using long boxes, which are exactly what they sound like—durable, stackable, corrugated cardboard boxes that can store approximately 200 comics. Although it'd be nice to display your collection to the world, exposure to light can damage the comics over time and cause them to fade. So, unless you're looking for a wizened, yellowed collection of the superhero stories of yesteryear, you're going to want to invest in some boxes. Add in a gross, cobweb-covered cake, and you'll have the perfect nerdy Miss Havisham aesthetic you've always dreamed of!

Older comic books in particular were printed on low-grade paper and newspaper pulp, which has a tendency to become brittle and acidic over time. Although it can be tempting to store them in an attic or closet, those environments can be subject to poor air

circulation, irregular temperatures, and fluctuating humidity levels, which can all contribute to degradation in quality. While you don't have to keep them in a humidor, for those who are interested, the ideal temperature for storage is 68°F or less, and the ideal relative humidity level is between 30 percent and 40 percent. An ideal storage space would be an air-conditioned room or a closet. Just make sure to keep an eye out for pests like rodents, silverfish, and nosy younger siblings.

However, what if you have something you want to give a little extra protection like that mint-condition copy of *Avengers* #57 (which can sell for as much as $20,000 at auction)? Enter the Certified Guarantee Company (CGC), the nationally recognized authority in the grading, restoration, and preservation of comic books. Issues submitted to the CGC are examined by a panel of experts who look at every nook, cranny, dog-eared page, and possible signs of damage it may have incurred over the years, and then graded on a scale from 0.5 (poor) to 10.0 (gem mint). After examination, the comic receives a numerical grade corresponding to its condition and relative value, and is then encapsulated inside an archival-quality case that will help it stand the test of time. It should go without saying that CGC-graded comics command the highest prices upon resale, but you spent all that money to protect it in the first place, so it makes sense. Think of it like Jake Gyllenhaal in *Bubble Boy* but without the excessive running time.

Most importantly, be sure to account for the sheer square footage that collecting comics can require. I remember when I used to be able to see certain parts of my apartment, but those days are, unfortunately, long gone.

79 Bring Your Portfolio to a Comic Book Convention

Do you fancy yourself the next Jack Kirby? Looking to be the Neal Adams of your friend group? Want people to compare you to Alex Ross? Well, if you ever hope to have a chance of drawing Earth's Mightiest Heroes professionally for Marvel Comics, you need to put your best foot forward and that means compiling a portfolio, a collection of your best completed work that will represent you as an artist. Much like a writer pens sample scripts or you have a resume for most other jobs, an artist's portfolio is their calling card, a way of showing prospective employers exactly what they can do and why they'd make a solid addition to their team.

So, how do you stand out from the crowd of potential artists at a place like Comic-Con? First and foremost, do your homework. Every comics publisher has different guidelines and rules when it comes to portfolio submission and reviews. Generally speaking, publishers—Marvel included—don't accept blind submissions; there are pre-determined times and periods during which one can submit materials or apply for a portfolio review, which usually takes place at comic conventions.

C.B. Cebulski, Marvel's go-to talent scout, has been outspoken on Twitter and in interviews about what to do and what not to do if and when you get the opportunity to submit yourself for consideration.[402/403] Here are a few to get you off on the right foot:

- Don't approach an editor you don't know at a con with sketchbook or samples in hand. Start a conversation first, then ask if they'll look.
- As a new writer/artist, your goal shouldn't be to break in to Marvel, it should be to make good comics!

No Hotel? No Problem!

The only thing harder than trying to secure a ticket to San Diego Comic-Con is trying to find a hotel room that is within reasonable walking distance or isn't going to cause you to take out a second mortgage on your house. Much like the ticketing system, the hotel distribution is also based on an eldritch, arcane lottery system whose rules are likely known only by the Watcher himself. So, what do you do if you don't get a room? Don't freak out. If camping outside Hall H all weekend isn't your bag, you can take to the Internet to find a solution. Sites like Airbnb.com, Flipkey, and even some scrupulous Craigslist listings allow you to rent out an enterprising stranger's home or apartment for the duration of the convention for a nominal fee. The best part? Although you won't have a maid to clean up after you, you will have the entirety of an apartment to yourself, which will make for a more authentic San Diego experience. And no housekeeping means no bleary-eyed scrambles to throw on a bathrobe before an enterprising maid gets more than an eyeful of something she definitely isn't paid enough to see.

- Don't make excuses for your artwork while your portfolio's being reviewed. Take responsibility for what you put on the page. Listen and learn.
- Don't ever bring your portfolio to the bar after the con. When the show ends, work ends, and the creators and editors just want to unwind.
- Always include a cover letter and contact information with your submissions. Otherwise, if they think you're talented, they have no means of contacting you!
- What should your cover letter entail? Keep it short and simple, polite and professional.
- Always personalize any communication you have with editors. Use their names. Mass "Dear Editor" e-mails and packages tend to get trashed.

- Success in comics does not come overnight. Sometimes it takes years. One artist kept submitting for 7 years before landing his first gig.

If a lot of this sounds like common sense, that's because it is. There's no secret to breaking in to the comics business, but with dedication, hard work, networking, and the ability to take and implement constructive criticisms, you too could join the ranks of the House of Ideas and, who know, maybe even pen the next great Avengers book.

80 Get a Degree in Marvel Studies

Okay, okay, this chapter title might be something of a misnomer as you can't actually major in "Marvel Studies," but if you're attending the University of Baltimore, you can get course credit for studying the Marvel Cinematic Universe. In the spring of 2015, the university offered a first-of-its-kind class called "Media Genres: Media Marvels," which examines how Marvel Studios broke cinematic ground by creating an interconnected cinematic universe that shared plotlines, background stories, characters and more to create a cohesive vision. Beginning with *Iron Man*, students will examine the films, comics, and television shows that come together to create the audiovisual awesomeness that has us flocking to the box office. Plus, it beats the pants off hearing what the one kid in your Intro to Philosophy class has to say about Nietzsche.

You may be thinking to yourself, "Hey, I like *Avengers* comics and Marvel movies as much as the next guy, but why is this worthy of study?" According to class instructor Arnold T. Blumberg, it's

because the Marvel Cinematic Universe is becoming what *Harry Potter* and *Star Wars* were to previous generations—engrossing entertainment empires that touch on a wide range of issues, from morality to gender, entertaining and informing. "We have a generation coming of age with these characters and this completely mapped out universe," said Blumberg. "But no matter what your age, there is always a fantasy/sci-fi/superhero realm that helps you to explore your place in the world, your identity, and your ideals," he continued.

In 2008, Marvel released *Iron Man*. Six years later, in 2014, they released *Guardians of the Galaxy*, the studio's 10th film. Just as *Captain America: The Winter Soldier* examined the ways in which we are willing to trade freedom for security, "every issue facing our world today is encapsulated in deceptively simple morality tales featuring four-color comic book heroes whose stories stretch back to 1939," said Blumberg.

Given Marvel's planned release dates through 2019, as well as plans to continue the franchise over the next decades, and these films will continue to have a profound cultural impact and help shape the face of global popular culture. That impact is precisely what the course is looking to explore. "One thing we'll do is dive into the impact of the *Guardians of the Galaxy* film," said Blumberg in a press release. "[It] proved two things: mainstream movie audiences are not remotely tired of superhero movies; and Marvel Studios can now release a sci-fi adventure that actually features talking trees and raccoons." [404]

No word yet on what the syllabus entails (hopefully shawarma tasting), but word on the street is that there's an extra lecture after you receive the course credits. With that said, you should probably start looking in to how to transfer to the University of Baltimore and enroll in classes. Lucky for you, you've read this book, so you'll sound super smart in class.

81 The Onslaught Saga

Over the years, Marvel has generated thousands of issues of high-flying, larger-than-life comic book adventures that stretch the limits of imagination and took beloved characters to new narrative heights. Then again, there were some storylines in there that left fans wondering what in the hell they had just plunked down their $2.99 for. The 1990s was a particularly difficult decade for comics publishers, and Marvel was no exception. Mismanagement at the corporate level and rampant speculation on gimmicky cover collecting left the House of Ideas in a precarious place financially. As a result, many big-ticket event comics came out in an effort to renew fan interest and bolster sales. The result was two of the most universally reviled crossover events in Marvel's long history: Spider-Man's "Clone Saga" and the Marvel Universe–spanning "Onslaught," which are considered by many to have contributed to the industry-wide implosion of the '90s.

What began as an X-Men-specific crossover event in 1996 soon spiraled out of control to encompass the entirety of the Marvel Universe, including the Avengers, the Fantastic Four, and pretty much every superhero under the sun. Less of a coherent event and more of a way to completely revamp the Marvel Universe, "Onslaught" saw Professor Xavier, having had his mind wiped by Magneto in "Fatal Attractions," possessed by a psychic demon with godlike powers.[405] Seeking the powerful mutant Nate Grey (aka X-Man) and Reed Richards' and Sue Storm's son Franklin Richards (who possessed powerful reality-altering abilities), Onslaught had a very simple objective: kill everyone that isn't Onslaught. Sure, he may have had designs on ruling the world too, but he seemed way more invested in that whole kill 'em all scheme.[406]

After attacking the X-Men, nearly killing them, and destroying the X-Mansion, they formed an alliance with the likes of the Avengers and the Fantastic Four in order to put a stop to Onslaught's rampage. However, Onslaught was one step ahead of the heroes, unleashing an army of reprogrammed Sentinels on New York City, sealing all the exits, and manipulating Franklin Richards' powers into creating a massive fortress on top of Four Freedoms Plaza, the Fantastic Four's temporary headquarters. Before the assembled heroes could launch their strike, Onslaught detonated a massive electromagnetic pulse that decimated the city, and destroyed files known as the Xavier Protocols, a database which contained instructions on how to defeat all of the X-Men including Charles Xavier.[407]

With Franklin Richards' powers bolstering him, Onslaught evolved into a newer, deadlier form. The combined might of the X-Men, the Fantastic Four, and the Avengers managed to shatter Onslaught's armor, revealing Charles Xavier trapped within. Thor managed to wrest Xavier free, but this had the unintended effect of making Onslaught even stronger now that he was free of Charles' influence.[408] The Invisible Woman and Cable teamed up with Apocalypse, of all people, in order to try and rescue Franklin, but once they realized the villainous mutant was trying to murder Franklin, they pulled back and rethought their plan.[409] Meanwhile, all attempts to battle Onslaught fell short; when the Hulk led a charge against him, Onslaught used his psychic abilities to sow the seeds of doubt and distrust among his allies.[410]

Things continued going downhill for our poor, put-upon heroes. Sentinels took down the S.H.I.E.L.D. Helicarrier;[411] Franklin was manipulated yet again into generating constructs of some of the Fantastic Four's greatest villains that they then had to fight;[412] and the Avengers battled Holocaust, the son of Apocalypse, and narrowly prevented him from destroying the Vibranium psi-shields that Tony Stark was constructing;[413] and, worst of all,

Onslaught managed to lure Nate Grey out of hiding, using his powers to delve into Grey's mind and exploring his memories of his home reality, the Age of Apocalypse, a realm ruled by mutants that had still ended in nuclear war. Onslaught's mind was made up—neither man nor mutant was fit to rule the world, and thus they must all perish by his hand.[414]

Now, in a third and final form, Onslaught had imprisoned both Franklin Richards and Nate Grey, adding their power to his own, and resembled a hulking juggernaut with Magneto's helmet. With his powers at peak capacity, he created a second sun that was drawing ever-closer towards Earth; if it wasn't stopped, it would exterminate all life on Earth, human, mutant, and otherwise. The situation seemed dire to say the least. A glimmer of hope came when the Hulk punched Onslaught so hard he shattered his armor again, but it had the unintended side effect of unleashing a psionic blast that caused Bruce Banner and the Hulk to be separated. Onslaught was now exposed in his psychic form, and the world's heroes seized on the opportunity.[415]

Ever the scientist, Reed Richards noticed that whenever a mutant came into contact with Onslaught, his powers grew stronger, but normal humans/non-mutants were able to absorb and siphon away his powers. Armed with this newfound knowledge, the Fantastic Four, Dr. Doom, Captain America, Iron Man, Wasp, Scarlet Witch, Giant Man, Black Panther, Namor, the Falcon, Hawkeye, and Bruce Banner all entered into Onslaught's energy field and greatly weakened the monster. Waiting until the last moment, the X-Men attacked the severely weakened Onslaught, destroying the psychic creature in a gigantic explosion that seemingly killed all of the heroes contained within its blast radius. Before they were lost forever, though, Charles Xavier managed to rescue Nate Grey and Franklin Richards from the astral planar prison in which they had been trapped.[416]

YOLO hashtagging teens may want you to believe that you only live once, but the Marvel Universe is a bit more forgiving. The seemingly dead heroes weren't dead at all. Rather, they had been secretly transported to a pocket dimension called Counter-Earth by Franklin Richards at the moment of Onslaught's destruction. On Counter-Earth, the heroes lived lives largely similar to their own back on Earth-616. With the heroes of the main Marvel universe missing, the Masters of Evil rebranded themselves as a new team of superheroes called the Thunderbolts in order to fill the void. Of course, they were secretly plotting world domination, but honestly, what did you expect from the Masters of Evil wearing different costumes? The heroes of Earth would eventually return from Counter-Earth—as would Onslaught—but those are stories for another chapter.[417] As for whether we'll see any of this up on the big screen? Oh god, I hope not.

82 Live Your Favorite Superhero Stories with The Marvel Experience

Anyone who has ever watched a Marvel Studios film or thumbed through an issue of the *Avengers* has likely thought to themselves, "Man alive! If only I could experience the high-flying thrill ride of these comic book capers in real life with my family and friends!" Okay, you probably didn't word it in as preposterous a manner as I just did, but I was doing my best to channel Stan Lee's carnival barker style from the 1960s. Fortunately, there is a way that you can live out your favorite Avengers adventures in real life and you won't have to expose your body to lethal amounts of gamma radiation in order to do so! Welcome to The Marvel Experience.

Though there's something to be said for the kitschy pleasures of Ice Capades–style affairs with superheroes performing triple Lutzes in between pantomiming comic book stories, Marvel's live shows have evolved by leaps and bounds over the years. Nowadays, there are two main ways to live out your Marvel Comics fantasies: Marvel Universe Live! and The Marvel Experience.

Marvel Universe Live! is, well, exactly what it sounds like—a live arena show that brings together a diverse cast of characters in a battle for the fate of the Cosmic Cube. Assembling an array of heroes including the Avengers, Spider-Man, Wolverine, and many more against a coalition of supervillains including Loki, Doctor Octopus, Red Skull, Electro, and other evildoers, Marvel Universe Live! involves everything from explosions to elaborate stages to laser lights to mid-air stunt work, to motorcycle tricks, and beyond. Oh, and there's more stage combat than you can fake shaking a stick at.

The Marvel Experience is a brand new interactive exhibition that's being billed as "The World's First Hyper-Reality Tour." Honestly, you can't get much more Marvel than a phrase like "Hyper-Reality." The traveling show, produced by Hero Ventures, covers two acres and includes seven "colossal" domes that will put audience members in the shoes of a newly recruited Agent of S.H.I.E.L.D. Training alongside the likes of Spider-Man, Iron Man, and the Hulk, audience members will experience an interactive show in a 360-degree, 3D, stereoscopic projection dome before culminating in an epic showdown against the Red Skull, M.O.D.O.K., and agents of Hydra. With a museum of Marvel memorabilia and a life-size Quinjet too, the Experience is easily the most fun you can have battling Nazis short of joining a rival prison gang.

83 The Comics Code Authority

Much like the FCC regulates what you can and cannot say and what types of wardrobe malfunction are acceptable for broadcast television, the Comics Code Authority regulated for years and years what publishers could put in the pages of professional comic books. For nearly 60 years, the iconic Seal of Approval adorned comic book covers, showing that they had passed a rigorous set of standards and were worthy of publication, but then in 2011, they quietly disappeared. Resembling a stamp, the seal was emblazoned with the words "Approved by the Comics Code Authority," the regulatory wing of the Comics Magazine Association of America, and it was their way of responding to critics who decried their product as tripe that was contributing to the moral degradation of America's youth. And Marvel Comics is largely responsible for its demise.

In 1954, everything changed for the comic book industry. Critics had grown increasingly vocal over the perceived immoral content contained within comic books; whether it was excessive violence, the glorification of evil, scantily clad women, or uncouth behavior, everyone from the Catholic Church to popular psychiatrists like Dr. Fredric Wertham campaigned to ban the sale of comic books to children on the grounds that they lead to juvenile delinquency and desensitized youth to violence.[418] Perhaps the biggest opponent that comic books have ever faced, Dr. Wertham made Helen Lovejoy look like she had never thought of the children a day in her life. His 1954 book *Seduction of the Innocent* put comic books in the crosshairs, claiming that they were almost solely responsible for the degradation of the moral fiber of American youth.

Senate hearings followed, and the publishers acted quickly, wanting to remove themselves from the spotlight, establishing the Comics Magazine Association of America in 1954 and a regulatory code to go along with it.[419] Wholesalers fell in line too—they would only distribute comics that bore the official Seal of Approval, which meant that the rest of the industry had to fall in line or suffer the financial burdens of self-distribution. The code prohibited certain elements that one might expect—depictions of excessive violence, sexual content, and language—but also wholly unexpected elements too—e.g. the words "horror" or "terror" in the title were prohibited; the notion that good always had to triumph over evil was strictly enforced; the sanctity of marriage had to be upheld in any and all love stores; and the inclusion of monsters like vampires, zombies, and werewolves was a definite no-fly zone.

Marvel made waves in 1971 when it published a three-issue *Spider-Man* arc about drug abuse at the behest of the United States Department of Health, Education, and Welfare.[420] Though Stan Lee has gone on record saying Marvel simply told the CMAA to go fly a kite, official CMAA files indicate that Marvel had asked for permission to publish the storyline, but was denied. The comic didn't glamorize drug use; rather, it portrayed it as a dangerous social ill. Frustrated with the CMAA's refusal, Lee published the storyline anyway after getting the blessing of publisher Martin Goodman. The issues, which ran from May to July 1971, did not bear the Seal of Approval.[421] DC Comics editor in chief Carmine Infantino decried Marvel's decision at the time, but later that year, they rolled out *Green Lantern/Green Arrow* #85, emblazoned with the Seal of Approval and the words "DC attacks youth's greatest problem...drugs."[422] Let me tell you—the view from that Ivory Tower must have been great.

Though Marvel took some heat for their Spider-Man story, it lead to a reevaluation of the Code itself. The CMAA responded by lifting sanctions on horror comics (although you still couldn't use

the words in the title), relaxing its stringent regulations towards sex and sexuality, and adding a section concerning the proper way in which to depict narcotics. Though it wasn't a major reversal in what you could or could not portray in comics, it represented a step forward for an industry that had been subject to stringent and often unwarranted censorship. Periodic revisions followed, and the advent of direct market retail, in which publishers could sell directly to comic book stores and newsstands, meant that there was

Two kids add their comic book collection to the back of a pickup truck on February 26, 1955. The Women's Auxiliary of the American Legion scheduled a burning of such books, inviting children to bring in 10 books in exchange for a "clean" book. The scheduled bonfire brought protests from the American Civil Liberties Union and the American Book Publishing Council. (AP Photo)

DAN CASEY

a new avenue of sellers that were willing to accept comics that did not bear the official Seal of Approval.[423]

When the 2000s rolled around, advertisers no longer based their decision on whether or not to run ads on whether a comic bore the stamp, and that was the true death knell for the iconic symbol. In 2001, Marvel drove another nail into the coffin by officially withdrawing from the Comics Code Authority, opting instead to use an in-house ratings system.[424] By the time 2011 rolled around, there were only two publishers left printing the Seal of Approval on their covers: Archie Comics and DC Comics. In January 2011, DC announced they were dropping the Seal of Approval, and Archie followed shortly thereafter.[425] It was the end of an era, but a huge victory for free speech, allowing comic book publishers and creators to exercise their First Amendment rights by publishing whatever they wanted, regardless of the archaic, draconian standards of an outdated organization. So, on behalf of all comic book readers, thank you, Marvel. Thank you very much.

84 Talk Like a Comic Book Pro

While many *Avengers* fans are familiar with phrases like "post-credits stinger" (the scene after the credits in many Marvel movies) and "Phase 1" (the numerical groupings applied to a group of Marvel Films building towards a cinematic climax, usually an *Avengers* film), but with over 50 years of comic book continuity and jargon behind it, being a true *Avengers* fan can be a daunting prospect for the uninitiated. So, while you likely have the cinematic slang mastered better than Tony Stark knows advanced electrical

engineering, allow me to enlighten you as to some important comic book terms that you'll want to add to your lexicon.

Title: This may seem self-explanatory, but it's a synonym for "series." e.g. *Mighty Avengers, Uncanny X-Men,* etc.

One-shot: Also known as a "done in one," this refers to a single-issue, self-contained story.

Miniseries: A short comic book arc with a definitive endpoint, usually ranging from four to six issues.

Maxiseries: A longer series, usually ranging eight to twelve issues in length. The term was most popular in the 1980s and has since fallen out of popular use.

Imprint: A trade name under which a work is published, usually referring to a collection of titles meeting a set of specific criteria designed to appeal to a certain demographic. e.g. Marvel's MAX imprint created R-rated comic book content designed to appeal to adult readers.

Universe: A series of disparate titles and characters that are connected by operating in the same overarching world.

Crossover: A comic book storyline that stretches across multiple titles. The very first crossover was Marvel's (then Timely Comics) *Marvel Mystery Comics* #7–8, which brought together the Sub-Mariner and the Human Torch from their separate features into the same story.[426]

Event: Whereas a crossover usually implies a minimum of two titles coming together to form one cohesive story, an event is a crossover that is happening across an entire universe simultaneously with most or all of the individual titles participating. e.g. Marvel's *Civil War* or *The Infinity Gauntlet.*

Event Book: A separate book designed to contain a miniseries or maxiseries.

Tie-in: An individual issue of a title that has a link to an ongoing event that is more of a subplot than part of the main sto-

ryline. As in *Civil War*, these issues are used to show how an event is affecting other parts of a universe.

Retcon: A portmanteau of "retroactive continuity," a retcon is a narrative change made after the fact that changes a fundamental piece of comics continuity to either alter something the creators felt was not working or change a piece of the universe's history. e.g. after Peter Parker revealed his identity during *Civil War*, he made a deal with Mephisto to make it so no one knew his secret, which many fans referred to as a retcon.

Relaunch: Taking an ongoing series and—staying in continuity—renumbering it beginning with issue #1. This is usually a way of giving a comic a fresh start and getting new eyes on it without hitting the reset button on everything that preceded it.

Reboot: Taking an ongoing series or line of titles and hitting the reset button, effectively undoing everything that came before it in order to give a title or line of titles a fresh start. The most recent example is Marvel's recent Marvel NOW! initiative, which essentially hit the reset button on their complete title line, starting many titles over at #1.

85 Write Using the Marvel Method

So you want to write comic books, huh? Well, best of luck to you because it can be an extremely unforgiving field full of unexpected twists, turns, and plot developments—and that's before you ever put pen to paper. Nowadays, there's a wide variety of acceptable writing styles, but back in the 1960s, Stan Lee, Jack Kirby, and Steve Ditko pioneered a system of writing that would come to be

known as the "Marvel Method." Rather than creating a full script, the writer would provide a brief synopsis of the story to the artist, who would fill in page-by-page details as they saw fit. Then, after the fact, the writer would come in and insert the dialogue. It may seem counterintuitive or even an unwieldy method of collaboration, but it was one that became pervasive at the House of Ideas, lasting for years to come.

According to comics historian Mark Evanier, the Marvel Method was "a new means of collaboration" that was "born of necessity" as "Stan Lee was overburdened with work" and this new way of generating material also made use of "Jack's great skill with storylines."[427] Though many of Stan Lee's synopses were notoriously brief, leading to some discrepancies as to who wrote what down the line, that wasn't par for the course, according to writer/editor Dennis O'Neil. "In the mid-'60s, the plots were seldom more than a typewritten page, and sometimes less," he explained. In the following years, though, "[writers] might produce as many as 25 pages of plot for a 22-page story, and even include in them snatches of dialog." Thus, the Marvel Method ran the gamut in terms of the burden it placed on writers, which was admittedly not as great of a burden as it was on artists.

Though many artists felt unfairly taxed by the Marvel Method, others felt that it was beneficial as a means of creativity because the artist's eye for the cinematic and sense of visual excitement would be better suited to determining how a given scene should unfold. Whether or not you agree with the method, it's hard to deny its effectiveness. The biggest gripe among artists is that they were being paid for art and art alone, rather than being given a co-writing credit or salary after they did a majority of the narrative heavy lifting. Still, whether or not you agree with the efficacy of the Marvel Method, it is difficult to deny its effectiveness. Considering it yielded classics like Spider-Man, the

Fantastic Four, the Avengers, and countless others, it's difficult to imagine a world in which the Marvel Method didn't exist. In fact, if it had, Stan Lee would likely still be slaving away over a hot typewriter to this day.

86 Ultimate Marvel

Throughout the book, you have likely seen several references to Earth-616 and Marvel's Ultimate Universe (Earth-1610). These are references to two distinct realities that exist within the larger Marvel Universe, often referred to as the Multiverse. The Ultimate Universe exists parallel to the main continuity, and in recent years, has begun to bleed into the primary continuity. With the rollout of Marvel's company-wide Marvel NOW! initiative, which essentially rebooted their entire product line, it's unclear as to the fate of the Ultimate Universe, but its legacy is intrinsic to the success of the Marvel Cinematic Universe and the way the House of Ideas has navigated the modern era.

The year was 2000 and the entire comics industry was in a slump as a result of the market crash caused by speculation on limited-edition covers and oversaturation. Marvel had recently emerged from the throes of bankruptcy, but there was a beacon of hope on the horizon in the form of a live-action *X-Men* movie coming that summer and a *Spider-Man* film the year after. Recently appointed Marvel president Bill Jemas took one look at the X-Men books—with complicated storylines and a sprawling cast of characters—and felt it was incomprehensible. "I went to Harvard law," he told a group of editors. "If I can't understand it, it's not because of me."[428]

Although Jemas, for a time, considered completely hitting the reset button on the Marvel Universe, they eventually settled on a parallel line of comics called the Ultimate Universe. It was designed with the modern reader in mind, updating storylines and revamping origins to make them more accessible to a new reader who was put off by 50-plus years of back issues and labyrinthine continuity. At Joe Quesada's suggestion, Brian Michael Bendis was hired to pen *Ultimate Spider-Man* and Mark Millar was tasked with writing *Ultimate X-Men*.

When the *X-Men* film released, it grossed $75 million in its first weekend, but the comic line saw no tangible increase in sales. Production delays on the comic and Fox moving up the release date of *X-Men* combined to create a perfect storm of missed opportunity

Brian Michael Bendis, the primary architect of the Ultimate Universe.
(Bobby Bank/Getty Images)

that led Marvel to miss its synergistic release window. However, after the initial speed bumps, the Ultimate Universe comics soon began building a sizable following and amassed a broad catalog of titles including *Ultimate Fantastic Four, Ultimate Iron Man,* an *Ultimate Galactus Trilogy,* and many more.

In the Ultimate Universe, Earth was bereft of superheroes until the late 20th century when there was a sudden and marked upswing in vigilante activity. The emergence of superhumans and mutants drove the public into a state of anxiety and hysteria, and led to a widespread backlash against anyone displaying "genetic aberrations."

The United States government responded in kind by creating S.H.I.E.L.D. and tasking Nick Fury (who bore a striking resemblance to Samuel L. Jackson) with monitoring and regulating "any unauthorized genetic mutations" over the age of 18. Select superpowered individuals were regulated and organized into state-sponsored Ultimates teams (akin to the Avengers). Those who did not comply could be treated as criminals by the U.S. government and hunted down.[429]

For the most part, the changes to the Marvel Universe were mostly cosmetic. Peter Parker was reimagined as a skateboarding teenage science prodigy who was bitten by a genetically engineered spider rather than a radioactive one. He still worked for the *Daily Bugle,* but as a webmaster for the eBugle rather than a photographer for the paper. At its core though, Bendis managed to capture the same angst and raw emotion of the original Stan Lee and Steve Ditko stories that enthralled a generation of comics readers.

Over the years, the Ultimate Universe has generally skewed a bit darker and more mature than its Earth-616 counterpart. Ultimate Captain America, depicted as something of a gung-ho jingoistic thug, once infamously uttered, "Surrender? You think this letter on my head stands for 'France'?" In 2009's *Ultimatum,* Magneto unleashes a massive tsunami on New York City that kills

millions, including Daredevil, Nightcrawler, and Dazzler. The body count only grows exponentially from there and ends with a mysterious assassin fatally shooting Cyclops in the head while speaking before a crowd of anti-mutant protestors. So, yeah, it's safe to say that things get pretty dark.

It isn't all doom and gloom though; Ultimate Marvel has also led to breakthroughs like the "Death of Spider-Man" in which Peter Parker perished and was succeeded by the half-Latino, half–African American Miles Morales, who has been one of the most celebrated, progressive new characters in Marvel's modern canon. Furthermore, the Ultimate line's photorealistic look became the industry standard, particularly for Marvel, as they moved toward more of a cinematic aesthetic. And as Marvel Studios kicked into high gear, they would carry many of the lessons learned from this line with them, seamlessly weaving elements of both the Ultimate line and Marvel's Earth-616 continuity into the Marvel Cinematic Universe we know and love today.

87 The Illuminati

Who keeps Atlantis off the maps? Who keeps the Martians under wraps? We do! We do! Okay, okay, so maybe that's the Stonecutters, but *The Simpsons* aren't the only one with a secret society pulling strings from behind the scenes to make sure their Machiavellian meddlings come to pass. The Marvel Universe has plenty of them—the Elders of the Universe, Hydra, the Shadow Council—but perhaps the most important one is actually comprised of some of the world's most powerful heroes. They are the Illuminati.

Assembled by Tony Stark and Black Panther in the wake of the Kree-Skrull War in order to combat and prepare for these kinds of universe-threatening crises, the Illuminati quickly transformed into more of a covert cabal that would meet in secret to determine how each of the world's supergroups should respond.

The original lineup included Doctor Strange, the Sorcerer Supreme; Namor, the Sub-Mariner and King of Atlantis; Iron Man; Reed Richards, the Fantastic Four's Mr. Fantastic and de facto leader; Black Bolt, King of the Inhumans; and Charles Xavier, the founder of the X-Men. T'Challa, the Black Panther was instrumental in bringing these men together when they first met in Wakanda, but was the only of the assembled to outright refuse to join on the basis that a secret organization would lead to corruption down the line.[430]

According to group creator Brian Michael Bendis, they were chosen because they each represent a different facet of the Marvel Universe:

"Namor, of course, is the king of 75 percent of the planet and represents a certain mindset; Tony Stark represents a certain type of hero—the Avenger type of hero, one who understands and appreciates that heroes can work with the government, rather than outside of it; Reed is the 'science' side of the heroes; Black Bolt represents the Inhumans, which are an important part of Marvel history and an important part of things that are to come, as was hinted at in *House of M*; Dr. Strange speaks for the mystical side of the Marvel universe; and Professor Xavier is there for the mutants. They all bring with them a unique viewpoint and perspective that isn't shard by the others."[431]

The Illuminati has indeed had their hands in many major events in the Marvel Universe, for better or for worse. When Mr. Fantastic secretly assembled all of the Infinity Gems and failed to will them out of existence, he distributed them to each member of the Illuminati to hide so that they can never be combined and used

The Illuminati: Charles Xavier, Reed Richards, Iron Man, Doctor Strange, Black Bolt, and Namor.

again.[432] They also created a powerful antimatter bomb capable of destroying an entire reality to be used when converging universes threatened to destroy the Earth-616 universe.[433]

Most infamously, though, they were responsible for the events known as World War Hulk. Approached by S.H.I.E.L.D. director Maria Hill after the Hulk destroys Las Vegas, the group formulates a plan to blast the Hulk deep into space to an uninhabited planet as a containment mechanism. Professor X abstained from the voting as he was not on Earth at the time, and Namor was the only one who objected, reasoning that they had no right to banish their ally.[434]

As it turns out, Hulk did not land on the intended planet, but rather a world of Hulk-like creatures where he rose through

the ranks of their gladiatorial combat system to become their king. It seemed as though Hulk had found peace, but one day the shuttle the Illuminati sent him there in explodes, wiping out most of the planet's populace, including Hulk's pregnant wife Caiera Oldstrong. You wouldn't like him when he's angry, but now the Hulk is blindingly furious. So, with vengeance in his heart, Hulk leads an army to Earth where he battles Iron Man (in his new "Hulkbuster" armor), defeating his one-time ally and destroying Stark Tower in the process. One by one, all the members of the Illuminati (save for Namor and Professor X) fall to the Hulk and his forces. Outfitted with obedience disks, they are made to battle one another, stopping just short of fighting to the death.[435] They are saved in the nick of time by an orbital strike from a prototype defensive satellite that Tony Stark had secretly launched. [436] Still, the damage was done and the Illuminati was shamed. There's definitely a lesson to be learned here—probably something like "just leave the Hulk alone already, will you?"—but knowing the Illuminati, they will continue to meet in secret and make the tough decisions that others cannot and will not make.

88 Vibranium

Thor's hammer is made of uru metal. Wolverine's razor-sharp claws are made of adamantium. The Hulk's purple pants are made out of a cotton/polyester blend (presumably). Yet, in the Marvel Universe, there are few substances more highly sought after than vibranium. Both on the big screen and on the printed page, vibranium is one of the most durable, strongest materials in the Marvel Universe. It may not be as durable as adamantium, but it can absorb more

force, which makes it one of the most highly prized substances in all the land.

First introduced in *Daredevil* #13, vibranium first appeared on Earth by way of a meteorite over 10,000 years ago. A variety of vibranium that absorbs soundwaves, vibrations, and kinetic energy was discovered in the African nation of Wakanda by King T'Chaka, the father of T'Challa, who you know better as the Avengers' Black Panther. Given its incredible rarity and value, T'Chaka concealed his country's natural cache of the resource from the outside world, opting instead to sell it off in extremely small quantities from time to time. As a result, he was able to heavily invest in Wakanda's infrastructure, making it one of the most technologically advanced, well-educated nations in the world.[437]

In the 1940s, an American scientist named Myron MacLain was enlisted by the United States government to create new tank armor by fusing iron and vibranium. His efforts proved unsuccessful, and after laboring for months, he fell asleep one night in his lab. While he was snoozing, an unknown chemical agent mixed in with the iron and vibranium, resulting in the alloy that would be used to create Captain America's shield. MacLain sought for years to duplicate the process, and though he never managed to duplicate it exactly, he did create adamantium while trying to replicate his past success.

Although we most frequently associate vibranium with Wakanda, there is another version called Antarctic vibranium too. While Wakandan vibranium absorbs energy and disperses it into its molecular bonds, Antarctic vibranium emits vibrations that cause the atomic bonds in nearby metals to weaken and sometimes liquefy. Better known as Anti-Metal, it was first discovered during an expedition to Antarctica, and later tracked to the Savage Land.[438] A powerful, dangerous substance, it was targeted by the Skrulls during their Secret War; posing as S.H.I.E.L.D. agents, they enslaved the local populace of the Savage Land and forced

them to harvest it.[439] Thankfully, not even the might of Anti-Metal could help the Skrulls when they attempted to invade Wakanda. This was neither the first time nor the last time Wakanda would face the threat of invasion at the hands of bloodthirsty madmen trying to get their hands on their vibranium. Then again, it helps tremendously when your sovereign ruler is a member of Earth's Mightiest Heroes.

89 Marvel vs. DC

No matter what walk of life you come from, it's more than likely that you've spent an embarrassing amount of time arguing with friends and co-workers over who would win in a fight, Batman or Captain America? Hulk or Superman? Wolverine versus…well, anyone really? In 1996, DC Comics and Marvel Comics teamed up to put some of these long-simmering debates to rest once and for all in a four-issue limited crossover series called *Marvel vs. DC Comics* (technically, the first and last issues were *DC vs. Marvel Comics*). In Mike Carlin's introduction to the *DC vs. Marvel Comics* collected edition, he recounted that 30 editors from Marvel and DC had to sign off on the story. To put things in perspective, only 29 editors had to sign off on this book, and that is still way too many editors. Penned by Ron Marz and Peter David and illustrated by Dan Jurgens and Claudio Castellini, *Marvel Comics vs. DC* promised to pit each respective universe's most popular heroes against one another in a series of knockdown, drag-out fights in which the outcome would be determined by popular vote and mailed-in readers' ballots. In short, it was everything I'd ever wanted as an eight-year-old.

Those Who Are Worthy

Captain America has his shield. Iron Man has his armor and repulsors. The Hulk has his...purple jorts. And, Thor has his mighty hammer Mjolnir. The mythical weapon, forged by Dwarven blacksmiths of the Asgardian metal *uru*, bears the inscription "Whosoever holds this hammer, if he be worthy, shall possess the power of Thor" on its base. Many have tried to wield the magnificent maul over the years, but only a few others than Thor himself have proven themselves worthy to hold it.

The first to raise it up was Beta Ray Bill, a member of the alien species known as Korbinites. Thereafter, Captain America, Eric Masterson (better known as Thunderstrike), Storm, Conan the Barbarian, Odin (Thor's father), Bor (Thor's grandfather), Buri (Thor's great-grandfather), Superman, Wonder Woman, Rogue, and several sentient constructs have all proven themselves worthy over the years. Most recently, Thor disgraced himself by opening the Tenth Realm to rescue his long-lost sister Angela, paving the way for a new, as-yet unnamed female Thor to take up the hammer in his stead. One thing's for certain though—no one can rock long blond locks and a breastplate quite like the original.

(Beta Ray Bill: Thor #337; Captain America: Thor #390; Storm: To Serve and Protect #3)

The conceit was simple: the fabric that separates the Marvel and DC universes was tearing and they were beginning to bleed into one another. Characters from each respective universe began popping up in familiar yet foreign locations. Spider-Man was swinging through the streets of Gotham City, J. Jonah Jameson wound up in Metropolis and promptly became editor-in-chief of the *Daily Planet,* and Wolverine and Gambit stole the Batmobile while Batman and Robin were distracted inside a Warner Bros. store. All the while, a brand new character from Marvel named Access, wielding the power to move between the two universes, appeared and tried his damnedest to keep things from getting too out of hand. Never mind the weird new environs our heroes found

themselves in; *Marvel Comics vs. DC* was a silly, lighthearted affair that was chock-full of fan service, in-jokes, and fanboy fights that people wanted to see.

Two brothers, one red and one blue, cosmic entities that represented the DC and Marvel universes, became aware of each other's existence and decided to challenge one another by putting forth their mightiest champions to see who was the strongest of them all. This wasn't a battle to the death though; in order to win, the champions had to fight until they had immobilized their competitors. After 11 battles, a winner and loser would be declared. The losing universe would simply cease to exist, which is about as high stakes as you can get in a situation like this. The editors of the book decided the outcome of the first six battles, but the final five were determined by the aforementioned audience vote, lending an element of democracy to the proceedings.

The first six fights, which lasted two to three pages apiece before a winner was declared, were between Thor and Captain Marvel, Aquaman and Namor, Flash and Quicksilver, Robin and Jubilee, Catwoman and Elektra, and Silver Surfer and Green Lantern. Thor, Elektra, and Silver Surfer emerged victorious for Marvel, while Aquaman, Flash, and Robin took down their challengers for DC. Thus, it all came down to the final five bouts, which pit the heavy hitters of both universes against one another: Lobo versus Wolverine, Wonder Woman and Storm, Spider-Man and Superboy, Hulk and Superman, and Batman fought Captain America.

Although Wonder Woman was wielding Thor's mighty hammer Mjolnir (which had the noticeable side effect of causing most of her clothing to disappear), Storm managed to weather her barrage of blows and emerge victorious. Obviously, Wolverine defeated Lobo, and Spider-Man managed to defeat Superboy too (in spite of the fact that it wasn't Peter Parker under the mask, but the ill-liked Ben Reilly). Kryptonite may be green, but

that's all the Hulk had in common with Superman's weakness as Superman handily defeated the angriest Avenger. Last but not least, Batman was able to take down Captain America with a well-timed Batarang to the neck. While technically, Marvel had emerged victorious by a margin of six to five, DC did not simply disappear. Access used his dimension-hopping powers to merge the two universes into one gloriously strange fusion known as the Amalgam universe.

For one week, Marvel and DC ceased their normal operations and put out a series of jointly published one-shots under the banner of Amalgam Comics. These one-off stories followed the events of the newly fused characters like Super Soldier (Superman and Captain America), Dark Claw (Batman and Wolverine), Dr. Strangefate (Dr. Strange and Dr. Fate), and Dr. Doomsday (Dr. Doom and Doomsday). And how could we forget Captain Marvel, the glorious fusion of Captain Marvel and Captain Marvel? The writers took the joke so far that each issue included a letters page full of fake letters from fake fans arguing over fake continuity in this new blended universe. At the end of the day though, Access was able to separate the two universes back into their original states. Impressed by each other's offerings, the two cosmic brothers simply shook hands, said "You've done well," and called it a day. Now only if we could get real-life conflicts to end as cleanly. Maybe the key to peace in the Middle East is sending them a goofy four-issue American comic book miniseries from 1996!

90 JLA/Avengers

When it comes to big-ticket superhero teams, the Justice League of America and the Avengers are like peanut butter and chocolate—two great tastes that taste great together. Well, this simile also presumes that typically peanut butter and chocolate exist in a universe unto themselves. Given that the Avengers started as a pale imitation of DC Comics' Justice League of America, it's fitting that the two would eventually come together. Indeed, people have long wondered what a Justice League of America and Avengers crossover event would look like and, no, 1996's *DC Comics vs. Marvel* definitely does *not* count regardless of how much silly, over-the-top fun it was. In 2003, it happened for real and a four-issue crossover event took place, co-published by Marvel Comics and DC Comics. Little did you know, though, *JLA/Avengers* was an event nearly 20 years in the making.

In 1979, DC and Marvel agreed to co-publish a crossover series starring their premiere superhero teams, written by Gerry Conway and featuring art by George Perez. Set to be a time travel story involving Marvel's Kang the Conqueror and DC's Lord of Time, work began on the book in earnest with Roy Thomas scripting the series based on Conway's plot and a scheduled release date of May 1983.[440] Although Perez had already penciled 21 pages by mid-1983, editorial disputes, purportedly caused by Marvel's contentious then-editor-in-chief Jim Shooter, derailed the project and prevented it from coming to pass. The cancellation of the original *JLA/Avengers* project also led to the axing of a planned sequel to 1982's *The Uncanny X-Men and The New Teen Titans* crossover.[441] In 2002, the two companies reached an agreement, and a new story

from Kurt Busiek with George Perez handling the art was in the works.

The story followed Krona, an exiled Oan (the blue-skinned aliens that granted Green Lantern his powers) who travels across the multiverse, destroying entire universes in order to seek the truth of creation itself. Arriving in the Marvel Universe, Krona encounters a cosmic being known as the Grandmaster, who challenges Krona to a game in order to save his universe. If Krona wins, the Grandmaster will lead him to a being who has witnessed creation itself. If he loses, Krona must spare the Marvel Universe. Each player will have a team of champions to represent their respective universes, but at the last moment Krona throws a wrench in the works, swapping champions so that the Avengers will play for Krona and the Justice League will play for the Grandmaster. In essence, if the Avengers want to save the universe, they must lose this cosmic game of chess.

The Justice League is tasked with retrieving 12 items of incredible power, six from each universe. Likewise, the Avengers are told they must stop the Justice League from completing their task if they want to prevent the world from being destroyed. The six items from the Marvel Universe are the Ultimate Nullifier, the Casket of Ancient Winters, the Evil Eye of Avalon, the Wand of Watoomb, the Cosmic Cube, and the Infinity Gauntlet. The six wondrous items from the DC Universe are the Book of Eternity; Kyle Rayner's Green Lantern Power Battery; the Orb of Ra; the Spear of Destiny; the Psycho Pirate's Medusa Mask; and the Bell, Jar, and Wheel of the Demons Three.

While in the Marvel Universe, the Justice League is horrified at the Avengers' apparent failure to transform their Earth into a better place. Meanwhile, in the DC Universe, the Avengers are surprised to see the seemingly futuristic paradise in which they live, as well as the revered position the Justice League occupies in their society.

Earth's Mightiest Heroes become convinced that the Justice League must be some sort of fascist organization that forced people to worship them as gods. Kind of rich coming from people that wear brightly colored spandex and live in a mansion in Manhattan, but the grass is always eviler on the other side, so they say.

A series of pitched battles takes place across both universes as varying combinations of Justice Leaguers and Avengers battle each other for control of the powerful artifacts. A massive battle in the Savage Land for control of the Cosmic Cube takes place and seemingly ends with Quicksilver claiming the Cube just as the Grandmaster and Krona arrive, remarking that the match is deadlocked at 6–6. Unbeknownst to the others, Batman and Captain America had been working together to investigate why the contest was taking place. Arriving before it's too late, Captain America purposely throws his shield at Quicksilver, knocking the Cube from his hands into Batman's clutches. With the score now at 7–5, the Grandmaster declares the Justice League the victors. Unwilling to accept defeat, Krona reneges on the deal, attacking the Grandmaster and, learning that the being who has witnessed creation is none other than Galactus, proceeds to summon the world-eater. Before Krona can destroy Galactus though, the Grandmaster uses the power of the assembled artifacts to merge the two universes.

Sorry, Amalgam-verse fans—there aren't any silly superhero mash-ups to be found here. In the newly created universe, the Justice League and the Avengers are longtime allies, traveling between their worlds in order to combat threats as they arise. However, the universes are inherently incompatible and they begin eating away at one another, destroying themselves in the process. The Phantom Stranger appears to lead the heroes to the Grandmaster, who informs them that he imprisoned Krona within the 12 artifacts, but Krona is using their power to merge the universes even further in

an attempt to create another Big Bang from which he could learn the secrets of creation itself.

In a final showdown, Captain America leads a coalition of every hero that has ever been a member of both the Avengers and the Justice League against Krona. The presence of so many heroes from disparate universes causes a chronal disturbance and various villains from the teams' pasts begin appearing to do battle with them. Though the heroes are falling one by one, Krona is eventually defeated when the Flash distracts the being long enough for Hawkeye to shoot an explosive arrow at the machine Krona used to keep the universes merged together. With the help of former Green Lantern Hal Jordan as the Spectre, the universes are returned to normal, and Krona implodes, transforming into a cosmic egg that will one day hatch into a new universe. When it does hatch, Krona will learn the secrets of creation by being a literal part of it, so everybody gets want they want in a manner of speaking. Well, Krona probably didn't want to be part of a balanced primordial breakfast, but just like beggars, megalomaniacal cosmic tyrants can't be choosers. The two supergroups part on amicable terms, admitting that whether they agree with the other's approach to defending their respective universes, the fact that they are taking a stand against evil is something of which they should be proud. That's all well and good, but 10 years later I'm still waiting for the sequel, *JLA/Avengers 2: The Cosmic Omelet.*

91 The Rights Stuff (aka Why We'll Never See *Avengers vs. X-Men*)

Ever since *X-Men* made box office history in 2000 by bring-ing superhero cinema into the mainstream, fanboys and fangirls across the land have been wondering when we'd see Spider-Man, Wolverine, and Iron Man going blow for blow and quip for quip on the same screen. The answer is, unfortunately, likely never. Long gone are the days of *Who Framed Roger Rabbit?* when mul-tiple studios were willing to come to a profit-sharing arrangement in order to fill the cinematic canvas with a cavalcade of their most iconic characters. Nowadays, every studio is trying to create a self-sufficient shared cinematic universe of their very own, and they don't have much of an interest in taking a diminished cut of the profits when they could take 100 percent for themselves. Why is this the case? It all started in 1971.

In the fall of 1971, then-publisher Chip Goodman licensed Marvel's characters to a concert promoter named Steve Lemberg who had designs to adapt them for musicals, radio plays, films, and more.[442] For a clearinghouse price of $2,500 (with the ability to renew indefinitely and complete, exclusive creative control over the characters), Lemberg laughed it up, saying, "I owned more rights to Marvel than Marvel had." Talk of a *Thor* radio series, a $2.5 million live arena show, and a Silver Surfer movie starring Dennis Wilson of the Beach Boys fame were all floated, but little came of these grand designs apart from a goofy Spider-Man rock album and a disastrous live show at Carnegie Hall.[443]

Marvel's new owners, Cadence Industries, managed to take back the rights from Lemberg, but this was the beginning of a pattern of packaging and selling off the rights piecemeal to make a quick buck that would repeat itself several times before we reached

the modern era. In 1976, CBS optioned two low-budget TV pilots based on Spider-Man and the Incredible Hulk, which went on to moderate success but were limited by the technology and budgets at the time. Other plans for Marvel TV properties fell through as networks balked at being perceived as too cartoonish; a *Human Torch* show was preemptively abandoned because CBS feared it would lead children to set themselves on fire.[444] A string of flops (*Howard the Duck*) and low-budget films (*Captain America* and a never-aired *Fantastic Four*) that were quietly shuffled on to home video followed, much to the Hollywood-obsessed Stan Lee's chagrin.[445]

It wasn't until then–Toy Biz CEO Avi Arad came into the picture in the early 1990s that Marvel's fortunes began to turn around. Arad and Toy Biz had been co-producers on the highly successful animated *X-Men* television series, and were very vocal throughout the production. Alongside Toy Biz co-owner Isaac Perlmutter, Arad negotiated a deal that saw Marvel acquiring 46 percent of Toy Biz in exchange for a master license to Marvel's massive catalog of characters of which they could make toys exclusively and royalty free.[446] Arad acted as a liaison between Hollywood and Marvel, and before long James Cameron was penning a *Spider-Man* treatment, Wesley Snipes was attached to star in *Black Panther*, and Wes Craven was lined up to direct *Doctor Strange*. By 1993, Arad helped establish Marvel Films, the publisher's first-ever in-house film wing, and it seemed like the House of Ideas was off to the races.[447]

Then-CEO Ron Perelman balked at the idea of getting into the expensive, often risky business of film production, and preferred to license the characters and properties to third-party studios instead, simply reaping the merchandising benefits. Soon, he reached an agreement with 20th Century Fox to produce a live-action X-Men film, and that would eventually wind up being the Bryan Singer–directed *X-Men*. When Arad heard that director Roger Corman's horrifically low-budget *Fantastic Four* film was set to come out

soon, he quickly paid off the producers and ordered every copy to be destroyed in order to avoid irreparably damaging the brand name. In 1996, Marvel Films became Marvel Studios and they focused on consolidating pre-production in an effort to exert more control over the process and keep it in-house before packaging it to studios.

After the success of 2000's *X-Men,* films began rolling out based on properties like *Blade* and *Fantastic Four.* All the licensing, though, led to reduced profits: by 2005, Columbia had produced *Ghost Rider* and two *Spider-Man* films; Fox had three *X-Men* films, *Daredevil, Elektra,* and *Fantastic Four;* New Line had three *Blade* films, but Marvel only saw a fraction of the profits. It wasn't until *Iron Man* that Marvel fully financed a film, but they had made the decision into their current model of focusing on core characters and building them up individually before bringing them together in *Avengers.* Arad quit, cashed out his stock, and walked away $59 million richer a year later, but the groundwork had been laid.[448]

As it stands now, the Marvel catalog is spread across three primary studios: Disney/Marvel, Fox, and Sony. Fox controls the Fantastic Four (including Doctor Doom, Silver Surfer, Galactus, and Annihilus) and the X-Men (including Deadpool); Sony has the rights to the complete Spider-Man universe; Lionsgate has the rights to Man-Thing (yes, Man-Thing); Universal holds the rights to Namor and his undersea kingdom; and Disney/Marvel Studios has the rights to every other Marvel character under the sun.[449] There are a few interesting exceptions and shared rights with characters like Wanda Maximoff and Pietro Maximoff, aka Quicksilver and Scarlet Witch. Since Fox technically owns the rights to the word "mutant" and all those connotations, the Quicksilver and Scarlet Witch you see in *Avengers: Age of Ultron* will be some of Earth's Mightiest Heroes, but they will neither be related to Magneto nor will they be mutants. Confusing, right?

With so many complex contracts and divvied up properties, it makes it difficult to imagine seeing certain classic comic book storylines up on the big screen, hence the move towards each studio taking a franchise and creating their own universe of films around it. Still, anything is possible. Marvel Studios president Kevin Feige confirmed in an interview that he would love to see a silver screen crossover. "I would say, not any time soon would we be in a position to team up with other studios who have a few of our characters, because we have so many characters ourselves," said Feige. "But I would never say never."[450] As we've now seen from Sony's recent co-producing agreement with Marvel Studios that let Spider-Man swing his way into the MCU, anything is indeed possible.

92 Avi Arad

While Marvel Studios president Kevin Feige gets much of the credit for transforming Marvel's film wing from bargain basement to box office behemoth, there is another man, without whom, none of this would be possible: Avi Arad. As you learned last chapter, Avi Arad is one of the most essential factors to the success of Marvel Studios as we know it today. In fact, Arad was one of the studio's co-founders, shepherding the fledgling film unit through its early days and helping to shape the Phase 1 slate that led us down the winding road to *Avengers*.

Outspoken, but rarely outsmarted, the Israeli-American businessman is a shrewd operator who recognized early on that Marvel was sitting on a goldmine. In the early 1990s, he and his Toy Biz co-owner Ike Perlmutter negotiated a deal that brought their toy manufacturer and Marvel closer together, securing an exclusive

master contract to produce toys based on their catalog of nearly 5,000 characters. In 1993, he became head of Marvel Films, which evolved into Marvel Studios, spearheading the company's push into meaningful television and film projects. In 1998, he and Perlmutter swooped in to rescue Marvel from bankruptcy, taking control of the company and heading up Marvel Entertainment.

Much like Feige, Arad had a deep and abiding love of the characters—he understood them in a way that others did not. When an early version of the *Spider-Man* script saw the wall-crawler slashing someone's throat, Arad was quick to put the kibosh on it. "That would be the end of everything," he told the screenwriters. "Spider-Man kills nobody."[451] What sets Arad apart though is his business savvy—when he saw that Columbia pulled $1.6 billion worldwide from *Spider-Man* and *Spider-Man 2* alone, while Marvel only received $75 million and nothing from home video releases, he knew things needed to change. "Nobody knows better than us how to make our characters come alive for audiences," he said. "We just want to get paid for it."[452] And get paid, they most certainly did.

At his behest, the plan he had concocted with Marvel's then–chief operating officer David Maisel went into effect: using $525 million in capital from Merrill Lynch, Marvel Studios would create its own films based on 10 of its characters and put up its own movie rights as collateral. It was a big risk, but it paid off in spades. Though growing rifts between Arad, Perlmutter, and Maisel ultimately led Arad to depart in 2006, his work was done.[453] Having reacquired the rights to *Iron Man* from New Line, they fast-tracked the film and on May 2, 2008, the Robert Downey Jr.–starring *Iron Man* hit theaters and made $100 million on opening weekend.[454] The credits rolled, and out strolled Samuel L. Jackson as Nick Fury teasing the future of Marvel's feature films with three simple, electrifying words: "The Avengers Initiative." Fast-forward to May 2012: *The Avengers* shattered records and delivered the biggest

opening weekend box office in history, and grossed $1 billion worldwide naught but a week later.[455]

Arad's legacy speaks for itself, and though he may no longer be at Marvel Studios, he is still producing films with them, as well as other independent projects. With a slate based on major video game properties like *Uncharted*, *inFAMOUS*, *Metal Gear Solid*, and *Mass Effect* on the way, it's safe to say that Arad is continuing to put fans first and will likely be laughing all the way to the bank.

93 The No-Prize

Ask any Marvel fan who has been collecting since the Stan Lee and Jack Kirby days about the greatest prize they could win from the House of Ideas, and chances are they'll say a mint-condition copy of *Amazing Fantasy* #15 signed by Steve Ditko. But, after some digging and prying, eventually they'll likely relent and tell you it's the Marvel No-Prize. First implemented in 1964, the No-Prize was a faux award originally given out by Marvel Comics to readers who had spotted continuity errors in Marvel's rapidly growing line of books and increasingly interconnected storylines. As it evolved, the nature of the prize changed to reward those readers for their "meritorious service to the cause of Marveldom," meaning they wrote in not just to point out continuity errors, but to find ways to creatively explain away how the errors were not errors at all.

Originally, Stan Lee would award the No-Prize in the letters column by printing the letter and letting the writer know they were the recipient of a genuine Marvel No-Prize. According to editor Mark Gruenwald, the No-Prize changed in nature over time because "some of those who were awarded them in print wrote in

to say that they hadn't actually received the No-Prizes they were promised."[456] So, Stan Lee obliged his eager editors-in-training by mailing them an envelope that was marked "Congratulations! This envelope contains a genuine Marvel Comics *No-Prize* which you have just won!" Of course, the envelope itself was empty, hence the joke. The envelopes became something of a collector's item among hardcore Marvelites, but there were still a few people who were slow on the uptake and wrote the House of Ideas to say, "What gives? My No-Prize envelope was empty!"[457] You should not befriend those people.

Marvel, always able to laugh at itself (well, usually able), even put out a book in 1982 called *The Marvel No-Prize Book* #1. Subtitled "Mighty Marvel's Most Massive Mistakes," it was printed with a deliberately upside-down cover and cataloged some of Marvel's weirdest continuity errors. For example, in *Daredevil* #29, Daredevil was drawn for one panel only with a gun and a holster; in *X-Men* #2, Beast wore gloves for some reason; in *Amazing Spider-Man* #2, Peter Parker was referred to as "Peter Palmer," and one issue later Doctor Octopus accidentally called him "Super-Man." As they noted in the book, it's a good thing that DC Comics' lawyers missed that particular issue.[458]

After Stan Lee stepped down as editor-in-chief in 1972, different editors adopted different policies toward awarding the prizes with some loving the tradition and others seeing them as a waste of time. They were discontinued in 1989 by then-owner Ron Perelman (who eventually drove the company into bankruptcy), but reinstated by editor-in-chief Tom DeFalco in 1991.[459] Executive editor Tom Brevoort took the prize into the 21st century in 2006 when he instituted the digital No-Prize, the first of which was given to a group of Marvel fans who donated comics to a number of U.S. armed forces stationed in Iraq.[460] Though the days of the physical paper No-Prize may have come and gone—and

editorial oversight may be much more tightly regulated—keep your eyes peeled because you too could find yourself in esteemed company if you manage to spot a goof.

Please note that if you find any errors contained within this book, you should put a mirror inside of an envelope, take it down to your local post office, mail it to yourself, and take a long hard look before asking yourself what you're even doing right now.

94 Take a Shot at Heroism (Cocktails)

What's the true mark of success? I used to think it was having a sandwich named after you at a local deli (okay, I still do), but an even bigger honor might be having a libation created in your honor. After giving your sweat, blood, and tears to save the world from all manner of evil, knocking back a nice, cold drink sounds like exactly what the S.H.I.E.L.D. medical officer ordered. So, before you go and see *Avengers: Age of Ultron* (or afterward), round up Earth's Mightiest Friends and sample some of the greatest cocktails inspired by Marvel's mightiest heroes.

After countless hours of research in the name of writing this book, I have determined that the best batch of *Avengers*-inspired cocktails in all the land come courtesy of UK-based comic book artist/mixologist Lily Mitchell. You can find these recipes and much more on her blog: www.the-more-i-arty.tumblr.com.[461]

Please note: Don't let absolute power (or Absolut power) go to your head. Please drink responsibly and make sure that you don't try to operate any Quinjets, Helicarriers, or cherry red flying Corvettes after imbibing any of the following recipes.

The Incredible Hulk
Hulk smashed.
1 part absinthe
1 part Midori
3 parts Mountain Dew
Garnish with fresh kiwi slice, serve in a Collins glass, and hope to god you wake up wearing more than just a pair of purple cutoffs.

The Thor
Stop! Hammered time!
1 part Lillehammer or berry liqueur
1 part mead
1 part lingonberry vodka
Serve with ice in a rocks glass. Make two because you will definitely want ANOTHER!

The Iron Man
Genius, billionaire, playboy, philanthropist, cocktail.
1 part grenadine
1 part Drambuie
2 parts orange juice
1 part Scotch
Garnish with an orange slice, serve in a Collins glass, and tip your bartender.

The Captain America
This may not be Super Soldier serum, but at least it's red, white, and blue. Just be sure to stop drinking before you wake up 60 years in the future.
1 part grenadine
1 part Blue Curacao
1 part Creme de Cacao
Garnish with a tiny American flag and serve in a shot glass.

The Black Widow
Wash the taste of Budapest right out of your mouth.
1 part Kahlua
1 part Russian vodka
2 shots of espresso
Serve hot in a mug and never tell anyone what's in your glass.

The Hawkeye
Warning: this may affect your aim.
1 part Strongbow cider
1 part WKD Purple
1 part Red Aftershock
Serve the Strongbow and WKD Purple in a pint glass, drop a shot of Red Aftershock into the glass, and chug like the Chitauri are about to attack.

The Loki
A few of these and you'll definitely be a God of Mischief.
1 part Blavod black vodka
1 part Blue Curacao
1 part Apple Sourz liqueur
2 parts fresh lime juice
1 part Goldschläger
2 parts mead
Serve in a martini glass with 2 lemon peel garnishes for a nifty little helmet.

(Note: layer the ingredients from the top down in order to create the desired color gradient.)

The Nick Fury
You may only be able to see out of one eye afterwards.
1 part Black Sambuca
1 part orange schnapps

1 part Shochu

2 parts fresh lime juice

Add lime wedge and crushed ice and serve in a pint glass. Garnish with black licorice lace eyepatch. Keep your text messages highly classified.

The Agent Coulson

This life-giving elixir goes great with the sea breeze off the shores of Tahiti.

1 part clear lemonade

1 part white rum

1 part gin

1 part vodka

1 part Cointreau

1 part triple sec

Serve up in a chilled cocktail glass. Don't even think about getting behind the wheel of Lola.

95 Eat Like an Avenger (Chicken Shawarma)

"Have you ever tried shawarma? ... I don't know what it is, but I want to try it."—Tony Stark

At the end of a long day of work, most of us want to curl up with a glass of wine or maybe a nice hearty bowl of mac 'n' cheese, but what about Earth's Mightiest Heroes? At the end of *Avengers*, we saw the team exhaustedly dining on one of the Middle East's finest fast-food items: shawarma. Not one of the typically talkative team uttered a word, which may have been partially due to the fact that they had just given their minds, bodies, and souls to save the

city of New York from Loki and his intergalactic army of Chitauri interlopers, but I prefer to think they were simply overwhelmed by the deliciousness that is fresh shawarma. So, before you go see *Avengers: Age of Ultron*, allow me to show you how to eat like an Avenger.

This recipe for Avengers Chicken Shawarma was developed by the foodie phenoms behind the webseries *Cinema & Spice*, where hosts Natasha Feldman and Julianna Strickland blend their two passions, food and film, to delicious effect.[462] I've tried many shawarma recipes, and it can be a difficult dish to make without the specialty appliances, but this recipe simplifies the process and yields decidedly delicious results. *(Serves six.)*

Chicken:
6 cloves of garlic, peeled
¼ teaspoon ginger, peeled
¼ cup of fresh lemon juice
¼ cup apple cider vinegar
¼ cup + 2 tablespoons olive oil
¼ teaspoon ground cloves
1½ teaspoons salt
1 teaspoon ground cumin
½ teaspoon caraway seeds
¼ teaspoon ground cardamom
½ teaspoon dried oregano
¼ teaspoon cinnamon
¼ teaspoon ground nutmeg
½ teaspoon fresh ground pepper
1 teaspoon cayenne
½ teaspoon pomegranate molasses
¼ yellow onion
2 lbs. chicken breast tenders
Olive oil

Wrap:
3 cups coleslaw
6 rounds of naan or pita bread
10 oz. hummus (optionally blended with parsley!)
Sriracha
1 Italian eggplant, thinly sliced
Tinfoil
Olive oil

First, combine garlic, apple cider vinegar, lemon juice, ginger, ¼ cup plus 2 tbsp. of olive oil, pomegranate, spices, molasses, and ¼ of a yellow onion in a blender. Pour the marinade into a plastic bag with the uncooked chicken tenders and refrigerate for 30 minutes.

After the chicken has marinated, heat a large pan with a few tablespoons of olive oil. Cook the chicken on medium high heat in the pan for 5 minutes on each side.

For the wrap: Slice the eggplant thin and fry it in roughly an inch of olive oil on high heat until golden brown, about a minute and a half on each side. After the eggplant is cooked, dab it with a paper towel and set it aside. Heat your bread over a burner or in the oven until warm. Add a generous spoonful of hummus on the bread, then add a few eggplant slices, a nice portion of 'slaw (check out their full episode on Yahoo for their Agent Coulson Coleslaw or substitute your favorite slaw recipe) and a chicken tender. Lastly, drizzle Sriracha over the chicken and wrap.

Serve hot and enjoy. You may not have saved the world, but you have saved dinner.

96 Build Your Own Iron Man Armor

Everyone wants a suit of Iron Man armor of their very own. The United States Navy is evidently working on a version of their own called the TALOS—Tactical Assault Light Operator Suit—which will "yield a revolutionary improvement in survivability and capability for special operators," according to Navy Admiral William McRaven.[463] You don't need billions of dollars in defense contracts to be like the Golden Avenger though. As Obadiah Stane was fond of saying, Tony Stark built his armor in a cave with a box of scraps, so what's to stop you from crafting Iron Man armor of your very own with some foam, an X-acto knife, epoxy, and a little bit of simple soldering? Nothing except your own willingness to get your hands dirty (and how confident you are with a hot-glue gun).

Seeing the incredibly detailed costumes that fans create is, without a doubt, one of the best parts of going to a fan convention. You know how fun it is to dress up for a costume party? Imagine that thousands of people are at the same party, except they have giant foam swords, painstakingly detailed re-creations of Loki's staff, and are better with styling a wig than many professional hairdressers. This is a hobby known as cosplay—a Japanese portmanteau meaning "costume play"—in which fans dress up and in some cases roleplay as their favorite characters.

So, how can you build your own suit of Iron Man armor? In truth, I don't have the technical expertise to tell you how to transform a pile of foam, glue, and LED lights into a fully functional set of Mark VI armor. Otherwise I would be spending my days constructing elaborate suits of armor for myself rather than writing this book. Fortunately, the Internet is your best friend where cosplay is concerned. Sites like DeviantART, Cosplay.com,

and CosplayTutorials are all tremendous resources for finding detailed how-to guides, asking whatever questions may pop up during your building process, interacting with like-minded community members, and even showing off your completed costumes. Nervous about getting your feet wet? Don't be—even if you're not ready to take the plunge, there are plenty of workshops offered at

A cosplayer dressed as Iron Man participates in Marvel's Iron Man 3 *panel at Comic-Con International 2012.* (Albert L. Ortega/Getty Images)

conventions and, in many cases, by your local comic book store or anime club. The cosplay community is tight-knit, very welcoming to newcomers, and helpful to those in need. Kind of like the Avengers! Just remember that when you get stopped every three feet by onlookers admiring your meticulously stitched Thanos costume, hand-smelted Infinity Gauntlet, and purple body paint, you asked for this. Now smile and try not to let the flashes from the cameras blind you.

97 The Shawarma Scene

Juicy strips of lamb, roasted for hours on an open spit, is sliced razor-thin, layered into freshly baked pita bread, and topped with onions, tahini sauce, lettuce, and tomato. Is your mouth already watering? These are the ingredients that make up that shining star of Mediterranean cuisine, shawarma. If you stayed after the credits during 2012's *Avengers,* you're likely well aware that it's a favorite meal of Earth's Mightiest Heroes as well. Having saved the city of New York from Loki and the Chitauri invasion, the Avengers exhaustedly sit at restaurant table wordlessly eating shawarma, a well-earned moment of peace after risking life and limb to save the city. Not a bad way to unwind after battling an intergalactic armada.

"Have you ever tried shawarma?" Iron Man asks Captain America earlier in the film. "There's a shawarma joint about two blocks from here. I don't know what it is, but I want to try it." Audiences everywhere lost their collective minds when, after the credits rolled, the Avengers actually wound up trying the delicious dish. The film, and that scene in particular, proved so popular that

shawarma restaurants reported as much as an 80 percent increase in sales in places like Los Angeles.[464] While it's no secret that shawarma is awfully delicious, the question remains: How did this scene come into being?

The original script made no mention of slow-roasted Mediterranean meats. Rather, when filming the scene in which Captain America and Chris Hemsworth rush over to an unconscious Iron Man and remove his mask to reveal Tony Stark, Robert Downey Jr. was supposed to awaken and ask, "What's next?" For Downey Jr., notorious for improvising and revamping lines on set, the sequence wasn't quite landing. Director Joss Whedon agreed and penned several different versions of the scene in his notebook. The variations included Stark wearily congratulating his fellow superheroes on winning the battle and then—once he learns there's more fighting to be done—remarking about how much

The Shawarma Scene's Secret Origins

While inarguably delicious, shawarma is definitely a weird choice for the Avengers' comfort food of choice. What inspired the team to have a Middle Eastern feast after saving the universe? It may have been actor Nicholas Brendon's audition for *Buffy the Vampire Slayer*. One enterprising fan named J.P. Gagen discovered on a DVD extra of *Buffy the Vampire Slayer*'s Chosen Collection that Joss Whedon recounted the one word that sealed the deal for Brendon during his audition: shawarma. Brendon had a terrific read-through, but it wasn't until the very end of his audition that he blew Whedon away. "Afterwards he was like, 'Does anybody feel like shawarma? I feel like some shawarma!'" Whedon recalled. "I was like, 'This guy speaks to me!' And that's when I knew there wasn't any other Xander." And just like there's only one Xander, there's only one marinated meat wrap that has captured our hearts and minds: shawarma.

(Puchko, Kristy. "Origins Of The Avengers Shawarma Joke Uncovered Deep In Buffy Bonus Features." *CinemaBlend*. Cinema Blend LLC, 10 Oct. 2012. Web. 19 Oct. 2014. <http://www.cinemablend.com/new/Origins-Avengers-Shawarma-Joke-Uncovered-Deep-Buffy-Bonus-Features-33474.html>.)

time off they'll be owed. Another version saw Stark waking up and telling Cap and Thor, "Please tell me nobody tried to kiss me."[465] Thankfully, the version that won out was the most random of the three, the one in which Tony Stark agrees to continue fighting so long as they can hit up a local shawarma restaurant he knows about in the neighborhood.

The fun doesn't stop there, though. Eagle-eyed viewers will likely have spotted the restaurant, Shawarma Palace, earlier in the film; it's visible after Iron Man flies through the giant Chitauri Leviathan and he crashes to the ground. Throughout the scene, Chris Evans is covering his face with his hands because he had grown a beard for another filming role and had to wear a prosthetic to cover it up. Robert Downey Jr. immediately began making fun of him for it. "Where is Chris Evans getting his face replaced?" he joked. "Chris, why the long face? Chris, why the WRONG face?" he continued. Chris Hemsworth's Thor was likely too busy eating to join in the ribbing. "I thought I might be sick," Hemsworth confessed in an interview. "I ate one [pita] each take, you know! And by the end, I was like, Whooooaaa…"[466] No matter how delicious that shawarma was, not even Hemsworth's Asgardian appetite could withstand such a grueling gastronomic gauntlet. The rest, as they say, is delicious history.

98 Be a Hero by Giving Back to the Comics Community

While you may not be able to fly around your neighborhood in a suit of specially crafted armor or wield the might of Mjolnir, you can still live up to the example set by Earth's Mightiest Heroes in your everyday life. Much like Daredevil's alter ego Matt Murdock

and She-Hulk spend their time in the courtroom defending the innocent, you can help the creators of the comics you love through a variety of different organizations. In most professional and academic fields, there is a trade union or organization of sorts to help advocate for their members' rights, ensure equitable treatment, and help provide a financial safety net for those in need. Unfortunately for comic book creators, there wasn't really any union of which to speak until fairly recently.

The Hero Initiative, launched in late 2000 by a consortium of comics publishers, is a federally chartered non-profit organization designed to help those comics creators who blazed the trail for those who followed in their time of need. Whether it is medical assistance, financial support, or the tool to help them find gainful employment, The Hero Initiative is there to help and has provided over $500,000 to more than 50 veterans of the comics industry during their time of need. Longtime Iron Man and Daredevil artist Gene Colan received financial aid during his twilight years; Howard the Duck creator Steve Gerber, who suffered from pulmonary fibrosis and was no longer able to work, had his mounting medical bills mitigated by the Hero Initiative. Colorist Tom Ziukô suffered from acute kidney failure and required colon surgery in 2011, and would have been unable to pay his medical bills and his mounting debt if it weren't for the Hero Initiative. We can't all be Tony Stark, but if you're inclined to give a little, it's an extremely worthwhile cause.

There are plenty of other ways to make a difference too. The Comic Book Legal Defense Fund (CBLDF) fights for First Amendment rights within the comics community, offering legal advice and counsel to members of the community who have come under fire for their creations. The Comic Book Project is a literacy initiative that takes young people and gives them the tools, training, and guidance needed to produce and publish a comic book of their very own, enabling them to become content creators rather than

mere sponges. Operation Comix Relief, started by Chris Tarbassian in 2003, takes donated comics and sends them to members of the armed forces overseas so that they can share the same joy we do when we read the latest issue of *Avengers*. Honestly, though, these are just a few of the many different comic and superhero-inspired charities out there. Some routine Google searching will likely yield dozens more, but the point is that you don't need to have Super Soldier serum flowing through your veins to make a difference; you just need the drive and compassion to find ways to make a difference in your community.

99 Celebrate Free Comic Book Day

You know what's great? Comic books. You know what's better than great? Free comic books. While economics professors would be more than happy to tell you that, like lunches, there's no such thing as a free comic book, the fact remains that no one likes a stick in the mud. Everyone likes free stuff. So, naturally, once a year, the comic book industry comes together to celebrate their medium of choice and give back to the community in the form of the aptly named Free Comic Book Day.

On the first Saturday of May each year, Free Comic Book Day is held at comic book shops all across the United States. Publishers and creative talent from all over the industry band together to put out a wide variety of comics designed especially for the day. Oftentimes, these are standalone stories or #1 issues, which not only appeals to preexisting fans, but also helps to bring new fans into the fold. The idea behind Free Comic Book Day is simple: by giving away a free sample of the product and actually getting people

to head down to the brick and mortar stores, you'll have a way to say thanks to longtime readers as well as entice new readers to take a chance on the hobby. Plus, plenty of stores wind up holding tie-in events with special signings, giveaways, and other community-oriented activities, so it's a great day to let your nerd flag fly.

Free Comic Book Day, or FCBD as it's known colloquially, traces its origins back to 2001, when comics retailer Joe Fielder of Flying Colors Comics in Concord, California, came up with the idea for the event in his "Big Picture" column in *Comics & Game Retailers* magazine.[467] Thanks to the emergence of comic book–inspired films like *X-Men*, the comics market was just beginning to emerge from the bust of the late 1990s caused by speculators and their obsession with the market for variant covers. One year later, the first Free Comic Book Day was held on May 4, 2002, the opening weekend of the first *Spider-Man* film, a brilliant idea from Image Comics co-founder Jim Valentino. And the rest, as they say, is history. Besides, what were you *really* going to do on that first Saturday of May anyway? Watch the Kentucky Derby?

100 Find Your Local Comic Book Shop and Set Up a Pull List

Part of what makes the Avengers so special isn't the fact that it brings together the best and brightest heroes in the Marvel Universe or that it brings our childhood comic book fantasies to life up on the big screen, but rather the sense of community that comes with being a fan. While you can easily find plenty of places to celebrate your fandom on the Internet (e.g. Reddit, Tumblr, and deviantART, to name a few), few things compare to the camaraderie and sense of community forged amidst the stacks and shelves

of your local comic book shop. Within those hallowed halls lies a whole world of superheroic knowledge and likeminded passion just waiting for you to experience.

While this book is a phenomenal place to answer most, if not all of your questions about the Avengers, both on-screen and off, it is nearly impossible to capture all of the nuance and trivia that has accrued over the 50-plus years of lore and continuity. Fortunately, your friendly local comic book store clerks live and breathe that sort of thing, and even if they can't answer your question regarding in which issue the Avengers/Defenders War storyline first began (the prologue was in *Avengers* #115, which led into *Defenders* #8, for the record), they can point you in the right direction or, even better, order the books for you.

Even though digital comics stores like comiXology or the Marvel Comics app make getting the latest issues and back issues of your favorite titles a breeze, there's something about walking into a brick and mortar store and taking in the smell of hot-off-the-presses comics that cannot compare to ones and zeroes on your iPad. Having difficulty keeping up with the countless *Avengers* titles? At the time of this writing, there are nearly as many monthly Avengers titles as this writer has fingers, so staying current can be difficult. Make your life easy by setting up a monthly pull list with your local comic book shop. It's like having your own personal Jarvis, except he won't clean up after you and will just sell you comic books.

If the sense of community and the chance to thumb through the latest issues in person weren't enough of a draw, many comic book shops also host live events like signings by your favorite creators, swap meets where you can trade your treasures for rarities you've only heard of in tale, art shows, and much more. Not sure where to find your nearest mom 'n' pop shop? Don't worry—tools like the Store Locator on Free Comic Book Day's website (www. freecomicbookday.com/storelocator) and Comic Shop Locator (www.comicshoplocator.com) will have you up and running at

Quicksilver-like speeds in no time. And while you're at your new favorite store, make sure to pick up an extra copy of this book. You know, for a friend. Or in case you lost this copy on the way there. Trust me, it'll come in handy.

Acknowledgments

While I couldn't have written this book without the steady companionship of copious amounts of iced coffee, Red Bull, and the often-judging eyes of my dog Maisie, I would be remiss if I didn't thank the many, many people who helped me bring this from concept to completion. First and foremost, thank you to my editor Jesse Jordan for helping me turn this beast of a manuscript into the book you hold in your hands; to Michelle Bruton for taking a chance on me; to Triumph for giving me this incredible opportunity; to my aunt, Mary Casey, for being a constant source of encouragement and reading draft after draft out of the goodness of her heart; to my colleagues at Nerdist for always having my back; to my wonderful partner-in-crime, Lauren Eilola, for her infinite patience, support, and late-night pick-me-ups of leftover sushi; and to my parents for being my number one cheerleaders since day one and filling my childhood with enough comic books to make a project like this even possible for me.

If I did not list you by name, it is nothing personal; my brain has simply devolved into mush after spending so much time thinking about Earth's Mightiest Heroes. Most importantly, thank you, the reader, for taking the time to share in this passion with me. You're the reason that we'll continue to have many more years of incredible stories about our favorite superheroes, after all.

Endnotes

1. Miller, Neil. "The History of The Avengers." Film School Rejects. N.p., 13 Mar. 2014. Web. 02 Aug. 2014. <http://filmschoolrejects.com/news/avengers-history-infographic.php>.

2. Howe, Sean. *Marvel Comics: The Untold Story.* New York: Harper, 2012. p. 47. Print.

3. "X-Men Vs. X-Men." Box Office Mojo. N.p., n.d. Web. 02 Aug. 2014. <http://www.boxofficemojo.com/showdowns/chart/?id=vs-xmen.htm>.

4. The Avengers (2012)." Box Office Mojo. N.p., n.d. Web. 02 Aug. 2014. <http://www.boxofficemojo.com/movies/?id=avengers11.htm>

5. Lee, Stan; Mair, George. *Excelsior!: The Amazing Life of Stan Lee.* Fireside Books. 2002. p. 5

6. "Stan Lee: From Marvel Comics Genius to Purveyor of Wonder with POW! Entertainment." Kugel, Allison. Web. 13 Mar. 2006. PR.com <http://www.pr.com/article/1037>

7. Howe, Sean. *Marvel Comics: The Untold Story.* New York: Harper, 2012. p. 19. Print.

8. Sanderson, Peter; Gilbert, Laura. "1940s." *Marvel Chronicle A Year by Year History.* Dorling Kindersley. 2008. p. 19.

9. Thomas, Robert. *Stan Lee's Amazing Marvel Universe.* New York. Sterling. 2006. p. 14

10. Howe, Sean. *Marvel Comics: The Untold Story.* New York: Harper, 2012. p. 24-25. Print.

11. McLaughlin, Jeff. "Stan Lee." *Stan Lee: Conversations.* Jackson, Mississippi. University Press of Mississippi. p. 138.

12. Howe, Sean. *Marvel Comics: The Untold Story.* New York: Harper, 2012. p. 1

13. Sanderson, Peter. "Comics in Context #14: Continuity/Discontinuity - IGN." IGN. N.p., 10 Oct. 2003. Web. 02 Aug. 2014. <http://comics.ign.com/articles/595/595576p1.html>.

14. Kugel, Allison. "Stan Lee: From Marvel Comics Genius to Purveyor of Wonder with POW! Entertainment The Exclusive PR.com Interview - PR.com." PR.com. N.p., 13 Mar. 2006. Web. 02 Aug. 2014. <http://www.pr.com/article/1037>.

15. Evanier, Mark, and Steve Sherman. "Jack Kirby Biography." Jack Kirby Museum Research Center. N.p., n.d. Web. 02 Aug. 2014. <http://kirbymuseum.org/biography/>.

16. Jones, Gerard. *Men of Tomorrow: Geeks, Gangsters, and the Birth of the Comic Book.* Basic Books. New York. 2004. pp. 195–96

17. Groth, Gary. "Jack Kirby Interview." The Comics Journal 134 (1990): n. pag. The Comics Journal. 23 May 2011. Web. 04 Aug. 2014. <http://www.tcj.com/jack-kirby-interview/2/>.

18. Interview, The Nostalgia Journal #30, November 1976

19. Evanier, Mark, and Steve Sherman. "Jack Kirby Biography." Jack Kirby Museum Research Center. N.p., n.d. Web. 02 Aug. 2014. <http://kirbymuseum.org/biography/>.

20. Ro, Ronin. *Tales to Astonish: Jack Kirby, Stan Lee, and the American Comic Book Revolution.* New York: Bloomsbury, 2004. p. 25-26.

21. Howe, Sean. *Marvel Comics: The Untold Story.* New York: Harper, 2012. p. 23

22. Ro, Ronin. *Tales to Astonish: Jack Kirby, Stan Lee, and the American Comic Book Revolution.* New York: Bloomsbury, 2004. p. 35.

23. Ibid, p. 41-43

24. Evanier, Mark, and Steve Sherman. "Jack Kirby Biography." Jack Kirby Museum Research Center. N.p., n.d. Web. 02 Aug. 2014. <http://kirbymuseum.org/biography/>.

25. Ibid.

26. Howe, Sean. *Marvel Comics: The Untold Story.* New York: Harper, 2012. p. 34-35

27. Jones, Gerard (2004). *Men of Tomorrow: Geeks, Gangsters, and the Birth of the Comic Book.* Basic Books. 2004. p. 282

28. Evanier, Mark, and Steve Sherman. "Jack Kirby Biography." Jack Kirby Museum Research Center. N.p., n.d. Web. 02 Aug. 2014. <http://kirbymuseum.org/biography/>.

29. The iconic blue uniforms emblazoned with the number 4 on their chests came at the behest of letter-writing fans.

30. East Germany began work on the Berlin Wall the same week as *Fantastic Four* hit newsstands on August 8, 1961.

31. Howe, Sean. *Marvel Comics: The Untold Story.* New York: Harper, 2012. p. 40-41

32. Ibid. p. 50-51

33. Lee, Stan; Mair, George. *Excelsior! : The Amazing Life of Stan Lee.* New York: Simon & Schuster. 2002. p. 160.

34. "Iron Man (Anthony Stark) - Marvel Universe Wiki." Marvel.com. Marvel Comics, n.d. Web. 09 Aug. 2014.

35. Wright, Bradford W. *Comic Book Nation: The Transformation of Youth Culture in America.* Johns Hopkins. 2001. p. 36.

36. Simon, Joe; Simon, Jim. *The Comic Book Makers.* Crestwood/II. 1990. p. 50.

37. "Captain America (Steve Rogers)." *Marvel Universe Wiki.* Marvel Comics, n.d. Web. 12 Aug. 2014. <http://marvel.com/universe/Captain_America_%28Steve_Rogers%29>.

38. DeFalco, Tom; Gilbert, Laura, ed. "1960s." *Marvel Chronicle A Year by Year History.* Dorling Kindersley. 2008. p. 88.

39. Evanier, Mark. *Kirby: King of Comics.* Abrams. New York. 2008. p. 127.

40. Groth, Gary. "Jack Kirby Interview." The Comics Journal 134 (1990): n. pag. The Comics Journal. 23 May 2011. Web. 04 Aug. 2014. <http://www.tcj.com/jack-kirby-interview/2/>.

41. Beard, Jim. "Follow the History of Ant-Man Pt. 1 | News | Marvel.com." Marvel. com. N.p., 18 Apr. 2014. Web. 06 Sept. 2014. <http://marvel.com/news/comics/2014/4/18/22366/follow_the_history_of_ant-man_pt_1>.

42. Pym developed it after going toe to toe with Porcupine in *Tales to Astonish* #48 (1959).

43. Beard, Jim. "Follow the History of Ant-Man Pt. 3 | News | Marvel.com." Marvel. com. N.p., 2 May 2014. Web. 07 Sept. 2014. <http://marvel.com/news/comics/2014/5/2/22454/follow_the_history_of_ant-man_pt_3>.

44. Beard, Jim. "Follow the History of Ant-Man Pt. 6 | News | Marvel.com." Marvel. com. N.p., 23 May 2014. Web. 06 Sept. 2014. <http://marvel.com/news/comics/2014/5/23/22573/follow_the_history_of_ant-man_pt_6>.

45. Lee, Stan; Kirby, Jack. *Avengers* #1. New York: Marvel Comics, 1963. Print.

46. Thomas, Roy; Buscema, John. *Avengers* #60. New York: Marvel Comics. 1969.

47. "Wasp." Marvel Universe Wiki. Marvel Comics, n.d. Web. 07 Sept. 2014. <http://marvel.com/universe/Wasp>.

48. "Hawkeye." Marvel Universe Wiki. Marvel Comics, n.d. Web. 07 Sept. 2014. <http://marvel.com/universe/Hawkeye_(Clint_Barton)>.

49. McCann, Jim; Diaz, Paco. *Hawkeye: Blindspot* #1. New York: Marvel Comics. 2011.

50. "Hawkeye." Marvel Universe Wiki. Marvel Comics, n.d. Web. 07 Sept. 2014. <http://marvel.com/universe/Hawkeye_(Clint_Barton)>.

51. Khouri, Andy, Curt Franklin, and Chris Haley. "Comics, Everybody: The History of Hawkeye Explained." Comics Alliance. N.p., 15 Oct. 2012. Web. 13 Sept. 2014. <http://comicsalliance.com/comics-everybody-history-hawkeye-lets-be-friends-again/>.

52. "Hawkeye." Marvel Universe Wiki. Marvel Comics, n.d. Web. 07 Sept. 2014. <http://marvel.com/universe/Hawkeye_(Clint_Barton)>.

53. Khouri, Andy, Curt Franklin, and Chris Haley. "Comics, Everybody: The History of Hawkeye Explained." Comics Alliance. N.p., 15 Oct. 2012. Web. 13 Sept. 2014. <http://comicsalliance.com/comics-everybody-history-hawkeye-lets-be-friends-again/>.

54. "Black Widow." Marvel Universe Wiki. Marvel Comics, n.d. Web. 07 Sept. 2014. <http://marvel.com/universe/Black_Widow_(Natasha_Romanova))>.

55. Claremont, Chris; Lee, Jim. *The Uncanny X-Men* #268. New York: Marvel Comics. 1990.

56. Brubaker, Ed. Deodato Jr., Mike. *Secret Avengers* #1. New York: Marvel Comics. 2010.

57. Straczynski, J. Michael; Djurdjevic, Marko. *Thor* #8. New York: Marvel Comics. 2008.

58. McCoy, Dan. "The Marriage of Njord and Skadi." Norse Mythology for Smart People. N.p., n.d. Web. 14 Sept. 2014. <http://norse-mythology.org/tales/the-marriage-of-njord-and-skadi/>.

59. "Loki." Marvel Universe Wiki. Marvel Comics, n.d. Web. 07 Sept. 2014. <http://marvel.com/universe/Loki>.

60. Lee, Stan; Kirby, Jack. *Thor* #127. New York: Marvel Comics. 1966.

61. Oeming, Michael Avon; Berman, Daniel; Divito, Andrea. *The Mighty Thor* #85. New York:

62. Simonson, Walter. *The Mighty Thor* #364. New York: Marvel Comics. 1986.

63. Straczynski, J. Michael; Coipel, Olivier. *Thor* #5. New York: Marvel Comcis. 2008.

64. Thomas, Roy; Buscema, John. *Avengers* #58. New York: Marvel Comics. 1968

65. Shooter, Jim; Perez, George. *Avengers* #162. New York: Marvel Comics. 1977.

66. Shooter, Jim; Zeck, Mike. *Secret Wars* #12. New York: Marvel Comics. 1985.

67. Thomas, Roy; Buscema, John. *Avengers* #54. New York: Marvel Comics. 1968

68. Shooter, Jim; Perez, George. *Avengers* #162. New York: Marvel Comics. 1977.

69. Shooter, Jim; Perez, George. *Avengers* #170-171. New York: Marvel Comics. 1978.

70. Lee, Stan; Kirby, Jack; Stone, Chic. "The Triumph of Magneto!" *X-Men* #11 New York: Marvel Comics. May 1965

71. Thomas, Roy. Buscema, John. "Mine is the Power" *The Avengers* #49 New York: Marvel Comics: February 1968

72. Englehart, Steve; Heck, Don. *Giant-Size Avengers* #4. New York: Marvel Comics. June 1975.

73. "Scarlet Witch (Wanda Maximoff)." Marvel Universe Wiki. Marvel Comics, n.d. Web. 07 Sept. 2014. <http://marvel.com/universe/Scarlet_Witch_(Wanda_Maximoff)>

74. Bendis, Brian Michael. Coipel, Olivier. *House of M* #1-8. New York: Marvel Comics. 2005.

75. Hickman, Jonathan. Coipel, Olivier. *Avengers vs. X-Men* #6. New York: Marvel Comics. 2012.

76. Fraction, Matt. Coipel, Olivier. *Avengers vs. X-Men* #7. New York: Marvel Comics. 2012.

77. David, Peter. Quesada, Joe. *X-Factor* #87. New York: Marvel Comics. 1993.

78. Lee, Stan. Kirby, Jack. *Avengers* #16. New York: Marvel Comics. 1965.

79. Englehart, Steve; Heck, Don *Giant-Size Avengers* #4. New York: Marvel Comics. June 1975.

80. Conway, Gerry. Buckler, Rich. *Fantastic Four* #150. New York: Marvel Comics. 1974.

81. David, Peter. Stroman, Larry. *X-Factor* #72. New York: Marvel Comics. 1991.

82. Slott, Dan. Gage, Christos. Chen, Sean. *Mighty Avengers* #31. New York: Marvel Comics. 2010.

83. Gage, Christos. McKone, Mike. *Avengers Academy* #1. New York: Marvel Comics. 2010.

84. Lee, Stan. Thomas, Roy. *Avengers* #66. New York: Marvel Comics. 1969.

85. Thomas, Roy. Buscema, John. *Avengers* #57. New York: Marvel Comics. 1968.

86. Englehart, Steve. Howell, Richard. *Vision and the Scarlet Witch* #12. New York: Marvel Comics. 1986.

87. Stern, Roger. Milgrom, Al. *Avengers* #243. New York: Marvel Comics. 1984.

88. Byrne, John. *West Coast Avengers* #42-45. New York: Marvel Comics. 1989.

89. Bendis, Brian Michael. Finch, David. *Avengers* #500. New York: Marvel Comics. 2004.

90. Aaron, Jason. Bendis, Brian Michael. Cho, Frank. *Avengers vs. X-Men* #0. New York: Marvel Comics. 2012.

91. Cronin, Brian. "Comic Book Legends Revealed #266." Comic Book Resources. N.p., 24 June 2010. Web. 23 Sept. 2014. <http://goodcomics.comicbookresources. com/2010/06/24/comic-book-legends-revealed-266/>.

92. Duca, Lauren. "Joss Whedon Was Left 'Pretty Devastated' After Losing 'Speed' Writing Credit." *The Huffington Post*. 10 June 2014. Web. 25 Sept. 2014. <http://www. huffingtonpost.com/2014/06/10/joss-whedon-speed_n_5473795.html>.

93. Earl, Chris. "Buffy the Vampire Slayer." *Starburst Magazine*. N.p., 14 Dec. 2011. Web. 26 Sept. 2014.

94. Whedon, Joss. "American Rhetoric: Joss Whedon - Equality Now Address." American Rhetoric. 15 May 2006. Web. 26 Sept. 2014. <http://www.americanrhetoric.com/ speeches/josswhedonequalitynow.htm>.

95. Woerner, Meredith. "Why Joss Whedon Almost Didn't Take on The Avengers." *io9*. Gawker Media, 27 July 2011. Web. 26 Sept. 2014. <http://io9.com/5825300/ why-joss-whedon-almost-didnt-take-on-the-avengers>.

96. Thomas, Roy, and John Buscema. *Fantastic Four* #119. New York: Marvel Comics, 1972.

97. Liss, David. Francavilla, Francesco. *Black Panther: The Man Without Fear* #513. New York: Marvel Comics. 2011.

98. McDuffie, Wayne. Pelletier, Paul. *Fantastic Four* #544. New York: Marvel Comics. 2007.

99. Thomas, Roy. Buscema, John. *Avengers* #62. New York: Marvel Comics. 1969.

100. Graser, Marc. "Marvel's Hiring Writers." *Variety*. 26 Mar. 2009. Web. 27 Sept. 2014. <http://variety.com/2009/film/news/marvel-s-hiring-writers-1118001734/>.

101. Barnes, Brooks. "With Fan at the Helm, Marvel Safely Steers Its Heroes to the Screen." *The New York Times*. The New York Times, 24 July 2011. Web. 28 Sept. 2014. <http://www.nytimes.com/2011/07/25/business/media/marvel-with-a-fan-at-the-helm-steers-its-heroes-to-the-screen.html?pagewanted=all&_r=0>

102. Leonard, Devin. "The Pow! Bang! Bam! Plan to Save Marvel, Starring B-List Heroes." *Bloomberg Business Week*. Bloomberg, 03 Apr. 2014. Web. 28 Sept. 2014. <http://www.businessweek.com/articles/2014-04-03/kevin-feige-marvels-superhero-at-running-movie-franchises>.

103. Barnes, Brooks. "With Fan at the Helm, Marvel Safely Steers Its Heroes to the Screen." *The New York Times*. The New York Times, 24 July 2011. Web. 28 Sept. 2014. <http://www.nytimes.com/2011/07/25/business/media/marvel-with-a-fan-at-the-helm-steers-its-heroes-to-the-screen.html?pagewanted=all&_r=0>

104. Dean, Michael. Brian Michael Bendis interview. *The Comics Journal* #266. February/March 2005.

105. Reynolds, Adrian. "PopImage." PopImage. N.p., n.d. Web. 28 Sept. 2014. <http://www.popimage.com/industrial/060600bendis1int.html>.

106. Bendis, Brian Michael. Oeming, Michael Avon. *Powers* TPB Vol. 3—*Little Deaths*. San Francisco: Image Comics. 2002.

107. Howe, Sean. *Marvel Comics: The Untold Story*. New York: Harper, 2012. p. 404-405

108. Schedeen, Jesse. "C2E2: Bendis & Bagley Get Brilliant" *IGN*. 19 Mar. 2011. Web. 28 Sept. 2014. <http://www.ign.com/articles/2011/03/19/c2e2-bendis-bagley-get-brilliant>.

109. Beck, Glenn. "Beck Ties New "Half-Black Half-Hispanic Gay Spider-Man" To Michelle Obama Saying That "We're Gonna Have To Change Our Traditions"" *The Glenn Beck Program*. Media Matters for America, 3 Aug. 2011. Web. 29 Sept. 2014. <http://mediamatters.org/video/2011/08/03/beck-ties-new-half-black-half-hispanic-gay-spid/183866>.

110. Leonard, Devin. "The Pow! Bang! Bam! Plan to Save Marvel, Starring B-List Heroes." *Bloomberg Business Week*. Bloomberg, 03 Apr. 2014. Web. 28 Sept. 2014. <http://www.businessweek.com/articles/2014-04-03/kevin-feige-marvels-superhero-at-running-movie-franchises>.

111. Lee, Stan. Colan, Gene. *Tales of Suspense* #79-81. New York: Marvel Comics. 1966.

112. Starlin, Jim. Englehart, Steve. *Captain Marvel* #28-33. New York: Marvel Comics. 1973-74.

113. Gillis, Peter. Infantino, Carmine. *Super-Villain Team-Up* #16. New York: Marvel Comics. 1979.

114. Gillis, Peter. Jones, Arvell. *Super-Villain Team-Up* #17. New York: Marvel Comics. 1980.

115. Godfrey, Alex. "Kick-Ass 2: Mark Millar's Superhero Powers." *The Guardian*. Guardian Media Group, 8 Aug. 2013. Web. 28 Sept. 2014. <http://www.theguardian.com/film/2013/aug/08/mark-miller-kick-ass>.

116. Millar, Mark. Hitch, Bryan. *Ultimates* #8. New York: Marvel Comics. 2002.

117. Millar, Mark. Hitch, Bryan. *Ultimates* #9. New York: Marvel Comics. 2003.

118. Millar, Mark. Hitch, Bryan. *Ultimates* #10. New York: Marvel Comics. 2003.

119. Millar, Mark. Hitch, Bryan. *Ultimates* #11. New York: Marvel Comics. 2003.

120. Millar, Mark. Hitch, Bryan. *Ultimates* #12-13. New York: Marvel Comics. 2003-2004.

121. Starlin, Jim. Lim, Ron. *The Thanos Quest* #2. New York: Marvel Comics. 1990.

122. Ibid.

123. Englehart, Steve. Rogers, Marshall. Lim, Ron. *Silver Surfer*, Vol 3. #8-9, 16-19. New York: Marvel Comics. 1988

124. Thomas, Roy. Kane, Gil. *Marvel Premiere* #1. New York: Marvel Comics. 1972.

125. Starlin, Jim. Lim, Ron. *The Thanos Quest* #2. New York: Marvel Comics. 1990.

126. Ibid.

127. Starlin, Jim. Lim, Ron. *Silver Surfer*, Vol. 3, #34. New York: Marvel Comics. 1990.

128. Starlin, Jim. Perez, George. *The Infinity Gauntlet* #2. New York: Marvel Comics. 1991.

129. Starlin, Jim. Perez, George. *The Infinity Gauntlet* #3. New York: Marvel Comics. 1991.

130. Starlin, Jim. Perez, George. Lim, Ron. *The Infinity Gauntlet* #4. New York: Marvel Comics. 1991.

131. Starlin, Jim. Lim, Ron. *The Infinity Gauntlet* #5. New York: Marvel Comics. 1991.

132. Starlin, Jim. Lim, Ron. *The Infinity Gauntlet* #6. New York: Marvel Comics. 1991.

133. "Actor's Toughest Role." *CNN*. Cable News Network, 2004. Web. 04 Oct. 2014. <http://www.cnn.com/CNN/Programs/people/shows/downey/profile.html>.

134. Reaves, Jessica. "Will Robert Downey Jr.'s Case Spark a Change in Drug Sentencing?" *Time*. Time Inc., 07 Feb. 2001. Web. 04 Oct. 2014. <http://content.time.com/time/nation/article/0%2C8599%2C98373%2C00.html>.

135. Welkos, Robert W. "Actor Robert Downey Jr. Given 6-Month Jail Term." *Los Angeles Times*. Los Angeles Times, 09 Dec. 1997. Web. 04 Oct. 2014. <http://articles.latimes.com/1997/dec/09/local/me-62196>.

136. "World: Americas Addicted Downey Jnr Jailed." *BBC News*. BBC, 08 June 1999. Web. 04 Oct. 2014. <http://news.bbc.co.uk/2/hi/americas/413283.stm>.

137. Angulo, Sandra P. "Arrested Development" *EW.com*. Entertainment Weekly, 24 Apr. 2001. Web. 04 Oct. 2014. <http://www.ew.com/ew/article/0%2C%2C107593%2C00.html>.

138. Lax, Eric, and Woody Allen. "Chapter 1: The Idea." *Conversations with Woody Allen: His Films, the Movies, and Moviemaking*. New York: Alfred A. Knopf, 2007.

139. Friedman, Roger. "Mel Gibson's New 'Passion' Is Robert Downey Jr." *Fox News*. FOX News Network, 14 Oct. 2003. Web. 04 Oct. 2014. <http://www.foxnews.com/story/2003/10/14/mel-gibson-new-passion-is-robert-downey-jr/>.

140. Eisenberg, Eric. "Jon Favreau Details His Fight With Marvel Studios To Cast Robert Downey Jr. As Iron Man." *CinemaBlend*. Cinema Blend LLC, 3 June 2014. Web. 04 Oct. 2014. <http://www.cinemablend.com/new/Jon-Favreau-Details-His-Fight-With-Marvel-Studios-Cast-Robert-Downey-Jr-Iron-Man-43293.html>.

141. "Iron Man Franchise." *Box Office Mojo*. IMDB.com, Inc., Web. 04 Oct. 2014. <http://boxofficemojo.com/franchises/chart/?id=ironmanfranchise.htm>.

142. Eisenberg, Eric. "Jon Favreau Details His Fight With Marvel Studios To Cast Robert Downey Jr. As Iron Man." CinemaBlend. Cinema Blend LLC, 3 June 2014. Web. 04 Oct. 2014. <http://www.cinemablend.com/new/Jon-Favreau-Details-His-Fight-With-Marvel-Studios-Cast-Robert-Downey-Jr-Iron-Man-43293.html>.

143. Fleming, Jr., Mike. "Robert Downey Jr Q&A: On 'The Judge,' Turning 50 With A New Baby, And Yes To 'Iron Man 4' - If Mel Gibson Directs It." *Deadline*. 3 Oct. 2014. Web. <http://deadline.com/2014/10/robert-downey-jr-qa-the-judge-iron-man-4-mel-gibson-845359/>.

144. Lee, Stan. Ditko, Steve. *Strange Tales* #115. New York: Marvel Comics. 1963.

145. Cornet, Roth. "Marvel's Kevin Feige: Doctor Strange May Team with The Avengers, Whole New Avengers Lineup Possible in Future - IGN." IGN. Ziff Davis, 21 July 2014. Web. 09 Oct. 2014. <http://www.ign.com/articles/2014/07/21/marvels-kevin-feige-doctor-strange-may-team-with-the-avengers-whole-new-avengers-lineup-possible-in-future>.

146. Millar, Mark. McNiven, Steve. *Civil War* #2. New York: Marvel Comics. 2006.

147. Millar, Mark. McNiven, Steve. *Civil War* #4. New York: Marvel Comics. 2006.

148. Millar, Mark. McNiven, Steve. *Civil War* #5. New York: Marvel Comics. 2007.

149. Millar, Mark. McNiven, Steve. *Civil War* #7. New York: Marvel Comics. 2007.

150. Brubaker, Ed. Epting, Steven. *Captain America*, Vol 5. #25. New York: Marvel Comics. 2007.

151. Bendis, Brian Michael. Maleev, Alex. *New Avengers: Illuminati* #1. New York: Marvel Comics. 2006.

152. Byrne, John. *Fantastic Four* #257. New York: Marvel Comics.

153. Bendis, Brian Michael. Yu, Leinil Francis. *New Avengers* #31. New York: Marvel Comics. 2007.

154. Bendis, Brian Michael. Bagley, Mark. *Mighty Avengers*, Vol. 1 #7. New York: Marvel Comics. 2008.

155. Bendis, Brian Michael. Reed, Brian. Cheung, Jim. *New Avengers: Illuminati* #5. New York: Marvel Comics. 2008.

156. Bendis, Brian Michael. Yu, Leinil Francis. *Secret Invasion* #1-3. New York: Marvel Comics. 2008.

157. Bendis, Brian Michael. Yu, Leinil Francis. *Secret Invasion* #6-8. New York: Marvel Comics. 2008-2009.

158. Bendis, Brian Michael. Yu, Leinil Francis. *Secret Invasion* #8. New York. Marvel Comics. 2009.

159. Bendis, Brian Michael. Deodato Jr., Mike. *Dark Avengers* #1. New York: Marvel Comics. 2009.

160. Interview with Brian Michael Bendis. *Wizard* #210. New York: Wizard Entertainment. April 2009.

161. Remender, Rick. Romita, John. *Dark Reign: The List - Punisher* #1. New York: Marvel Comics. 2009.

162. Goldman, Eric. "Stan Lee Previews His Marvel's Agents of SHIELD Cameo." *IGN*. Ziff Davis, 31 Jan. 2014. Web. 01 Oct. 2014. <http://www.ign.com/articles/2014/02/01/stan-lee-previews-his-marvels-agents-of-shield-cameo>.

163. Harras, Bob. Neary, Paul. *Nick Fury vs. S.H.I.E.L.D.* #1. New York: Marvel Comics. 1988.

164. Bendis, Brian Michael. Deodato Jr., Mike. *Dark Avengers* #1. New York: Marvel Comics. 2009.

165. Thomas, Roy. Buscema, Sal. *Avengers* #72. New York: Marvel Comics. 1970.

166. Brubaker, Ed. Aja, David. Lark, Michael. Gaudiano, Stefano. *Secret Avengers*, Vol. 1 #5. New York: Marvel Comics. 2010.

167. Howe, Sean. *Marvel Comics: The Untold Story.* New York: Harper, 2012. p. 83-84

168. Hickman, Jonathan. Weaver, Dustin. *S.H.I.E.L.D.* #1. New York: Marvel Comics. 2010.

169. Boucher, Geoff. "Nick Fury No More? Samuel L. Jackson Says 'Maybe I Won't Be Nick Fury'" *Hero Complex.* Los Angeles Times, 14 Jan. 2009. Web. 01 Oct. 2014. <http:// herocomplex.latimes.com/uncategorized/nick-fury-no-mo/>.

170. Chaykin, Howard. Starlin, Jin. *Marvel Spotlight* #31. New York: Marvel Comics. 1976.

171. Harras, Bob. Neary, Paul. *Nick Fury vs. S.H.I.E.L.D.* #1-6. New York: Marvel Comics. 1988.

172. Bendis, Brian Michael. Yu, Leinil Francis. *Secret Invasion* #1-8. New York: Marvel Comics. 2008-2009.

173. Bendis, Brian Michael. Hickman, Jonathan. Caselli, Stefano. *Secret Warriors* #1. New York: Marvel Comics. 2009.

174. Bendis, Brian Michael. Coipel, Olivier. *Siege* #4. New York: Marvel Comics. 2010.

175. Yost, Chris. Fraction, Matt. Bunn, Cullen. Eaton, Scott. *Battle Scars* #6. New York: Marvel Comics. 2012.

176. Spencer, Nick. Ross, Luke. *Secret Avengers*, Vol 2. #1. New York: Marvel Comics. 2013.

177. Eisenberg, Eric. "Agent Coulson Wouldn't Be Alive Without Twitter." *CinemaBlend.* Cinema Blend LLC, 30 Sept. 2014. Web. 02 Oct. 2014. <http://www.cinemablend. com/television/Agent-Coulson-Wouldn-t-Alive-Twitter-67600.html>.

178. Strom, Marc. "Marvel One-Shots: Expanding the Cinematic Universe." Marvel. com. Marvel Comics, 2 Aug. 2011. Web. 02 Oct. 2014. <http://marvel.com/news/ story/16398/marvel_one-shots_expanding_the_cinematic_universe>.

179. Spencer, Nick. Ross, Luke. *Secret Avengers*, Vol 2. #1-3. New York: Marvel Comics. 2013.

180. Bendis, Brian Michael. Maleev, Alex. *Mighty Avengers* #12. New York: Marvel Comics. 2008.

181. "Maria Hill." Marvel Universe Wiki. Marvel Comics. Web. 07 Sept. 2014. <http:// marvel.com/universe/Hill,_Maria>.

182. Millar, Mark. McNiven, Steve. *Civil War* #1. New York: Marvel Comics. 2006.

183. Bendis, Brian Michael. Yu, Leinil Francis. *Secret Invasion* #4-5. New York: Marvel Comics. 2008.

184. Bendis, Brian Michael. Yu, Leinil Francis. *Secret Invasion* #8. New York: Marvel Comics. 2009.

185. Spencer, Nick. Ross, Luke. *Secret Avengers*, Vol. 2 #1. New York: Marvel Comics. 2013.

186. Lee, Stan. Kirby, Jack. *Strange Tales* #135. New York: Marvel Comics. 1965.

187. Ayers, Dick. Friedrich, Gary. *Captain Savage and His Leatherneck Raiders* #2-4. New York: Marvel Comics. 1968.

188. "Hydra." Marvel Universe Wiki. Marvel Comics. Web. 07 Sept. 2014. <http://marvel. com/universe/Hydra>.

189. Bendis, Brian Michael. Hickman, Jonathan. Caselli, Stefano. *Secret Warriors* #1. New York: Marvel Comics. 2009.

190. Lee, Stan; Heck, Don. *Avengers* #15. New York: Marvel Comics, 1965.

191. Lee, Stan; Heck, Don. Avengers #28. New York: Marvel Comics, 1966.

192. Thomas, Roy. Buscema, John. *Avengers* #59. New York: Marvel Comics, 1968.

193. Shooter, Jim. Hall, Bob. *Avengers* #217. New York: Marvel Comics, 1982.

194. Slott, Dan. Khoi, Pham. *Secret Invasion: Requiem*. New York: Marvel Comics. 2009.

195. Lee, Stan. Kirby, Jack. *Avengers* #6. New York: Marvel Comics. 1963.

196. Lee, Stan. Kirby, Jack. *Avengers* #7. New York: Marvel Comics. 1963.

197. Lee, Stan. Heck, Don. Ayers, Dick. *Avengers* #9. New York: Marvel Comics. 1964.

198. Lee, Stan. Heck, Don. *Avengers* #15. New York: Marvel Comics. 1965.

199. Thomas, Roy; Buscema, John. *Avengers* #54. New York: Marvel Comics. 1968

200. Stern, Roger. Buscema, John. *Avengers* #270-277. New York: Marvel Comics. 1986-87.

201. Valentino, Jim. Trimpe, Herb. *Guardians of the Galaxy* #28-29. New York: Marvel Comics. 1992.

202. David, Peter. Deodato Jr., Mike. *Incredible Hulk* #448. New York: Marvel Comics. 1997.

203. Busiek, Kurt. Bagley, Mark. *Thunderbolts* #3. New York: Marvel Comics. 1997.

204. "Masters of Evil." Marvel Universe Wiki. Marvel Comics. Web. 27 Sept. 2014. <http://marvel.com/universe/Masters_of_Evil>.

205. Remender, Rick. Zircher, Patrick. *Secret Avengers* #21.1. New York: Marvel Comics. 2012.

206. Remender, Rick. Scalera, Matteo. *Secret Avengers* #32. New York: Marvel Comics. 2012.

207. Brady, Matthew. "Delivery Room." *Wizard* #72. pp 56-60. August 1997.

208. Busiek, Kurt. Bagley, Mark. *Thunderbolts* #10. New York: Marvel Comics. 1998.

209. Busiek, Kurt. Bagley, Mark. *Thunderbolts* #12. New York: Marvel Comics. 1998.

210. Busiek, Kurt. Bagley, Mark. *Thunderbolts* #13. New York: Marvel Comics. 1998.

211. Busiek, Kurt. Bagley, Mark. *Thunderbolts* #23. New York: Marvel Comics. 1999.

212. Busiek, Kurt. Bagley, Mark. *Thunderbolts* #25. New York: Marvel Comics. 1999.

213. Busiek, Kurt. Bagley, Mark. *Thunderbolts* #30. New York: Marvel Comics. 1999.

214. Nicieza, Fabian. Bagley, Mark. *Thunderbolts* #50. New York: Marvel Comics. 2001.

215. "Thunderbolts." Marvel Universe Wiki. Marvel Comics. Web. 27 Sept. 2014. <http://marvel.com/universe/Thunderbolts>.

216. Parker, Jeff. Sepulveda, Miguel. *Thunderbolts* #141. New York: Marvel Comics. 2010

217. Way, Daniel. Dillon, Steve. *Thunderbolts*, Vol. 2 #1. New York: Marvel Comics. 2013.

218. Acker, Ben. Blacker, Ben. Sandoval, Gerardo. *Thunderbolts*, Vol. 2 #28. New York: Marvel Comics. 2014.

219. Warner, Kara. "Guardians of the Galaxy Interview: James Gunn Talks Sequel & Secret End Credits Scenes." Screen Rant. 23 July 2014. Web. 27 Sept. 2014. <http://screenrant.com/guardians-of-the-galaxy-2-james-gunn-post-credits/>.

220. Englehart, Steve. Milgrom, Al. *West Coast Avengers* #17. New York: Marvel Comics. 1987.

221. Englehart, Steve. Milgrom, Al. *West Coast Avengers* #18-23. New York: Marvel Comics. 1987.

222. Byrne, John. *West Coast Avengers* #43-44. New York: Marvel Comics. 1989.

223. Walker, Karen. "Shattered Dreams: Vision and the Scarlet Witch." *Back Issue* #45. Raleigh, NC: TwoMorrows, 2010. 59-65.

224. Beard, Jim. "Avengers Classics: Visionquest." Marvel.com. Marvel Comics, 7 Oct. 2011. Web. 06 Oct. 2014. <http://marvel.com/news/comics/16792/avengers_classics_visionquest>.

225. "Avengers West Coast." Marvel Universe Wiki. Marvel Comics. Web. 27 Sept. 2014. <http://marvel.com/universe/Avengers_West_Coast>.

226. Bendis, Brian Michael. Coipel, Olivier. *Siege* #4. New York: Marvel Comics. 2010.

227. Rogers, Vaneta. "Ed Brubaker Tries to Keep the Secret Avengers Secrets." Newsarama. 9 February 2010. Web. <http://www.newsarama.com/4704-ed-brubaker-tries-to-keep-the-secret-avengers-secrets.html> 14 Oct 2014.

228. "Serpent Crown." Marvel Universe Wiki. Marvel Comics. Web. 07 Sept. 2014. <http://marvel.com/universe/Serpent_Crown>.

229. Brubaker, Ed. Deodato, Mike. *Secret Avengers,* Vol. 1 #2. New York: Marvel Comics. 2010.

230. Remender, Rick. Zircher, Patrick. *Secret Avengers*, Vol. 1 #21.1. New York: Marvel Comics. 2012.

231. Spencer, Nick. Ross, Luke. *Secret Avengers*, Vol. 2 #1. New York: Marvel Comics. 2013.

232. Spencer, Nick. Ross, Luke. *Secret Avengers*, Vol. 2 #1-5. New York: Marvel Comics. 2013.

233. O'Neil, Dennis. Kirby, Jack. Whitney, Ogden. *Strange Tales*, Vol. 1 #149. New York: Marvel Comics.

234. Lee, Stan. Colan, Gene. *Tales of Suspense*, Vol 1 #84. New York: Marvel Comics. 1966.

235. Lee, Stan. Colan, Gene. *Tales of Suspense* #79. New York: Marvel Comics. 1966

236. Lee, Stan. Colan, Gene. *Captain America,* Vol. 1 #133. New York: Marvel Comics. 1971.

237. Gruenwald, Mark. Neary, Paul. *Captain America,* Vol. 1 #313. New York: Marvel Comics. 1986.

238. "Skrulls" Marvel Universe Wiki. Marvel Comics. Web. 07 Oct 2014. <http://www.marvel.com/universe/Skrulls>

239. Thomas, Roy. Buscema, Sal. *Avengers* #89. New York: Marvel Comics. 1971.

240. Thomas, Roy. Buscema, Sal. *Avengers* #90. New York: Marvel Comics. 1971.

241. Thomas, Roy. Buscema, Sal. *Avengers* #91. New York: Marvel Comics. 1971.

242. Thomas, Roy. Buscema, Sal. *Avengers* #92. New York: Marvel Comics. 1971.

243. Thomas, Roy. Adams, Neal. *Avengers* #93. New York: Marvel Comics. 1971.

244. Thomas, Roy. Adams, Neal. Buscema, John. *Avengers* #94. New York: Mavel Comics. 1971.

245. Thomas, Roy. Adams, Neal. *Avengers* #95. New York: Mavel Comics. 1972.

246. Thomas, Roy. Adams, Neal. *Avengers* #96. New York: Mavel Comics. 1972.

247. Thomas, Roy. Buscema, John. *Avengers* #97. New York: Mavel Comics. 1972.

248. Shooter, Jim. Zeck, Michael. *Marvel Super Heroes Secret Wars*, Vol. 1 #1. New York: Marvel Comics. 1984.

249. Ibid.

250. Shooter, Jim. Layton, Bob. *Marvel Super Heroes Secret Wars* #5. New York: Marvel Comics. 1984.

251. Shooter, Jim. Zeck, Michael. *Marvel Super Heroes Secret Wars* #10. New York: Marvel Comics. 1985.

252. Shooter, Jim. Zeck, Michael. *Marvel Super Heroes Secret Wars* #11. New York: Marvel Comics. 1985.

253. Shooter, Jim. Zeck, Michael. *Marvel Super Heroes Secret Wars* #12. New York: Marvel Comics. 1985.

254. Howe, Sean. *Marvel Comics: The Untold Story.* New York: Harper, 2012. p. 264-265

255. Raphael, Jordan, and Tom Spurgeon. *Stan Lee and the Rise and Fall of the American Comic Book.* Chicago: Chicago Review, 2003. p. 204.

256. Irving, Christopher, and Seth Kushner. "Jim Shooter's Secret Origin, in His Own Words - Part One." *Graphic NYC.* 20 July 2010. Web. 02 Oct. 2014. <http://www.nycgraphicnovelists.com/2010/07/jim-shooters-secret-origin-in-his-own.html>.

257. Howe, Sean. *Marvel Comics: The Untold Story.* New York: Harper, 2012. p. 175

258. Ibid, p. 210.

259. Martin, Robert Stanley. "Jim Shooter—A Second Opinion, Part One: The Best Job He Can." *The Hooded Utilitarian.* 7 Jan. 2013. Web. 02 Oct. 2014. <http://www.hoodedutilitarian.com/2013/01/jim-shooter-a-second-opinion-part-one-the-best-job-he-can/>.

260. Ibid.

261. Howe, Sean. *Marvel Comics: The Untold Story.* New York: Harper, 2012. p. 219-220

262. Ibid. p. 300

263. Beard, Jim. "Avengers Classics: The Korvac Saga." Marvel.com. Marvel Comics, 30 July 2010. Web. 1 Oct. 2014. <http://www.marvel.com/news/comics/avengers_classics_the_korvac_saga>.

264. Shooter, Jim. Perez, George. *Avengers* #168. New York: Marvel Comics. 1978.

265. Shooter, Jim. Mantlo, Bill. Wenzel, David. *Avengers* #174. New York: Marvel Comics. 1978.

266. Howe, Sean. *Marvel Comics: The Untold Story.* New York: Harper, 2012. p. 214.

267. Layton, Bob; Michelinie, David. *Iron Man* #124. Marvel Comics

268. "Iron Man (Anthony Stark) - Marvel Universe Wiki." Marvel.com. Marvel Comics, n.d. Web. 09 Aug. 2014.

269. Doran, Michael. "Director Jon Favreau Talks Iron Man 2, Avengers." Newsarama. N.p., 1 Oct. 2008. Web. 14 Aug. 2014. <http://www.newsarama.com/1166-director-jon-favreau-talks-iron-man-2-avengers.html>.

270. "Jarvis, Edwin." Marvel Universe Wiki. Marvel Comics, n.d. Web. 18 Aug. 2014. <http://marvel.com/universe/Jarvis%2C_Edwin>.

271. Nelson, Randy. "You'll Need To Assemble $113M To Buy Captain America's Avengers Mansion." Movoto. N.p., 2 Apr. 2014. Web. 13 Sept. 2014. <http://www.movoto.com/blog/novelty-real-estate/captain-america/>.

272. Schneider, Daniel B. "F.Y.I." *The New York Times.* 08 Feb. 1997. Web. 13 Sept. 2014. <http://www.nytimes.com/1997/02/09/nyregion/fyi-529508.html>.

273. Sanderson, Peter. *The Marvel Comics Guide to New York City.* New York. 2007. Gallery Books.

274. Nelson, Randy. "You'll Need To Assemble $113M To Buy Captain America's Avengers Mansion." Movoto. N.p., 2 Apr. 2014. Web. 13 Sept. 2014. <http://www.movoto.com/blog/novelty-real-estate/captain-america/>.

275. "Infinite Avengers Mansion." Marvel Universe Wiki. Marvel Comics, n.d. Web. 18 Aug. 2014. <http://marvel.com/universe/Infinite_Avengers_Mansion>.

276. "Underspace." Marvel Universe Wiki. Marvel Comics, n.d. Web. 18 Aug. 2014. <http://marvel.com/universe/Underspace>.

277. Irvine, Alexander. *Marvel Vehicles: Owner's Workshop Manual.* San Rafael, CA: Insight Editions, 2014. p. 28-29

278. Ibid. p. 32

279. Ibid. p. 33

280. Beard, Jim. "Avengers Classics: Acts of Vengeance | News | Marvel.com." Avengers Classics: Acts of Vengeance. Marvel Comics, 18 Feb. 2011. Web. 06 Oct. 2014. <http://marvel.com/news/comics/15242/avengers_classics_acts_of_vengeance>.

281. Byrne, John. *Avengers: West Coast* #53. New York: Marvel Comics. 1989.

282. Byrne, John. Ryan, Paul. *Avengers* #313. New York: Marvel Comics. 1990.

283. Gruenwald, Mark. Dwyer, Kieron. *Captain America* #367. New York: Marvel Comics. 1990.

284. Byrne, John. *Avengers: West Coast* #55. New York: Marvel Comics. 1990.

285. Michelinie, David. Larsen, Erik. *Amazing Spider-Man* #329. New York: Marvel Comics. 1990.

286. Englehart, Steve. Buscema, Sal. *Defenders*, Vol. 1 #8. New York: Marvel Comics. 1973.

287. Englehart, Steve. Brown, Bob. *Avengers*, Vol. 1 #116. New York: Marvel Comics. 1973.

288. Englehart, Steve. Brown, Bob. *Avengers*, Vol. 1 #118. New York: Marvel Comics. 1973.

289. Markstein, Don. "Captain Marvel" *Don Markstein's Toonopedia*. Web. 15 Oct 2014. <http://www.toonopedia.com/capmarv2.htm>

290. Lee, Stan. Colan, Gene. *Marvel Super-Heroes*, Vol. 1 #12. New York: Marvel Comics. 1967.

291. Conway, Gerry. Boring, Wayne. *Captain Marvel*, Vol. 1 #22. New York: Marvel Comics. 1972.

292. Starlin, Jim. *Captain Marvel*, Vol. 1 #29. New York: Marvel Comics. 1973.

293. Starlin, Jim. Englehart, Steve. *Captain Marvel*, Vol. 1 #33. New York: Marvel Comics. 1974.

294. Starlin, Jim. *The Death of Captain Marvel*. New York: Marvel Comics. 1982.

295. Stern, Roger. Green, Dan. *Doctor Stranger*, Vol. 2 #60. New York: Marvel Comics. 1983.

296. Stern, Roger. Buscema, John. *Avengers*, Vol. 1 #273-277. New York: Marvel Comics. 1986.

297. Stern, Roger. Buscema, John. *Avengers*, Vol. 1 #281-285. New York: Marvel Comics. 1987.

298. Ewing, Al. Land, Greg. *Mighty Avengers,* Vol. 2 #4. New York: Marvel Comics. 2014.

299. Thomas, Roy. Colan, Gene. *Marvel Super-Heroes*, Vol. 1 #13. New York: Marvel Comics. 1968.

300. Thomas, Roy. Kane, Gil. Buscema, John. Romita, John. *Captain Marvel*, Vol. 1 #18. New York: Marvel Comics. 1969.

301. Shooter, Jim. Perez, George, Layton, Bob, Michelinie, David. *Avengers*, Vol. 1 #200. New York: Marvel Comics. 1980.

302. Busiek, Kurt. Perez, George. *Avengers*, Vol. 3 #4. New York: Marvel Comics. 1998.

303. Busiek, Kurt. Perez, George. *Avengers*, Vol. 3 #7. New York: Marvel Comics. 1998.

304. Felder, James. Kavanagh Terry. Polina, Adam. Williams, Anthony. *The Rise of Apocalypse* #1-4. New York: Marvel Comics. 1996-1997.

305. Lee, Stan. Kirby, Jack. *Fantastic Four*, Vol. 1 #19. New York: Marvel Comics. 1963.

306. Thomas, Roy. Heck, Don. Roth, Werner. *Avengers Annual*, Vol. 1 #2. New York: Marvel Comics. 1968.

307. Busiek, Kurt. Davis, Alan. *Avengers*, Vol. 3 #41. New York: Marvel Comics. 2001.

308. Busiek, Kurt. Dwyer, Kieron. *Avengers*, Vol. 3 #54. New York: Marvel Comics. 2002.

309. Heinberg, Allan. Cheung, Jim. *Young Avengers*, Vol. 1 #1. New York: Marvel Comics. 2005.

310. Stern, Roger. Buscema, John. *Avengers*, Vol. 1 #267-269. New York: Marvel Comics. 1986

311. Remender, Rick. Duggan, Gerry. Kubert, Adam. *Uncanny Avengers*, Vol. 1 #8AU. New York: Marvel Comics. 2013.

312. Heinberg, Allan. Cheung, Jim. *Young Avengers*, Vol. 1 #1. New York: Marvel Comics. 2005.

313. Heinberg, Allan. Cheung, Jim. *Young Avengers*, Vol. 1 #2. New York: Marvel Comics. 2005.

314. Heinberg, Allan. Cheung, Jim. *Young Avengers*, Vol. 1 #3. New York: Marvel Comics. 2005.

315. Heinberg, Allan. Cheung, Jim. *Young Avengers*, Vol. 1 #5. New York: Marvel Comics. 2005.

316. Heinberg, Allan. Cheung, Jim. *Young Avengers*, Vol. 1 #6. New York: Marvel Comics. 2005.

317. Heinbeg, Allan. Cheung, Jim. *Avengers: The Children's Crusade* #1. New York: Marvel Comics. 2010.

318. Heinberg, Allan. Cheung, Jim. *Avengers: The Children's Crusade* #2. New York: Marvel Comics. 2010.

319. Heinberg, Allan. Cheung, Jim. *Avengers: The Children's Crusade* #3. New York: Marvel Comics. 2011.

320. Heinberg, Allan. Cheung, Jim. *Avengers: The Children's Crusade* #4. New York: Marvel Comics. 2011.

321. Heinberg, Allan. Cheung, Jim. *Avengers: The Children's Crusade* #5. New York: Marvel Comics. 2011.

322. Heinberg, Allan. Cheung, Jim. *Avengers: The Children's Crusade* #6. New York: Marvel Comics. 2011.

323. Heinberg, Allan. Cheung, Jim. *Avengers: The Children's Crusade* #7. New York: Marvel Comics. 2011.

324. Ibid.

325. Heinberg, Allan. Cheung, Jim. *Avengers: The Children's Crusade* #8. New York: Marvel Comics. 2012.

326. When Iron Lad returned to the future, a new version of the Vision was created based on Iron Lad's brainwaves and personality. The Vision wound up falling in love with and having a relationship with Cassie Lang, just as Iron Lad had. This romantic jealousy and rage over her death led Iron Lad to destroy what he perceived as a simple android copy of himself.

327. Heinberg, Allan. Cheung, Jim. *Avengers: The Children's Crusade* #9. New York: Marvel Comics. 2012.

328. Ibid

329. Interview with Roger Stern. O'Shea, Tim. "Marvel 75: When the Avengers Came Under Siege Pt. 1" Marvel.com. Marvel Comics. 20 Aug 2014. <http://www.marvel.com/news/23114/marvel_75_when_the_avengers_came_under_siege_pt_1>

330. Stern, Roger. Buscema, John. *Avengers* #273. New York: Marvel Comics. 1986.

331. Stern, Roger. Buscema, John. *Avengers* #274. New York: Marvel Comics. 1986

332. Beard, Jim. "Avengers Classics: Under Siege." Marvel.com. Marvel Comics, 2 Apr. 2010. Web. 11 Oct. 2014. <http://marvel.com/news/comics/11879/avengers_classics_under_siege>.

333. Stern, Roger. Buscema, John. *Avengers* #274. New York: Marvel Comics. 1986.

334. Stern, Roger. Buscema, John. *Avengers* #275. New York: Marvel Comics. 1986

335. Stern, Roger. Buscema, John. *Avengers* #276-277. New York: Marvel Comics. 1986

336. Stern, Roger. Buscema, John. *Avengers* #277. New York: Marvel Comics. 1986

337. Busiek, Kurt. Perez, George. *Avengers* Vol. 3 #20. New York: Marvel Comics. 1999.

338. Busiek, Kurt. Perez, George. Avengers Vol. 3 #21. New York: Marvel Comics. 1999.

339. Busiek, Kurt. Perez, George. *Avengers* Vol. 3 #22. New York: Marvel Comics. 1999.

340. Pak, Greg. Romita Jr., John. *World War Hulk* #1. New York: Marvel Comics. 2007.

341. Ibid.

342. Pak, Greg. Romita Jr., John. *World War Hulk* #2. New York: Marvel Comics. 2007.

343. Pak, Greg. Romita Jr., John. *World War Hulk* #3. New York: Marvel Comics. 2007.

344. Pak, Greg. Romita Jr., John. *World War Hulk* #4. New York: Marvel Comics. 2007.

345. Pak, Greg. Romita Jr., John. *World War Hulk* #5. New York: Marvel Comics. 2008.

346. Ibid.

347. Ibid.

348. Fleming, Michael. "Artisan Deal a Real Marvel." *Variety*. N.p., 16 May 2000. Web. 12 Aug. 2014. <http://variety.com/2000/film/news/artisan-deal-a-real-marvel-1117781709/>.

349. Fritz, Ben; Harris, Dana. "Paramount pacts for Marvel pix." *Variety*. N.p., 27. Apr. 2005. Web. 12 Aug. 2014.

350. Davis, Erik. "Captain America Casting: Channing Tatum and Ryan Phillippe Try Out." Fandango. N.p., 17 Mar. 2010. Web. 08 Sept. 2014. <http://www.fandango.com/movie-news/captain-america-casting-channing-tatum-and-ryan-phillippe-try-out-591945>.

351. Schwartz, Terri. "Chris Evans Reveals He Said 'No Thanks' To 'Captain America'" MTV News. N.p., 14 July 2011. Web. 08 Sept. 2014. <http://www.mtv.com/news/1667297/chris-evans-captain-america-audition/>.

352. Jensen, Jeff. "This week's cover: An exclusive first look at Captain America: The First Avenger." *Entertainment Weekly*. October 28, 2010.

353. Ibid.

354. Shooter, Jim. "Roy Thomas Saved Marvel." JimShooter.com. N.p., 5 July 2011. Web. <http://www.jimshooter.com/2011/07/roy-thomas-saved-marvel.html>.

355. Howe, Sean. *Marvel Comics: The Untold Story*. New York: Harper, 2012. p. 193

356. Shooter, Jim. "Roy Thomas Saved Marvel." JimShooter.com. N.p., 5 July 2011. Web. <http://www.jimshooter.com/2011/07/roy-thomas-saved-marvel.html>.

357. Roy Thomas interview. "'Roy the Boy' in the Marvel Age of Comics" *Alter Ego* #50. Raleigh, NC: TwoMorrows Publishing. 2005. p. 4

358. Spurlock, David J.; Buscema, John. *John Buscema Sketchbook*. New Jersey: Vanguard Productions. 2001. p. 6

359. John Buscema interview. Thomas, Roy. *Alter Ego*, Vol. 3 #13. Raleigh, NC: TwoMorrows Publishing. <http://twomorrows.com/alterego/articles/13buscema.html>

360. Stern, Roger. Buscema, John. *Avengers* #275. New York: Marvel Comics. 1987.

361. John Buscema interview. Thomas, Roy. *Alter Ego*, Vol. 3 #13. Raleigh, NC: TwoMorrows Publishing. <http://twomorrows.com/alterego/articles/13buscema.html>

362. Interview with Roger Stern. Cooke, Jon B. "Rog-2001: Sterno Speaks!" *Comic Book Artist* #12. Raleigh, NC: TwoMorrows Publishing. 2001.

363. Khoury, George. "Interview With Roger Stern, October 2006." Marvel Masterworks. Marvel Comics, Oct. 2006. Web. 14 Oct. 2014. <http://www.marvelmasterworks.com/features/int_stern_1006_3.html>.

364. Gruenwald, Mark. "Mark's Remarks" *Avengers* #288. New York: Marvel Comics. 1988.

365. George Perez interview. O'Neill, Daniel Patrick. "Career Moves" *Wizard* #35. New York: Wizard Entertainment. July 1994.

366. Sanderson, Peter; Gilbert, Laura. "1970s." *Marvel Chronicle A Year by Year History*. London: Dorling Kindersley. 2008. p. 171

367. Interview with George Perez. MacDonald, Heidi. Fantagraphics. 1985. *Titans Tower*. Web. 14 Oct. 14. <http://www.titanstower.com/focus-on-george-perez/>

368. Interview with Kurt Busiek. B., Sergio. *Comic Book Gazette*. 15 April 2006. Web. <http://freewebs.com/marvelgazette/interviews.htm#109788978>

369. Busiek, Kurt. "Biography" Busiek.com. Web. 14 Oct 2014. <http://www.busiek.com/site/biography/>

370. Busiek, Kurt. Perez, George. *Avengers*, Vol. 3 #1-3. New York: Marvel Comics. 1998.

371. Busiek, Kurt. Davis, Alan. Dwyer, Kieron. Reis, Ivan. Garcia Manuel. *Avengers*, Vol. 3 #41-55. New York: Marvel Comics. 2001-2002.

372. Busiek, Kurt. Stern, Roger. Pacheco, Carlos. *Avengers Unlimited* #1-12. New York: Marvel Comics. 1998-1999.

373. Busiek, Kurt. Perez, George. Vey, Al. *Avengers*, Vol. 3 #19-22. New York: Marvel Comics. 1999.

374. Englehart, Steve. "First Marvel Scripts I (uncredited)" Steve Englehart Official Site. Web. 18 Oct 2014. <http://www.steveenglehart.com/comic/First%20Marvek%20Scripts%20I.hmtl>

375. Howe, Sean. *Marvel Comics: The Untold Story*. New York: Harper, 2012. p. 126

376. Englehart, Steve. Perez, George. *Avengers*, Vol. 1 #141-144, #147-149. New York: Marvel Comics. 1975-1976.

377. Englehart, Steve. Heck, Don. *Giant-Size Avengers* #4. New York: Marvel Comics. 1975.

378. Englehart, Steve. Milgrom, Al. *West Coast Avengers* #17-23. New York: Marvel Comics. 1987.

379. Millar, Mark. Land, Greg. *Ultimate Fantastic Four* #21-23. New York: Marvel Comics. 2005.

380. Kirkman, Robert. Phillips, Sean. *Marvel Zombies* #1. New York: Marvel Comics. 2006.

381. Kirkman, Robert. Phillips, Sean. *Marvel Zombies* #2. New York: Marvel Comics. 2006.

382. Kirkman, Robert. Phillips, Sean. *Marvel Zombies* #3. New York: Marvel Comics. 2006.

383. Kirkman, Robert. Phillips, Sean. *Marvel Zombies* #2. New York: Marvel Comics. 2006.

384. Kirkman, Robert. Phillips, Sean. *Marvel Zombies* #3. New York: Marvel Comics. 2006.

385. Kirkman, Robert. Phillips, Sean. *Marvel Zombies* #4. New York: Marvel Comics. 2006.

386. Kirkman, Robert. Phillips, Sean. *Marvel Zombies* #5. New York: Marvel Comics. 2006.

387. Lee, Stan. Heck, Don. *Avengers*, Vol. 1 #13. New York: Marvel Comics. 1965.

388. Shooter, Jim. Byrne, John. *Avengers*, Vol 1. #164. New York: Marvel Comics. 1977.

389. Shooter, Jim. Byrne, John. *Avengers*, Vol 1. #165. New York: Marvel Comics. 1977.

390. Shooter, Jim. Byrne, John. *Avengers*, Vol 1. #166. New York: Marvel Comics. 1977.

391. Strom, Marc. "Marvel One-Shots: Expanding the Cinematic Universe." Marvel. com. Marvel Comics, 2 Aug. 2011. Web. 16 Oct. 2014. <http://marvel.com/news/ story/16398/marvel_one_shots_expanding_the_cinematic_universe#ixzz1XWSoJ8UQ>.

392. Johns, Geoff. Coipel, Olivier. *Avengers*, Vol. 3 #69. New York: Marvel Comics. 2003.

393. Johns, Geoff. Coipel, Olivier. *Avengers*, Vol. 3 #70. New York: Marvel Comics. 2003.

394. Lovett, Jamie. "Stan Lee Explains Why No Cameo In X-Men: Days Of Future Past." Comicbook.com. N.p., 27 May 2014. Web. 15 Oct. 2014. <http://comicbook.com/ blog/2014/05/27/stan-lee-explains-why-no-cameo-in-x-men-days-of-future-past/>.

395. Sullivan, Kevin P. "Here's The Real Story Behind Stan Lee's Deleted 'Guardians Of The Galaxy' Cameo." *MTV News*. Viacom, 4 Sept. 2014. Web. 15 Oct. 2014. <http://www. mtv.com/news/1920383/guardians-of-the-galaxy-stan-lee-cameo/>.

396. Busiek, Kurt. Pacheco, Carlos. *Avengers Forever* #1. New York: Marvel Comics. 1998.

397. Busiek, Kurt. Pacheco, Carlos. *Avengers Forever* #2. New York: Marvel Comics. 1999.

398. Busiek, Kurt. Stern, Roger. Pacheco, Carlos. *Avengers Forever* #4-7. New York: Marvel Comics. 1999.

399. Busiek, Kurt. Stern, Roger. Pacheco, Carlos. *Avengers Forever* #8. New York: Marvel Comics. 1999.

400. Busiek, Kurt. Stern, Roger. Pacheco, Carlos. *Avengers Forever* #12. New York: Marvel Comics. 2000.

401. Parker, Jeff. Kirk, Leonard. *Agents of Atlas* #1. New York: Marvel Comics. 2006.

402. Thibault, Jason. "Marvel's Talent Scout C.B. Cebulski Tells You How to Break Into Comics - Optimum Wound." Optimum Wound. N.p., 12 May 2010. Web. 25 Sept. 2014. <http://www.optimumwound.com/marvels-talent-scout-c-b-cebulski-tells-you-how-to-break-into-comics.htm>.

403. Cebulski, C.B. "C.B. Cebulski." Twitter. <http://www.twitter.com/cbcebulski>.

404. *First-of-Its-Kind Course to Examine 'Universe' of Cinematic Storytelling, Perspectives in Ongoing Marvel Films*. News Releases. University of Baltimore, 16 Sept. 2014. Web. 20 Sept. 2014. <http://www.ubalt.edu/news/news-releases.cfm?id=2086>.

405. Nicieza, Fabian. Kubert, Andy. *X-Men*, Vol. 2 #25. New York: Marvel Comics. 1993.

406. Lobdell, Scott. Waid, Mark. Kubert, Adam. Green, Dan. *Onslaught: X-Men* #1. New York: Marvel Comics. 1996.

407. Waid, Mark. Kubert, Andy. *X-Men*, Vol. 2 #55. New York: Marvel Comics. 1996.

408. Lobdell, Scott. Madureira, Joe. *Uncanny X-Men*, Vol. 1 #336. New York: Marvel Comics. 1996.

409. Loeb, Jeph. Churchill, Ian. *Cable,* Vol. 1 #35. New York: Marvel Comics. 1996.

410. David, Peter. Medina, Angel. *Incredible Hulk*, Vol. 1 #445. New York: Marvel Comics. 1996.

411. Ostrander, Jim. Lyle, Tom. *Punisher,* Vol. 3 #11. New York: Marvel Comics. 1996.

412. DeFalco, Tom. Pacheco, Carlos. *Fantastic Four*, Vol. 1 #416. New York: Marvel Comics. 1996.

413. Waid, Mark. Deodato Jr., Mike. *Avengers*, Vol. 1 #402. New York: Marvel Comics. 1996.

414. Lobdell, Scott. Waid, Mark. Kubert, Andy. *X-Men*, Vol. 2 #56. New York: Marvel Comics. 1996.

415. Lobdell, Scott. Waid, Mark. Kubert, Andy. Bennett, Joe. *Onslaught: Marvel Universe* #1. New York: Marvel Comics. 1996.

416. Ibid.

417. David, Peter. Larroca, Salvador. *Heroes Reborn: The Return* #4. New York: Marvel Comics. 1997.

418. Nyberg, Amy Kiste. "Comics Code History: The Seal of Approval." Comic Book Legal Defense Fund. Web. 12 Oct. 2014. <http://cbldf.org/comics-code-history-the-seal-of-approval/>.

419. "The Press: Horror on the Newsstands." *Time*. Time Inc., 27 Sept. 1954. Web. 12 Oct. 2014. <http://content.time.com/time/magazine/article/0%2C9171%2C820350%2C00.html>.

420. Thompson, Don. Thompson, Maggie. "Crack in the Code." *Newfangles* #44. Mentor, Ohio: D&M Thompson. February 1971.

421. Nyberg, Amy Kiste. "Comics Code History: The Seal of Approval." Comic Book Legal Defense Fund. Web. 12 Oct. 2014. <http://cbldf.org/comics-code-history-the-seal-of-approval/>.

422. O'Neil, Dennis. Adams, Neal. *Green Lantern/Green Arrow* #85-86. New York: DC Comics. 1971.

423. Weldon, Glen. "Censors and Sensibility: RIP, Comics Code Authority Seal Of Approval, 1954 - 2011." *NPR*. NPR, 27 Jan. 2011. Web. 12 Oct. 2014. <http://www.npr.org/blogs/monkeysee/2011/01/27/133253953/censors-and-sensibility-rip-comics-code-authority-seal-1954-2011>.

424. Yarbrough, Beau. "Marvel Bids Farewell to the Comics Code Authority, Reveals the Origin of Wolverine." *Comic Book Resources*. 17 May 2001. Web. 12 Oct. 2014. <http://www.comicbookresources.com/?page=article&id=232>.

425. Nyberg, Amy Kiste. "Comics Code History: The Seal of Approval." Comic Book Legal Defense Fund. Web. 12 Oct. 2014. <http://cbldf.org/comics-code-history-the-seal-of-approval/>.

426. Burgos, Carl. Everett, Bill. *Marvel Mystery Comics* #7-8. New York: Timely Comics. 1940.

427. Evanier, Mark. *Kirby: King of Comics*. New York: Harry N. Abrams. 2008. p. 112

428. Howe, Sean. *Marvel Comics: The Untold Story*. New York: Harper, 2012. p. 404

429. "Ultimate Universe." Marvel Universe Wiki. Marvel Comics, Web. 04 Oct. 2014. <http://marvel.com/universe/Ultimate_Universe>.

430. Bendis, Brian Michael. Maleev, Alex. *New Avengers: Illuminati* #1. New York: Marvel Comics. 2006.

431. Brady, Matt. "Illuminating the Illuminati with Brian Bendis." *Newsarama*. Tech Media Network, 11 July 2005. 3 Oct. 2014. <http://web.archive.org/web/20090214062949/ http://forum.newsarama.com/showthread.php/threadid/48704>.

432. Bendis, Brian Michael. Reed, Brian. Cheung, Jim. *New Avengers: Illuminati*, Vol. 2 #2. New York: Marvel Comics. 2007.

433. Hickman, Jonathan. Schiti, Valerio. *New Avengers,* Vol. 3 #19-23. New York: Marvel Comics. 2014

434. Bendis, Brian Michael. Maleev, Alex. *New Avengers: Illuminati* #1. New York: Marvel Comics. 2006.

435. Pak, Greg. Romita Jr., John. *World War Hulk* #4. New York: Marvel Comics. 2007.

436. Pak, Greg. Romita Jr., John. *World War Hulk* #5. New York: Marvel Comics. 2008.

437. Booker, M. Keith. *Encyclopedia of Comic Books and Graphic Novels.* p. 63. Santa Barbara, CA: Greenwood. 2010

438. Lee, Stan. Kirby, Jack. Romita Sr., John. *Daredevil* #13. New York: Marvel Comics. 1966.

439. Bendis, Brian Michael. Tan, Billy. *New Avengers* #41. New York: Marvel Comics. 2008.

440. Perez, George. Interview by David Anthony Kraft. *David Anthony Kraft's Comics Interview* #6. Fictioneer. August 1983.

441. O'Neill, Patrick Daniel. "Career Moves" (George Perez Interview). *Wizard* #35. New York: Wizard Entertainment. July 1994.

442. Howe, Sean. *Marvel Comics: The Untold Story.* New York: Harper, 2012. p. 119

443. Ibid, p. 121-122

444. Ibid. p. 215.

445. Hartlaub, Peter. "Cool Comic-book Films / Golden Age on Silver Screen for Marvel Heroes." *SFGate*. Hearst Communications, 28 Apr. 2002. Web. 01 Oct. 2014. <http:// www.sfgate.com/movies/article/Cool-comic-book-films-Golden-age-on-silver-2844167. php>.

446. Howe, Sean. *Marvel Comics: The Untold Story.* New York: Harper, 2012. p. 355

447. Ibid, p. 356.

448. Ibid. p. 426-427.

449. Lee, Carl. "Answered: Which Studios Own Which Marvel Characters." *Screen Rant*. Screen Rant, LLC, 4 June 2014. Web. 01 Oct. 2014. <http://screenrant.com/ marvel-comics-movies-characters-carl-6766/>.

450. Wakeman, Gregory. "Spider-Man, Avengers, X-Men Crossover Possible, Notes Kevin Feige." Yahoo Movies UK. 5 Nov. 2013. Web. 30 Sept. 2014. <https://uk.movies.yahoo. com/spider-man-avengers-x-men-crossover-possible-notes-191800081.html>.

451. Bowles, Scott. "Marvel's Chief: A Force Outside, 'a Kid Inside'" USATODAY.com. Gannett Co., 05 June 2003. Web. 01 Oct. 2014. <http://usatoday30.usatoday.com/life/ movies/news/2003-06-05-marvel_x.htm>.

452. Howe, Sean. *Marvel Comics: The Untold Story.* New York: Harper, 2012. p. 426

453. Ibid, p. 426-427

454. "Iron Man (2008) - Box Office Mojo." Box Office Mojo. IMDB.com, Inc., Web. 01 Oct. 2014. <http://www.boxofficemojo.com/movies/?id=ironman.htm>.

455. "Marvel's The Avengers (2012) - Box Office Mojo." Box Office Mojo. IMDB.com, Inc., Web. 01 Oct. 2014. <http://www.boxofficemojo.com/movies/?id=avengers11.htm>.

456. Gruenwald, Mark. "Avengers Assemble: Mark's Remarks." *Avengers* #269. New York: Marvel Comics. 1986.

457. Ibid.

458. Stern, Roger. Grant, Steven. Owsley, Jim. Camp, Bob. Kirby, Jack. Ditko, Steve. Colan, Gene. Buscema, John. Miller, Frank. *The Marvel No-Prize Book* #1. New York: Marvel Comics. 1983.

459. Michelinie, David. Larsen, Erik. *Amazing Spider-Man* #347. New York: Marvel Comics. 1991.

460. Brevoort, Tom. "Friday, 5:50." *Blah Blah Blog*. Marvel.com. Marvel Comics. Web. 11 Aug 2006. <http://www.marvel.com/blogs/Tom Brevoort/entry/396>

461. Mitchell, Lily. "Avengers-themed Cocktail Recipes." TheMoreIArty. N.p., 17 May 2012. Web. 03 Oct. 2014. <http://the more i arty.tumblr.com/post/23225882371/some-avengers-themed-cocktail-recipes-i-played>.

462. Strickland, Julianna, and Natasha Feldman. "The Avengers Chicken Shawarma." *Cinema & Spice*. Yahoo, 11 July 2013. Web. 1 Oct. 2014. <http://www.cinemaandspice.com/episode/the-avengers/the-avengers-chicken-shawarma>.

463. Opam, Kwame. "US Military's 'Iron Man' Armor Will Be Ready for Testing by June, Says Admiral." The Verge. Vox Media, 11 Feb. 2014. Web. 24 Sept. 2014. <http://www.theverge.com/2014/2/11/5402562/us-militarys-iron-man-armor-will-be-ready-for-testing-by-june-says>.

464. "'Avengers' Joke Skyrockets Shawarma Sales In Los Angeles." Http://www.tmz.com. N.p., 7 May 2012. Web. 23 Aug. 2014. <http://www.tmz.com/2012/05/08/avengers-movie-shawarma/>.

465. Breznican, Anthony. "Best of 2012 (Behind the Scenes): The Story of the After-credits Shawarma Scene in 'The Avengers' | EW.com." EW.com. *Entertainment Weekly*, 29 Nov. 2012. Web. 23 Aug. 2014. <http://insidemovies.ew.com/2012/11/29/avengers-shawarma-scene/>.

466. Ibid.

467. Miller, John J. "The 1900s: The Century in Comics." CBGXtra. N.p., 12 Dec. 2005. Web. 20 Aug. 2014. <http://www.cbgxtra.com/knowledge-base/for-your-reference/the-1900s-the-century-in-comics>.